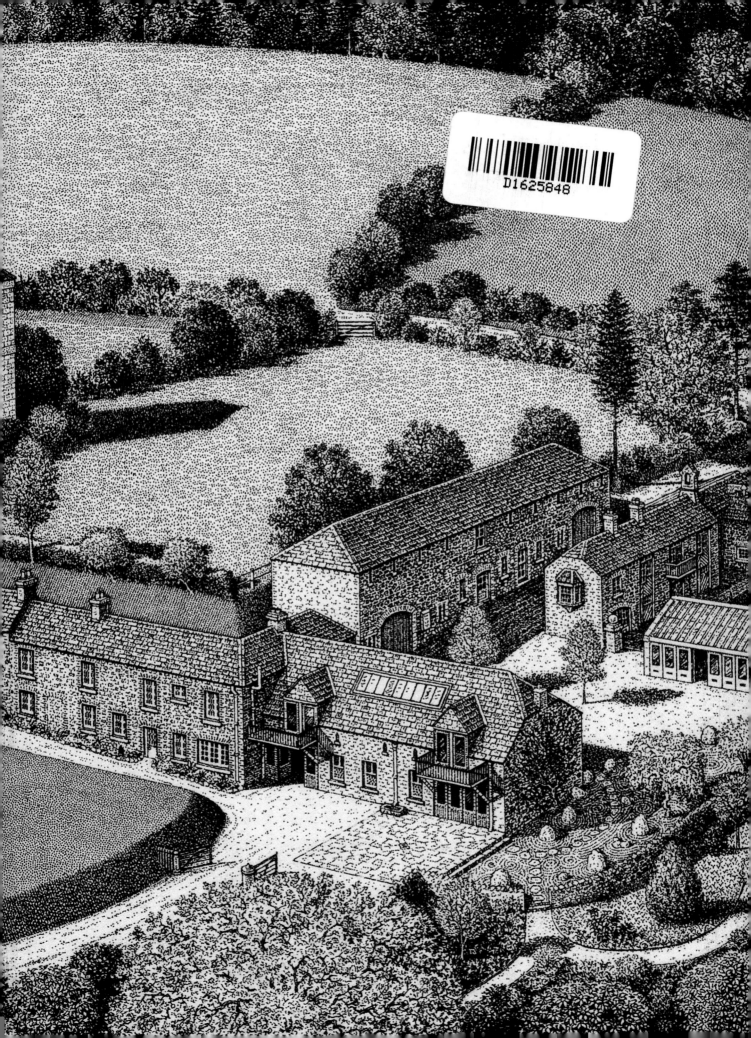

ANNAGHMAKERRIG

ANNAGHMAKERRIG

SHEILA PRATSCHKE

EDITOR

RUAIRÍ Ó CUÍV & EVELYN CONLON

ASSOCIATE EDITORS

THE TYRONE GUTHRIE CENTRE

in association with
THE LILLIPUT PRESS

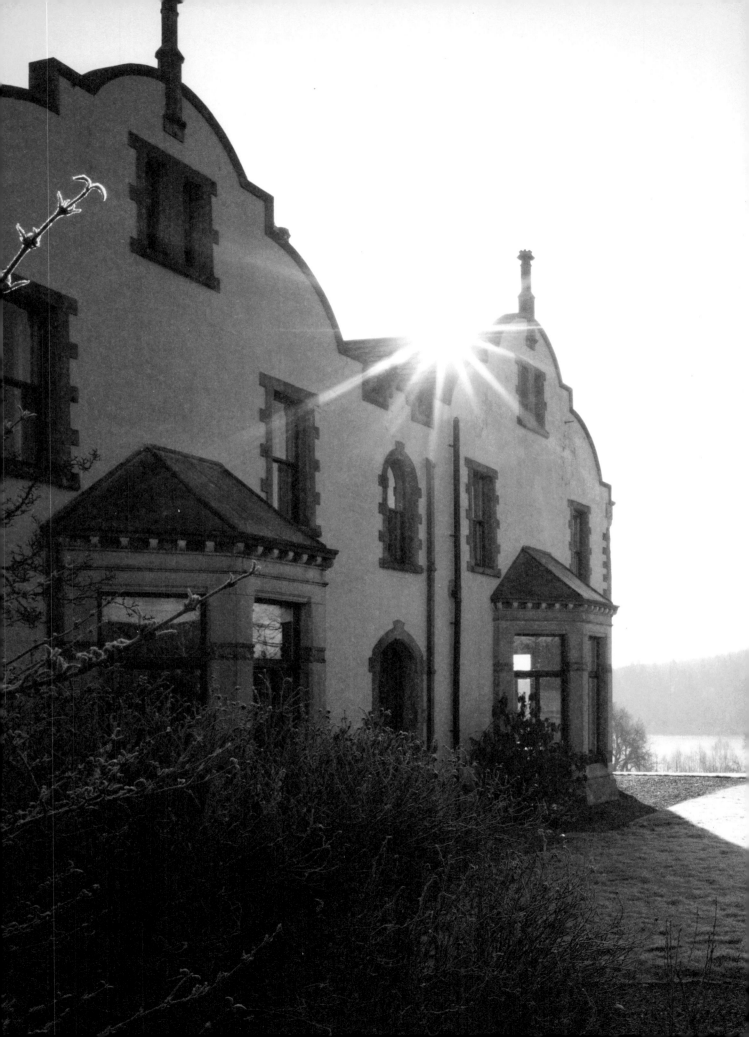

CONTENTS

III

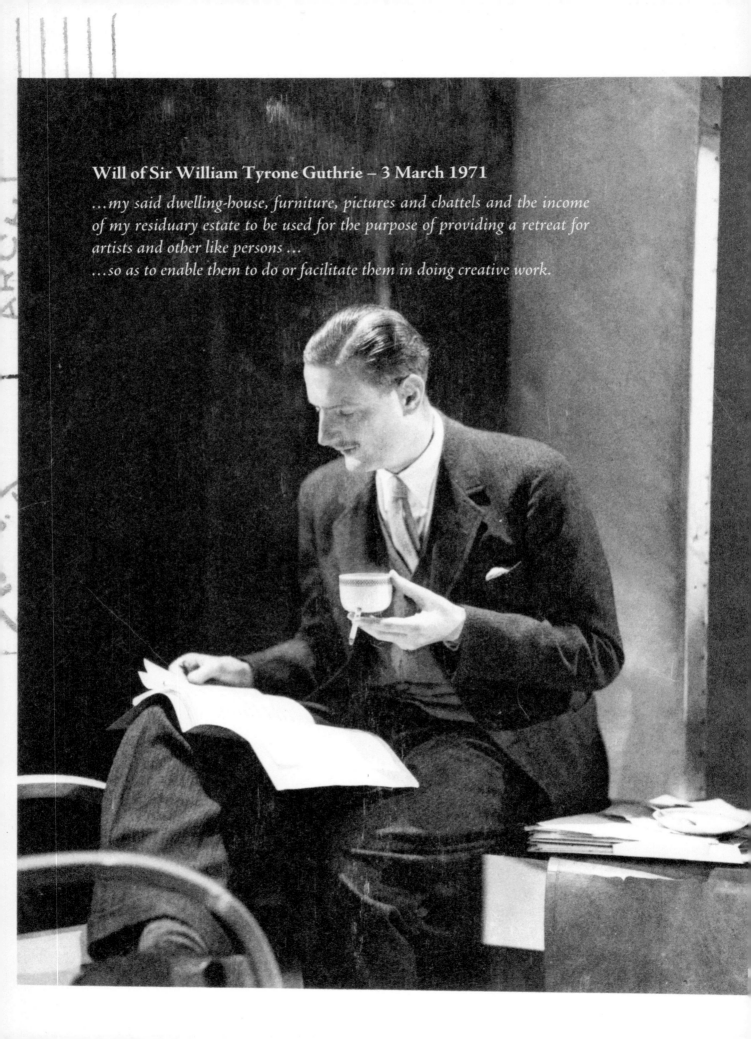

Will of Sir William Tyrone Guthrie – 3 March 1971

…my said dwelling-house, furniture, pictures and chattels and the income of my residuary estate to be used for the purpose of providing a retreat for artists and other like persons …

…so as to enable them to do or facilitate them in doing creative work.

I wanted a memorable book to celebrate twenty-five years of the Tyrone Guthrie Centre. If it could not be all-embracing in terms of resident artists, it should resonate with their dreams and creativity. All of us who have worked together at Annaghmakerrig should feel proud ownership of this book, just as we do of the house. I am happy that many old and new friends find a place here: the hundred or so whose work is represented and the thousands whose names are listed.

The isolation and unspoilt landscape of Annaghmakerrig make it a place where one's humanity is inseparable from the mysteries of nature, where instinct and intuition come to the surface with an unquestioned validity. Through the white gates one takes that liminal step into a world with its own rhythms and exigencies, where some certainties and securities allow for the most daring and exploratory of work. There is danger in the air where art is made. Sometimes artists need an Annaghmakerrig, a parallel universe where comfort and anxiety, conversation and silence, reassurance and challenge can be juggled in the company of fellow artists.

From delicate tools and wisps of paintbrush to grinder and power-saw; from silken threads and silver wire to the fleece of Jacob's sheep, mosses and lichens; from the cobwebs of ideas to the rich tapestry of a completed book or painting; from heart and mind to pages of writing and music; from beginning to end, from commencement to completion, the working artists of Annaghmakerrig have sustained its songlines in magical existence.

Some say it's the ley lines; it is certainly something to do with the people. On behalf of the artists, I pay tribute to Doreen, Ingrid, Teresa, Lavina, Teddy, Mary, Valerie, Martin and Denise who work here with me. As well as Mary and Bernard Loughlin, other staff had a long association with this place: Ann, Fred, Regina and others whose stay was shorter but nonetheless significant.

I am deeply grateful to Evelyn Conlon and Ruairí Ó Cuív, to Anne Brady and Antony Farrell – my wonderful collaborators on this project.

Above all, this book is an acknowledgement of the generosity of an extra-ordinary Monaghan family; of the bequest of its last son, Tyrone Guthrie, born with the twentieth century, his sister Peggy and both their partners – Judy Bretherton and Hubert Butler – who were all part of the dream. I hope that their gentle shades are pleased with the first twenty-five years of their great Annaghmakerrig project.

SHEILA PRATSCHKE **Director, Tyrone Guthrie Centre 2001–06**

I finally came to fully understand the value of the Tyrone Guthrie Centre two years ago, when I was asked to catalogue the visual arts collection. My experience of working there confirmed the notion I had that this is a magical place for artists.

Twenty-five years ago, I remember the excitement in the arts community when the Centre was established. I had just begun working with John Hunt installing art exhibitions up and down the country, meeting artists in their studios or in exhibition spaces. 1982 was a bleak year in Ireland but it was also a heady time. It seemed as if society was on the rack and yet there was increasing activity from within communities. One of these was the arts community where there was a growing belief that artists had an important role to play in society. So the opening of the Tyrone Guthrie Centre was a beacon of hope. The gift of the Centre was recognized for the fact that artists were placed centre stage; once there, the artist is in control, and this has been a dominant thought in my considerations for this book.

My attempt to reflect the twenty-five years of visual arts presence in Annagh-makerrig is grounded in research but is ultimately based on intuition. The fundamental issues were to choose a range of artists from the hundreds who have stayed over the years, to maintain gender balance while reflecting the north, south and international dimensions. My approach reflects the development of my knowledge through art history and through working with contemporary artists. My judgment shifts according to time and context. It is context that led me to the selection of artists in this book.

First and foremost I thought about how artists have used Annaghmakerrig. I have the sense from conversations, and even from the type of work in the art collection, that the Tyrone Guthrie Centre is a place to get away to, an opportunity to develop work and, most of all, a place to think. In making a selection, inevitably some are well known but I hope to surprise by other choices. I have picked artists who obviously have a deep affinity with Annaghmakerrig: those who have made repeat visits and, equally striking, the many who made once-off visits but had strong feelings about the place. So often their account of a time in Annaghmakerrig matched a notion I had about an important moment in their careers. I, of course, have focussed on artists whose work excites me. My interest in the diversity of arts practice is reflected in the styles and media with which they express themselves. Artists whose work is conceptual are an important part of my selection and I realize that my love of drawing is something I have indulged. Other images of art being made at Annaghmakerrig have not been curatorially selected.

I decided on a slightly hands-off approach to the actual choice of artworks for the book and I offered artists an opportunity to make their own selection. Most considered for themselves what should represent them while others wanted me to suggest work from a range of ideas. Many recounted personal stories of how the Centre had impacted on their lives, giving relief and stimulation (sometimes at times of great personal pressure), or igniting the spark of an idea which led to the creation of significant work.

Ultimately, I hope I have created a kaleidoscopic view of the Tyrone Guthrie Centre through the work of thirty-five visual artists.

RUAIRÍ Ó CUÍV **Associate Editor – Visual Art**

In the first days after agreeing to get involved with the compilation of this book I realized the near impossibility of the task, not from the scarcity of material from which to choose, but the opposite. How could anyone possibly select from all the work that has been conceived, begun, discarded and completed in this house? And the more I read the more overwhelmed I became. At some point I decided to try to get a sort of representation as opposed to an image. This too appeared almost impossible, because that would entail including not just what I might like or love but also what did not move me. Often the piece that does nothing for us is the one that secretly intrigues us – why does it move other people? The embarrassment of riches from which to choose almost tempted me to look for my hatpin. With the selection presented in these pages I hope that I have in some way done justice to all the people who have worked in Annaghmakerrig since the doors were first thrown open to artists. It is only a corner of the mirror, a truncated glimpse of the thousands of ventures that learned to stand on their shaky feet in the rooms of this house, and it could not be any more than that because of the lack of space.

The positive role that this workplace has played in so many lives cannot be remarked upon too often. We arrive, creative cases all, with the subject matter of despair or hope in our dreams. We begin the task of building an edifice for others to read, look at or listen to, one that flags our belief that it is indeed impossible to live by bread alone. The delicacy of the venture is given a hiding place. As the senses of priority are decided so the battleground of faith in the imagination is cleared. Assiduous shedding and re-organization goes on, all of it helped by the fact of the function of the place, which is to confirm the struggle for finding new names and new colours for sunsets. People come here, often anxiously, into the home of faded voices that mingle with the present. They come to reject the assurance of conformity and to get on with the work. Many leave drained and dazzled, a little like I feel as I hand over this selection. I would like to acknowledge the help given to me in the process of this work by Theo Dorgan, Rathmines Public Library and Agnes Rowley.

EVELYN CONLON **Associate Editor – Literature**

I

It was back in 1962. We were friendly with a law student called Henry Murphy who arrived one evening seeking refuge from what he called 'the Guthrie annual dinner'. A few questions and we discovered it was Tyrone Guthrie, the director, and that he (Guthrie) and Henry's father had known each other since childhood and were still friends. Why, we wanted to know, was Henry 'seeking refuge'?

'Because they keep booming away at each other about religion and poetry and sometimes Guthrie sings and the old man accompanies him with his pipe in his mouth, stuff like Thomas Moore's "Oft in the Stilly Night" and "Sweet Vale of Avoca". It's excruciating. The dog howls and has to be put out. Apart from that Guthrie's slightly unnerving.'

'In what way?'

'Because if he's not singing or talking about religion he sometimes questions me, a lot of questions I can't answer. He's like a cross between a psychiatrist and a headmaster and looks like an eagle. He's seven feet tall you know.'

'Ah, come on Henry!'

'Six feet six at least, huge.'

We talked some more. I poured Henry a generous libation before asking:

'Any chance of gate-crashing?'

'You'd like to meet him?'

'Very much so.'

And so we arrived. Henry's father was a solicitor with the unchristian name of Baldwin, a clear indicator of family politics, Redmondites, Castle Catholics, a left-over breed long since extinct. Dinner was at the port stage in the living room. There was no singing in progress and within minutes the conversation became animated. I remember asking Guthrie if he'd seen the photograph of Kenneth Tynan that week in *The Observer*. It captured Tynan with one eye watchful and knowing, the other slightly hooded and enigmatic. It was an interesting photograph.

'Do you think Tynan's good?'

'I think he's great.'

'A critic? Great! Are you serious? They're all eunuchs, some more perceptive than others but eunuchs nonetheless ... more creativity in a nursery rhyme than anything most of them manage to churn out.'

Straightaway the modulated voice, the force of personality, the instinct to dispute and electrify (shock) was in that first response. I was too startled to disagree, being brought up to believe that you don't use words like eunuch in mixed company.

He then asked me if I'd read Tynan's attack on Truman Capote's *In Cold Blood*. No, I'd missed it.

'Tynan', he said, 'focussed on Capote's *use and abuse* of the two murderers for commercial gain and lacerated his callous indifference to their execution, bleating on about how a man with Capote's influence, connection and largesse should have tried to intervene and save them; fraudulent stuff from beginning to end. Capote's response was witty and devastating. It made Tynan seem like a hypocrite and marked very clearly the difference between a critic and a creative writer.'

Years later I thought it curious that in James Forsyth's biography *Tynan* is not mentioned in the Index.

Even at the time I felt the sharpness of that response was in some way personal. It didn't change my opinion about Tynan. He was by far the most original and perceptive critic of that time.

'Enough about *Mister* Tynan. What do you do to earn your crust, Eugene?'

'I'm a farmer,' I said, which is what I put on my passport.

'And a writer,' Baldwin boomed. 'Eugene has written stories and a television Christmas play about a parish priest and a tinker. I found it very affecting.'

I didn't dare look at Guthrie but heard him ask:

'And are you writing now?'

'No.'

'And why is that?'

'I'm milking cows.'

'Do you like milking cows?'

'I quite like it.'

'More than writing?'

'I haven't thought about it.'

Henry was right. He was like a psychiatrist, all questions and implied judgment. I felt I was expected to go away and rationalise about the direction of my life. As they were leaving I asked if he'd like to see some of the stories I'd published in small magazines.

'No,' he said,'I'd like to see a *new* story and we must talk again. You'll come over some evening. Bring the new story with you and read it to us.'

And so ended that first meeting. I was quite certain we'd never see or hear from him again. Then a postcard arrived. As he met us at the door of Annaghmakerrig he asked:

'Did you bring your new story?'

'I thought you were joking.'

'I never joke about writing.'

Thereafter we met here at Drumard or at Annaghmakerrig, infrequently because he was away so much directing plays, opera and pageants in America, Europe, Australia and, alongside this work-load, founding the Guthrie Theatre in Minneapolis, which proved to be a triumph against all the odds and continues to flourish as one of the great theatres of the world. It's almost unbelievable that one man could initiate and accomplish so many brilliant and varied productions in such a short span.

A little aside here that doesn't appear in Forsyth's or Guthrie's autobiography. We were talking about Patrick White's *The Aunt's Story* and *Riders in the Chariot,* which we both admired. White had won the Nobel Prize for Literature. I'm not certain how they got into contact in Australia but Guthrie was invited to an early dinner that was being prepared by White's male partner. During this pre-dinner period he was asked if he would care to look at the draft of a play White was working on. He was then left alone in a study with the draft which was, he said, full of wonderful prose, none of it remotely dramatic. They agreed not to talk about it during dinner, after which he was ushered back to the study and left to complete reading the work. 'Tough going,' he said, 'very tough going.'

An hour later he came back to the dining room.

The partner had cleared the table. Patrick White was waiting alone at the far end with pen and note book.

The first thing we need, I said, is a good red pencil. I meant that as a warning shot across the bows but clearly he didn't pick up on it. He fought tooth and nail to retain every suggested cut till finally I gave up. We read it through again and I went back

to my hotel baffled and exhausted. It may be that some day it'll be produced and recognized as a masterpiece but I very much doubt it.'

The point of his anecdote was that a man of White's stature can be so besotted with his own creation that he can't take advice from someone who knows every aspect of theatre and is also a script doctor second to none.

Throughout those last ten years of his life the story he first requested from me became a stage play, which he disemboweled in a long constructive letter urging me to put it aside as derivative and start a different work. 'Do keep writing,' he urged me. 'You can write. Not too many can.'

A year later he was on the panel of the first Irish Life Drama Awards. The plays were submitted anonymously. Out of 169 submissions *King of the Castle* came a unanimous first. He had no idea I'd written it and sent a warm, congratulatory telegraph from America.

It was first produced at the Gaiety in the Dublin Theatre Festival of 1964. The critics in general praised it. The public in general sat in uneasy silence. The league of decency paraded outside with placards. *Philadelphia Here I Come* followed and was hugely and rightly enjoyed by both critics and public. It was the launching pad for Friel's extraordinary career as a master dramatist, a writer more than deserving of the Nobel Prize.

I wrote another play called *Breakdown* (1966), which got its first reading at Annaghmakerrig with T.P. McKenna, an actor friend, Guthrie and myself.

I remember after the reading Guthrie pursed his lips and uttered a slow *Yaas*, which I gradually learned to interpret as 'Yes and No'.

It was produced at the Gate, televised and disappeared, a very contemporary attack on Fianna Fáil mohair suits and corrupt business practice. The accountant in the play was called C.J. Shine! It was all too obvious.

As I type this piece Mister Haughey is being buried.

In the last production of *King of the Castle* at the Abbey there was a line cut as meaningless despite my protests:

> Pull down a horseman and when you're at his throat you'll get some Scober
> in the saddle.

In the context of the play and the period it meant:

Get rid of the old colonial masters and you'll get a greedy, crooked Haughey type on horseback to replace them. No better, no worse. Man and womankind are much of a muchness everywhere, in every period of history.

The following year, 1967, was the tri-centenary of Jonathan Swift's birth. There were worldwide productions, memorial documentaries, seminars and academic works flowing from universities. Old plays were being revived, new ones written. I was fascinated by *Gulliver's Travels* and the little I knew of Swift's astonishing life.

I wondered about a play and started reading. I talked with Guthrie.

'Don't read the critics,' he said. 'With rare exceptions they write lit jargon for each other. Read the man himself, his correspondence and a couple of biographies. That should get you going.'

'The correspondence,' I said, 'runs to three bulky volumes.'

'Will you have *time* to farm, research and write?'

'I can try.'

He then mentioned that he was contracted next to directing a James Bridie play at the Citizens' Theatre in Glasgow where I was born and had lived for ten years. Given

that fact he could try to get me a bursary from the Scottish Arts Council and arrange that I be attached to the Citizens' as an observer. It was an offer I couldn't refuse. These proposals were put into the pipeline immediately.

I sold the cows, closed the house and we (my wife Margot and four children) went to live for six months in an apartment of the house I was born in:

<div align="center">

Innisfree

Milrig Road

Mill Street

Rutherglen

</div>

When I was a child I remember our telephone number was Rutherglen 60. Hard to believe now that there was ever such a two-digit number in that vast, sprawling city, but then it was a very long time ago, the thirties. There were three murders the week we arrived.

I sat in on many productions. There were two memorable ones, a truly magical *Tempest* which went on to London to great acclaim and packed houses. In Glasgow it had played to virtually empty houses. Then there was Guthrie directing Bridie's play *The Anatomist*, a work he had directed back in 1931 at the New Westminster Theatre, a black play about body snatching (Burke and Hare were real people) and murder. It was full of macabre humour, boisterous shouting and some really scary scenes. He relished every minute of rehearsal and so did the actors. It was a revelation to see him work when he was happy. He had chosen his cast carefully and gave only the faintest hints. There were no 'profound' speeches or tedious analysis, just winks of encouragement. At most he'd cross the floor, take an actor gently by his or her arm and talk quietly as they listened, nodding. It was very clear that they didn't just respect him; it was something more akin to veneration. The banter during tea breaks was wonderful. He could do a Scottish accent effortlessly.

That production was a huge success. The Lord Mayor held a special dinner to honour the great-grandson of the Reverend Thomas Guthrie D.D. whose statue adorns Princes Street in Edinburgh alongside Walter Scott. It was a very posh affair followed by laudatory speeches.

Then Guthrie stood up to reply. He lambasted the invited guests. He 'could see', he said, 'dripping diamonds' and sense bulging wallets and was aware of all the Rolls Royces parked outside. 'Glasgow', he went on to say, 'was reputed to be the second city of a now expiring Empire, a city which cannot even support a theatre in the heart of the Gorbals and if I have described Belfast as a cultural Sahara let me say now that Glasgow is, at present, a cultural slum.'

He then sat down. Not being there I don't know if there was a stunned silence, tepid applause or the now compulsory 'standing ovation'. The latter I doubt very much. He was with us for lunch the next day. I'd heard and asked him about the dinner. He shrugged dismissively. 'I may have drunk too much whiskey.'

We came back to Drumard in May of 1968.

I remember sitting outside as dawn was breaking, absorbing everything I could see and hear around me for hours. Just being home. That was when I realised yet again the heartbreak that permeates Chekhov's *Cherry Orchard*. To leave the place you've known and loved deeply must be a form of dying and for Guthrie Annaghmakerrig had associations that went back not only to childhood but for centuries. He was conscious that his thousand acres with its forest and gracious house above the long lake was what historians call 'escheated land' and that the native Irish had been there a long, long time before English maps and boundaries were drawn up. He wasn't sure, he said, where the rock in the river was but he loved the sound of Anna-Ma-Kerrig.

'It has a soft beginning and a hard ending, like life itself!'

Later, as Chancellor of Queen's, he caused great upset by saying publicly:

'How would you feel if the Germans came here in 1940 and stayed for 400 years?' A simplistic, shock-tactical thing to say, but deliberately said. A few days later a heavyweight delegation came down from Queen's and asked him to resign. He said if he was caught telling lies he'd resign but not for asking a question intended to help. When comes such another?

Swift was completed and tried out at the Belfast Arts Festival 1968. It was read by actors from the combined English National and Abbey Theatres. Colin Blakeley took the lead with an emotional intensity not normally associated with first readings. Guthrie sat aside from the actors describing scene settings.

What I remember about Belfast was the warm involvement of an attentive audience. Joe Tomelty sitting in front of me whispered to the man beside him: 'I'd like to have written that.' Seán Ó Riada came to both readings. We were friendly in U.C.C. He sat high up in the lecture hall with his back to the performance for the second reading. 'Why?' I asked him afterwards. 'I wanted to hear it without the distraction of actors; it's disturbing stuff.'

A year later the Abbey production was a travesty. MacLiammóir playing Swift was almost blind. He had to learn the lines with a succession of readers repeating the lines over and over. The rehearsal period was extended from three to six weeks. It was not a happy time. Swift's anguish and incisive wit became blurred into great baroque gestures, guttural mutterings and headshakings, wonderful in themselves but not remotely connected with what was written, no sense of a man losing his mind in a morass of tormenting memories. A great actor miscast. Certainly it was impossible not to like him greatly but 'the play is the thing' and for me the production of that play was a nightmare.

The response was predictable. Almost every reviewer and commentator used the word 'rambling' or 'old-fashioned' with the exception of Christopher Fitz-Simon who fastened on MacLiammóir's misinterpretation.

Swift's will fascinated Guthrie:

> He gave what little wealth he had
> To build a house for fools and mad
> And showed by one satiric touch
> No nation needed it so much.

His bequest of Annaghmakerrig to the nation was influenced by Swift's gesture. It was during a rehearsal lunch break that he had a thirty minute meeting with Haughey, then Minister for Finance. They discussed details of Annaghmakerrig House being left to the nation as an Arts Centre. He was adamant that the Arts Councils north and south should work together in the running of the Centre, dispensing bursaries to artists on a pro rata basis. Haughey agreed.

When I asked how the meeting had gone he said:

'It was as if I was *asking* a favour not *giving* a gift!'

He then asked me if I'd ever met Haughey.

'No,' I said, 'and have no wish to.'

'A reptilian little man,' he muttered, not a snap judgment easily forgotten.

I came back to my border farm swearing I'd never, ever write another play. I would milk cows and write prose that no one could mutilate on a stage and that is what I began to do.

Guthrie at this time had become deeply and financially involved with a jam factory called Farmhouse Preserves. The aim, far from making money, was philanthropic: to create work in the fruit fields and give employment locally in the disused railway station which he converted. The office was in the high signal box where (when not abroad) he strode about dictating letters that were chatty and un-businesslike.

It was probably the most exotic, eccentric office in the world and part of him delighted in that. I put a share of money into the venture as requested but hesitated about planting a field of raspberries. When he asked why I said I had reservations about the man he'd employed to run the business.

'For example?'

'I've never heard *anyone* speak well of him.'

'That's of no consequence.'

He was wrong. He told or wrote Friel that the jam factory was the most important production of his life. When it went very wrong it literally broke his heart, 'the hard ending'.

Meantime I'd written *Cancer,* the first story of the *Victims* Trilogy, and was embarked on the second when that unmistakable voice came on the phone to say he'd been asked by the New Zealand Arts Council to commission a work based on the old morality play *Everyman.* He'd been in touch with Alec Guinness who'd said yes to the lead. The money involved was substantial. Would I like to think about it? Meantime he wrote:

'It can't be a play in the strict sense, more a pageant, hopefully far removed from the commercial theatre, a universal work dealing with the big themes, love and hate, war and peace, life and death, God and the religions with their crazy histories, the here and now and the hereafter if there be such overcrowded mansions in the universe! What do you think? My feeling is it's very much the sort of work you should attempt. Peggy saw your *Pageant* directed by Barry Cassin in Limerick Cathedral and was hugely impressed.'

I knew that he knew I was licking my wounds after *Swift.* He also knew I'd written a story meantime and asked me to bring it and read it. This I did. *Cancer* dealt with sectarian hatred and two brothers who were jealous of each other. As always he listened very attentively.

'That gets it but I wonder about the mix of the human and the political?'

We then talked about the *Everyman* project for New Zealand. Had I given it any thought?

I said I'd jotted down ideas, a rough outline, which was true, but I did not say it wasn't *working* in my imagination, which had already moved onto *Heritage,* the second story of the *Victims* Trilogy.

Three days later he was dead.

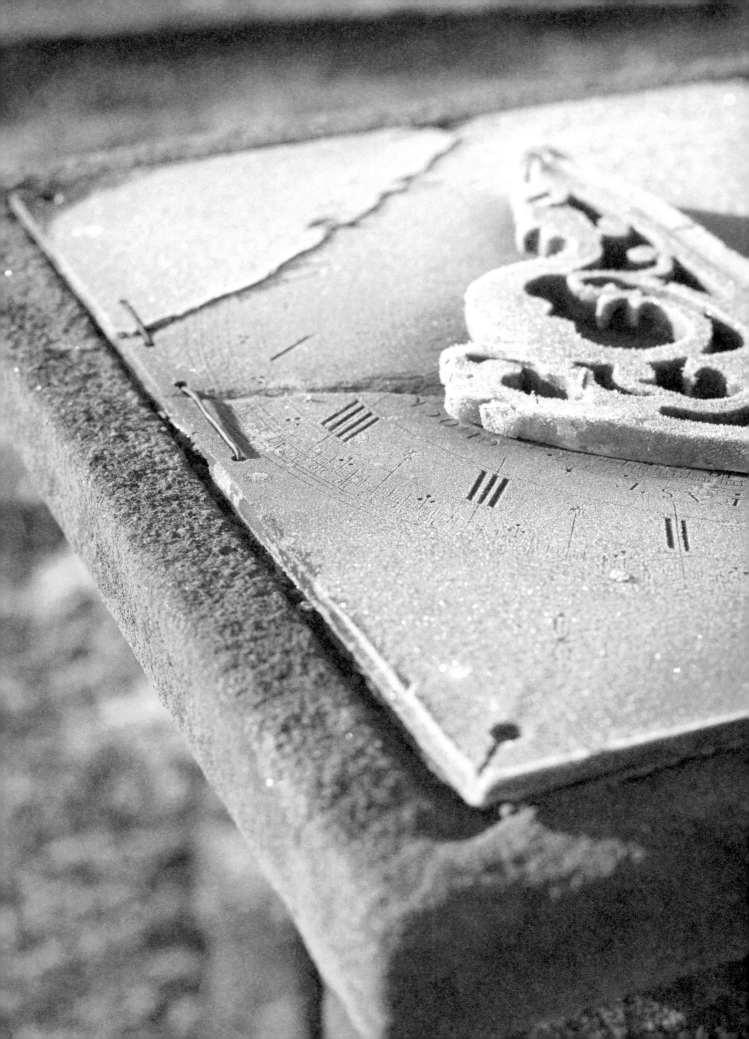

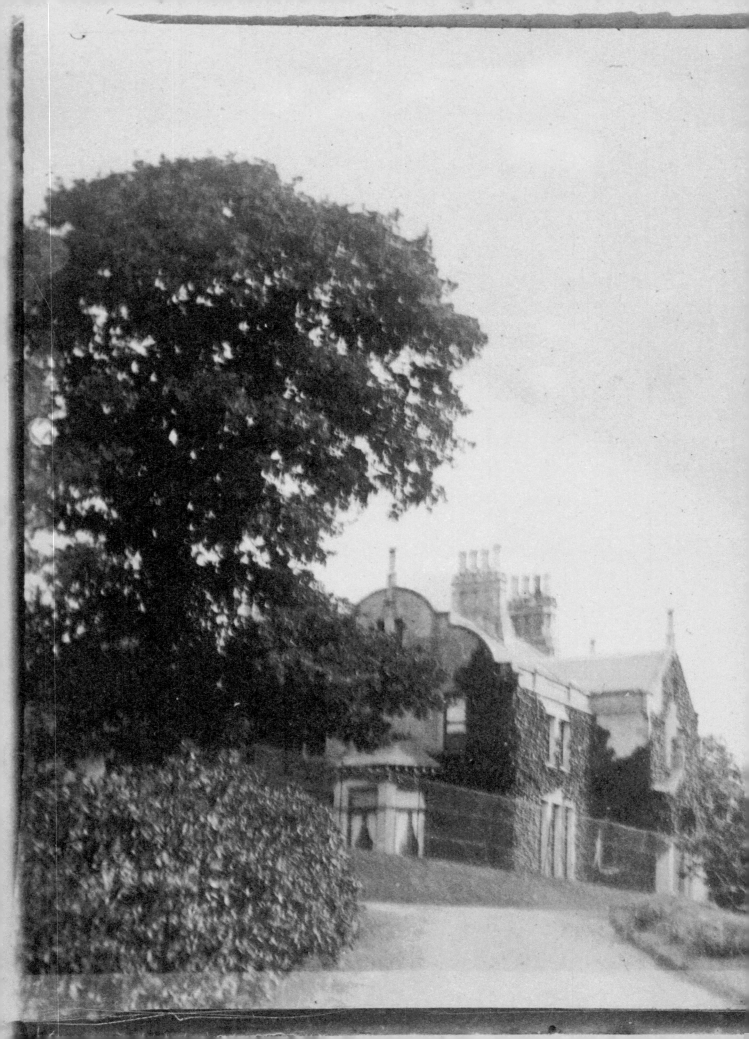

But for me, at that point, there were the beginnings of life in two very different worlds. Since Hubert Butler's father was still alive – as a somewhat disturbed old man living at Maidenhall in the south – I was first taken north with the Butlers, to live at Annagh-makerrig in Co. Monaghan. This was the family house of Peggy's mother, Norah Power, before she married Dr Guthrie, an Edinburgh physician who had moved his practice to Tunbridge Wells. But on his early death in the late 1920s, Mrs Guthrie, partly blind now, returned to live at Annaghmakerrig. Peggy and Tony had spent their childhood holidays here, and loved the place, and after their father died the house in Tunbridge Wells was sold and Annaghmakerrig became the Guthrie family home.

By the time I arrived there, late in 1939, old Mrs Guthrie – Mrs G as she was always called – lived there with her tiny tidy Yorkshire nurse-companion, Miss Worby, known as Bunty, with a fair deal of help inside and outside the house, for it was a large house and, in those days, a working farm and estate.

Annaghmakerrig was, and still is, a lovely, winding corridored, secret cubby-holed, Victorian house, with many variously angled roofs and rounded gable ends in the Dutch manner, set on a hill in rhododendron blooming grounds, overlooking a big lake, and surrounded by fir and pine forests. A touch of Bavaria. In winter one expected snow and glittering ice on the lake.

Indeed that was my first experience of Annaghmakerrig, during the icy snowbound winter of 1940: a horse pulling a big wooden sleigh drawing up at the front door steps – that, and being pushed about, with other children, on nursery chairs over the frozen lake, while the adults skated around us. And later summers there, playing in a wooden Wendy House on the front lawn under the big sycamore tree – a little house called 'Rosebud'.

Years later, when I first saw *Citizen Kane*, I was reminded of my early years at Annaghmakerrig. In those last images of the burning sleigh and the melting letters of its name, 'Rosebud', I had a sudden memory of my own childhood at Annaghmakerrig.

Afterwards, living at Maidenhall, we children only went to Annaghmakerrig for Christmas and summer holidays. So the place was always a great treat. Looking back I'm a little surprised at this, for Annaghmakerrig was a household where a formal order prevailed, very different from the informal, workaday world I came to know later at Maidenhall. At Annaghmakerrig there was a precise Victorian manner of things, a nineteenth century air and ethos, serenely, not to say strictly maintained in the house and on the estate – an almost feudal world which continued there for fifty years after Queen Victoria had died. The house and its inhabitants were imbued with things and thoughts Victorian – by way of the heavy drapes and furnishings, the red bound copies of *Punch* and the *Illustrated London News* in the morning room, paintings of farm animals and bewhiskered nineteenth century military ancestors: permeated especially by the Protestant work and self-help ethic, where pleasure was always to be earned, where it was not merely incidental, chanced on in pursuit of some much more serious goal.

And yet the pleasure for us children there was often incidental and unearned. It lay all around us – through the winding corridors, endless rooms and attics of the house and about the wider estate. And when Bob Burns, Mrs G's chauffeur/handyman, met us at Newbliss off the Dundalk train in the immaculate, leather-smelling green

Austin and the house finally reared up across the lake over the last hill, I always felt a thrill of pleasure for the impending adventure and surprises.

I was lucky indeed, living there in my early years and afterwards at Maidenhall – all unaware of my real background, of my grandfather in Dublin, coming to fear every knock on the door, the postman as stork, delivering another baby; of my mother an office wage slave, filing papers nine-to-five, and my father holding up four ale bars in London and Cheltenham.

Annaghmakerrig then – moated by lakes, remotely distant beyond its three avenues, inviolate behind its fir-clad hills, boggy fields and brackish canals – was a dream kingdom, a view of the exotic over that last hill. And the whiff of this, too, in winter, once up the steps and into the big hall; the smell of Aladdin oil lamps and candle wax, for this was the only form of lighting in the house until the 1950s.

Settled and secure, the house offered both mystery and comfort – the soft carpeted, lamp-lit rooms, warmed by log fires, where from pools of rose-gold light shadowy spaces ran away everywhere, down long corridors into ghost-haunted nooks and crannies, hidden rooms filled with novelties, secrets. In winter the house was clearly divided between light and dark, just as the seasons of our visits were equally extreme, divided into either midwinter or midsummer holidays. We children never knew the place in its rehearsal seasons of spring and autumn. For us when we arrived, the curtain was always about to rise on Christmas or the play was in full summer swing.

Which season offered the better drama? Winter was the more obviously exciting, with its central drama of Christmas itself. But the teasing prelude was almost as good. Dumb Crambo and charades – getting dressed up in the hall from boxes of Victorian finery and tat. Children's parties – musical chairs to the dance of 'The Dashing White Sergeant', from the cabinet gramophone; 'Oranges and Lemons say the Bells of Saint Clements', the procession through a pair of arched arms where you were trapped on the last words of 'Here comes a candle to light you to bed, Here – comes – a – chopper – to – chop – off – YOUR HEAD!'

And then the long woolly stocking at the end of the bed on Christmas morning, waking early in the dark, the thrill of touching its bulky folds, but resisting it until dawn; simple wartime fillers in the event, pencils and sharpeners, a notebook, a torch, an apple. The thrill was in the earlier unknowing.

And later the opening of the real presents, that evening round the fir tree in the study at the end of the hall: the magic of the candles all over it, the intoxicating smell of melting wax and warmed fir needles. And finally the heart-stopping moment when the piles of labelled brown paper parcels under the tree could be set upon and fiercely unwrapped. Though the brown paper and every bit of string had to be kept, afterwards to be folded and the string wound up in balls by Mrs Guthrie.

If Christmas at Annaghmakerrig, with its silks of Araby in the charades, its décor of tinsel and coloured streamers, its warm perfumes of wax, fir and almond cake icing, had a touch of *A Thousand and One Nights*, our summer holidays were straight out of *Swallows and Amazons*. The drama moved from the house to the lake – a windblown watery theatre: boating, bathing, fishing, picnicking.

There were two heavy rowing boats and big crayfish under the stones in the shallow water by the boathouse. So that to avoid what I understood to be their fierce pincers I soon learnt to swim, surging away as quickly as possible into deeper waters. Again, the spaces of the lake, like those of the house, always beckoned: an equal

invitation to promote our fantasies. For the lake was silent and private then, a water which we children could make over entirely in our own images, living Ransome's books in reality, or creating our own fictions, as explorers and cartographers, making for secret waters, compassing the island on stakes, the prow of the boat pushing through a carpet of waterlilies there; or daringly swimming beneath them, seeing the tangle of their long slimy stems sinking from the sunlit surface into the greeny-black depths – the sudden fear of sinking too far, of drowning in the forested underworld, these realms of the big fish that had snatched at the legs of Jeremy Fisher.

Life at Annaghmakerrig made the heart beat faster. My own real family, or what little I knew of it, faded into the background. Instead, at Maidenhall and Annagh-makerrig, I found two much more engaging families. And in Tony Guthrie, a father figure no doubt.

By the time I arrived at Annaghmakerrig in 1940, he was the well-known theatre producer and administrator of the Old Vic and Sadler's Wells in London. And during the next few years, up on holidays from Maidenhall, Tony and his wife Judy would come over from London for a few days, and always at Christmas, and then there would be the real 'drama', for me and the other children staying in the house.

Dressed up for charades, waiting in the hall before making our entrances into the drawing room – Tony or Peggy or her great friend Ailish Fitzsimon directing us, to see that we made our entrances at exactly the right moment. And although we children knew nothing of real theatre then there was a theatrical heightening of reality, a mood of sudden invention flooding the staid Victorian house, with Tony master of the revels, alchemist in the dross-to-gold department.

Tony was a transforming influence for me. It was from him, over the next few years at Annaghmakerrig that I had the first intimations that life need not be unhappy, dull, difficult, penny-pinching – that in the stage setting of the house with its Victorian props and costumes, life could be 'produced' to show a much more significant, exciting side; that in Tony's inventive hands it could be transfigured into all sorts of magic, when the workaday would be banished in the cause of illusion. And just as importantly, I came to see that all this make-believe world was valid (which other grown-ups were wont to deny – 'Don't tell lies, Joe!') since the fun and games were promoted by this scion of the family, this more than adult, this giant visiting uncle. Tony was six foot six in his socks.

He towered over everything. Eyes narrowed from the smoke from a dangling cigarette, pondering some dramatic plan – anything, as I see it now, which would kick ordinary life in the pants, or celebrate it, or alter it entirely. There wasn't a moment to waste in this transformation of the mundane, nothing of life that couldn't be got at, tinkered with, transformed by his vital spirit into something unexpected, astonishing, spectacular. Everything was prey to his inventions. Evenings, taking to the soft-toned Bluthner piano in the drawing room, he would sing with his high voice old ballads with exaggerated relish, a Thomas Moore melody or 'The Skye Boat Song'. Or just as suddenly, in his quick military way, he would go to the cabinet gramophone, wind it up, put on a record and bring forth *The Pirates of Penzance*, annotating the songs mischievously, taking different roles, counterpointing the words in a basso profondo or an exaggeratedly high tenor voice.

A man overcome with endless schemes, fits of energetic, creative or sometimes destructive fever, whether directing us in our charades or in leading an attack on the garden scrub, with bonfires, the whole household commandeered, the grown-ups issued

with bow-saws, scythes and choppers, we children the lesser spear-carriers, as the wilderness rapidly diminished, the whole tiresome business made fun, produced as vivid spectacle, like the mob scene in *Coriolanus*.

'On! On!' he would shout, rising up suddenly from behind a bush like a jack-in-the-box, with a mock-fierce smile, urging us on, prophet-like, to smite the nettles and brambles – storming the barricades of convention, in life as in theatre, gathering up every sort of hungry cat and setting them among the complacent pigeons, to propose and often to achieve the unlikely or the impossible. Like Peggy and Hubert, he was another most unconventional figure whom I took courage from, in my own feelings of difference. I was lucky. Life at Annaghmakerrig became a repertory theatre for me, a cabinet of curiosities filled with surprises, which I could pick and finger and possess. A time of gifts indeed.

The First Appearance at the Edinburgh Festival

of

· ·THE SCOTTISH THEATRE

General Manager : COLIN WHITE

which presents

THE FIRST PRODUCTION SINCE 1554

of

ANE SATYRE OF

"THE THRIE ESTAITES"

by Sir David Lindsay of the Mount

Adapted by ROBERT KEMP Produced by TYRONE GUTHRIE

Costumes and Decor by MOLLY MacEWEN

Music specially composed by CEDRIC THORPE DAVIE

with

BRYDEN MURDOCH	DUNCAN MACRAE
LENNOX MILNE	ARCHIE DUNCAN
MOLLY URQUHART	PETER MACDONELL
JAMES GIBSON	CHARLES BROOKES
ANDREW GRAY	MOULTRIE KELSALL
DOUGLAS CAMPBELL	WALTER ROY
IAN STEWART	JEAN TAYLOR SMITH
Etc.	Etc.

First Performance

Tuesday, 24th August 1948

Then performances NIGHTLY at 7.30 until
11th September, with two Matinées each week
on Tuesdays and Saturdays at 2.30 p.m.

⑤

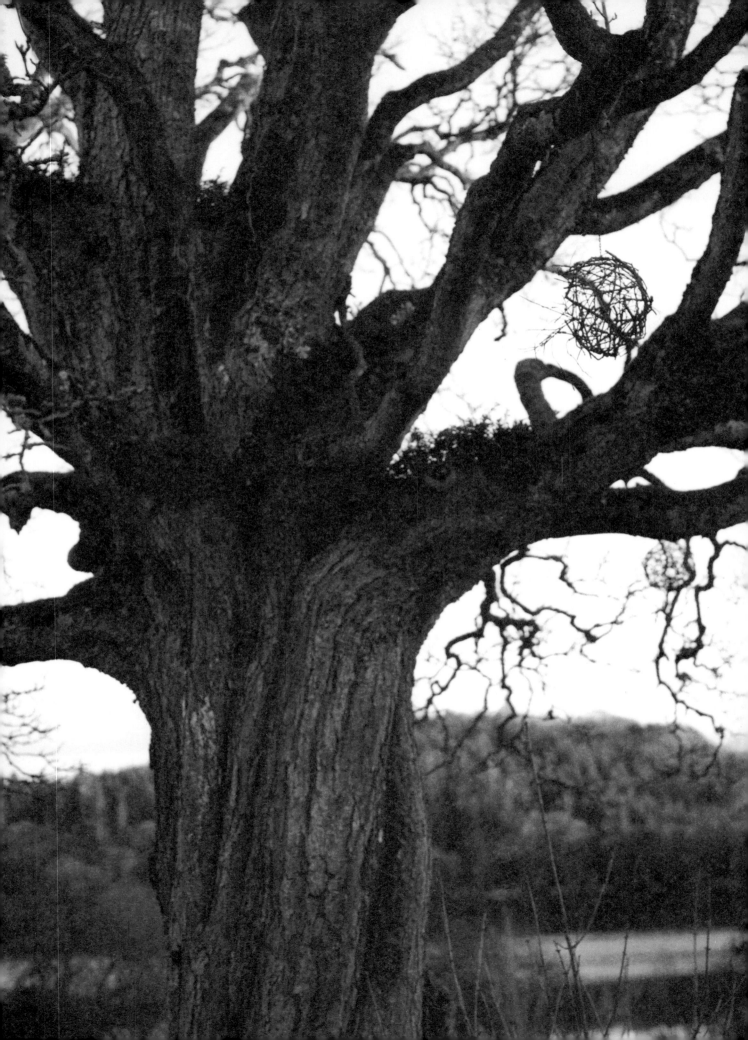

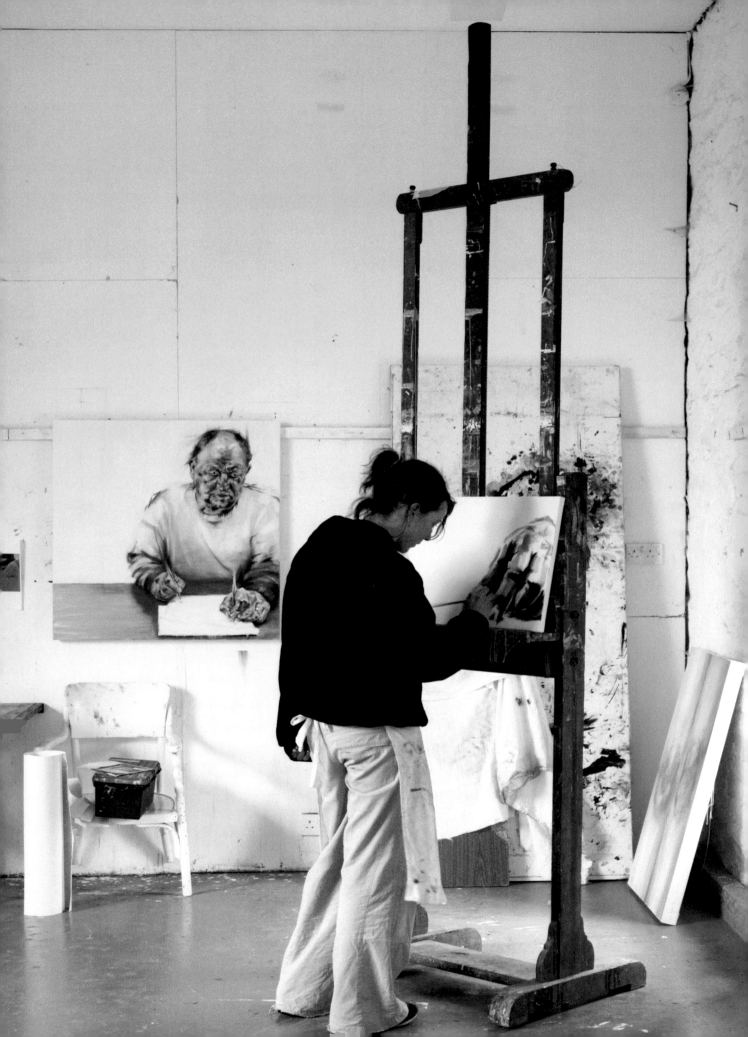

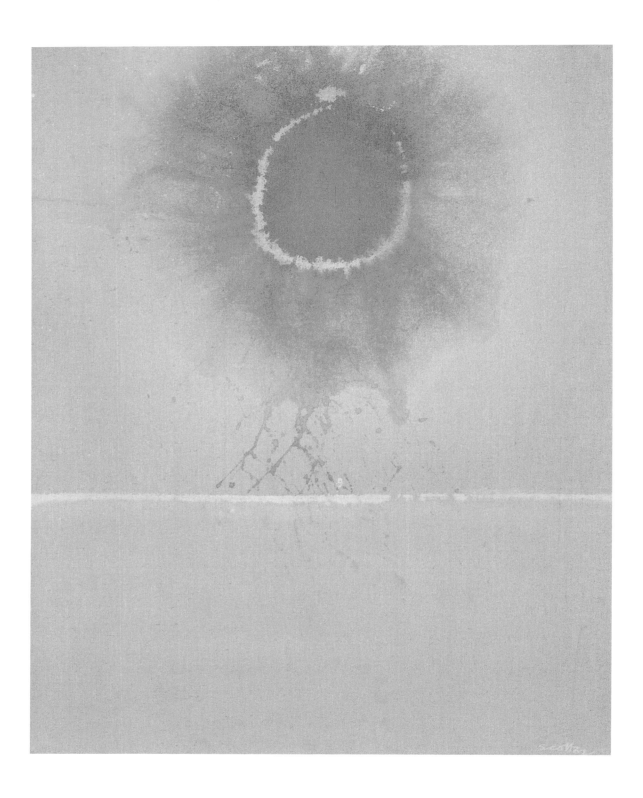

PATRICK SCOTT *Device*
c. 1962
Tempera on linen
122 x 82 cms

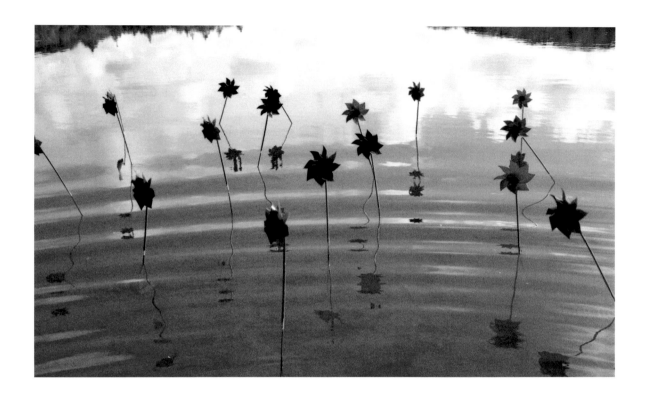

AIDEEN BARRY *Storm Reader*
(installation from the performance)
2004
Mixed media

CIARÁN LENNON *Folded*
1972, remake 2004
Folded linen steeped in acrylic
13 x 33 x 33 cms

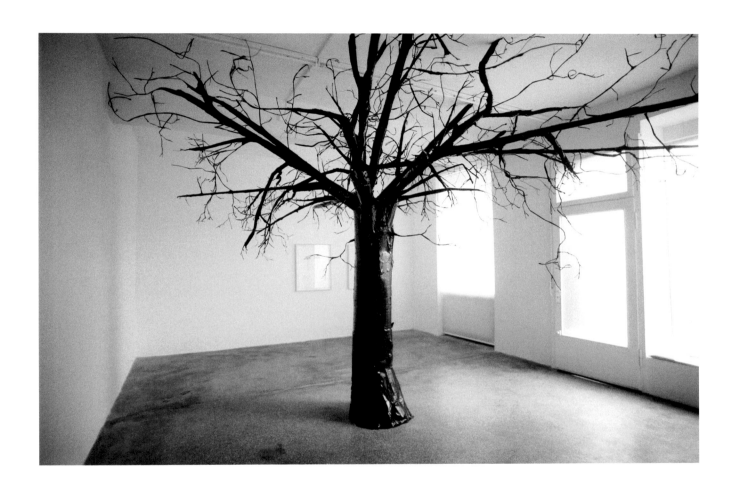

KATIE HOLTEN *One Fine Day*
2005
Tree constructed from cardboard, wood, wire and gaffer tape. Drawings: Ink on paper.
The Heins Schuermann Collection, courtesy VAN HORN, Düsseldorf
76 x 56 cms

MARK ORANGE *Untitled*
2001
35mm transparency
Variable

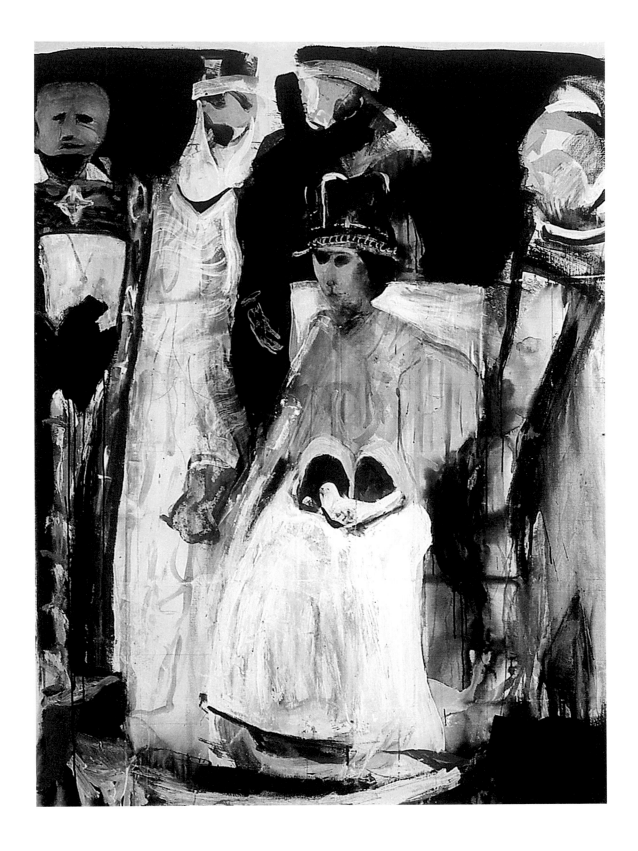

BRIAN MAGUIRE *Elizabeth at 18*
2003
Acrylic on canvas
183 x 135 cms

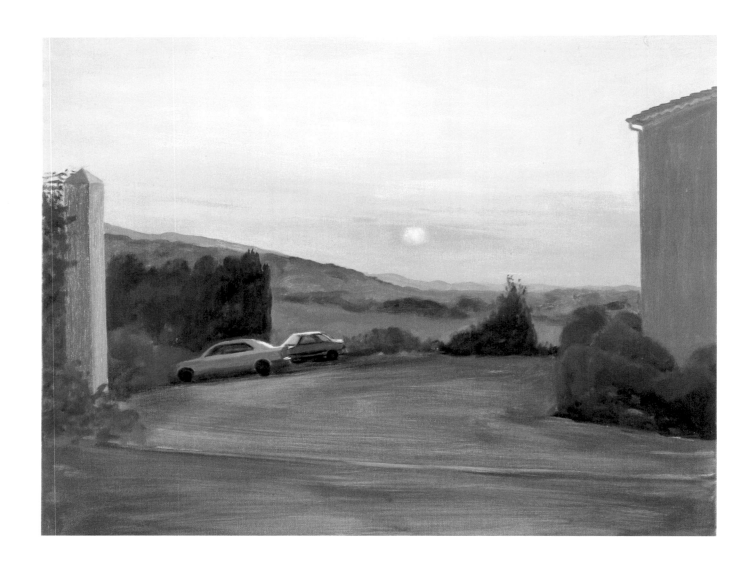

EITHNE JORDAN *Cars, Sunrise*
2005
Oil on linen
50 x 65 cms

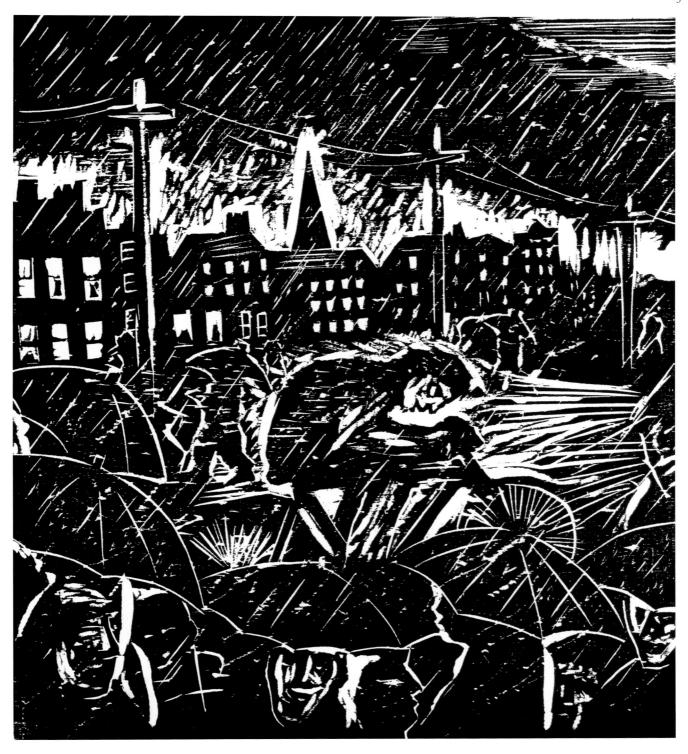

MICHAEL LYONS *from Ecce Huer*
2004
Woodcut
23 x 20.5 cms

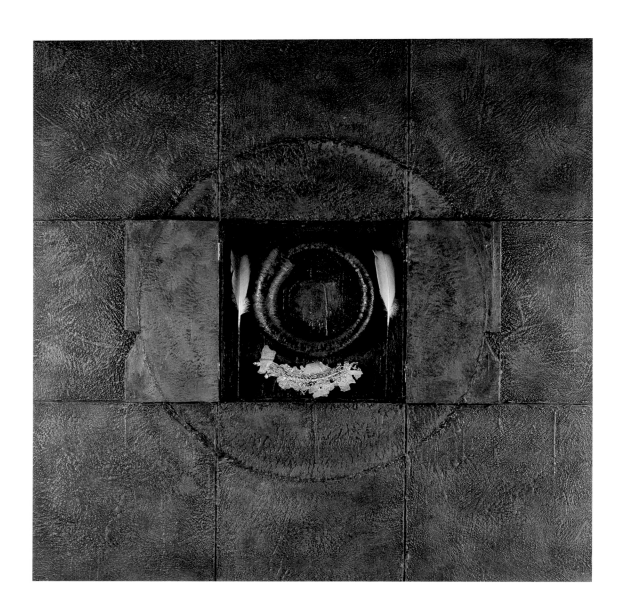

HELEN COMERFORD *Saturn*
(from Planetary Series)
2003
Encaustic painting, lead feathers,
graphite and wax
120 x 120 cms

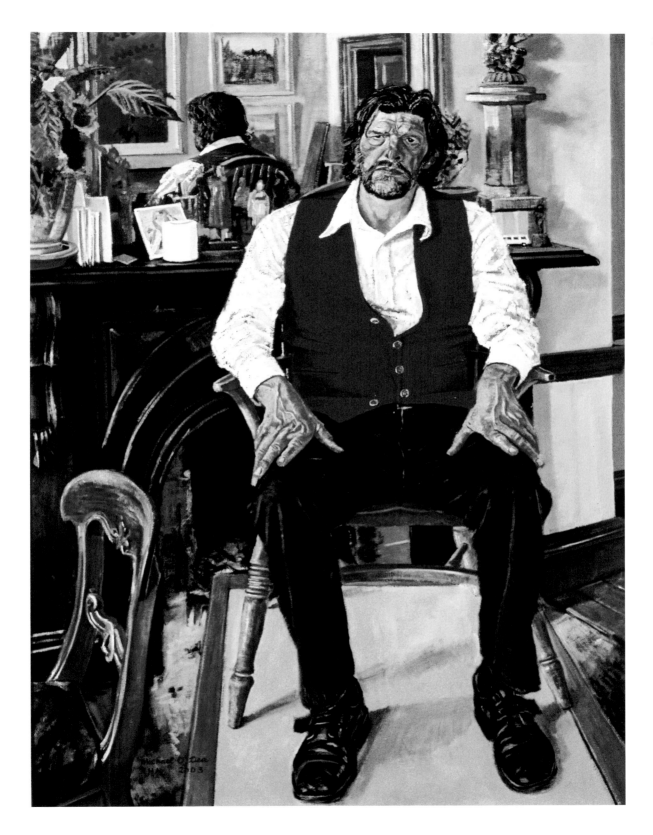

MICK O'DEA *Micheál O'Siadhail*

2004
Oil on linen
129.5 x 96.5 cms
Collection of the Crawford Municipal Art Gallery Cork

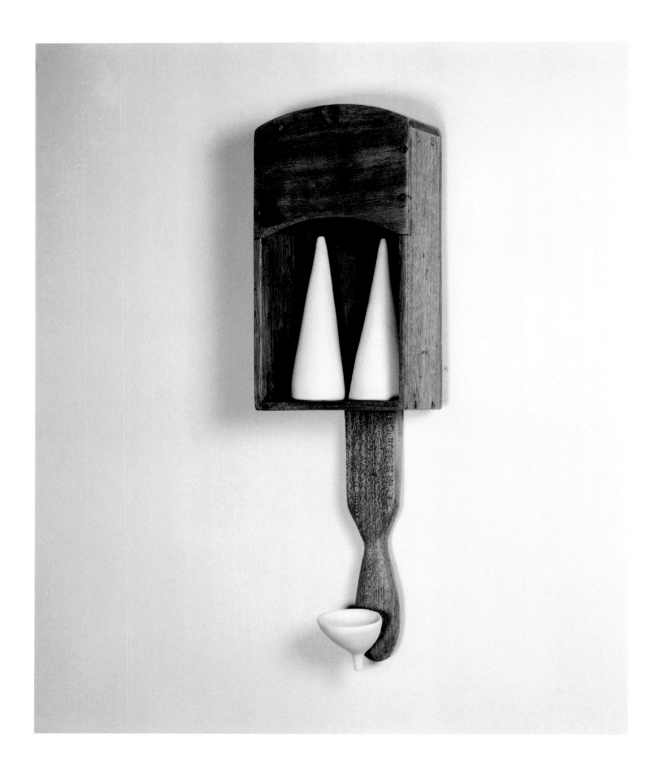

MARIE FOLEY *A Milk-Yielding Tree*
2002
Porcelain and wood
50 x 14 x 10 cms

LAURA GANNON *Stills from Emily's Notes*
2003
Super 8 film
Duration: 4 minutes

30

KATE BYRNE *2 + 2*
2005
Lambdachrome photographic print
122 x 140 cms

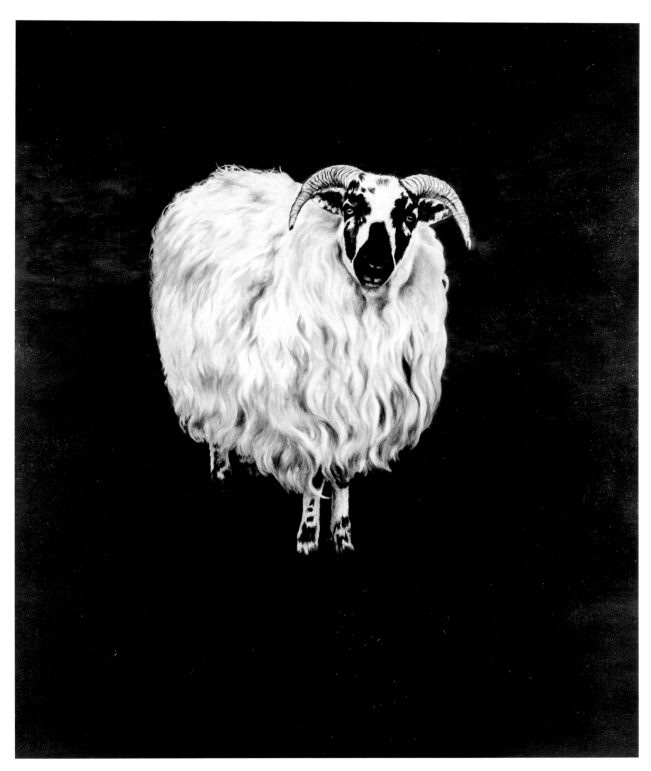

DERMOT SEYMOUR *Bogewe*
2001
Oil on canvas
183 x 153 cms

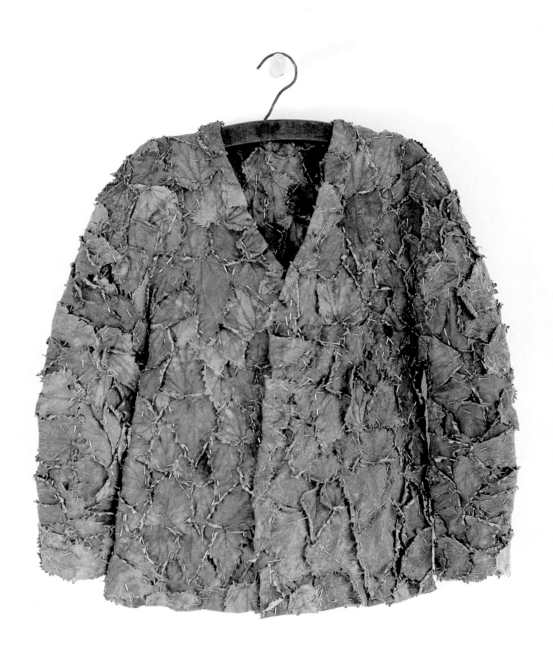

ALICE MAHER *Nettle Coat*

1995
Nettles, pins, coat-hanger
62 x 62 x 7 cms
The Arts Council/An Chomhairle Ealaíon

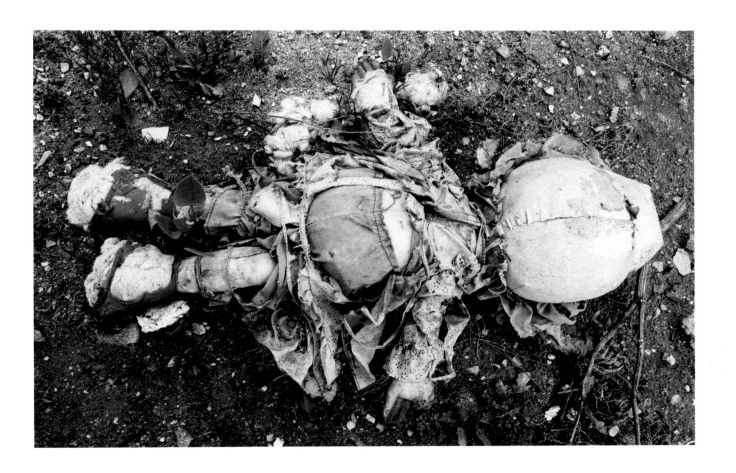

MARY FITZPATRICK *Abandoned Doll, Failaka*
2000
Silver Gelatin Print
61 x 91.5 cms

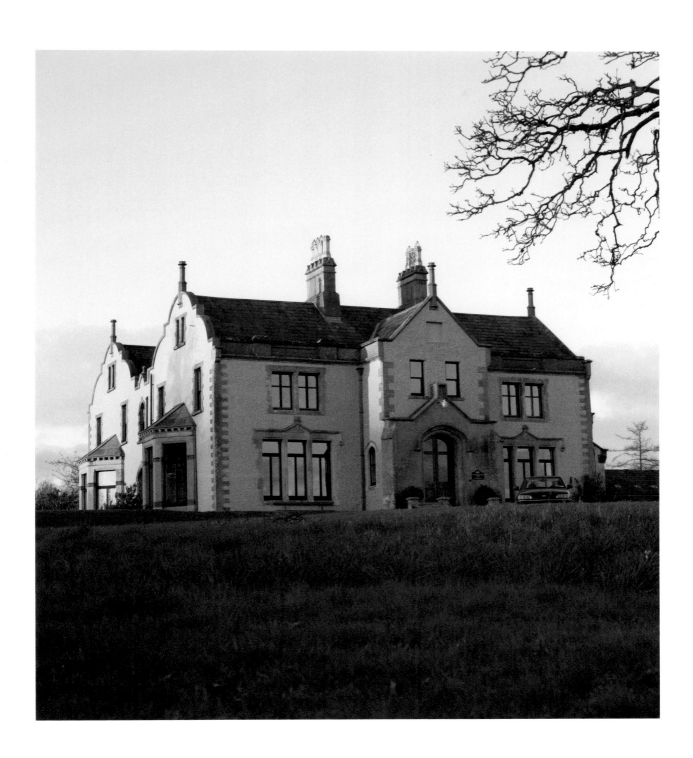

This is a tale of two catalogues, one house, a collection of over seven thousand books and pamphlets and one of the more unusual 'Big House' libraries on this island. My mother had never warned me that it is foolish to volunteer and so in the summer of 1981 when, just two years qualified as a librarian and keen to get as much experience as possible, an unusual query came my direction, it was my hand that shot up automatically. Bernard Loughlin had inquired in library circles if there might be someone willing to take on the project of sorting and cataloguing the library at Annaghmakerrig on a *pro bono* basis. And so began my involvement and love affair with Annaghmakerrig and its eclectic collection of books and fascinating individuals. For the next few years, any free time was spent in the Tyrone Guthrie Centre, sorting and cataloguing the books. These were days of the old thump, click, clack typewriter with the bell that dinged at every return of the carriage, and small, fiddly catalogue cards. Typing errors – and there were many of those – called for little strips of Tipp-Ex paper to be inserted, the errant letter retyped so it was impregnated with white, and the correct letter to be inserted. My occasional over-enthusiastic thumping of the letter 'o' produced a small hole, whilst several keys regularly became so attached to each other that nothing could be typed. Each book needed individual cards to be typed for author, title, and subject to be then filed in a dictionary catalogue.

A degree of order began to be restored and as my card catalogue grew I was immodestly proud of my efforts – that is until the evening chatting animatedly to the kindly Mervyn Wall, who remarked confidentially, 'I don't know what that girl is doing in the library, I just can't make head or tail of it.' Despite my pleasure at being described as a 'girl', I took the coward's way out and muttered something about its being most likely work in progress and that all would undoubtedly become clear one day. For Bernard had rightly ordained that whatever 'system' was going to be used, it would have to respect the integrity and homely feeling of the house with its fine rooms; and so books were, and still are, scattered all through it in every nook and cranny. This is a 'real' librarian's nightmare, where ultimate control is relinquished and trust is vested in the reader, in this instance, the residents of the Tyrone Guthrie Centre.

As I began to separate the various books into different piles the lives, if not the stories, of the various inhabitants of the house began to afford me the odd glimpse of the different personalities reflected in print. And they were strong personalities – the eminent and extraordinary figure of Dr Guthrie – the Divine whose social conscience stirred Scotland to fund a series of ragged schools; from another branch the contrasting figure of the Irish actor, Tyrone Power, who made his fame and name playing the first of the 'stage Irishmen' in most of the English speaking world, publishing his memoirs of his travels in America before his untimely descent into a watery grave; his grandson who was first sent to Ireland as part of the Famine Relief Works, fell in love with an Irishwoman and tied his life to the house and lands. He also travelled extensively in China and New Zealand and wrote about his experiences in these lands. And of course the biggest piles of books which accumulated on the library floor and table bore Tyrone Guthrie's name, many with inscriptions to 'Darling Tony' and one that carried his lovely childhood bookplate of Ravens with the admonitory verse:

42

Black is the raven
Black is the rook,
But, blacker the child
Who steals this book.

As the piles grew, so did my respect and admiration for this man who seemed to have touched the lives of so many people, giving them the gift of his energy, imagination and inspiration. The obvious warmth and love of his parents and in particular his mother Norah shines through the hand-written inscriptions on the books. We can also begin to imagine how his life was affected by the Great War in which he was too young to fight, but by which he was surrounded, as can be glimpsed in an inscribed copy of Vera Britten's *Testament of Youth*. But the most lavish inscriptions appear in the great array of dedications to him from his peers on the world stage. The innumerable copies of Shakespeare's plays, in a great variety of editions which have his pencil's annotations and often hastily scribbled notes and set designs, show a director immersed in his passion and obsession.

The various companies for whom he worked over the years gave him gifts of books as expressions of their gratitude, one of the most remarkable of these being a very large, handsomely bound tome, its pages full of nineteenth and twentieth century scraps. The collecting and pasting of scraps into sometimes specially produced folios was something of a craze in the late nineteenth century, particularly after the development of colour printing. Some publishing houses made their reputation in the production of such colour miniature 'scenes' – in particular the company of Marcus Ward in Belfast. Many, though not all, of the scraps in this particular volume were from Marcus Ward. At first glance, it seems a strange, almost frivolous gift for a man of his stature. Yet, a closer look at its tightly packed pages reveals rich pickings for someone in the world of theatre: there are costumes from various centuries and countries; vignettes of comic scenes, depictions of settings both humble and grand, each scrap capable of being the inspirational spark that would ignite his creative fires. The dedication is formal:

> Presented to Tyrone Guthrie by the Governors of the Old Vic
> and Sadler's Wells theatres in grateful recognition of his splendid services
> as producer and administrator for over ten years.

There were lots of works on costume, dance and stagecraft together with many, many collections of plays by authors both famous and long-forgotten. There too were some of the earliest publications of the Queen's Festival in Belfast from the late 1960s, slender pamphlets from relatively unknown poets, including Seamus Heaney's first published collection *Twelve Poems,* and an even earlier publication in magazine format of a chapter of James Joyce's work in progress – *Finnegans Wake* – proof, if any were needed, of his strong rootedness in Ireland.

The library was and still is, as the title of this piece implies, 'a cabinet of curiosities full of surprises' – a phrase borrowed from Joseph Hone. There family bibles and theological tracts share shelf space with early children's books of the improving kind, inscribed by fond mothers to children of past generations of the families of the house. There was a healthy number of novels of dubious quality bearing the name 'Bunty' – the name by which Norah Guthrie's companion Miss Worby was known. The books were mostly in good condition, regardless of the fact that many of them had travelled by ship

from America in the early years of the nineteenth century, and others from England and Scotland. They have a well-loved look and in one of those chance conversations around the dinner table at Annaghmakerrig I discovered why. Ruth McCabe told of how as a child she had regularly visited the house with her father Eugene, and of how Judy would sit by a large log fire in the wonderful drawing room, gently fanning the pages of the books to ensure that the cold and damp of a winter in Monaghan had not afflicted them with mould or foxing.

All of these books were duly recorded in the ever-growing card catalogue which now had not just the family books, and books which were Tyrone Guthrie's personal collection, but as the weeks and months went by were joined by autographed copies from the grateful residents of the newly opened Tyrone Guthrie Centre. All the while the card catalogue, like Topsy, just 'growed' and I advanced in my career to the point where there could be nothing that might distract from the work in hand and no more happy excursions to Newbliss and Annaghmakerrig.

By the time Sheila Pratschke approached me over a year ago to ask what she should do with the Library, things had moved on apace in the world of librarianship. Card catalogues were like some rare species, virtually extinct, and automation had provided libraries and their users with undreamt-of access to the great libraries of the world, with opportunities for the busy researcher and reader to view, in some instances, the bindings, title pages and illustrations of many of the books, and in certain others the ability to read the entire book online. Clearly my card catalogue should be consigned to one of the house's many hidden cubby-holes for some future archaeologist to find and dissect. Add to that the reality of twenty-something years of creativity at Annagh-makerrig as evidenced in a growing collection of contemporary literature and it was obvious that here was now a very different library with very different needs.

This was a project that demanded a range of different talents and I have been fortunate to have been partnered by Yvonne Desmond, a Faculty Librarian in the Dublin Institute of Technology. Her time and expertise were given on a partnership basis by the Institute as part of their involvement with the arts. After an initial assessment we decided that the way forward was an automated system capable of expanding with the collection, with an easy-to-use browse feature and a permanent presence on the web. We wanted something flexible that would enable us to add images of jackets, illustrations or bindings, together with notes on inscriptions and dedications and something to which over time, and as the technology advanced, we could add value. The next consideration was space, because although the house has expanded into the farmyard, there was little possibility of acquiring a room large enough to hold all the books. Throughout various stages of development and reconstruction at Annagh-makerrig the books had been boxed and re-boxed for safekeeping and so began the slow, tedious task of reassembling and resorting pile after pile of, for me, now very familiar titles and authors. Because it is and was firstly a home from home – though many would agree that home was never really like this – some books stayed obediently where they were placed whilst others migrated from library to drawing room to bedrooms but rarely, I'm pleased to say, from the house itself. And overriding all of these parameters was the necessity that whatever kind of library was created should feel right, that it should not intimidate, rather that it would encourage the residents to broaden their horizons or to occasionally submerge themselves in the works of some now forgotten author, or simply to be a solace to the insomniac.

Together Yvonne and I began sorting, re-sorting and creating catalogue records, occasionally loading up the cars with boxes of poetry or art catalogues to take back to Dublin to add to the system whenever time allowed. Without the insight and stamina of this experienced and phenomenally hard-working librarian, I would still be found on the library floor buried up to my eyes in piles of books, muttering 'I could swear I've already catalogued this.' Like nesting Russian dolls we saw the library as having many different component parts – a Guthrie library incorporating the family material, and a Tyrone Guthrie Centre library of works donated to the Centre since its opening. One category above all had grown exponentially – the poetry collection – and Sheila Pratschke suggested that we carve out a special space that would serve as a poetry library. Apart from the numerous volumes of poems inscribed by their authors and the growing collection of poetry translations, two specialist publishing houses had started sending regular donations of their books to Annaghmakerrig: Bloodaxe Books in England and Gallery Press in Ireland. In a sunny corridor close to Guthrie's old study a space was allocated and lined with beautifully crafted bookshelves that seemed like they were always there. Add to this a large spider plant and a comfortable chair and here is a small piece of paradise for any poetry lover. At the time of writing this there are ambitious plans to add to the catalogue record, where possible, an audio-clip of individual poets reading one or two of their poems, making this little corner of Monaghan more available to the many who will never have the privilege of staying here, whilst at the same time building an archive for the future.

Like the poetry collection, the number of artists' and exhibition catalogues had expanded dramatically over the years. This type of publication is more important than many realize, as these slender publications, mostly issued by small, private galleries, are ephemeral by nature and often do not make it into the national collections. This small

collection is something that with time may prove an invaluable resource. Together with the numerous books on art that Tyrone Guthrie owned, it was clear that here was a small stand-alone collection and so Sheila began the process of creating an art library in an adjoining building. In time this space will also accommodate another Dublin Institute of Technology and Tyrone Guthrie Centre partnership project, as yet in its early development – the project we to date we have christened ArtLog. But more about that later.

Back in the main house and in the library itself the books have begun to gather like homing pigeons, and at the time of writing this there is a theatre and drama collection, a fiction collection and the beginnings of a small collection of non-fiction and reference works. Once again, it has been possible to gather together the family library, the various publications by the different branches and generations of families whose DNA went to make up the special person that became Tyrone Guthrie. Apart from the benevolent Divine, Dr Guthrie, the world famous actor Tyrone Power and the industrious and scholarly Dr Moorhead, there are the books owned by the various women of the house, or gifted by them with loving inscriptions to their children.

A factor linking the disparate and eclectic items in the library is the special nature of the inscriptions. One of the earliest and possibly the longest is from a friend of Susan Alibone whilst she was still Mrs Humphreys and before her marriage to Dr John Moorhead in 1831. It is inscribed on a book of poems by a now forgotten poet, Robert Pollak:

> Will Mrs Humphreys accept this little gift from a friend who wishes to retain a place in her esteem and kind remembrance? That friend hopes that while this excellent poem will be kept of his friendship and regard, it will also remind his sister in the Gospel, of these virtues of charity and humility which she has delighted to practise, and which we are required to exercise in imitation of the perfect example of our Blessed Lord and Saviour, Jesus Christ.
>
> *Signed Jas. Holtby.*

Another is recent and succinct:

> Newbliss Oblige!

What they all have in common is their affection and humanity for the individual, and for the organization that is the Tyrone Guthrie Centre at Annaghmakerrig.

In our involvement with Annaghmakerrig we have come to appreciate its uniqueness and the special relationship of the individual to this place. Let us call this the Annaghmakerrig factor. We began to wonder if the effect and influence of location on artists and their artwork might be captured for future generations. Coming from a background that is concerned with preserving the record of the memory of the Irish people, be it through print, photograph, letter or manuscript, I had become exercised about the future of what we call manuscripts and the survival of contemporary electronic formats. In seventy-five years, when Annaghmakerrig celebrates its first century, what will remain as evidence of the evolution of the work – be it poem, novel, play, painting, sculpture, musical composition, or some unique blend of all the above? To date, cultural historians writing about the arts have relied on archives of correspondence, diaries, handwritten manuscripts and artists' sketch books. With the advances of email, mobile telephony, digital photography and other such tools, it is unlikely that many of these older forms of documentation will survive. This is the age of the finished product. How many of us, in our daily operations, retain copies of documents in their various stages of editing? We are going to be the poorer without this rough-hewn work, before the

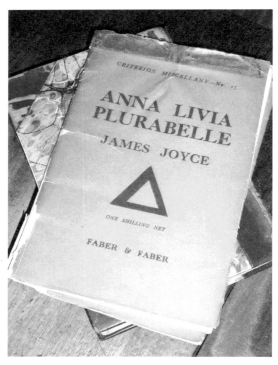

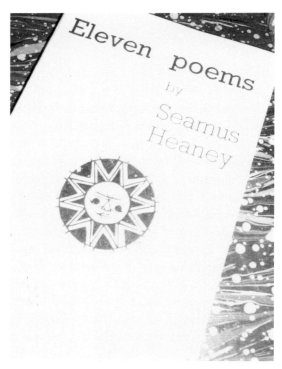

editing and polishing and finishing takes place. What could be done to capture and save some of this artistic process for future generations? This was the question we asked. Discussions were started with the innovative Digital Media Centre at DIT. Together we came up with the project we are now calling ArtLog, currently being designed and developed, whereby we hope to set in place something as unique and special as Annaghmakerrig itself.

Annaghmakerrig is a place of heightened creativity in a state of process. ArtLog is the application of innovative technology to record, archive and analyse this cultural activity in the Tyrone Guthrie Centre. ArtLog aims to provide a safe environment, where on a voluntary basis residents will go to record either through word document, video, blog diary, scanned images, or audio recording their responses to a day, or several days' work at Annaghmakerrig, leaving us the kind of information available in the past through formal 'archive' documents. It is an exciting challenge, many light-years removed from the initial modest task begun on an ancient typewriter many years ago.

II

Everything on the tongue goes stunned bird.
Long past the hissy-fit thralls of April,
rashes of phlox, purple thistle snowing a little.
And then, like too much love,
there was altogether too much gardenia
in the huddled yards. The heat in a flick of wind
picked itself up and dragged off,
old dog, into the damp cane fields, bee drone,
sighing, sighing of highway, hawks' cries.
A screen door slammed lightly.
A woman hummed nonsense to herself.
The thousand burnt-orange camellias
bent in rot, long past wisteria,
long past bitter kumquat, past the sweet white ache
of mock orange – it was not God,
but those lithe lord gods themselves,
mocking birds, intoning every other voiced thing
from dirt-slicked limbs of magnolias until, distracted,
they tipped past the waxed leaves the sun makes silver of;
not God, lord gods; not love, insistence, disregard.

28.4.1999

Words fail me, Clio. How did you track me down, did I leave bloodstains in the snow? I won't try to apologize. Instead, I want simply to explain, so that we both might understand. Simply! I like that. No, I'm not sick, I have not had a breakdown. I am, you might say, I might say, in retirement from life. Temporarily.

I have abandoned my book. You'll think me mad. Seven years I gave to it – seven years! How can I make you understand that such a project is now for me impossible, when I don't really understand it myself? Shall I say, I've lost my faith in the primacy of text? Real people keep getting in the way now, objects, landscapes even. Everything ramifies. I think for example of the first time I went down to Ferns. From the train I looked at the shy back-end of things, drainpipes and broken windows, straggling gardens with their chorus lines of laundry, a man bending to a spade. Out on Killiney bay a white sail was tilted at an angle to the world, a white cloud was slowly cruising the horizon. What has all this to do with anything? Yet such remembered scraps seem to me abounding in significance. They are at once commonplace and unique, like clues at the scene of a crime. But everything that day was still innocent as the blue sky itself, so what do they prove? Perhaps just that, the innocence of things, their non-complicity in our affairs. All the same I'm convinced those drainpipes and that cloud require me far more desperately than I do them. You see my difficulty.

I might have written to you last September, before I fled, with some bland excuse. You would have understood, certainly at least you would have sympathised. But Clio, dear Cliona, you have been my teacher and my friend, my inspiration, for too long, I couldn't lie to you. Which doesn't mean I know what the truth is, and how to tell it to you. I'm confused. I feel ridiculous and melodramatic, and comically exposed. I have shinned up to this high perch and can't see how to get down, and of the spectators below, some are embarrassed and the rest are about to start laughing.

I shouldn't have gone down there. It was the name that attracted me, Fern House! I expected – Oh, I expected all sorts of things. It turned out to be a big gloomy pile with ivy and peeling walls and a smashed fanlight over the door, the kind of place where you picture a mad step-daughter locked up in the attic. There was an avenue of sycamores and then the road falling away down the hill to the village. In the distance I could see the smoke of the town, and beyond that again a sliver of sea. I suppose, thinking about it, that *was* much what I expected. To look at, anyway.

Two women met me in the garden. One was large and blonde, the other a tall girl with brown arms, wearing a tattered straw sun hat. The blonde spoke: they had seen me coming. She pointed down the hill road. I assumed she was the woman of the house, the girl in the sun hat, her sister perhaps. I pictured them, vigilantly silent, watching me toiling toward them, and I felt for some reason flattered. Then the girl took off her hat, and she was not a girl, but a middle-aged woman. I had got them nearly right, but the wrong way round. This was Charlotte Lawless, and the big blonde girl was Ottilie, her niece.

The lodge, as they called it, stood on the roadside at the end of the drive. Once there had been a wall and a high pillared gate, but all that was long gone, the way of other glories. The door screeched. A bedroom and a parlour, a tiny squalid kitchen, a tinier bathroom. Ottilie followed me amiably from room to room, her hands stuck in the back pockets of her trousers. Mrs Lawless waited in the front doorway. I opened the kitchen cupboard: cracked mugs and mouse-shit. There was a train back to town in an hour, I would make it if I hurried. Mrs Lawless fingered the brim of her sun hat and considered the sycamores. Of the three of us only blonde Ottilie was not embarrassed. Stepping past Charlotte in the doorway I caught her milky smell – and heard myself offering her a month's rent in advance.

What possessed me? Ferns was hardly that Woolsthorpe of my vague dreams, where, shut away from the pestilence of college life, I would put the final touches to my own *Principia*. Time is different in the country. There were moments when I thought I would panic, stranded in the midst of endless afternoons. Then there was the noise, a constant row, heifers bellowing, tractors growling, the dogs baying all night. Things walked on the roof, scrabbled under the floor. There was a nest of blackbirds in the lilacs outside the parlour window where I tried to work. The whole bush shook with their quarrelling. And one night a herd of something, cows, horses, I don't know, came and milled around on the lawn, breathing and nudging, like a mob gathering for the attack.

But the weather that late May was splendid, sunny and still, and tinged with sadness. I killed whole days rambling the fields. I had brought guidebooks to trees and birds, but I couldn't get the hang of them. The illustrations would not match up with the real specimens before me. Every bird looked like a starling. I soon got discouraged. Perhaps that explains the sense I had of being an interloper. Amid those sunlit scenes I felt detached, as if I myself were a mere idea, a stylised and subtly inaccurate illustration of something that was only real elsewhere. Even the pages of my manuscript, when I sat worriedly turning them over, had an unfamiliar look, as if they had been written, not by someone else, but by another version of myself.

Remember that mad letter Newton wrote to John Locke in September of 1693, accusing the philosopher out of the blue of being immoral, and a Hobbist, and of having tried to embroil him with women? I picture old Locke pacing the great garden at Oates, eyebrows leaping higher and higher as he goggles at these wild charges. I wonder if he felt the special pang which I feel reading the subscription: *I am your most humble and unfortunate servant, Is. Newton*. It seems to me to express better than anything that has gone before it Newton's pain and anguished bafflement. I compare it to the way a few weeks later he signed, with just the stark surname, another, and altogether different, letter. What happened in the interval, what knowledge dawned on him?

We have speculated a great deal, you and I, on his nervous collapse late in that summer of 1693. He was fifty, his greatest work was behind him, the *Principia* and the gravity laws, the discoveries in optics. He was giving himself up more and more to interpretative study of the Bible, and to that darker work in alchemy which so embarrasses his biographers (cf. Popov *et al.*). He was a great man now, his fame was assured, all Europe honoured him. But his life as a scientist was over. The process of lapidescence had begun: the world was turning him into a

monument to himself. He was cold, arrogant, lonely. He was still obsessively jealous – his hatred of Hooke was to endure, indeed to intensify, even beyond the death of his old adversary. He was –

Look at me, writing history; old habits die hard. All I meant to say is that the book was as good as done, I had only to gather up a few loose ends, and write the conclusion – but in those first weeks at Ferns something started to go wrong. It was only as yet what the doctors call a vague general malaise. I was concentrating, with morbid fascination, on the chapter I had devoted to his breakdown and those two letters to Locke. Was that a lump I felt there, a little, hard, painless lump ..?

Mostly, of course, such fears seemed ridiculous. There were even moments when the prospect of finishing the thing merged somehow with my new surroundings into a grand design. I recall one day when I was in, appropriately enough, the orchard. The sun was shining, the trees were in blossom. It would be a splendid book, fresh and clean as this bright scene before me. The academies would be stunned, you would be proud of me, and Cambridge would offer me a big job. I felt an extraordinary sense of purity, of tender innocence. Thus Newton himself must have stood one fine morning in his mother's garden at Woolsthorpe, as the ripe apple dropped about his head. I turned, hearing a violent thrashing of small branches. Edward Lawless stepped sideways through a gap in the hedge, kicking a leg behind him to free a snagged trouser cuff. There was a leaf in his hair.

I had seen him about the place, but this was the first time we had met. His face was broad and pallid, his blue eyes close-set and restless. He was not a very big man, but he gave an impression of, how would I say, of volume. He had a thick, short neck, and wide shoulders that rolled as he walked, as if he had constantly to deal with large soft obstacles in air. Standing beside him I could hear him breathing, like a man poised between one lumbering run and another. For all his rough bulk, though, there was in his eyes a look, preoccupied, faintly pained, like the look you see in those pearl and ink photographs of doomed Georgian poets. His flaxen hair, greying nicely at the temples, was a burnished helmet; I itched to reach out and remove the laurel leaf tangled in it. We stood together in the drenched grass, looking at the sky and trying to think of something to say. He commended the weather. He jingled change in his pocket. He coughed. There was a shout far off, and then from farther off an answering call. 'Aha,' he said, relieved, 'the rat men!' and plunged away through the gap in the hedge. A moment later his head appeared again, swinging above the grassy bank that bounded the orchard. Always I think of him like this, skulking behind hedges, or shambling across a far field, rueful and somehow angry, like a man with a hangover trying to remember last night's crimes.

I walked back along the path under the apple trees and came out on the lawn, a cropped field really. Two figures in wellingtons and long black buttonless overcoats appeared around the side of the house. One had a long-handled brush over his shoulder, the other carried a red bucket. I stopped and watched them pass before me in the spring sunshine, and all at once I was assailed by an image of catastrophe, stricken things scurrying in circles, the riven pelts, the convulsions, the agonized eyes gazing into the empty sky or through the sky into the endlessness. I hurried off to the lodge, to my work. But the sense of harmony and purpose I had felt in the orchard was gone. I saw something move outside on the

grass. I thought it was the blackbirds out foraging, for the lilacs were still. But it was a rat.

In fact, it wasn't a rat. In fact in all my time at Ferns I never saw sign of a rat. It was only the idea.

The campus postman, an asthmatic Lapp, has just brought me a letter from Ottilie. Now I'm really found out. She says she got my address from you. Clio, Clio … But I'm glad, I won't deny it. Less in what she says than in the Lilliputian scrawl itself, aslant from corner to corner of the flimsy blue sheets, do I glimpse something of the real she, her unhandiness and impetuosity, her inviolable innocence. She wants me to lend her the fare to come and visit me! I can see us, staggering through the snowdrifts, ranting and weeping, embracing in our furs like lovelorn polar bears.

She came down to the lodge the day after I moved in, bringing me a bowl of brown eggs. She wore corduroy trousers and a shapeless homemade sweater. Her blonde hair was tied at the back with a rubber band. Pale eyebrows and pale blue eyes gave her a scrubbed look. With her hands thrust in her pockets she stood and smiled at me. Hers was the brave brightness of all big awkward girls.

'Grand eggs,' I said.

We considered them a moment in thoughtful silence.

'Charlotte rears them,' she said. 'Hens, I mean.'

I went back to the box of books I had been unpacking. She hesitated, glancing about. The little square table by the window was strewn with my papers. Was I writing a book or what? – as if such a thing were hardly defensible. I told her. 'Newton,' she said, frowning. 'The fellow that the apple fell on his head and he discovered gravity?'

She sat down.

She was twenty-four. Her father had been Charlotte Lawless's brother. With his wife beside him one icy night when Ottilie was ten he had run his car into a wall – 'that wall, see, down there' – and left the girl an orphan. She wanted to go to university. To study what? She shrugged. She just wanted to go to university. Her voice, incongruous coming out of that big frame, was light and vibrant as an oboe, a singer's voice, and I pictured her, this large unlovely girl, standing in a preposterous gown before the tiered snowscape of an orchestra, her little fat hands clasped, pouring forth a storm of disconsolate song.

Where did I live in Dublin? Had I a flat? What was it like? 'Why did you come down to this dump?' I told her, to finish my book, and then frowned at the papers curling gently in the sunlight on the table. Then I noticed how the sycamores were stirring faintly, almost surreptitiously in the bright air, like dancers practising steps in their heads, and something in me too pirouetted briefly, and yes, I said, yes, to finish my book. A shadow fell in the doorway. A tow-haired small boy stood there, with his hands at his back, watching us. His ancient gaze, out of a putto's pale eyes, was unnerving. Ottilie sighed, and rose abruptly, and without another glance at me took the child's hand and departed.

There we kept time pressed apart
like a row of books supported by two book-ends;
there we erased the pitch and toss
of all the lives we'd lived –
the pot holes of disaster.

The 'where-oh-where' of now is the question of that time
when as Vladimir and Estragon we walked the avenue
with our water-bottles of laughter, our occasional fights.
We flew saucers of friendship above the stars
which landed in the 'Big House'
as when dawn brought the demon Harding to cook
our breakfast complete with pike and hangover.

If the snake of time has shed its skin again
I know that artichokes are different from thistles.
We left our marks – a painted room – a broken pane of glass,
a hedge of beans, a colony of spinach.

I went to Annaghmakerrig in the Autumn of 1981.
I remember wind, rain, storms, some sun,
the lake, woods, birds, the dark,
fires, food, drink, artists pleasant and
unpleasant. My room was beside the
music room where I worked on early
parts of my opera, The Intelligence Park.

Gerald Barry

The eighteenth-century Swedish naturalist,
Carolus Linnaeus,
like Aristotle long before him,
was convinced
that swallows wintered underwater
in the riverbeds they nested on.

The truth is no less strange:
small birds flying south to Africa
navigating only by the Pole Star;
a displacement of the elements either way –
like love, when it arrives overnight
and seemingly from nowhere.

Each time we waved the other off
at airports, we had to believe
what was travelling far
would survive to return by instinct
and seem again to have always been there,
swooping and soaring above our joyous heads.

MOYA CANNON *Viol*

Wherever music comes from
it must come through an instrument.
Perhaps that is why we love the instrument best
which is most like us –

a long neck,
a throat that loves touch,
gut,
a body that resonates,

and life, the bow of hair and wood
which works us through the necessary cacophonous hours,
which welds dark and light into one deep tone,
which plays us, reluctant, into music.

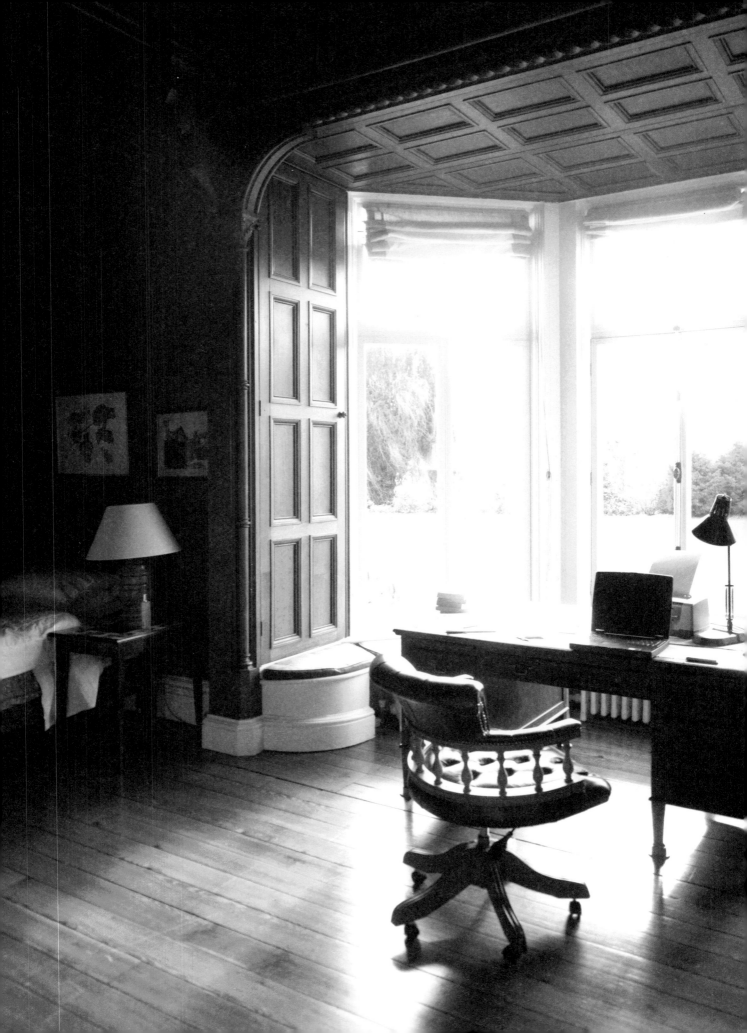

PORTIA Ah chome here because ah've allas chome here an' ah reckon ah'll be chomin' here long ater ah'm gone. Ah'll lie here whin ah'm a ghos' an' smoche ghos' cigarehs an' observe ye earthlin's goin' abouh yeer pintless days. Mebbe ah'll see me father pickin' stones from hees forty fields an' be able ta watch him athout shiverin', tha way ah never could whin ah war livin'. Mebbe ah'll see you, older, doin' some nigh' fishin' here an' mebbe, jus' mebbe, ya'll looche up from yar fishin' for a second, jus' a second, an' ya'll have seen me or felt a breath through yar hair thah warn't tha wind, or heerd a rustle from tha copse that warn't some nigh' animal. Thah'll be me. Mebbe. Mebbe me sons'll be min an' ah'll walche amon' thim an' mebbe ah'll be longin' ta be livin' agin, though ah don' thinche tha's a possibility.

SLY No! Lave me be! Ah druv thah childt twice a wache, ever wache ta Dublin for hees singin' lessons in tha hay sason, whin tha chows was chalvin, whin there war more than enough worche ta be done ah home. Ah druv him, [*points to Marianne.*] acause you says ah should, liche a fuchen slave, seventa mile each way an' he'd sih i'tha bache a' tha char, radin' hes music booches, hummin' to heself, wouldn' gimme tha time a' day noh if hes life dipinded an ud. Ah was hes father an' he leh me know he wanted no part a' me. God forgimme, buh times ah'd looche ah him through tha mirror an' tha though'd go through me mine thah this be no human childt buh some little outchaste from hell. An then he'd sing tha long drive home an' ah knew ah war listenin' ta somethin' beauhiful an' rare, though ah'm no judge a' these things, an' me aul' rough heart'd milt though he did noh sing for me. An' ah'd be proud, so proud thah this odd creature war mine. Chome, Mother, home, boh me children is gone, me grey-eyed ghirl, me son, me cold, hard twins.

HARRY CLIFTON *The Seamstress*

I have a seamstress, making a shirt for me
In sultry weather, in the months we are together.

She measures my shoulders with tape, I feel on my back
The cool of her wooden yardstick, and submit

To a temporary contract, binding me
To the new and the strange. Together we lose ourselves

Among shades of blue, the melancholy feast
A culture of silkworm creates, as Chinese tailors

Stand and wait. For me it's the stuff of dreams,
For her a labour of love … In her house on stilts

Where women are still slaves, she sews the collarless
Garment of pure freedom I have asked for

When I leave, keeping only for herself
Dry tailor's chalk, and the diagram of a body.

All journeys end someplace, and he was happy
Waiting for it to happen; there would be
Suddenly at a stop somebody laughing,
And looking from the window he would see

The scenery wheel into place, composing
The proper setting and a mutual need
At evening would draw words and hands together
Until a love in doubt was love indeed.

But when he came where bands and tourists gathered
And she was there he found himself afraid,
And fumbled for that more successful other
And watched the one who loved her most recede,

As in stepped once again the sad impostor
Who had stood in for him many times before,
The capable, the talkative, the clever,
Who thought his real self was such a bore
He would not even trust him in the moment
When the great clock of night shook warnings down
Of mornings which would come for every lover
When all but the sad daylight would be gone.

And through the days that followed he deceived her
About the waiting self behind his pride,
The self that stood there humbly, like a landscape,
Finding its plea for love again denied.

I first visited Annaghmakerrig as an actor in the autumn of 1981 before it was officially opened. Part of a large cast, we all played Murder in the Dark *after rehearsals and terrified ourselves.*

I returned several times in the 1980s to work on projects with the company Olwen Fouere and I had formed called Operating Theatre.

BABEL, *a five-CD set, took ten years of my life to compose and I worked on three of its songs at Annaghmakerrig in 1989. How strange and wonderful to return again in 2005 after a gap of sixteen years. The heating! The en suites! The studio off the piano room! And the soon-to-be new sound studio!*

What is the same is that art and the artist are cherished and made to feel worth something.

A place of hope, refuge, inspiration, encouragement, creativity, occasional despair, fear, banging-of-head-against-wall, hair-tearing, eating, drinking, cursing, walking, dreaming … (no sex in the Big House please, we're artists).

A treasure beyond gold.

PAUL DURCAN *Elvira Tulip, Annaghmakerrig*

Elvira Tulip is loitering on a grass bank above me
In a blue swimsuit, explaining to me what it means
To be experimental – Virginia Woolf, Samuel Beckett –

While behind her strides
The Steward of Annaghmakerrig humming in Catalan:
Where would I be without my wheelbarrow?

I am standing under her down in the gravel
Clad from head to foot – jeans, T-shirt,
Jumper, trainers – blinking up at her,

My young teacher, my young virtuoso,
My idea, my reality, my dance, my fix
On the cosmos as it is late in the afternoon.

Where would I be without my wheelbarrow?
My wheelbarrow that's got two handles and one very small rubber wheel.
Is there not one woman in the world who would marry me for my wheelbarrow?

As soon as I walked in, I knew he wanted to touch it. It was a small lift, just a box on a rope really. You could hear the churning of the wheel high above, and the whole thing creaked as it wound you up through the building.

I stood over to give him room – not easy when you are so big. Then, of course, I realized I hadn't pressed the button yet, so I had to swing by him again, almost pivot, my belly like a ball between us. I was sweating already as I reached for the seventh floor.

You know those old bakelite buttons – loose, comfortable things, there's a nice catch to them when they engage. If someone's pushed it before you, of course, they just collapse in an empty sort of way and your finger feels a bit silly. So I always pause a little, before I hit number seven. And in that pause, I suppose, I get the feeling that this bloody box could go anywhere.

'Oh, I'm sorry,' he said, even though there was no need for it. American. In a suit. Quite tall.

'Oh. Sorry.' I said it too. Well you do, don't you?

The button went in with a soft crunch – wherever he was going, it wasn't to my floor. He eased back into the far corner and we waited for the doors to close.

This blasted lift. Six times a day I go up and down in this box, maybe more, waiting for the machine to make up its mind; waiting for it to finish thinking; checking the building, floor by floor. It's so ancient – it should have those screechy trellis gates, like a murder mystery (I should have an ash blonde permanent wave, the American should be packing a snub little gun). But it doesn't. There are just these two endlessly reluctant doors of metal, that click and surge, as though to close, and then change their mind.

I gave a little social sigh – *Well, here we all are* – and flicked a glance his way. He was looking at my stomach, but staring at it. Well, people do. So I blinked a bit and smiled my most pregnant smile, all drifty and overwhelmed – *Isn't nature wonderful?* These days, my skin smells of vegetable soup. I mean quite nice soup, but *soup* – you know? I tell you – reproduction, it's a different world.

He looked up at my face then, and smiled. The doors heaved a little in their furrows and then decided against it. Very serious eyelashes. Very bedroom.

'So. When's the happy day then?' he said.

As if it was any of his business. As if we had even been introduced. When you're pregnant, you're public property, you're fair game. 'Well hello,' they say in shops, 'how are *you* today.' It's like the whole world has turned American, in a way, and here was the genuine article, corn fed, free range; standing there in his nice suit and inquiring after my schedule.

'What do you mean?' I wanted to say. 'I am just suffering from bloat.' Or, 'Who says it's going to be happy? It might be a most miserable day of my life. I might be, for example, screaming in agony, or haemorrhaging; I might be dead.'

'Oh.' I looked down at my belly like I just realized it was there – *What, this old thing?*

'Six weeks,' I said.

'Hey!' he said back. Like a cheerleader. I thought he might reach out and give me a playful little punch on the arm – *Go for it!*

I turned and jabbed the 'doors close' button. At least I thought it was the 'doors close' button, it was actually the 'doors open' button – there is something so confusing about those little triangles – so the doors which were, at that exact moment, closing, caught themselves – *Ooops!* – and slid open again.

We looked out into the small lobby. Still empty.

'Well, good luck!' he said.

And he gave a little 'haha' laugh; rocking back on his heels a bit, while I jabbed at the other button, the correct one this time, the one where the triangles actually point towards each other, and, *Ok*, said the doors – *Now we close.*

Someone got a pot of gloss paint and dickied them up, years ago. Thick paint, you can see the swirl of the brush still in it, a sort of 1970s brown. The doors meet, and sigh a little, and you look at the place where the paint has flaked. You look at the place where the painter left a hair, in a big blonde S. You stand three inches away from another human being, and you think about nothing while the lift thinks about going up, or down.

Decisions decisions.

Good luck with what? The labour? The next forty years?

The lift started to rise.

'I'll need it,' I said.

This building used to be a hotel. I can't think of any other excuse, because there is dark green carpet, actual carpet, on the walls of the lift, up to what might be called the dado line. Above that, there's mirror made of smoked glass, so that everyone in it looks yellow, or at least tanned. Actually, the light is so dim, people can look quite well, and basically you look at them checking themselves in the glass. Or you look at yourself in the glass, and they look at you, as you check yourself in the glass. Or your eyes meet in the glass. But there is very little real looking. I mean the mirror is so hard to resist – there is very little looking that goes straight from one person across space to the other person, in the flesh as it were, as opposed to in the glass.

Or glasses. One reflection begs another, of course, because it is a mirror box – all three walls of it, apart from the doors. So your eyes can meet in any number of reflections, that fan out like wings on either side of you. The American in the corner was surrounded by all my scattered stomachs, but he was staring straight at the real one. And,

No you can't, I thought. *Don't even think about it.*

I look so strange anyhow these days. I misjudge distances and my reflection comes at me too fast. I felt like I was tripping over something, just standing there. The American's hands were by his sides. The left one held his document case and the right one was unclenching, softly.

And then, as a mercy, we stopped. The third floor. Ping.

'You'll be fine,' he said, like he was saying goodbye. But when the doors opened, he didn't leave, and there was no one there. They stayed open for a long time while we looked at an empty corridor; then they shut, and it was just me and him, listening to the building outside, listening to our own breathing, while the lift did absolutely nothing for a while.

I always look people in the eye, you know? That is just the way I am. Even if they have a disability, or a strangeness about them, I look them straight in the eye. And if one of their eyes is damaged, then I look at the good eye, because this is where they *are*, somehow. I think it's only polite. But I am not always right. Some people want you to look at their 'thing' and not at them. Some people need you to.

There was that young transvestite I met in the street, once; I used to know his mother, and there were his lovely eyes, still hazel under all that mascara and the kohl. Well I didn't know where else to look at him, except in the eye, but also, I think, I wanted to say hello to him. *Himself.* The boy I used to know. And of course this is not what he wanted at all. He wanted me to admire his dress.

Or Jim, this friend of mine who got MS. I met him one day and I started chatting to him of course – and then I found I was talking faster, like really jabbering, because it was him I wanted to talk to, him and not his disease – and he was sliding down the wall in front of me, jabber jabber jabber jabber, until a complete stranger was saying to him, 'Would you like me to get you a chair?'

I would prefer it if he looked at me, that's all – the American. Even if I was sliding down the mirrored wall in front of him, even if I was giving birth on the floor. I would prefer it if he looked at the person that I am, the person you see in my eyes. That's all. I put my hand on my stomach to steady the baby, who was quiet now, enjoying the ride – and silent, as they always are. But sometimes they leave a bubble of air in there, with their needles and so on. They leave air in there by accident and, because of the air, you can hear the baby cry – really hear it. I read that somewhere. It must be the loneliest sound.

We are all just stuck together. I felt like telling him that too.

Anyway, what the hell. There was this guy looking at my stomach in the lift on the way up to the seventh floor one Tuesday morning when I had very little on my mind. Or everything. I had everything on my mind. I had a whole new person on my mind, for a start, and the fact that we didn't have the money really, for this. I had all this to worry about, a new human being, a whole universe, but of course this is 'Nothing'. *You are worrying about nothing*, my husband says. Everything I think about is too big, for him, or too small.

Of course he is right. I pick the things off the floor because if I don't *our life will end up in the gutter.* I put the tokens from the supermarket away because if they get lost *our child will not be able to afford to go to college.* My husband, on the other hand, lives in a place where you don't pick things up off the floor and everything will be just fine. Which must be lovely.

'It's perfectly natural,' he says, when I tell him the trouble I am having with the veins in my legs, or the veins – God help us – in my backside. But sometimes I think he means, *We're just animals, you know.* And sometimes I think he means, *You in particular. You are just an animal.*

By the time we passed the fifth floor I had the sandwich in my mouth. Roast beef, rare, with horseradish sauce. That's why I was in the lift in the first place, I had just waddled out for a little something, and God, it tasted amazing. I lifted my chin up to make the journey down my throat that bit longer and sweeter, and maybe it was this made him breathe short, like he was laughing, made me look at him finally, sideways, with my mouth full.

'Well, that sure looks good,' he said.

This American laughing at me, because I am helpless with food. And because I look so stupid, and huge, this man I have never met before being able to say to me,

'Would you mind? May I touch?'

I could feel the lift pushing up under my feet. My mouth was still full of roast beef. But he stretched his hand out towards me, anyway. It looked like a hand you might see in an ad – like that old ad for Rothmans cigarettes – slightly too perfect, like he was wearing fake tan. I turned around to him, or I turned the baby round to him, massively. I did not look him in the face. I looked sideways a little, and down at the floor.

I wanted to say to him, *Who is going to pay for it?* Or love it. I wanted to say, *Who is going to love it?* Or, *Do you think it is lonely, in there?* I really wanted to say that. I swallowed and opened my mouth to speak and the lift stopped, and he set his hand down. He touched all my hopes.

'It's asleep,' I said.

The doors opened. So we were standing like that, him touching my belly, me looking at the ground, like some sort of slave woman. Thinking about his eyelashes. Thinking that, no matter what I did these days, no matter what I wore or how I did my hair, I always looked poor. Lumbered.

He said, 'Thank you. You know, this is the most beautiful thing. It's the most beautiful thing in the whole world.'

Well he would say that, wouldn't he.

Someone carved a pair of posts
as if they were wood,
curved mill-stones, cider presses,
milk coolers, and a well-head.

When they flooded the quarry store
to make the reservoir
at Quabbin they buried ground
in water and said au revoir

to the world they'd seen,
each eyed and shafted quern
set in the hubbed sun space
of a zen cairn

on the Upper Lever. A rock presides
above the stone collection
which comes to rest quietly. The river
dawdles, and flows on.

DAVID FERGUSON, choreographer, *Opium* and *In the air*

It was the winter of 1989. My first visit to Annagmakerrig. I had been tipping around with writing songs. Keith Donald had told me about the place. 'Go up there and write for a whole week.' The notion daunted me. It was too big of a statement to make. Going away somewhere to write songs for a week! What if I came away with nothing? Failed? Then I was done for with the songwriting. Have to stop all those fanciful Top of the Pops notions ... knuckle down to the day-job. Stick with the factory floor.

Eventually I wrote the letter. Maybe they wouldn't accept me? Then at least I'd have tried. I did ... they didn't ... the letter came ... directions to no-man's-land ... something about don't take the first signpost saying where you should go, take the second. Reference to the 'Big House' increased my trepidation. Mixed images of Anthony Perkins and the big house in Psycho, Dickens' Bleak House, and dredged-up rememberings of landlords, evictions and the like, assailed me.

Entering the Big House, my fears were not assuaged. Its occupants all looked knowing ... successful ... slightly sympathetic. They'd written barrowloads of books, composed operas, oratorios, Latin masses ... and God knows what else. And the poets ... they were the most fiercesome ... took you all in – in one raised eyebrow ... this newest interloper with his three-minute ditties. I knew I shouldn't be here. A painter offered a multi-coloured hand and I knew I wouldn't be sitting with the poets for the ordeal ahead that was dinner. The poets had bad press.

But after that first dinner a poet struck up a conversation with me about poetin' and how the Irish read more poems than any other race ... but how you'd still only sell a few hundred poetin' books. I began to feel better already ... sure didn't Red Hurley sell an awful lot more than that of my song. Maybe these poets weren't such hot shots after all. Emboldened, I coyly suggested, 'Well sure maybe if you put the poems with some other art form like painting ... or music, you'd have two audiences instead of one,' I brazened. But not without some foundation. I had seen Noirín Ní Riain sing her ancient songs to a series of Batik paintings.

Talk about making a cross for your back. The poet disappeared back to his poetin' but reappeared with a sheet of paper in his hand. 'Could you put music to that?' says he, with nary a flicker of anything in his voice.

I took the page. 'Fire, Snow and Carnevale' it said at the top. I read it slowly ... then read it again. This was their way of finding me out – I should never have mentioned the Red Hurley song. They always get you in the end – those effin' poets ...

always want to be looking at the fuckin' lake and looking pained.

It was good, I liked it ... had a beginning and an end, not like some of that stuff they come up with.

'Do you want me to put music to it as it is?' says I, not missing a beat but then pausing. Let the question hang. Pose, pause and pounce, I had learned up at the IMI on one of those management courses for the day job. 'Or ... do you want me to try and make a song of it?'

'Do whatever you like with it,' was the answer.

Now I was really up against it ... and I had only six days left. I'd never get back here if I didn't come up with the goods – the poets would see to that ... maybe even the painters would join forces with them.

I never left the piano room the whole of that week ... only for bread and water. No meandering walks through the loop of the forest; none of those wonderfully peppered, never-resolving discussions after dinner; no boisterous nights at the Black Kesh auctions where you could bid for a calf or a bale of hay (the rooster we bought at a later time and then sat on the floor of the Big House looking at it through the peepholes of the box it came in. Where would we hide it ... and how would we keep it quiet in the morning before it woke up the whole place and Bernard Loughlin came tearing up? Why did we buy it anyway? I think it was the poets ... again).

The music room was a place beyond. Anything sounded good on the big grand. I propped up my twenty-five pound Grundig (proceed of the Red Hurley royalties) on the lid ... stuck the poem in front of me ... all thoughts of working on any other idea now scrapped. I couldn't get a melody to go with it ... and the Mick Cullen, towering over me on the music room wall. I moved the piano over to the window, bumping and grinding it across the floor, like I had seen Fats Domino once do. Fats with his pink Cadillac. The Carnevale was killing me. Why couldn't the poets keep it simple ... words that could rhyme ... like jambalaya ... on the bayou.

By now I had decided that I couldn't come up with a lofty enough melody to satisfy the poem so, second option ... dumb it down, make it rock'n'roll ... after all he said it. 'C'mon baby and be my guest ... let's join the party and meet the rest.' Now that I'd gotten away from Mick Cullen, Fats Domino was driving me crazy. Fats Domino and the Carnevale. Mardi Gras in Monaghan. N'Orleans to Newbliss. This was getting me nowhere ... and the poets were waiting ... lying in the long grass of the Big House, ready to bite the leg off any would-be songwriter a wanderin' into their territory.

Worse then happened. A real songwriter turned up – all the way from Canada. A songwriter with beautiful lyrical songs ... albums of them ... and she could sing like a lark, play the piano better nor Fats Domino ... and a dozen other instruments besides. Poet was impressed I could tell. This one had set the whole of Morte D'Arthur, or some other epic poem to music ... and recorded it. I was for the P45.

Then the more fatal blow ... 'Could I come up and hear the piece you're working on ... when you're finished?' Christ, now they were ganging up on me. What could I say only 'yes' and then discreetly enquire about the CIE bus back to Dublin. How would I explain to Keith Donald that I didn't even last the first week ... and not even a song in my satchel, going.

Feck the poet and his title – 'Carnevale' was definitely going, if I was to stay ... and save any face ... and those long verses – stanzas they have to call them! Remember Hank – start-with-the-hook-and-keep-repeating-it – Williams. They were going too.

It would be called Winter, Fire and Snow.

By Saturday, my official going day, I had the song done – if shakily. But it was done, in A minor for the verse and brightening in to C major for the choruses. This was no musical tour-de-force on my part, but C was the only key in which I could play. Never mind, I told myself, Irving Berlin was the same.

'Alright so,' I said after a fortifying feed of rashers and sausages. 'C'mon up and I'll play it to ye.' Going up the back stairs from the kitchen I could have been 'Walkin' to New Orleans' it was that long. The music room never seemed bigger – like those big Broadway places, where they audition hopefuls for the 'next big show' ... and then slaughter them.

The piano in the light of the far window seemed to keep moving farther and farther away from me. I reached it, stuck up my scratched-out lyrics beside the poet's crafted images and silken words. Jesus, he was going to kill me.

They pulled two of those woodeny chairs. Sat. Waiting. Watching. Listening for the death of words. I knew I should have left in Carnevale. He'd probably walked for miles above Siena to come up with that one. And worse, the poem was about his little son going out to one of those carnivals ... all dressed up ... and him, the Dad-poet offering up a little prayer that he'd come safely home 'riding the tail of the wind'. It was too close a poem ... too personal ... family. I should never have opened my gob ... interloped ... gone between them.

I hit the A minor ... gentle as I could ... soothe them ... ease them into it ... create a mood ... calm the poet.

In winter fire is beautiful ...
Beautiful like a song ...

God I was glad I kept his opening two lines. How could he not like what he himself had written? But poets were contrary beasts. A wrong inflection ... the emphasis on a word in the wrong place ... anything! Those woodeny chairs would hit you an awful belt if flung from a distance.

Somehow I got through the song ... tried to stop the last line from racing as fast as my heart. 'In winter fire is beautiful ... all of the winter long.'

May the ghost of Hank Williams look down on me ... and the spirit of Fats Domino descend on them – the hanging jury.

I looked up ... Loreena McKennit ... and Macdara Woods applauded.

I noticed they kept perfect time.

Winter, Fire and Snow

Key Amin.

In Winter, Fire is Beautiful,
Beautiful like a Song;
In Winter, Snow is Beautiful,
All of the Winter long.

But you, little son, come safely home.
Riding the tail of the wind,
May you always come this safely home
In Winter, Fire and Snow.

The Day gets dark uneasily
Darker and darker still,
And you are gone to Carnevah,
And I feel the winter chill

But you little son etc...

The Faber Castells ripen in your hand.
You've been drawing since breakfast:
sky after sky, face after face, but something
in yours says they're not quite right.

Every fresh character is dipped
in your range of skins –
beige, primrose, lemon, sand –
and still found wanting.

You finally settle on maize
but not before almost a sheaf
of paper has been scorched
with a repertoire of possible flesh.

The pages rustle into place. I'm watching you
and every irreproachable, off-tone face
is your own in the back of our first white Polo
when summer landed you wide-eyed at the door.

Your head then was marooned in arrival
like our papier-mâché moon.
See how you've given it petals,
wings, hair I can run my hand through

the way the wind cross-hatches
an open field where corn is sweetening
in its cornsilk skin; where yellow
falters, gold begins to maize.

This excerpt is the main theme from 'Renaissance Man', which I wrote in 2005 at the Tyrone Guthrie Centre in Annaghmakerrig in commemoration of my father. This piece was very special for me, and an important part of the experience of writing it was having the space and time to give it the thought and contemplation it needed. Annaghmakerrig gives you that space and time to work while also providing creative stimulation, both in its surroundings and in the many interesting and imaginative people you meet. The staff also makes a crucial contribution to the success of the working environment; they make you feel that they are concerned that everything be right for you regarding the practicalities of living, while at the same time letting you do your own thing – an amazing balancing act!

In my opinion the Tyrone Guthrie Centre with its beautiful grounds, stately house, and great people is one of the few places in the world where the saying 'you can't go back ...' doesn't apply. I've proved that to myself many times and hopefully will do so many times in the future ...

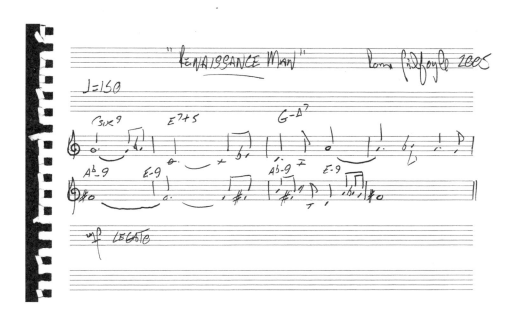

ANNE HAVERTY *from One Day As a Tiger*

I used to be quite a normal fellow. I was never a chap who needed much explaining. And yet the most crucial acts of my life defy any reasonable explanation – defy it, yet cry out for it. After all, you cannot ruin people's lives without attempting to explain why and how you did.

A couple of years ago everyone in Fansha knew all there was to know about me. I was Pierce Hawkins's younger brother, the smart fellow who was going on to be a professor up in Trinity College, Dublin. In the history department in Trinity they might not have put it quite like that but the gist would have been the same. I was Dr Williams's – Harvey's – favourite, a young historian who had shown signs of brilliance and, if he played his cards right, had a brilliant career ahead of him.

Then there set in what you could call my madness – or maybe the word 'folly' is more accurate since I had my own excuses, inadequate though they may have been. Anyway, it was when the white candles on the blooming chestnut trees in Front Square were pristine and upright that I found I could not endure my life any longer and came back to Fansha once and for all. When I could not bear anymore the thought of the flowering chestnut in the middle of the long field, and the pink hawthorn and the white hawthorn of Fansha and the green fields carpeted with buttercups an incredible yellow; the pomp of a summer to come going on without me.

Up at Trinity they were appalled, and strident in the expression of their appalledness.

'I am appalled,' Harvey declared, 'at this decision. Mr Hawkins, I must tell you plainly, I am appalled.'

The 'Mr Hawkins' unnerved me. To Harvey, for several years past – how many? three or four anyway – I had been Martin. After those first undergraduate years of mutual familiarization, getting the measure of each other, I was no longer, with professorial condescension, Mr Hawkins, but Martin. The bright amenable student with just the right mix of originality and cynicism. His right-hand man, selected after long observation and groomed from then on to assist him in his research into nineteenth-century agrarian policy, in line for a graduate post and in due course a Fellowship. Harvey was ambitious for me. Or at least in his ambitions for himself was included; even, with time and as our work enmeshed, essential.

Harvey's reversion to 'Mr Hawkins' in this exchange expressed of course his outrage; but also, I knew, with a new sensation of delinquent independence, his recognition of me as an adult, a newly formidable fellow with a mind of his own. His 'Mr Hawkins' was a gesture of respect, of appeal man to man.

And yet, no longer Martin, I felt a great loneliness descend upon me as I cast off from our coolly uncommunicative but implicitly intimate circle. The circle in which I knew who I was and where I stood and who Harvey was and how we all fitted in together, himself and myself and the others, students and staff, friendly satellites by and large in orbit around us. The classical walls of Trinity encircling our world within, our charmed lives of complacency; the city and its people outside a picturesque and remote backdrop, their minds unilluminated with radical perceptions on Victorian agriculture and so of no possible interest.

As far as Harvey could see, I was electing to join them in their darkness. Adult I may well have been. But a pitiable one who had made a foolhardy, not to say insane, decision. Sure, I was the first to see that, from any point of view apart from my own, my decision was insane.

His appeal, however, cut no ice with my resolve. As a recognition of our new relationship, I heard myself call him Dr Williams in our few remaining exchanges on the couple of afternoons that I went in to clear out my desk. There was an awful lot of paper. This was what my life amounted to in the end – a great heap of paper. I dumped it in a corner in boxes labelled 'Research Notes H. Williams'. I don't suppose he ever gave me any credit; I never saw his book. I did leave him in the lurch, right in the middle of things. Apart from the events of the last year, I have been ever since a solitary individual. Marty Hawkins, the unfrocked eremite of Fansha.

Pierce was sorry. He expressed his sorrow for me, he told me how sorry he was that I was unhappy up at Trinity. He had no wish to be at Trinity himself, but he liked having me there, he liked being proud of me. He liked the appropriateness of our futures, he a flourishing farmer, me his successful younger brother in the groves of academe, adding in future years some modest illustriousness to the name he would carry on. He liked things to be safe and categorized. Foilmore would be his and my fine career would be mine.

I know he regretted my failed career. Deeply. But I also know he used to say to relations or to anyone around who enquired – 'Martin? Oh, he went up to Trinity. But he came down out of it again.'

Dismissively. Implying with this country locution that the place wasn't good enough for me. This illustrates Pierce's sense of loyalty, though I can claim in my arrogant fashion that it was in a way true. It wasn't good enough. But Pierce couldn't be expected to see that. He didn't see it. He took it on trust however, or pretended to, stoutly. This was typical of Pierce. He always let on to understand me, to accept my own proud estimate of myself. Sometimes I think that I existed purely for this one malicious purpose, to test Pierce. To test the grandeur and nobility of his character, to allow him to emerge from the crucible of the consequences of my failure and my inadequacies finer than ever.

'There are no flies on Pierce.'

That was what they used to say about Pierce, respectfully, the people around. This astonished me, when I could see that my brother was riddled with flies. Where I was concerned, anyway.

I am a flawed character. Riddled with flaws. One small virtue in my favour however may be that I do not regard my own self with any more importance than I regard others. Except for those who are dead. The dead have earned their self-importance, it seems to me, and an infinite pathos, and a life of form and brilliance even if there was nothing of apparent brilliance about their earthly life. This might be one of the emotive reasons why I abandoned history and threw up my university career. Who was I, living and deficient in sympathy and understanding, to rake through the bones of the dead?

This reaction in me is not fully consistent. It's not one I am always able to sustain either in principle or in practice. I am not, even if I give that impression, quite inhuman. There have been a few among the living to whom I have granted inordinate significance. But terrible things resulted from that.

It is hard for me to remember my first lie, since I've told so many. And now I'm at it again. Can I lie here and sidestep some memory I'd rather not entertain, and then let fiction take care of it elsewhere, because that is sometimes what fiction does? It becomes a receptacle for those truths we would rather not allow into our tales of the self.

The made-up characters feel their way by virtue of thoughts that novelists deny having. So I'd like to describe my first stab at fame, even though it shames me. It was a combination of lies and a fondness for words that started me. I can still remember the liquid feel for those words for rain. How the beads were blown against a windowpane, and glistened there, and ran. The words for rain were better than the rain itself. I wanted to type up words.

I went to UCD for a disastrous few terms. Instead of attending university, I spent the year selling second-hand beds and wiring houses with my cousin Vincent O'Neill, who introduced me to clients as a science student. Or, with his father, Pop O'Neill, I'd sit supping bottles of stout at the kitchen table on his pension day. We'd be waiting for Vincent to come home with the dinner. Nothing good ever came out of Co. Clare, sniffed Pop. That was because Vincent was born there. Like my father, Pop had been a policeman, and before that was a member of the Connaught Rangers who'd mutinied in India over England's treatment of the Irish in the Troubles.

For five days he'd stood in the burning sun, and sometimes the memory would come back, and he'd rage and stare at me – *A student, my arse!* He'd shout. *Useless! Useless! Useless!* Other times, I'd sit with Kitty, Vincent's wife, who was heavily pregnant, both of us looking into the fire for hours on end. I was filled with guilt at spending my mother's money, and taking a place at university that Una would have relished.

Then one day I upped and left for London, and found a job with Securicor. In my underpants I sat on half a million pound notes in Ealing during a heatwave in 1968. I lodged with a family called Healy whose youngest son was called Dermot. In that house Dave Allen was all the rage. I passed a window in the High Street and saw a manual typewriter in a window. I bought it with my first week's wages.

The typewriter was a great liar. It wrote out refurbished poems by Dylan Thomas, snatches of pop poetry by the Liverpool poets that had been published in the Penguin Modern Poets series, and many disjointed lines by virtue of ee cummings and William Carlos Williams. It lied beautifully at times. As a night watchman I walked factories near Smithfield Market that were filled with the rank corpses of cattle. Hides hung from the walls. There was one corner that was stacked with horns and hooves. I read Camus. Beyond the fence at the end of the yard trains flew by scattering the rats.

I disappeared from Ireland and my family. I sat by the back window of Healy's and read *Portrait of the Artist as a Young Dog*. Then I moved on to Dylan's poems. The words shimmered on the paper and released themselves from the

prison of the sentences they were in. They became things in themselves. A single word collected a myriad of meanings. Verbs bounced in open spaces. A noun was like a bowl of cream. It contained vast worlds. An adjective made an image infinite.

But it was the responsibility for the everyday kept me calm. The groan of an oven in the foundry. The stiff hides. The rats racing over the railway lines. Lorries, after a drive from Scotland, blowing their horn at the gate sometime near dawn. Heathrow, where two of us loaded gold onto a plane at nine in the morning, and unloaded the same gold that evening at five. In between the gold had been to France and back again. It was something to do with keeping the foreign exchange rate correct. Those gold bars fascinated me. How easy it would be to rob them. Later the same gold bullion was stolen.

Then I became a guard in Heathrow dealing with aliens from Pakistan. I had my own office off two cells where prisoners were put. The prisoners were young Pakistanis who had been sent to England, with, in many cases, their home village putting up the fare. They arrived without proper authorization and I led them across the tarmac. They followed in my wake according to custom. I made phone calls on their behalf to various embassies, relations and immigrant services, then locked them away and lifted out Dostoevsky.

A citizen of London, I returned home to a wedding in Cavan via the Holyhead boat. I hitched to Cavan. That afternoon I found myself at the reception seated by the editor of the *Anglo-Celt*, the local newspaper where I had published my first story.

How is the writing going on? he asked.
Oh fine, I said.
He filled me out another glass of wine.
I'm glad to hear it, he said.
Thank you.
So will we be seeing a book out soon?
Not yet. *(Pause)* But I have a play finished.
And is it going on?
Yes.
Where? In the Abbey?
Oh no. I searched round frantically. On TV.
TV, he said.
ITV actually.
Well that's wonderful.
I got a thousand pound.
You're made up. He raised his glass. What's it called?
Night-crossing, I said.
To *Night-crossing*, he said. We touched glasses.
It starts with two lads leaving Ireland on the Holyhead boat.
Sounds good.
The dancing began and I forgot all about the play I'd never written. A week later I was sitting in Ward's Irish house when Dermot Burke, my next-door neighbour in Cavan, and now by another coincidence my next-door neighbour in Piccadilly, came in with a smile on his face and a copy of the *Anglo-Celt*. He clamped it down on the bar.

Look, says he.

And there I was on the front page with a cigarette in my mouth over a small headline that read: CAVAN AUTHOR FINDS FAME. Oh, Bourke brought that copy of the *Anglo-Celt* everywhere, into every company I found myself in; he produced it out of his pocket as we sat with friends, he had it photostatted and posted it around.

He'd set me questions about the plot, and the more he asked the more I had to invent.

In time I invented a producer from ITV, a Mr Evans, if you don't mind, who lived in Hammersmith. Apparently I saw him from time to time. He went over the shots and camera angles with me. I even eventually set a date when it would be broadcast to the nation – 10 November, let's say. In fact I began to believe in it myself. I believed the script existed. The more of the story I invented, the more real it became.

Then I'd suddenly wake out of a dream terror-stricken by my duplicity. Slowly I tried to extricate myself from the lie. There were problems with the production monies, I said. There were production difficulties. Something had gone wrong down the line. The date for the broadcast came and went. No one mentioned it.

But in fact I had set myself a duty. Everything I write now is an attempt to make up for that terrible lie. Had I not lied I might never have tried my hand at fiction. The truth is the lie you once told returning to haunt you.

I work at the Post Office.
I hate my job,
but my father said
there was no way
I could empty bins
and stay under his roof.

So naturally,
I took a ten week
extra-mural course
on effective stamp-licking;
entitled
'More lip and less tongue'.

I was mostly unpleasant,
but always under forty
for young girls
who bought stamps with hearts
for Valentine's Day.

One day a woman asked me
could she borrow a paper-clip,
she said something about
sending a few poems away
and how a paper-clip
would make everything so much neater.

But I've met the make-my-poems-neater type before;
give in to her once,
and she'll be back in a week asking,
'Have you got any stamps left over?'

Well I told her where to get off.
'Mrs Neater-poems,' I said,
'this is a Post Office
not a friggin' card shop,
and if you want paper-clips
you'll get a whole box full
across the street for twenty pence.'
Later when I told my father,
he replied,
'Son, it's not how I'd have handled it,
but anything is better than emptying bins.'

The table was always covered by a cloth for breakfast. The room as usual had its air of formal gloom. Father was reading the bloodstock sales catalogue and only grunted when I came in. Mother was always surrounded by her own delicacies, a comb of heather honey, her small silver teapot with china tea, the sticky barbados sugar for her porridge, the silver paper knife laid beside her plate each morning with which she opened the envelopes with an elegant twitch of her wrist. She looked up from a letter and smiled.

'Dear boy.'

She held up her face for a kiss. It was as if nothing had changed. I was repelled by the thought of touching her scented skin and walked past her to the hot-plate on the sideboard. I inspected the food under the silver covers, some destined to be eaten, the rest to be thrown to the pigs, and decided that I didn't feel like food. I poured myself a cup of tea and carried it with care to the table and sat down.

I stared out of the window at the garden as there seemed nothing else to do. The grass was still white with last night's dew. A gardener pushing an empty barrow crossed the lawn.

'I hope you're not sulking.'

My mother's voice insinuated itself into my ear like silk into a needle's eye.

'Why should I sulk?'

I knew by the stillness of my father that he was listening.

'I just hoped. That's all. It's too childish to sulk.'

There was a silence. Even though I didn't take sugar I picked up my spoon and stirred my tea.

'Aren't you eating?'

'No.'

'Why not?' There was a touch of anger in her voice.

'I'm not hungry.'

'Are you ill? You usually eat such a good breakfast.'

Her eye lit on an unopened letter in front of her. She picked it up and examined the writing and the post-mark before slitting the top of the envelope. As she extracted the letter she spoke again.

'I do believe you are sulking. You used to sulk as a little boy. An unpleasant habit.'

'I'm not sulking, mother.'

'Then why aren't you eating any breakfast?'

Father stirred uneasily behind his paper. She unfolded the letter and looked idly at it.

'I've told you, I'm not hungry.'

'It's from Maud.'

She frowned as she read.

'She wants to come and stay for the opening meet. Nonsense.'

'What do you mean, nonsense?'

'Of course you're hungry. Young people of your age are always hungry, unless they're ill.'

'I'll never mount Maud again,' said father. 'Not after last time.'

'I can't write and tell her that.'

'Bloody woman needs a camel not a horse.'

'I'll butter you some toast, my darling, and a little of my special honey. It's perfectly delicious this time.'

'How often do I have to say I'm not hungry?'

'He's not hungry,' suggested father from behind the paper.

Mother's mouth tightened ominously.

'The condemned man did not eat a hearty breakfast.' I regretted the rotten joke immediately. Father laid the paper down beside his plate.

'Alexander ...'

Mother held up her hand.

'We have never had trouble ...'

'Nor are you having trouble now. I have no ulterior motive in not eating. You don't have to believe me, but it's the truth. Cousin Maud can ride Morrigan.'

Father looked at me as if I were mad.

'For the opening meet? Don't be such a damn fool.'

'As I won't be here I don't see why she shouldn't ... or you could organise some sort of shuffle round.'

'What do you mean you won't be here?'

'I suppose I will be heading for Belgium by then.'

'There you are,' said mother, 'I told you he was sulking.'

'I see.'

'But, dear boy, you don't have to go before the opening meet.'

'Today.'

'Today?' Her voice was shrill and very angry.

'Yes. So if you'll excuse me I'd better ...'

'Don't you think you're treating us a little unfairly?'

'You confuse me. Last night you said you wanted me to join the army. Today I join the army. I can't see what you're complaining about.'

'You are being extremely insolent.'

'I'm sorry. I don't intend to be. I don't want any more arguments, discussions. I find it impossible to discuss with you. I must just go. I had hoped that you would understand.'

'You don't have to go today.'

'I do. I had thought of just getting up and going. Crack of dawn, something like that, but I thought better of it.'

She gestured helplessly with her hands.

'If you must, you must. Other young men don't carry on with all this ...'

'I have to catch the Dublin train. I think I should go and pack.'

'... fuss.'

In spite of the petulance of her words, I was conscious of a radiance coming from her, a feeling of triumph.

'I think we should send him up in the motor, don't you, Frederick?'

'I would prefer to go by train. I'm afraid I shall have to ask you for some money, father. I'm sorry.'

'By all means.'

He picked up the paper again and retired behind it. His hands were shaking.

Mother dabbed at the corner of her mouth with her napkin, removing all traces of the special honey, the nutty-tasting toast.

'You have been very thoughtless, dear boy, but I will forgive you. Come. Let me do your packing for you.'

She got up and came over to me. She touched my face with a cool finger. I shook it away as I would a fly.

'Let me help you.'

'I'm only bringing my tooth-brush.'

'You're so absurd.'

'Yes.' I stood up.

Father blew his nose behind the paper.

'Well,' he said, 'if you've made up your mind to go, the quicker you go the better.'

'Quite.'

'Pity about the opening meet.'

'Yes.'

'I'll fix something up for Maud. Pity to let her ride Morrigan. She'll pull the mouth off her. Might even have a stab at her myself.'

'I'd like that.'

'Mmmm.'

He got up abruptly and made for the door.

'Your grandfather was a soldier. I can't say it got him anywhere. I'll be in the study when you're ready. Sure you don't want the motor?'

'Quite sure.'

I listened to his feet crossing the hall. I listened to him open and close the study door.

'I am so proud of you,' my mother said behind me.

I laughed and went upstairs to pack.

I put my tooth-brush and some underclothes into a small brown leather case and then sat on the end of my bed. They would put moth-balls in all the drawers and in the tall mahogany press, and they would forget to open the window, and after a while anonymity would take over. That would be right. If ever I came into the room again I would be a different person. The door opened and father came in. He looked at me for a moment before speaking.

'I have to go out,' he said.

I nodded. He held a bundle of notes out towards me.

'Yes. I have to. Something has come up.'

'That's all right, father.'

'Here. It's all I have about the place, but I'll send you more.'

'Thank you.'

I took the money and didn't know what to do with it.

'Don't let yourself go short. Anything you want ...'

'Thank you.'

'I have to go. I couldn't just sit down there.'

'I know.'

'Your mother will want to say goodbye on her own. I do insist that you are kind to her.'

'Yes.'

'Put that money away boy, you'll lose it.'

I pushed it into my coat pocket.

'It'll be all right.'

He probed in his waistcoat and pulled out his gold watch. 'Sentimentality doesn't suit either of us. Let us call this a traditional gesture. It was my father's. Balaclava and all that nonsense. Take it, take it for God's sake. He was a great horseman. A giant. I've no doubt he was a rotten soldier though. At least he died in his bed. Now it's yours. I don't need a watch these days. The whole house full of damned clocks. Ticking everywhere. Put it away.'

It was warm in my hand with the warmth of his body. I put it into my pocket along with the money.

'Thank you. I'd give Charlie Brennan my coat and let him take over as whip.'

'Brennan?'

'He's as good a man as any.'

'I'll bear him in mind. Well ... Packed?'

'Just the tooth-brush. No point ...'

'Quite.'

'It's a pity about the opening meet.'

'Next year.'

I bent down and picked up the case. I held out my hand.

'Goodbye.'

He took it.

'Goodbye, my boy. Don't, ah, indulge in too much foolishness.'

'I'll write.'

'Yes. Forgive me for not coming down.'

'Goodbye.'

I left him standing there.

Mother was standing in the drawing-room waiting for me. She threw out her arms as I came in, with a splendidly theatrical gesture. I walked towards her. The room seemed about a mile long. I finally reached her and her hands flew like two birds around my neck and she pulled my face down to hers. I kissed one cheek and then the other. She still held me. I put up my hands and unfastened hers. Her eyes were the most triumphant blue.

'You'll come to see us in your uniform, won't you?'

'Mother, there's just one thing I must say before I go.'

'Yes?'

'About what you said last night.'

She smiled at me.

'Go ahead, darling.'

'I don't believe you. I never will believe you.'

She laughed a little.

'Run along, dear boy, you'll miss your train.'

I turned and went towards the door. The journey was not so long that way.

She called after me.

'Write. Do write. I will be so looking forward to your letters.'

In the hall the servants gathered round clutching at my hands and touching my coat. Mrs Williams the cook cried into a large blue handkerchief.

The word had got around quickly. 'I'll see you all at Christmas,' was all I could think of to say and then I ran down the steps and got into the motor. I opened the window so that I could smell the turf smoke and catch a glimpse of the two swans rocking gently on the lake.

How many miles to Babylon?

A strange thought for such a moment.

Four score and ten, sir.

It was the only thing in my mind. The strange bumpy rhyme that I hadn't heard for years.

Will I get there by candlelight?

The orange leaves from the chestnut trees danced in front of us all the way down the avenue.

Yes and back again, sir.

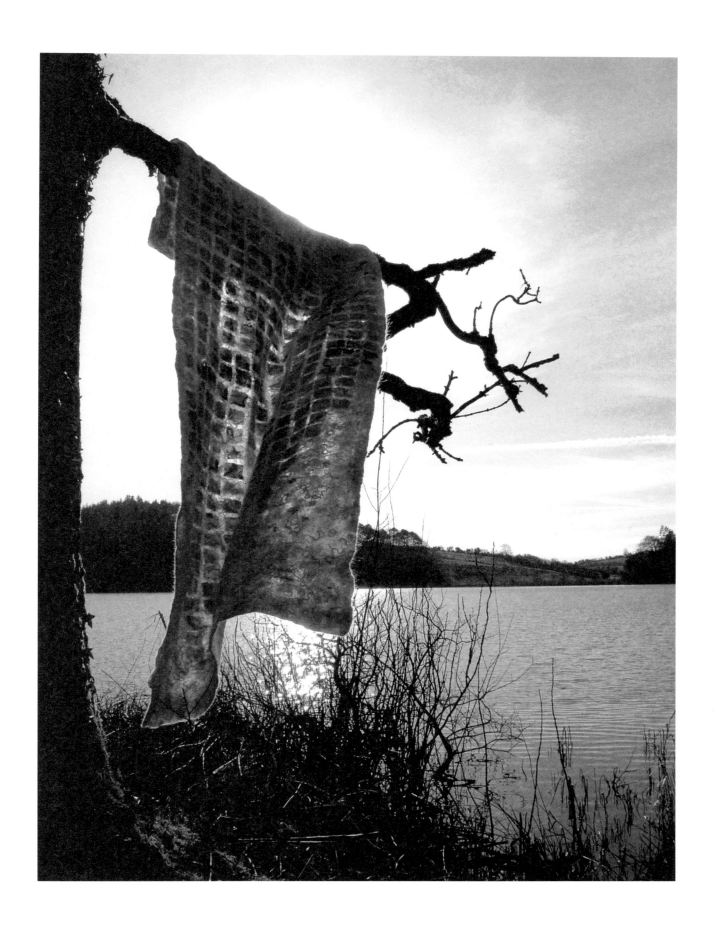

'At eight-thirty a.m.
A Titian-headed girl
Said good-bye to her mother
Going down the steps
Through yellow light and the trees
Away to the beaches and May.'

'That's beautiful.' And the way she says it,
Her eyes all warmth, you'd think
She surely meant it.
What's the purpose of the lie.
What's the purpose of the great room,
Where the trailing cobweb glistens
And the ghosts tap their bones on the piano-lid,
Shuffle the sheets of Debussy, and the dust
Settling ...
Do you know what I mean?

What too's the purpose of training American glory
Under subtle pretence of business and the like ...
Yet was that glory sweeter than the violets
Wet, wet violets sold in Stephen's Green,
Gentler, sharper, sharper than the candle-flame,
Candle guttering in Pembroke Road.

Listen people ...
Only he could tell us the truth about it all:
The man who worried epic out of the sod
Stamped on the ashes till they glowed
The man who gleaned the lyric at the heart of the clod
The man who reaped what he sowed.
But how well we know, yes, what he would say,
Crashing through the cobwebs (lovely cobwebs!) to the
 fine raw day.
Listen people ...
'That's not poetry! Pure shite,
 pure shite!'

'Yes, Patrick. That's very well put. But
Don't you think ...'
'The Muse is queer. She's like a goad.
Poetry's never written unless a man's
All on fire to do it, on fire with
Happi-
 ness, on fire with
Sor-
 row,'

O to get out of it
O to get out of it
O to get out of it
Or drink the Shannon dry!

Ah the eyes are warm again and the May days
Have come back to the room.
Crackling paper, spilling water,
Beautiful shades out of business.
Ah the eyes are warm again,
'Read us another one John.'

'At four-thirty a.m.
A white-haired woman
Said good-bye to guests
Leading them down the steps
Through the night-stock fragrance
Out into the reaches of November.'

The work I have been involved in so far falls into two types: image driven – Seven Days, Drowning Room and Burn. And more formal: driven primarily by experiments in approach – Hereafter and Sugar. I feel most in touch when following a track that starts from destruction and negation yet arrives at a conclusion that is productive and occasionally comic. Story is important. There is nothing stronger than finding an image that feels resonant of many. But just beyond that is a step where the drama of an image combines and becomes the drama of a narrative. Here it starts to feel like its own animal – one that I still barely know.

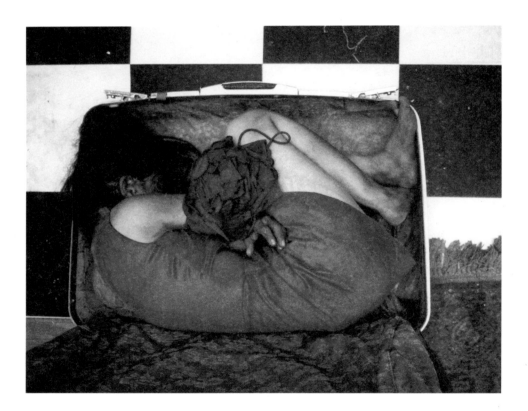

Thomas, now sixteen, was apprenticed to a cooper, a job he found tiresome and almost demeaning. Unlike his employer, he could read and write, and thought it absurd that Uncle Neville had arranged things thus, so that he bent wood all day in heat-moulded curves, and held copper rings at the blazing forge, and shovelled away shit from beneath the carthorses. But Neville assured him that it was a short-term measure, a stopgap, he said, until he received sure intelligence of the future from Honoria, from the wise, all-knowing zone in which she now had her being. Neville saw the world simply bisected, the living and the dead, still communing, still corresponding, still offering each other advice, but despite his expensive visits to Madame d'Espérance's Salon, he had yet to discover how to rescue the children from the predicament into which he had cast them.

After only a month at the cooper's, Thomas learned the necessity of initiative and found his own employment, together with an advance in salary to break his indenture. He presented himself at Mr Martin Childe's Magic Lantern Establishment, and pronounced himself desirous of a career in the projection of images. Mr Martin Childe was a barrel-shaped man – he might, indeed, have been fashioned by a cooper – who wore corduroy trousers and jacket and a neck scarf tied like a flower. He quizzed Thomas on the reason for his attraction to lantern technology and found in the boy a kindred spirit: both loved, above all, the phantasmagoria, the gruesome narratives of horror, spooks and unseemly violence, and neither, it seemed, enjoyed the Temperance slide shows, or the long, pious sequences on The Life of Christ in Palestine. Mr Childe thought Thomas respectable, intelligent and of excellent taste: he offered him a repast of corned beef and sherry and then employment at various tasks – taking admission, sweeping the auditorium, learning, by stages, the mechanisms of gas jets and lenses and star-dissolving taps (whatever they were). He held rectangles of images up to the window and demonstrated the rudimentary physics and optics by which lantern slides, hand-painted on glass, were enlivened by airy expansion into public vision. They shook hands vigorously as Thomas departed.

'Master Strange,' said Mr Childe – who relished Thomas's surname and used it frequently – 'welcome, my boy, to the Childish Establishment!' Thomas could hardly believe his luck. He ran home along High Street, whooping and leaping like a boy on a deck, and burst into their small room to greet Lucy and Neville with his eyes fired up and aglow, lively and bedazzling, like twin gas flames at an eight o'clock magic-lantern show.

Lucy could not bring herself to seek work in the bristle factory, although the turnover was high and they often had positions vacant. She was disturbed by the thought of damage to her hands, even though she longed – in a way she could not even identify – for a small community of sympathetic women. She was not well educated enough to apply for work as a governess, and had virtually no skills that would recommend her to an employer. The idea of working as a nanny did not appeal, nor did she wish to be a domestic servant.

Lucy found work at last in an albumen factory. Albumen, she discovered, was the substance used in the manufacture of photographic paper, and it was obtained, quite simply, from the white of eggs. When she first applied for the position, she met a woman with a huge bosom – a Mrs McTierney – who tested her ability to crack open eggs. Lucy was given six eggs and instructed to part them cleanly, as if she were performing an operation on a living being. She was fastidious and quick: she passed the test. Mrs McTierney said that usually girls were nervous when she watched, and often wrecked or spilled at least one or two. She fingered the ruffles of her blouse and looked at Lucy sternly.

'I'm never nervous,' Lucy heard herself declare, 'it's not in my nature.'

It was true. She suddenly knew it. She was never nervous.

At work Lucy sat at a long bench with twenty-three other women (two-dozen hard eggs, they joked), each with a mountain of stacked eggs at their side and a kind of trough between them. Together the women spent the day separating yolks and whites, whites and yolks, so that the viscous shiny liquid filled a pool before them. They had vigilantly to check for blood or yolk in the white, and to watch, necessarily, for shell and rottenness. Egg odour entered their skin and hair, and sticky matter stained their work aprons and pinafores; but otherwise the job was easy and even meditative. Sometimes the women worked silently, cracking eggs side by side, each enclosed in her own sealed and uncracked thoughts; more often, however, they chattered together. Once a week each contributed a farthing to hire a reader, who sat alongside them, reading aloud from serials, or newspapers, or collections of short stories. Words circulated in the air like a new kind of energy, in waves and particles, focussed and diffuse, showing and obscuring what might exist in the world. Lucy loved the timbre of the reader's voice and her habit of clicking her teeth with her tongue at her own points of concern in the narrative.

Mrs McTierney supervised, strolling slowly, her hen-like bosom swelling before her.

The workers were now and then rotated to different tasks, so that Lucy had also the job of whisking the albumen in drums to a high bubbly froth, or tipping the liquid into storage for fermentation. Most of all she liked to work with the paper. A single sheet was dipped and floated in albumen solution, then hung up to dry. Lastly it was rolled and sorted into piles of first- or second-grade paper. Everything about this process of labour stank, but it had about it the pre-industrial gratification of completion, of an entire act of manufacture, seen through to the packages neatly addressed and sent away to photographers.

Years later Lucy found herself using the albumen paper that she and her co-workers may have produced. It was a moment of such profound memory retrieval that with it came the sour smell of fermented albumen and recalled to her the faces of all the women she had loved. She held the paper to the light to discover its grade and to inspect it for streaks or tiny cracks; she rubbed it between her fingertips and assessed the quality of the surface and gloss, checking to see if it was single or double-tipped, and knew at that moment that honourable work returns itself in these stray unguessable circuits; some random experience of labour returns as good tidings; some object sent into the world, blank, potential, arrives as the fortunate component of wholly new meanings.

Years later, too, Lucy flicked through her diary of Special Things Seen, and saw that on her first day at work in the albumen factory she had left at four o'clock in the afternoon, and recorded that the sky was the colour of a sheet of photographic paper, drenched in wet egg-white, a bright screen, gleaming lightly as it hung to dry.

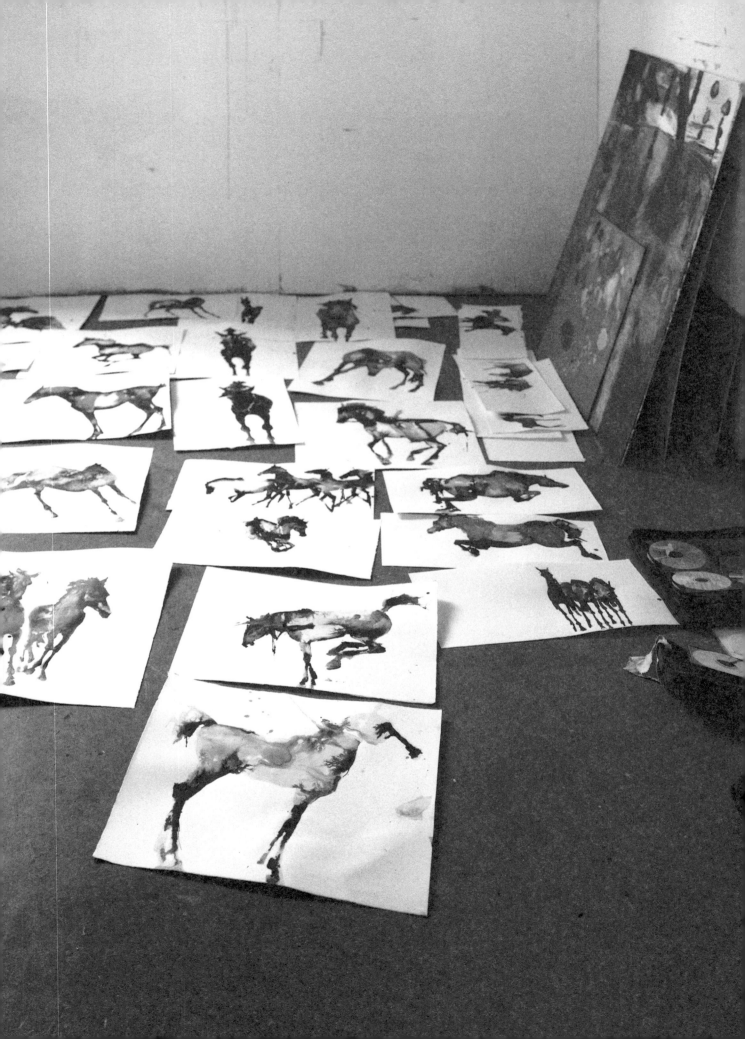

Chapter One

I married Billy Fennell in a cold, lambing season. Before I reached the chapel snow was falling and while we stood at the altar, taking our vows, I knew the snow would last. Billy was like a stranger standing there in a pinstripe suit and tie. Behind him, the Station depicted Jesus falling for the second time. The priest looked cold – there was a shake in his hands but he took his time with the consecration. When I drank from the chalice I tasted blood. Billy was asked if he would take me as his wife. When he hesitated I knew how much this meant to him, and then it was my turn. Finally, we were blessed and made to sign our names.

Out in the graveyard cherry blossom mixed with the falling snow on a lather of wind and when we ran down to the photographer's office the sign said it was closed. I was glad to be married and did not mind about the weather. We walked across the Slaney bridge to the hotel and ate roast beef and cabbage and watched the birds panicking on the lawn.

Nobody came to our wedding. Our marriage was witnessed by a cousin of Billy's who owned the sweet-shop next to the chapel gates and a layman from the boarding school. My father did not approve of me marrying Billy – he would not say why – and my mother was dead. She did away with herself when I was a child and I can't remember much about her except that she forbade me to eat the berries off the yew and made me drink goat's milk when I was sick. Even to this day, I can't abide the taste of milk.

Billy's father was in bed with pleurisy the day we married and his mother was in the nursing home in Baltinglass. He had no siblings and I had only the one brother who went off to England shortly after my mother's funeral and I hadn't seen him since. I came from people who were distant but Billy wasn't like that. I knew that if I died Billy Fennell would eat me sooner than bury me.

When I first saw Billy I was leading my father's brood mare around the ring at the Tinahely Show. She was our 16.2 red chestnut who always won first prize. Some said we should stop entering her but my father paid no heed. Billy stood outside the ring and stared. He wasn't afraid to stare. After I got the ribbon my father took the reins and somebody from the *Farmer's Journal* took his photograph. Billy came over to ask about her pedigree and took me to the tent for tea. I ate ham sandwiches with mustard and then we went to look at the poultry. I was thinking about rearing turkeys and selling them at Christmas. My father turned pale when he saw me with Billy and bade me to load up the mare and come home.

'Don't you know we're late for the milking as it is?' he said when he got me in the car but it wasn't true. When we got back to the yard the cows hadn't even come down as far as the Pond Field gate.

Billy wrote shortly after asking to see me. I made the mistake of showing this letter to my father who said I was going nowhere with anybody until I came of age. Billy wrote back, and said he'd wait. When the two years passed, I met him every Friday at the end of the avenue. Rain or thunder I walked to the road of a Friday and, rain or thunder, Billy's car was there, parked under the chestnut at the road. In fact, I

preferred rain and thunder, those wild nights when we would drive out to the Cahore to watch the sea going mad and talk about the past until it grew dark.

Billy was a big man with long arms and his voice was hill water running over stones. Sometimes, when we were courting, I closed my eyes and imagined him asking me if I had shut the hen-house door or if there was a clean shirt in the house. His eyes were a dark creosote brown, the same as mine. I was, in truth, afraid of him even though he never took advantage of me. I sometimes wondered what he saw in me, for I took after my mother's people: I had nothing only a small frame and a fine imagination. After two years of courtship that began and ended at the foot of my father's avenue, I married this plain-spoken man and went to live with him on the back of Mount Leinster. My name was Rose Tyrell before I married. I was twenty-three years old and Billy was almost thirty. Neither one of us believed in God. We believed in land and trees. We believed in ghosts and the things that can't be named and neither one of us took the sun's rising or rainfall for granted.

We were hungry on our wedding day. Billy asked for more spuds and gravy and got the girl to bring hot apple tart and custard. Across the room a middle-aged woman sat staring at me. Her powder was far too pale for her complexion, same as she'd dipped her face into a bag of plain flour. She watched me for a long time before she came over.

'Well, Billy, aren't you the sly one? I'm after hearing the news above in the sweet-shop,' she said. 'Half a Bunclody will be bawling tonight.'

'Rose, this is Mrs Byne.' He stood up and looked down on her.

'Ah now! None of this Missus carry-on. Call me Nan.'

'Nan's our neighbour, Rose.'

Her eyes took root in my hair, crawled down along my navy blue suit and dipped onto the patent leather of my wedding shoes.

'Make sure and call in some evening when you're settled, Rose.'

'I will of course,' I said.

She looked up at Billy and her expression changed.

'Well, I won't keep yez. Lovebirds.' Her teeth were false. 'Good luck now! Ye will need luck same as the rest of us.' She laughed a terrible laugh and went away.

Billy looked at me. It was the first time we had looked at each other properly since we'd married. I knew he was glad to have me as his own and not to have to drive for miles to speak to me. Now that we had crossed the starting line I was impatient to get on with it, to get out of my good clothes, and begin. My clothes were a nuisance. My waistband was tight and my wool blouse made me want to claw my skin 'til it bled. When I was a child, I'd scratch a hive until it bled, preferred a bad bruise to the nettle's sting. I'm a woman of extremes. That afternoon, I wanted to lie down naked, outside, and let him see me naked. I wanted him to show me the harm he could do me without doing me harm. Five seasons would not have been enough on that, my wedding day.

'You'll have a drink, Rose.'

I shook my head.

'Come on, so.'

When we went up the street the car wouldn't start but the butcher boy gave us a push so we started on the run and turned back in the direction of Mount Leinster. A veil of snow covered Bunclody that Tuesday afternoon. Rooks were repairing nests in the sycamores above the stream and the crows looked savage

balanced on the electric wires. When the shop lights went out I thought the power was gone but then we met a hearse on the co-op road and I realized it was only a funeral.

I was his wife now. Christ, to be his wife, it felt so strange. I had lost my name, my father's name, and exchanged it for another. I resented this, felt bitter that I could have no name of my own. And then I remembered that time Billy went off to Leitrim and was gone for a whole fortnight and wrote how he'd missed me on the Friday, how he'd gone away from all the men in the field admiring the Suffolks and clenched a thistle so he'd have a good reason to feel pain. When the men stared, he didn't care. All he could think about was me stepping over the threshold of my father's land, to marry him. He said the day would come, and now the day had come. I didn't know what to feel and for some reason wished my mother was alive. I felt hot. I am hot-blooded and seldom feel the cold. Billy grabbed my knee in a donkey bite, his thumb and fingers digging into my flesh. When I flinched he laughed and I was afraid of him again.

He kept on driving, past farmhouses that reminded me of December months on calendars. The steep mountain road got steeper until the dwelling houses disappeared and the land turned stony. The light on Mount Leinster's mast burned red. It seemed a long time before I saw another house sheltered by a belt of fir. The car lurched as we crossed over the roots of a tree. Billy drove round the back and parked in the yard. There were fertiliser bags and dunghills high after the winter months but the diesel tank looked pretty in the snow and his sheds were granite. When I stepped out the wind made the heaving conifers moan and somewhere a wood pigeon called out (who are you? who are you? who? who?) and two black dogs flew around the side of the house and stopped dead and bared their teeth until Billy told them to lie down.

I wasn't carried across the threshold. I walked into a kitchen that smelled of glue and mutton grease. No light was burning but when my eyes adjusted to the gloom I saw an old man leaning over an upside-down bicycle, mending a puncture.

'And what are you doing up?' Billy said.

'Ah, I was fed up.'

'Aye. A fine day for mending bicycles it is, and you wud pleurisy. It's in your bed ya should be.'

'Bed! I've spent half me life in bed. I'll die in that bed before long.'

'Rose, this is me father,' he said. 'Da, this is Rose. We're after gettin' married.'

'Married?' He stopped and straightened himself. He wasn't tall. 'Well, now, I thought you might be going to a wedding wud the suit but I'd no notion it'd be your own.' He held out his hand. 'It's dirty but it's daycent,' he said. 'I go be the name of Martin.' His palm was dry. 'Would you like tay? Put the kettle on the gas there Billy and give the woman something.'

'We had a feed down the town.'

'Aye, wasn't it the layste ya could do? Sure we'll have a drop so. It's not every day we've a weddin' in the house.'

He went to the dresser. It was a big dresser with odd plates leaning against one another and a marmalade cat sleeping on the top shelf beside a jar of weed-killer. She stretched herself when Martin reached for the bottle but she didn't wake. Then a creature ran out of the dark, gave a great cry and nuzzled Billy's leg.

'Don't feed her,' Martin said. 'She's had one. She'll get a pot belly and die if ya keep feeding her.'

When Billy lit the gas-fire I saw the white-faced lamb, woodworm in the ceiling boards, lamb droppings on the floor and on the mantel two china dogs whose ears were chipped, staring into the future. We drank whiskey. I had never tasted drink in the afternoon. Martin looked like he was perishing with the cold but I knew by him that he was thinking hard, putting things together in his mind, like a man trying to solve a piece of long division without paper, but he kept on sanding the tyre and stuck a patch over the hole.

'There now,' he said, 'that much is done. Good health!'

He looked into my eyes and raised his glass. He had the bluest eyes I have ever seen. They were the eyes of a man who knows without saying much. I wondered what age he was. I wondered Billy hadn't told him about us but then all Billy said was that he had the pleurisy. I drank the whiskey and didn't care. It was my wedding day. I was out of my father's house and had entered another where people did not mind about small things like shite or weddings or snow.

We drank and said little for a time. The silence between the talk deepened in the falling snow. I began to feel hot again and finally I stood up.

'I have to strip!'

The men laughed.

'Sure, go up to the room there so,' said Billy.

I didn't know where the room was. I climbed stairs and looked into rooms until I saw my suitcase on a bed. The room smelled of mice and a wallpaper paste. Billy'd brought my things up from home the last time he'd called. It was the first time he'd set foot on the floor but my father said nothing that day. He sat outside with the black knife, cutting seed potatoes. I used to like that job when I was a child. He had taught me to find the eyes and to cut between them so they would sprout when they were in the clay. That day he just looked at us, finding the eyes, and now I wasn't sure I'd ever see him again.

The room must have been Billy's mother's room. I saw a cat on the windowsill, a beautiful dark brown cat curled up breathing faintly. I reached over to stroke her but when my hand touched the fur I realised it was only an old fur cap. I knew by the way my things were that Billy hadn't touched them. I was glad of that for no reason except that I believed the man I'd married was not eager to know anything he should not know about me. Billy always said that people find out things soon enough and the less you know, the better. He said he'd courted other women, women who went through him like he was nothing, only a chest of drawers. He said I wasn't like that. I reminded him of the salt wind that cuts the trees down to size.

The relief of taking off my wedding clothes was without comparison. I felt free again although, now that I think about it, freedom was a thing I wasn't used to so it might have been something I felt for the first time. I pulled on an old dress, a jumper, found socks and went back down the stairs. The men were drinking at the gas-fire and it struck me that Billy and his father got along better than any relatives I had ever known.

'I'm an old man now,' Martin said. 'The longer you live, the less you know, but I've a feeling ye two will get along.'

'It'll soon be dark,' Billy said. 'I better go up the fields.'

'Ah, the fields!' said Martin. 'Do you know an'thing about the treachery and seduction of land, Rose?'

'I was hoping I'd left all that behind me.'

'Behind you?' he said 'Nobody layves a thing behind them, girl, especially them that tries.'

'And you? Did you leave nothing behind?'

'I did me best. That's why I'm still walking around, the tormented man I am.' He laughed hard and I thought he might cry.

Billy took off his suit whose lining, in the light, looked silver. He stripped down to his vest and underpants, pulled a pair of trousers from a rope over the hearth. I had never seen his legs. They were the whitest, hairiest legs and he was unashamed, as well he might be. There were patches on his shins where the wellingtons had rubbed them bare.

'Well, Billy, there's nothing I know about you at all and now I'm thinking that maybe there's nothing I don't know just the same,' said Martin.

Billy was such a big man. I believed he could protect me from the world and yet he made me feel afraid. But I need to feel afraid. Happiness makes me uneasy. I am one of these women who expect the worst. I court the worst. Pain, well pain is to be expected. Happiness is altogether another thing. When happiness comes it's sudden but I'm never ready and then it passes and I'm sorry.

'Ye are cut from the same cloth, yez are. I know!' Martin shouted. 'Rose! This house hasn't seen a woman since Ruby left for Baltinglass.' He looked at the floor. 'Well, I'm off to the graveyard.' He got up and went to the font beside the back door and shook holy water over us the way my father used sprinkle it over new calves.

'The graveyard!' he shouted, and stumbled to bed.

I liked him, this man who blessed us and knew nothing of our marriage. I did not care that my husband married me unknown to his father or that my father wouldn't come to the chapel or that my mother was dead or that I had not seen or heard from my brother in years. I didn't care about anything except that I was on Mount Leinster, married to Billy Fennell.

When Billy opened the door the snow was almost a foot over the ground and I was shocked again by the way time passes.

'Lord Christ almighty!' he said. 'The ewes! We may fetch them in. Will ya come Rose?'

Billy whistled and the dogs appeared like two willing shadows out of nowhere. He gave me a coat and we climbed his fields whose ditches ran behind the yard and made a boundary with the wood. His flock was the speckle-faced black Suffolks crossed with the stubborn Border Leicester. The dogs responded to Billy's whistling, going left and right and crouching as he bade them. The ewes wanted to go with the snow, not against it, and I knew they'd smother in the drifts if we left them out. We brought the flock home to the yard and divided them into sheds and sorted out which lambs belonged to which ewes. It wasn't easy. There was awful confusion with the ewes roaring and the lambs bleating and us, with the dogs snapping, trying to get them paired off into all his little sheds. The ewes were demented, sniffing under lambs' tails and pucking them away to save their own milk for their own but finally we sorted out who was whose. Billy brought barley down from the loft on his back and I filled barrels with water from the pump but

Billy refused to let me carry anything. The ewes were thirsty and it took over an hour before they quietened. One ewe was down. Billy felt her tits and looked under her tail and got a basin of hot water and washing-up liquid from the house.

'You're in the deep end now. Your hand is smaller nor mine, Rosie. Lather it well.'

I did this. I pushed my soapy hand into the ewe. She was lying there straining with her eyes bulging out of her head. I felt so sorry for her, I would have done anything.

'Can you feel the feet?'

'I think so.'

'Do you think there's one or two in her? How many legs?'

'I can't feel but the one, Bill.'

'Aye. There's the trouble. One leg is turned. Now. You've to pull the other foot round, the feet should be together otherwise the shoulder'll get stuck. Now wait, wait 'til she's ready. When she stops pushing, you push the lamb back into her and bring the foot round. It'll be no bother to you. Be aisy.'

Billy talked to the ewe, calling her, 'Magsy, Magsy, me poor Magsy,' and I found the other foot and pulled and soon a speckled face slithered out, a wet ewe lamb. Billy cleared the mucus off her nose and blew into her mouth but she didn't move.

I recognized dead weight.

'We're too late,' I said.

He took the lamb by the front feet and plunged her in the water bucket and threw her on the straw. We waited and nothing happened. An eternity passed during which time I saw my mother hanging from a length of clothesline on the cow-house beam and then the dead lamb shook her head and splattered us.

'Thank God!' I said.

Billy laughed. 'Doesn't matter how long you farm,' he said. 'You always get a kick out of that.'

The ewe came over and licked her lamb. Soon she got up, stumbled and went, blindly, to suck. The ewe stood, hating us, and let her milk down.

'Aye, she's only the one in her, same as me own mother,' Billy said. 'Go on now, good girl, and get the beestings.'

The lamb sucked and its tail turned into a crazed thing. It made me think of the stubborn beech leaf that even winter cannot blow away. I've always thought it must be lovely to have a tail, and wondered what it is that humans have now that the tail is gone. I have never minded facing anybody but when people look at me from behind it makes me uneasy, as though I'm deformed because I've no tail. It's not something I can explain.

Billy brought down a fresh bale of straw and shook it out over the floor and we washed our hands in the basin of dirty water. 'You did well,' Billy said. 'You have the touch. I didn't like to say an'thing but that was close. And you know that's the worst of farming: it's the losses. People say you expect the losses but in truth you never do and when they come they're fresh, and worse than the one before.'

I was sweating. Billy was watching me.

'Come here to me,' he said. He held my face in his hands. 'You're mine now,' he said. 'There's no going back, do you hear me, Rose?'

'I'll never go back.'

We stood there for a long time. His arms tightened round me.

'You're thinking.'

'I'm thinking it'd be lovely to have a tail.'

'You have a tail,' he said. 'Come here to me, I'll show you.'

He stripped me and I was afraid of him again, afraid his savage might would rise up and hurt me or, worse still, that nothing like that would happen but it was slow and strange and painful and in the end, easy. It was easy as ripping a seam. I conceived a child that night. I knew this the way, without reason, I feel dread under happy circumstances and it comes to pass.

I got up. Beyond the shed door the snow was still falling. The wind made the clouds race, made savage attempts to lift the corrugated iron off the rafters. In a gust I heard cones falling off the larches. I thought of the seeds scattering, falling on infertile ground, and the waste of that. When I turned, Billy was dressed, and the lamb looked older.

'What did the landlords leave us, Bill?'

'Trees,' he said.

'Aye.'

'You'll catch your end, Rose.'

He dressed me. He wiped my thighs with his sleeve and sat me on his knee and pulled my socks up over my bare feet and turned my clothes right side out, buttoned my coat.

'Jaysus, Rosie.'

That was all he said, and I said nothing.

'I love the way you say nothing,' he said.

The wind blew all that night. It swept the snow into the corners of the yard. It filled the dip-tub and did its best to tear the ivy off the walls. Billy slept in his jumper and snored. At some point I woke and heard a door bang shut or perhaps I dreamt it. I thought about Billy grasping the thistle, how I took the thorns, the proof of his love, out of his hand with tweezers when he came home.

Memory is strange, almost as strange as time. That night, lying there in the shelter of my husband's body, listening to the wind, I believed no harm would come to us. I believed that nature would have the grace to withhold her claws and keep us from the betrayals every mortal who walks the earth endures.

Chp 5 - 2006

Chp 6
Bonfire(?)
Dun-D leaves
Mist-D in car

Chp 7
Scary Mist - see giant
Ridge
Ogham mustard mission

Chp 10
Mice bottles
girl-boss-break-off
mission
into the hole

Chp 12
crack - the Court
Hazar - fair green
choice of home - no

Chp 16
Pilgrims
Slendalo - Death of
Theatrics - Death
Wolf

Chp 20
bug - Bat - Burst
Donnal - Jalpac - King
Lash - BOON

Chp 27
Fairy Tale - Dana
(includes wat
- Dana sees what
she did - runs
away

Epilogue
Airplane
Dana, Gabe,
Abraham

Chp 14 - Wolf
Running with
(Fagles, Falcon)
Fearless
gun seat

Chp 15
Wolf wounded
Donn (Dal Jalapac)
Must go to
the wolf

Chp 17
Fairy tale
Mt - tooded
Luc - wealth

Chp 2, 3
Night in Mt
a Mt jet on Mist
Donn ?
(The Chronicler)
Donn Scathach
Book at Obscurdani's

Chp 26
Morriow
Dana

Chp 27
Glen - Donut
by Bob - Abraham with
Dana

Chp 18
back to Persia (?) bottle
stormtrack? kids
Mrs Scathle & kids
talk

Chp 2, Br 2 - Gabe
Fairy tale - Egane ?
Fairy Luc?
Kids tells now ?
Succeed - where is
where is kids now?

Chp 26
Fairy tale at night
reunion of tarps
Edane
- Luc - Party - IVY Haunt
Hc & T T OC
Pavilions
DARLING(?)

Chp 25 (B?)
Battle for the
Sion

Chp 13
Woods -
Nature
- oakmen
Wolf - ?
Chp 17
- heals -
monster
men) - on path

Chp 21
- Decision to
reunions Donna gauntlet
to help Abraham talk w/
Mrs monsters

net

Why are there no photos of baby Bunty?

If you look down through the plughole of the sink in the upstairs bathroom –
through the gaps in the corroded metal swirl perished through thirty years of spat
toothpaste, water from a leaking tap, and tightly coiled here and there with
drenched dead hair – you'll see a plastic lice comb, lodged at an angle with just an
edge exposed, its tiny teeth bleached clean.

I put it there. I pulled it from Mum and pushed it through the overflow
hole below Armitage Shanks. I wanted to keep my lice. They were my secret and it
was interesting to me to have something living in my hair. I liked to feel the tickle
of one as it inched along my eyebrow or wended its way round my ear. If I was
quick enough, I'd catch it and snatch it between my nails, and turn it this way and
that under my nose. Before they were raked out that Sunday night, we'd been
happily cohabiting in my head.

Mum hummed on our way to the bathroom that evening, as she does
when she moves from one place to another, or when she goes to answer the front
door. Or when something has gone wrong like her cheese soufflé not rising. Then
she'll hum a different, louder hum as she scrapes the hot eggy mixture into the bin.

Up the stairs goes little me; I'm as sleepy as can be. Loud hum, soft hum, as a
slipper pounded each stair. Up I went too, following her and the Frog, his bony
bruised legs like strips of mixed-up Plasticine gripping around her soft centre. I
climbed two steps at a time behind them, pulling at the loose banister. And how
many times have I told you not to? The sock in my left shoe had slipped down past
the heel and my skin was sticking to the shiny leather inner.

Nothing felt nice that evening to begin with. It was Sunday, only one more sleep
till Monday, which meant school. Sunday also meant *The Muppet Show*.

My father would join us in the playroom for this half-hour each week.
When we heard him coming we'd jump out of the bookshelves we had fashioned
into boats or burst through the cushions of our secret homemade dens. Once he
had settled in a chair with its stuffing pulled out and found a space around our
lives for his Jameson's and jiggly ice, he'd sniff and say has someone let that
damned cat in again? We'd sniff too, bubbly snot under our noses, and say we
couldn't smell anything.

My father laughed at the two old judges and at 'Pigs in Space' with his
mouth thrown so wide I could see two strings of saliva near his throat, like a
puppet mouth, a muppet mouth, as well as some stuck liquorice and silver shapes
on grey like the sparkles on the rocks on Sandymount Strand.

I sat on the floor beside the television because of my lazy eye, and cried. I
cried about school and about having no friends. The more my father laughed, the
more I cried. But the more I cried, the less anyone listened and the less I could

make out what Miss Piggy was saying. The playroom was steamy through my pig pink eyes, the way it went when Mum had forgotten our fish fingers on the grill.

I got myself to sleep that Sunday night and other nights by banging my head against my bedroom wall. This gave me a big hairstyle and made a large chalky hole, which I could hide things like Playmen and Monopoly pieces in.

As I rocked in bed, I liked to think about my favourite clothes and me inside them. But the me in my head wouldn't have brown hair; it would be yellow, like Charlie's from the *Chocolate Factory*. I would be thin, so that you could see my ribs even when I wasn't breathing in, and I would be a boy. My three best things were:

- My purple corduroy cap that Mr McNellis gave me before he had his heart attack. I hadn't seen it for a while; maybe it was in the clothes basket in the downstairs bathroom.

- My *Man from Atlantis* swimming togs, which were orange, tight and to the knee. With my flippers on, arms flat by my sides, I'd twist underwater in the shallow end of the pool, pretending to rescue people like the girl who couldn't swim in the red Polyotters. Before I went under I'd have to memorize where my victims were – Doctor Nugent said I might be allergic to chlorine so until Mum bought me some new goggles I had to swim with my eyes shut.

- The Frog's verruca socks, which I teamed with a pair of red-rimmed Y-fronts with pictures of soldiers on them and a matching polyester vest. I like to wear this outfit when practising my running – on your marks, get set and up the laneway behind the blue garage as fast as I could.

But none of these things had my name sewn into any part of them, like Kate's and Oscar's did. They went to boarding school and had their own pairs of socks and gym kits and wash bags and suitcases, all with their first and second names written in. They had particular things they had to do at particular times of the day.

When I ask Mum why there are no baby pictures of me when there's a pictorial shrine to Punding and the Frog, it was because I was born in the winter when it was dark, she'll say, or because I didn't like my picture being taken, or because photography just wasn't something we were thinking about at the time.

That I was a gender dysmorphic middle child with homicidal tendencies, a bucket-shaped faced, left-handed, lazy-eyed, mildly brain damaged (as a result of repeated, self-inflicted blows to the head), lice-infested, chronic bed-wetter with possible attention deficit disorder, wasn't mentioned.

But I didn't kill Granny. I know it looked a little suspicious because I was the one who found her. My father didn't blame me when I told him that she wasn't moving in her bed, but I know what he must have been thinking and I bet he said something to Mum.

And if someone looked through my bedroom window at the exact moment that I was applying blusher to my cheeks on the day of Granny's funeral they would have seen me smile and they might have thought there was something a bit fishy about that. But Mum had suggested that I might want to wear a nice skirt and look like a proper girl on that day. Then she hummed as she folded the cleaned sheet from Granny's bed and put it back into the hot press.

I read in Mum's copy of *Good Housekeeping* that blusher should be applied to the apples of your cheeks and that the best way to find these apples is to smile.

Methodical dust shades the combs and pomade
while the wielded goodwill of the sunlight picks out
a patch of paisley wallpaper to expand leisurely on it.

The cape comes off with a matador's flourish
and the scalp's washed to get rid of the chaff.
This is the closeness casual once in the trenches

and is deft as remembering when not to mention
the troubles or women or prison.
They talk of the parking or calving or missing.

A beige lino, a red barber's chair, one ceramic brown sink,
and a scenic wall-calendar depicting the glories of Ulster,
sponsored by JB Crane Hire or some crowd flogging animal feed.

About, say, every second month or so
he will stroll and cross the widest street in Ireland
and step beneath the bandaged pole.

Eelmen, gunmen, the long-dead, the police.
And my angry and beautiful father:
tilted, expectant and open as in a deckchair

outside on the drive, persuaded to wait
for a meteor shower, but with his eyes budded shut,
his head full of lather and unusual thoughts.

This is my father's story. It isn't mine at all. I wrote it down one night so soon after hearing him tell it, I remembered every word. My father is not a man to bother writing a thing down, unless a message to pin on the stable door for the herd, or the boy that feeds the dogs. He's not exactly a talking man either, unless about horses. Most of his yarning goes on in his head while he's walking the Meath fields, or leaning over the gate of a paddock. When I think of him, I think of him as I so often saw him, walking green fields dusty with buttercups, stopping only to stare at his prize cattle cropping the rich grass, or to scotch a thistle with a blade he had fitted to the butt of his walking stick. His eye was always quick to see the weeds that seemed to spring up overnight and which, if left uncut, self-sowed themselves and multiplied seven times seven. In Meath a man must restrain the land, or it would strangle him. But in Roscommon, where he was born, the fields were thin and the grass wiry and sparse. There, poverty had the dignity of a lost cause well fought. When my father talked of his bare-footed boyhood in blue Roscommon, it seemed very far away to me, as if he was a different person from the boy he talked about.

I think he must have found it hard himself sometimes to believe that he was once that boy – as hard as the boy would have found it to believe that he would one day be this quiet man who would not leap over a wall if there was a gate or a stile, and who, if he went out in the evening-time, would go out only, as the poet says, to stand and stare.

But if I found it hard to imagine the lad he remembered was him, this story is his all the same, and not mine. It is his, even in the way one word goes before another.

'Did I ever tell you about a dog I had?' he asked me one day. 'A dog by the name of White Prince? He was the wonderfullest dog in the world. He was a cross between a wire-haired terrier and a blood-hound and he was pure white, with the hair bristling on him like a hedgehog when he smelled a fight. A dog was no good to a fellow in those days if it wasn't a fighting dog. That was all we kept dogs for: to set them on one another. Every fellow in the village had a dog. And the fellow that had a dog to beat all the other dogs was a fellow that was looked up to the length and breadth of Roscommon. I used to have great dogs. But White Prince was about the best I ever had. I was very proud of him and I took him with me everywhere. On Saturdays I was sent over to my grandmother's to do the shopping for her in her own village that was a lot bigger than our village. My grandmother lived seven miles away, but by going over the fields as I did that was nothing – not in those days. And naturally that Saturday I brought White Prince along with me. We set off, the two of us, the dog and me – I was whistling, and kicking at sods of dry grass that were thrown up by the hooves of an old mare that was always breaking loose and clattering over anyone and everyone's few acres. The dog was running along in front of me barking for joy. I was glad I had him along with me for company, although I knew my grandmother hated the sight of him. Yes – well I knew it.

'We got to my grandmother's house about two o'clock in the afternoon. It was drawing in towards winter and the evenings were getting short, so although it was only two o'clock the night was beginning to show in the sky already. My grandmother was sitting on the side of her old settle bed, and she said she was sitting there for two hours waiting for me. "Take care would you think of bringing that blaggard of a dog into the village with you," she said, knowing he'd fight every dog in the village and that he wouldn't come home till he did. Nor me either. "And take care would you think of leaving him here," she added as an afterthought.

'I didn't know what to do. I thought things over for maybe a minute, and I decided that perhaps it was just as well not to bring my brave fighter into a village that was still strange to him. I called him into the house and waited till my grandmother turned to the dresser to take down her knitting. Then I went out quickly, stopping the dog from coming after me by blocking the door with the butt of my boot. When I was outside and the door shut I drew down the hasp. There used to be a hasp on the outside of the doors of most houses in those parts then and when it was caught down no one who was inside could get out. It seems queer, now that I come to think of it, but then it seemed the most natural thing in the world. When I put down the hasp my grandmother and the dog were locked inside, and my mind was at rest on one score anyway. My grandmother was a kind woman at heart, and even if that was not the case, she was feeble and I knew she wouldn't be fit to lift a hand to the dog. There was only one thing she would do to him if she could, and that was the one thing I made sure she couldn't do: let him out and stray him on me.

'I went down the pebbly lane, jingling the coins in my trouser pocket, and feeling a very big fellow, when all was said and done. But I was only half-way down the lane, when I heard a shattering noise behind me, and I looked around in time to see my fighting dog come leaping into the air through a gaping hole he'd made for himself in my grandmother's window. He glittered all over with sparkles of broken glass, and behind him on the sill a pot of red geraniums was reeling around like a drunk. I didn't wait to see if the pot fell, but went running down the lane, with White Prince after me, and now he was barking and yelping and snapping at my heels with his pride and his joy and his devilment. The more the dog ran the more excited he got. But the more I ran the more frightened I got. It was only when I came in sight of the village I stopped running and sat down on a stile, and took out the silver shilling my grandmother had given me and the six heavy coppers. Fast and all as I had run I hadn't lost the money. I looked at it for a long time and I felt a bit better. I felt some of the importance creeping back into me that I'd felt when I set out from the door after putting down the hasp. I started to plan in my mind the way I'd ask for my messages in the shops, but when I tried to remember what I was to buy I couldn't for the life of me remember. And I was afraid to go back and ask my grandmother to tell me them again.

'I'd get her tea and sugar anyway, I decided, and a loaf of bread, and if there was any money left, I'd get her a piece of bacon. She'd be so mad about the broken window she wouldn't open the parcel till after I'd be gone home. But I was sorry I reminded myself of the broken window, because the thought of it gave me a queer feeling. I looked around at the dog, thinking to give him a kick by way of thanks for all the trouble he'd got me into, but he was sitting in the middle of the road looking up at me, with his head cocked to one side and one ear up and the

other ear down and I hadn't the heart to touch him. I couldn't think to do anything more than give him a whistle to get up, and come along with me. And after that the two of us made for the main street of the village, trotting along together as great pals as ever we were.

'It was half-dark by this time and the lamps were being lit in the shop windows. In every shop I could see shop-boys kneeling into the window spaces to trim the wicks of the lamps and in some shops they'd already touched a match to the wick and were putting down the globes over the flame. The lamps in the shop windows were hanging-lamps, and after they were lit they swung back and forth for a few minutes, sending big unnatural shadows of the shop-boys out over the footpath, in a way that would make you scared to look at them. I looked into the shops instead, where the lamps were fastened to the walls and their yellow light was steady. The crinkly tin reflectors behind them reminded me of our kitchen at home.

'I went into the biggest shop in the street. They sold drapery on one side, but on the other side they sold tea and sugar and bread, and bulls'-eyes in jars — a thing I never saw anywhere else but there. The window on that side was filled with plates of raisins and plates of flour, and plates of rice and plates of prunes. The window on the drapery side was filled with ladies' bonnets and caps, and yards of lace and coloured tape and strings of bootlaces in black and brown. I liked doing messages in this shop. We hadn't any as big as it in our own village. I liked looking into the glass cases, and I liked looking at the big lamps as long as they were still and not sending their shadows flying about. Most of all I liked looking at the big ball of twine inside a tin canister with a hole in it, and listening to the whirl and spin of the twine every time a shop-boy gave it a tug and drew out enough to tie up a parcel. I liked the noise of the money, too, rattling about in a drawer under the counter, when the drawer was pulled out to give someone change.

'I was so happy that evening looking around me and taking notice of everything, I didn't heed what my brave fighter was doing. The last I'd seen of him he was only smelling around, doing no harm to anyone, and, as long as no other dog came into the shop, I felt it was safe enough to let him smell around as much as he liked. But, as I was leaning on the counter watching the boy totting up the price of my messages, I felt something brush past my leg, and I looked down in time to see the white stump of the dog's tail disappearing under the counter. There was a space between two of the counters, so the shop-boys could get in and out if they wanted, but there was a board across the opening, and they had to lift up that board going in or going out. The board was to keep out people that had no business behind the counter, but you'd never know there was a passage underneath, if you didn't happen to look close. White Prince wasn't the sort to miss much though, I can tell you, and he didn't miss that passage between the counters. He went inside, and I held my breath.

'He was very quiet for a while. Then all of a sudden one of the boys bent down to pick up a penny he'd let drop, and he must have seen the white stump of a tail wagging away in the darkness under the shelves, because he let a yell out of him, and started ordering the poor dog out, stamping his feet at him and waving a sweeping brush that he'd grabbed up in a fit of rage. I don't know what the poor dog was doing, but whatever it was the shop-boy must have thought it was something he shouldn't be doing. And to make matters worse the shop-boy that was yelling at him to get out was standing up against the counter and blocking the

way out all the time he was yelling. So I suppose the poor dog got confused. I suppose he was sure and certain the fellow would kill him with the big sweeping brush if he didn't get out quick somehow. You never know what an animal is thinking, but they have very clever ideas. When White Prince saw there was no regular way out I suppose he started planning on getting out some irregular way. I suppose he said to himself if a trick was worth doing once it was worth doing twice! Anyway, however, it was with the dog in his own mind, the next thing I saw was my flashing fighter rising up in the air and leaping into the window, knocking the bonnets to right and left and slapping up against the glass with a crash. Then there was a sound of splintering that was ten times worse than the one I'd heard in the lane back at my grandmother's, and down came a ten-times heavier shower of splinters as White Prince went flying into the street with his four paws stiff out under him and streamers of lace and ribbon and tapes trailing after him into the street outside. I was struck cold with fright. I couldn't lift up a foot from the floor, much less get out of the shop. I thought as true as God I'd be put in prison for life. The shop was in an uproar, everyone running out and shouting and holding up their hands and whistling for the dog to come back, with one breath, and with another calling God to witness what they'd do to him if he did. Then everyone ran out into the street, shading their eyes with their hands and peering into the blackness to see which way the dog had gone, although it was easy to see the way he went, with the stream of muddy tapes and bonnet-strings he'd left behind him. Ribbons and tapes stretched half-way up the street, and maybe further, only it wasn't bright enough to see far. Then the shop-boys started after him. The shop-keeper himself was fit to be tied. He divided his time between shaking his fist into the dark and running over to the window and pushing bonnets back through the hole in the glass.

'There was a terrible lot of talk, I needn't tell you. Everyone was asking everyone else how much the cost of new glass would be. And the women were asking whether the things that got muddy would be sold off cheap. I was alone in the shop but I could hear the talk outside in the street because the hole in the window made it easy to hear. I'd have run off like the dog, if I had got my change, but I'd have thought it as bad to go back to my grandmother without that as I'd think it to go to prison with the dog. So I stood waiting in the shop, and cursed White Prince and planned what I'd do to him when I got him. But when I thought of the big bullies of shop-boys that were chasing after him at that minute, I got very sorry for him. And at the thought that if they caught him I might never see him again, I made up my mind that if only they'd come back and give me my change I'd go looking for him myself and I swore that if I found him I wouldn't hurt a hair on his head.

'I was standing in the shop for a long while, because the shop-keeper had got a hammer and a fistful of nails and he was nailing boards over the broken window. Then when he came in at last he took up a piece of paper and a pen and he started to draw up a notice. But he found the pen-work hard going and catching sight of me he said I looked as if I was at school long enough to be able to write. "Write down BUSINESS AS USUAL," he said. I am glad to say just then one of the shop-boys that had gone after the dog, came back, and took the pen out of my hand and wrote it himself, although he was panting fit to burst his ribs. If only I'd had my change that would have been the time for me to make off, when the fellow was winded, but I

hadn't got it. I was glad to see though that he hadn't forgotten about the change. "I'll have it for you in a tick," he said, and sure enough he gave it to me.

'When I counted the change and saw it was right I started for the door. But before I got to it, the shop-keeper called me back. "Which road are you taking out of the town, young lad?" he said. I went stiff with fright. I thought they'd found out the dog was my dog. But no! "Whichever way you're going," he said, "let you keep an eye out for that tinker of a dog. I'll give you sixpence if you come back with him!"

'"All right, sir," I said, and I was just going to go out of the door when he came after me again and insisted on escorting me into the street. "The cur was all white, but for an odd spot of black here and there on him I think," he said.

'"He was pure white, sir," I said politely. "There was no black on him at all."

'"Is that so?" said the man. "You've a good pair of eyes." He looked around at the crowd. "That information is worth something I suppose;' he said, thinking maybe to encourage others to turn informer. "That information is worth at least a bag of sweets, I think," he said, and he went back inside the shop and I had to wait while he took down the jar of bulls'-eyes and shook them into a big paper bag with a mitred mouth on it. He filled the bag so full it wouldn't close over in the end. He had to swing it round and round, till it had two little paper ears sticking up on it. But the ears made me think of the way the dog cocked his ear when we stopped on our way into the village, and I wished I hadn't brought him with me at all. I took hold of the bag of sweets though, and I pelted off down the road towards my grandmother's, and I can tell you it was no snail's pace I went, at least until I was out of the village and was back in the decent dark of the country road. I slowed down then because according as the road between me and the shop was growing longer the thought of the broken window of the shop was getting fainter, although according as the same road got shorter between me and my grandmother the thought of her broken window was getting stronger. But I was glad the dog had gone off with himself because it would have ruined everything if he'd come running up to me wagging his tail before I got out of the village. If he did there wouldn't be one in it that wouldn't know he was my dog, and there wouldn't be one that wouldn't be after me as well as him. I'd have had no chance at all against so many, and some of them maybe with bicycles. I hope he went home, I said to myself. I hope he didn't get himself lost.

'I didn't need to worry. When I came out into the real open country, what did I hear in the dark ahead of me but a growl and after that I heard a sort of scuffling on the gravelly road, and then more growling and snarling too. I wasn't long telling that the loudest snarl of all the snarls was the snarl of White Prince. Then I caught sight of him – shining bright against the black hedge. He was up on a rise of the bank, and there was a half-circle of dogs around him and he was snarling at them and baring his teeth. Not one of the other dogs would dare go an inch nearer to him, but not one of them would draw back an inch from him either. Then White Prince must have heard my footsteps, because he took courage, and giving a fiercer snarl than any that went before, he put his teeth into something that was lying on the grass beside him, and made off down the road, with all the other dogs after him barking fit to wake the dead. That was the way I put it to myself that night. But I remember thinking, too, that as far as I was concerned they could wake every corpse that ever was planted – as long as they didn't draw down the living on us. I looked back nervously in the direction of the village. There

was nothing to be seen of it only a light here and a light there winking through the trees. So I ran after the dogs. I caught up with them in a bit. White Prince had stopped again on top of another bank and left down his precious load, whatever it was. But the half-circle of mangy curs was around him again in no time, this time, and the poor dog gave me a look as much as to say, "What are you standing there for? Beat off these devils of dogs, will you, and come and look at what I have here!" I felt myself it was high time to put a stop to things as they were, and I took up a stick and began to beat off them dogs. It was no easy job, but I drove them off one by one until in the end there was only one lanky yellow cur left. But he was as hard to shake off as twenty dogs. Forty times he slunk off and forty times he slunk back, till at last I threw the stick at him and gave him a good crack on the skull. At that he let out a yell at the scudding clouds and off with him to wherever he came from.

'"Come on now, you!" I said to White Prince, and I was about to set off again for my grandmother's house. I forgot he had been carrying something. But after a while I began to think it strange that he wasn't frisking along in front of me, and when I looked around there was the poor dog staggering under the weight of whatever it was that he had hanging out of his jaws.

'"What have you got, you blaggard?" I said, and he dropped it down at my feet. What do you think it was? A leg of mutton! White Prince stared up at me. His little bright eyes were glinting, and his tail was wagging like a bush in the wind.

'I was ready to kill him there and then on the road for the robber and thief he was, when all of a sudden I remembered how mad my grandmother would be waiting for me, and I remembered, too, that she might still be hasped into the house, which would make her ten times madder. I got an idea.

'"Good dog!" I said, patting him on the head, and taking the parcel from him. "Come on!" I shouted, leaping over the hedge and into the fields with the groceries under one arm and the leg of mutton under the other.

'May God forgive me, I washed that leg of mutton in a stream of clear springwater, and before my grandmother had time to know I was back at all I had the leg of mutton planted down on the kitchen table. Then I ran out again to where my white fighter was waiting for me and half a hundred stars as well, that had slipped out without my noticing them. We went back home, the two of us over the fields again, and the dog ran along in front of me, barking and wagging his tail again, as if nothing at all had happened. And if that dog was as happy as me, he had no conscience either.'

I
Put in mind of his own father and moved to tears
Achilles took him by the hand and pushed the old king
Gently away, but Priam curled up at his feet and
Wept with him until their sadness filled the building.

II
Taking Hector's corpse into his own hands Achilles
Made sure it was washed and, for the old king's sake,
Laid out in uniform, ready for Priam to carry
Wrapped like a present home to Troy at daybreak.

III
When they had eaten together, it pleased them both
To stare at each other's beauty as lovers might,
Achilles built like a god, Priam good-looking still
And full of conversation, who earlier had sighed:

IV
'I get down on my knees and do what must be done
And kiss Achilles' hand, the killer of my son.'

White Night

In the distant past I can see
A house on Petersburg Quay,
Your first flat, where you,
A daughter of the steppe,
Had come from Kursk to be
A student and fall in love.

One white night we sat late
At your window, gazing out
At the city stretching away
Beyond the endless Neva,
Gas-flames flickering
Like moths in the streetlamps.

That spring-white night we spoke
Tentatively, constrained
By mysteries while, far off
In the countryside, nightingales
Thronged the thick forests
With the thunder of their song.

The singing went on and on,
The birds' tiny voices
Exciting a spring fever
Deep in enchanted woods;
And there the dawn wind bore
The sound of our own words.

Orchards were in flower
As far as the eye could reach,
And ghostly birches crowded
Into the roads as though
To wave goodbye to the white
Night which had seen so much.

Earth

Spring bursts in the houses
Of Moscow; a moth quits
Her hiding place and flits
Into the light of day
To gasp on cotton blouses;
Fur coats are locked away.

The ivy shakes itself
And stretches in its pot;
Attic and dusty shelf
Inhale the open air.
This is the time for twilit
Trysts beside the river,

Time for the injudicious
Out-in-the-open voices
And gossip like thaw-water
Dripping from the eaves;
Sob stories and laughter
Dance in the woken leaves.

Outside and in, the same
Mixture of fire and fear,
The same delirium
Of apple-blossom at
Window and garden gate,
Tram stop and factory door.

So why does the dim horizon
Weep, and the dark mould
Resist? It is my chosen
Task, surely, to nurse
The distances from cold,
The earth from loneliness.

Which is why, in the spring,
Our friends come together
And the vodka and talking
Are ceremonies, that the river
Of suffering may release
The heart-constraining ice.

Traipsing from school, I used mouth them
Eleusinian, Rubicon,
Big and elaborate and lapidary,

Dominions of sound. Tonight I need
A second language like the silent reading
Of place-names for a homecoming,

A meal eaten under one red candle
Which you clear away, humming and swaying
To a quick clatter of stacked plates.

Listening, I would learn by heart
Those dialects of touch and gesture
That utter you like forms of greeting,

And would give them force of law
By right of seizure on old words,
The blue, possible vowels I starve for.

But you draw down your face to become
Other and hidden, a known country
I can cross to only in silences,

Through plain water. So I say nothing,
Hunkering over the fire-guard
To tend a small coal with brass tongs.

You have prepared a room for me,
a desk below a high window
giving on coachhouses, lanes,
a wild garden of elder and ash.

Home, you say, let this be
a home for you. Unpack
your clothes, hang them
beside mine. Put your sharp
knife in my kitchen, your books
in my stacks. Let your face
share my mirrors. Light
fires in my hearth. Your talismans
are welcome. Break bread
with me. Settle. Settle.

He has rouged his cheeks with a red stone and darkened his eyes with black liner stolen from the Opera House. His eyelashes have been thickened with a paste and his hair swept back with pomade. At home alone, he smiles and then grimaces in the mirror, creates a series of faces. Stepping frontways to the mirror, he adjusts his tights and his dance belt: the mirror is tilted downwards so he can see no more than his mid-torso. He stretches his arm high beyond the reflection, takes a bow, and watches his hand re-entering the mirror. He steps closer, exaggerates his turnout, tightens the upper muscles of his legs, brings his hips forward. He removes the tights to unhook the dance belt, stands still and closes his eyes.

A row of lights, a sea of faces, he is in the air to great applause. The foot-lights flicker and the curtains are opened again. He bows.

Later he removes the rouge and the eye make-up with an old hand-kerchief. He shifts the few pieces of furniture – sideboard, arm-chairs, cheap wall paintings – and begins to practise in the dark cramped space of the room.

In the afternoon his father returns earlier than usual and nods in the manner of men grown accustomed to silence. His eyes rest for a moment on the row of notes Rudi has taped to the mirror: *Work on battements and accomplish proper order of jetés coupés. Borrow Scriabin from Anna. Lineament for feet.* At the end of one row of notes, the word *Visa*.

Hamet glances at the handkerchief on the floor near Rudi's feet.

Silently he steps past his son, pulls the armchair back to its original position near the door. Beneath his mattress, Hamet has enough money for the fare. Two months' wages, bundled in elastic. He has been saving for a shotgun. Geese and wild fowl. Pheasants. Wood-cocks. Without ceremony, Hamet takes the money from under the mattress and tosses it to Rudik, then lies back on the bed and lights himself a cigarette to argue against the scent of the room.

On the way to Leningrad – or rather on the way to Moscow, which is the way to Leningrad – there is a stop in the little village of Izhevsk where I grew up. I told Rudi he would know the village by the red and green roof of the railway station. If he wanted to, he could drop in at my old uncle Majit's house, sleep the night, and if he was lucky he might even get a lesson from him on stilt-walking. He said he'd think about it.

I had helped Rudi try out the stilts once before in the Opera House, when he had a walk-on as a Roman spear-carrier. We had been cleaning up after the show. He was still in his costume. I thrust the stilts into his hands and told him to get on them. They were short, only three quarters of a metre. He laid them on the floor, put his feet on the blocks, tied the straps tight and then sat there, dumbfounded, finally realizing there was no way for him to get up from the floor. He said: Albert, you bastard, take this wool out of my eyes. He unstrapped the stilts and kicked them across the room but then retrieved them and stood centre stage, trying to figure it out. Finally I got a stepladder and talked him through how it was done. He stepped up to the top of the ladder, and I gave him the most

important pointers. Never fall backwards. Keep your weight on your feet. Don't look down. Lift your knee high and the stilt will follow.

I strung a rope across the stage at about armpit level so he could hold on to it if he fell. He tried to balance on the stilts at first, the hardest thing of all, until I told him that he needed to move, and to keep moving.

He progressed precariously up and down the length of the rope, holding on most of the time.

When I was young, my uncle Majit used to practise in an abandoned silo just outside our village. He did it there because there was no wind and every other ceiling was too low for him. He had twenty or thirty different pairs of stilts, all made from ash wood, ranging from a half a metre to three metres. His favourites were the metre-high ones because he could bend down and talk to us children or rub the tops of our heads or shake our hands as we ran beneath him. He was the finest stilt-walker I ever saw. He would build a new set and step onto them and right away find the sweet spot for balance. Within a day or two he'd be running on them.

The only time Uncle tumbled was when he was teaching us how to fall properly. Never backwards! he shouted, you'll crack your skull open! And then he would start falling backwards himself, shouting, Never like this! Never like this!

As he was toppling, Uncle would switch his weight and turn the stilts and just at the last instant he would fall forwards instead, landing with his knees bent and sitting back on his heels. He was the only stilt-walker I ever met who never even tweaked his collarbone.

I tried teaching Rudi the stilt technique over the last couple of evenings before he left, but his thoughts were elsewhere. Just the notion of going away was a walk in the air for him anyway. I told him that if he looked out from the train he would see children beyond the fields, my nieces and nephews, their heads bobbing above the corn. And if he looked behind the station he might see a group of them playing stilt football. Sit on the left-hand side of the train, I told him.

I'm sure he never did.

APRIL 15, '59

R –

The magic of a dance, young man, is something purely accidental. The irony of this is that you have to work harder than anyone else for the accident to occur. Then, when it happens, it is the only thing in your life guaranteed never to happen again. This, to some, is an unhappy state of affairs, and yet to others, it is the only ecstasy.

Perhaps, then, you should forget everything I have said to you and remember only this: The real beauty in life is that beauty can sometimes occur.
– Sasha

Tenebrae IV

music michael mcglynn

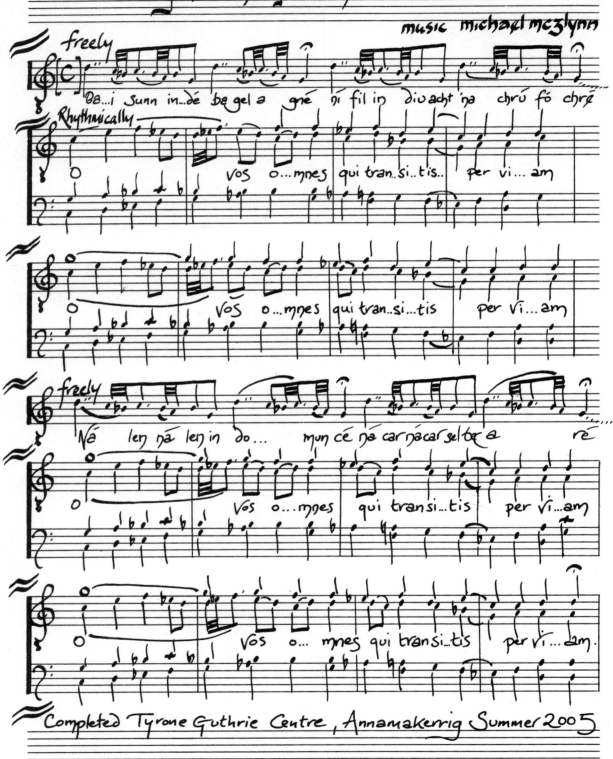

Completed Tyrone Guthrie Centre, Annamakerrig Summer 2005

PYPER: Again. As always, again. Why does this persist? What more have we to tell each other? I remember nothing today. Absolutely nothing.

Silence.

I do not understand your insistence on my remembrance. I'm being too mild. I am angry at your demand that I continue to probe. Were you not there in all your dark glory? Have you no conception of the horror? Did it not touch you at all? A passion for horror disgusts me. I have seen horror. There is nothing to tell you. Those willing to talk to you of that day, to remember for your sake, to forgive you, they invent as freely as they wish. I am not one of them. I will not talk, I will not listen to you. Invention gives that slaughter shape. That scale of horror has no shape, as you in your darkness have no shape. Your actions that day were not, they are not acceptable. You have no right to excuse that suffering, parading it for the benefit of others.

Silence.

I will not apologize for that outburst before you. You know I am given to sudden fits like that. The shock you gave never left my system entirely. I still see your ghosts. Very infrequently. During daylight now. Dear Lord, you are kind in small mercies. Did you intend that we should keep seeing ghosts? It was the first sign that your horrors had shaken us into madness. Some were lucky enough to suffer your visions immediately. Those I belonged to, those I have forgotten, the irreplaceable ones, they kept their nerve, and they died. I survived. No, survival was not my lot. Darkness, for eternity, is not survival.

Silence.

There is a type of man who invites death upon himself. I thought once this is the stuff heroes are made from. I enlisted in the hope of death. I would be such a man. But mine was not the stuff of heroes. Those with me were heroes because they died without complaint for what they believed in. They taught me, by the very depth of their belief, to believe. To believe in you. What sense could you make of their sacrifice? I at least continued their work in this province. The freedom of faith they fought and died for would be maintained. There would be, and there will be, no surrender. The sons of Ulster will rise and lay their enemy low, as they did at the Boyne, as they did at the Somme, against any invader who will trespass on to their homeland. Fenians claim a Cuchullain as their ancestor, but he is ours, for they lay down for centuries and wept in their sorrow, but we took up arms and fought against an ocean. An ocean of blood. His blood is our inheritance. Not theirs. Sinn Féin? Ourselves alone. It is we, the Protestant people, who have always stood alone. We have stood alone and triumphed, for we are God's chosen.

Silence.

Leave me. Do not possess me. I do not wish to be your chosen.

RADIO 1974

Creed recognised her voice because he had heard it on the radio fifteen years ago. He imagined the earpiece of the phone pushed under her blonde hair and her lips speaking. She did not apologize for ringing and she used his father's first name.

The crisis came at 1.03 am. JJ didn't wake but the nurse saw him convulse, the right hand with the long yellow fingers rising slowly from the pillow, the arm also rising then collapsing in a spasm as a scrap of paper will collapse when burning. His black fringe fell over his eyes.

First there was a wind and then rain. Creed drove for an hour through small towns where the wind blew grit along the pavements and the lit shop windows seemed empty, their shelves gathering dust. After that the road passed between trees which strained as if they were being sucked upwards by the wind. Gale warning, the radio said. Dogger bank, Cromertie, Forties.

The telephone had made her voice sound exactly the way it had sounded on the radio fifteen years before. Are you aware of JJ's condition? she asked. I haven't seen or spoken to my father for fifteen years, he said. They don't know how long he's got, she said, I'll stay away tonight if you want to see him.

In 1974 JJ had brought home a piece of sandpaper found in the street after a bomb. Smell it, he said. It smelt of marzipan and Creed had thought about raisins, chopped almonds, orange peel. That's gelignite, JJ said.

It was nine o'clock when he got to the hospital and the rain was blowing lean and horizontal across the carpark.

He went to the reception desk and the duty nurse checked the register. He followed another nurse to the ward. Her rubber-soled shoes hummed on the oily, polished floor. Her linen skirt made a clean rattle against the back of her knees. Somewhere in this hospital there were stiff rows of those uniforms hanging on pegs and nurses dressing. Just a minute. A dab of perfume between the breasts. Ready sister.

The nurse nodded to him and pointed. Room 203. The door was ajar. Creed pushed it and saw JJ lying on the bed, the blanket pushed back and his knees tucked towards his chest. The hospital gown did not meet properly at the back so that he could see all the way down his father's spine to the grinning, white moth of his buttocks. He used to lie in the bath like that, reading a paperback, a cigarette dissolving in the soapdish.

I shouldn't be here. It should be Angela Doherty with her blonde hair that would wrap you better than a hospital gown as you lay dying. I am no more help than the ashtray on the bedside locker. Than the yellow Sanyo face of the radio beside it that stares at the back of your sleeping head.

He sat on the metal-framed chair beside the bed and lit a cigarette. History is a river, you used to say, and your river started for me when you told me how you once climbed out of a bedroom window and walked down the street to watch a house on fire. It was snowing. The snow fell into the fire and the boy's bare

feet blazed in the snow. The flame crept up through his body to light the folded touchpaper of pneumonia in his lungs.

Didn't stop you smoking though. You always had long yellow fingers from smoking. Long, thieving fingers. He looked into his father's face. The stubble was grey in places. The hair in each nostril was grey. Where are you daddy? Are you in the long corridor with the years opening off it, wondering which one will you hide in next? Don't go into 1974. I'm in there.

You have a long record of disbelieved histories. Did you ever really have pneumonia? When I was old enough to be a boy in the snow I asked you what you did during the war and you said you were in the secret service and that you were part of a team that made a battleship disappear behind a secret forcefield.

A secret forcefield. Now that's privacy for you, deeper than sleep. My daddy's ship was anchored behind a secret forcefield in 1942.

In 1974 a Unionist walked onto the balcony of Stormont Castle in the Province of Ulster to announce the beginning of the Ulster Workers' strike. We listened to him on the radio. Hearing the broken veins that started at the corner of his nose and spread onto his cheeks. Hearing the people beneath the balcony pointing flags, microphones and placards while we sat at home and listened and pointed the silence which was the only thing we had to point with.

Creed had thought that refugees were people in muddy straw hats walking on a road which is raised between rice fields. Smoke rises from the city behind them and no-one looks back. But everyone finds their own refuge and that night the power stations began to close and Catholic cars began to stream south so that in the darkness it looked as if all the light in Northern Ireland had been imprisoned in cars and driven indefinitely across the border.

However the veins on your nose were not broken by history and your skin is not yellow because of it. The day you left us I asked you where you were going and you said you were going to a secret conference on the future of the North. When you didn't come back I found a photograph of her in the back of a wallet you left behind. Her two lips confer with yours.

At least she got you a private room. Matt blue with soft fluorescent lights. No windows but by the look of you you're not going to have any more need of windows. You can die in the dark as well as any other way if it comes to it. My mother did, but that was after you left. Without aid or succour of daylight.

Your lips are moving as you sleep JJ. My mother said that you began to fox sleep before you left so that you could avoid talking, or explaining. Foxing sleep in the henhouse of her mind.

Your sleeping lips are saying that you were never a member of the secret service and that you never went to secret meetings on the future of the North.

I have a photograph of a civil rights' meeting. You were still a history teacher when the photograph was taken. That could be you standing on the windy platform with the big ears and the fringe hanging over your eyes, hiding them so I can't see if that is the moment when you first smelt the exotic aroma of 1969, 1970, 1971, 1972, 1973 and 1974 and Burntollet and Reginald Maudling and Free Derry, Bloody Sunday, bloody this, bloody that. You met Angela Doherty at one of those meetings. Afterwards you sat in a pub, smoking and telling her that history is a river.

You took her to my mother's funeral and no-one spoke. She was wearing a black poloneck with a white miniskirt and white knee-length boots. I watched her and wondered why you had left us and gone with her. I hope that it was the aroma that led you there. That you came like a cannon on the walls of Derry and made the tear-gas and blood flow from her blue eyes.

But if I woke you you'd probably tell me that she was in the secret service as well.

Are you frightened now that the river has carried you past her into the dark estuary? If I wake you the estuary of your eye will be yellow with liver damage. The river of your eye flooded with unnavigable disease.

I will not wake you now. I will let you sleep because for all your secret service and secret meetings you were as frightened as the rest of us that day you took us out of school and put us in your car and followed all the rest of them across the border on the day during the strike when Harold Wilson, Prime Minister of Great Britain and Northern Ireland, was to speak on television and radio the words that would send troops against the strikers.

Creed extinguished his last cigarette. As he walked back along the corridor he remembered Angela Doherty's voice of protest on the radio in 1974. History is a river, she said, and he had turned to look at his mother.

Outside the hospital the rain had stopped but the wind tugged at the steering of the car and the trees on either side of the road moved wildly as if some huge, shambling thing was forcing its way through the branches.

He turned on the radio and the nurse called a doctor who noted 1.03 am as being the time of death.

They had crossed the border that day and driven south until evening. They stopped on a quiet road because the car radio would not work when the car was moving. His father searched the dial for Harold Wilson's voice.

Spongers, Harold Wilson called the strikers, living off the British taxpayer. They listened to the broadcast and when it was over his father turned it off and sat back so that there was silence for a moment. Although it was not yet dark Creed could see white moths moving in the ditches at either side of the road.

Wilson's given in, JJ said, he's backed down to the bastards. Does that mean we can go home? his mother asked.

And as he drove away from the hospital Creed wondered at how much it cost to turn and walk against the stream of refugees. Even for a moment to turn back and walk towards the flames of a city, and the silence therein.

Our History Master was a curly-headed young priest who leaned too close to us in class, the better to inspect our copybooks, *moryah*. Often I felt his downy cheek press against mine, though I doubt if he knew what he was doing: he was as ignorant and naive as the rest of us. Yet he could be enthusiastic; in our first term, before the official N.I. Syllabus swallowed us, we learnt about something called Early Irish Civilization. I loved it, Larne flints, osiered banquet halls, the bronze trumpet of Lough na Shade. *Then it was back to the Origins of the Industrial Revolution.*

Once myth and reality warmly met, when we swarmed over Navan Fort. Sheep grazed where Cuchulainn and his High King, Conor, argued; a quarry ate the grass where Deirdre first saw her young warrior. But we were doing English and Modern History for our State exams, not Irish, so the mythic figures melted into the mizzling rain, the short views returned: we were standing on a large green hillock in the County Armagh, Northern Ireland, not on the magic mound of Emain Macha, the hillfort of the Red Branch knights. *There would surely be a question on William Pitt, and the Corn Laws.*

History Walks were rarer than Geography, perhaps because they feared to disturb our local nest of pismires. History lay about us in our infancy, with many levels, but only one stratum open. They did not have to explain to us why our new Cathedral had been built on a higher hill. We explored our ancient rival when we ran footloose through town. We marvelled at its echoing emptiness, the rotting flags of Imperial wars. The roll call in the side chapel of the Royal Irish Fusiliers might have taught us something; Os and Macs mingled in death with good Proddy names, Hamilton, Hewitt, Taylor, Acheson.

Instead we ran down the curling, cobbled hill, giggling with guilt. Doomed as any Armada, the lost city of Ard Macha coiled in upon itself, whorl upon whorl, a broken aconite. Layer upon layer had gone to its making, from Cuchulainn to St Patrick, from fleet-footed Macha to Primate Robinson's gaggle of Georgian architects. But the elegance of the Mall was of no avail against simple-minded sectarianism; Armagh, a maimed capital, a damaged pearl.

We sensed this as we sifted through the shards in the little County Museum. Bustled around the glass cases by Curly Top, we halted before a Yeoman's coat, alerted by our party song, 'The Croppy Boy'. And we read about the battle of Diamond Hill between 'Peep-o'-Day Boys' and Catholic Defenders which led to the founding of the Orange Order at Loughgall, a canker among the apple blossoms.

We did not discuss this in our History Class, which now dealt with the origins of the First World War, from the shot in Sarajevo. It did crop up in R.K., Religious Knowledge, when the Dean warned us against the dangers of Freemasonry. A Catholic could never become King of England or President of the United States; everywhere the black face of Protestantism barred the way to good Catholic boys. Amongst the cannon on the Mall the Protestant boys played cricket, or kicked a queer-shaped ball like a pear. According to my Falls Road pal, Protestant balls bounced crooked as the Protestants themselves. One day that banter would stop when a shot rang out on the Cathedral Road.

Creon

Oedipus

Watercolour designs by TANYA MOISEIWITSCH for *Oedipus Rex*

GINA MOXLEY *from Tea Set*

I had a pain in my sainted hole from the Millennium. It got acute about August. I didn't want to do anything for it, to have to do anything for it, to have to think about it. There was nobody I wanted to spend it with.

Opened the door to my mother's place, this was in August now, and I knew the minute I went into the flat. Not that there was a smell or anything, or an atmosphere or whatever. She was conked out on the couch, the remote in her right hand, the solar eclipse on the news on TV…

That's why I thought I'd work for the Millennium, get a job, at a loose end anyway, might as well clean up.

'A guy once, I was walking to the bus stop, where I lived then was suburbia, and this guy, it was winter, raining, really lashing, only about half three or four in the afternoon but pitch and I had to go to town or something, doesn't matter, scuttling along, and this guy ducked in under the umbrella and went WAAAAAAAAH … so close … just right in my face like that. I got such a shock. That Trinity of fear, straight to the armpits and pubes. But no scream. No noise whatsoever came out of my mouth. Just breath. Hot breath. Hot, shallow breath. You could see it. The guy was just a harmless headcase, harmless until he had an idea not to be but that's all he was that day. So, it was really only a small fright by comparison to what must've happened to you but what shook me was that the response I thought I was having wasn't translating. And I felt so stupid. He skedaddled as soon as he had an effect. I puked over the wall next to the delicatessen and just went and got the bus. Nearly missed it and it was hardly ever on time. Come to think of it, that was probably the ten past three and not the twenty to four. I asked for a … however much the tickets from there were then and my voice came out no problem, just a bit fracturedy the way it is after you vomit. And that was after a small fright. Didn't even mention it to anyone, well, to who anyway? Because I felt so stupid not being able to rely on myself to scream in my own defence, that my own voice deserted me. Was that what happened to you?'
'Partly,' she whispered, 'partly that.'

PAUL MULDOON *Lines for the Centenary*
of the Birth of Samuel Beckett (1906–1989)

Only now do we see how each crossroads
was bound to throw up not only a cross
but a couple of gadabouts with goads,
a couple of gadabouts at a loss

as to why they were at the beck and call
of some old crock soaring above the culch
of a kitchen midden at evenfall,
of some old crock roaring across the gulch

as a hanged man roars out to a hanged man.
Now bucket nods to bucket of the span
of an ash yoke, or something of that ilk …

Now one hanged man kicks at the end of his rope
in another little attack of hope.
Now a frog in one bucket thickens the milk.

The orchard walls are high and hard to climb
and I've stood sentinel here for a long time.

A long time since I dropped down on this side
with the bow and arrows Quintus had wind-dried.

Wind-dried yew is proof against warp and mould
but not the mindfulness of a five year old.

My five year old had eyed me through and through:
'Tell the buriers to bury me with you.'

With me he'd learn the ways of the yew stave
a Salish man might bring with him to the grave.

The grave already held two powder kegs
and I came to as they were breaking my legs.

They were breaking my legs so I would fit
when I came to and called for an end to it.

An end to the ration of bread and beer
and the rationale for having dropped me here.

They dropped me here still bloody from the 'scratch'
I might have got from a shadowy sasquatch.

A shadowy sasquatch from Klamath Falls
who might be set on scaling the orchard walls.

The orchard walls are high and hard to climb
and I've stood sentinel here for a long time.

Dear Sheila,

You ask how I approach film, but without being facetious, it often feels like it's the other way round and that films approach us. The ones I've made, even the ones with autobiographical elements, involved a lot of prepping, a lot of research. Yet the actual making feels like clearing a space for something to happen rather than adding to 'a body of work'.

I like Charles Ludlam's story about the Chinese archer who always hit the bull's eye because he shot the arrow first and drew the target in afterwards. It's like the part of scriptwriting when you are keeping things fluid while you explore all the things it has to offer – this amazing sense of process and result working together. Sometimes this happens when you're shooting. You are acutely aware of how it's working, of how it's coming together – yet what's happening in the moment – the intensity of it – cuts through any notion of film as illusion and reveals film-making as an act of awareness.

With love and every good wish,

Pat

JPW You see, Benimillo, God created the world in order to create himself. Us. We are God. But that neatly done he started making those obscure and enigmatic statements. Indeed his son did a lot of rather the same thing. The Last Supper, for instance: the wine, the conversation, Jewish wine being passed around. [*He rises unsteadily.*] Christ standing up, 'In a little while you will see me, in a little while you will not see me.' They must have thought the man was drunk. But he had learned the lingo from his father. God taking his stroll in the Garden, as we were told, and passing by innocent Adam, he would nod, and say [*he nods and winks*], 'I am who am.' And that was fine until one day, Adam, rather in the manner of Newton, was sitting under a tree and an apple fell on his head, jolting him into thought. 'Whatever can he mean,' said Adam, '"I am who am"?' And he waited until the next time God came strolling by, and he said, 'Excuse me' – or whatever they said in those days. I must find out. And he put the question to God. But God said, 'Out, out!' 'I only asked!' said Adam. But God said, 'Out!' And, naturally, after such rude, abrupt and despotic eviction, the wind was taken out of Adam's intellectual sails: not surprising that he was not up to pursuing the matter. Which is a pity. Because, the startling thing, God had got it wrong. Because what does it mean, 'I am who am'? It means this is me and that's that. This is me and I am stuck with it. You see? Limiting. What God should have been saying, of course, was 'I am who may be'. Which is a different thing, which makes sense – both for us and for God – which means I am the possible, or, if you prefer, I am the impossible. Yes, it is all crystal clear.

Once at sea, everything is changed:
Even on the ferry, where
There's hardly time to check all the passports
Between the dark shore and the light,
You can buy tax-free whiskey and cigars
(Being officially nowhere)
And in theory get married
Without a priest, three miles from the land.

In theory you may also drown
Though any other kind of death is more likely.
Taking part in a national disaster
You'd earn extra sympathy for your relations.

To recall this possibility the tables and chairs
Are chained down for fear of levitation
And a death's-head in a lifejacket grins beside the bar
Teaching the adjustment of the slender tapes
That bind the buoyant soul to the sinking body,
In case you should find yourself gasping
In a flooded corridor or lost between cold waves.

Alive on sufferance, mortal before all,
Shipbuilders all believe in fate;
The moral of the ship is death.

I

Nuair a éiríonn tú ar maidin
is steallann ionam
seinneann ceolta sí na cruinne
istigh im chloigeann.
Taistealaíonn an ga gréine
caol is lom
síos an pasáiste dorcha
is tríd an bpoll
sa bhfardoras
is ria19nann solas ribe
ar an urlár cré
sa seomra iata
is íochtaraí go léir.
Atann ansan is téann i méid
is i méid go dtí go líontar
le solas órga and t-aireagal go léir.
Feasta
beidh na hoícheannta nios giorra.
Raghaidh achar gach lae i bhfaid is i bhfaid.

II

Nuair a osclaím mo shúile
ag teacht aníos chun aeir
tá an spéir
gorm.
Canann éinín aonair
ar chrann.
Is cé go bhfuil an teannas
briste
is an ghlaise
ídithe ón uain
is leacht meala leata
mar thúis
ar fuaid an domhain,
fós le méid an tochta
atá eadrainn
ní labhrann ceachtar again
oiread is focal
go ceann tamaill mhaith.

III

Dá mba dhéithe sinn
anseo ag Brú na Bóinne:
tusa Sualtamh nó an Daghdha,
mise an abhainn ghlórmhar,
do stadfadh an ghrian is an ré
sa spéir ar feadh bliana is lae
ag cur buaine leis an bpléisiúr
atá eadrainn araon.
Faraoir, is fada ó dhéithe
sinne, créatúirí nochta.
Ní stadann na ranna nimhe
ach ar feadh aon nóiméad neamhshíoraí amháin.

IV

Osclaíonn rós istigh im chroí.
Labhrann cuach im bhéal.
Léimeann gearrcach ó mo nead.
Tá tóithín ag macnas i ndoimhneas mo mhachnaimh.

V

Cóirím an leaba
i do choinne, a dhuine
nach n-aithním
thar m'fhear céile.
Tá nóiníní leata
ar an bpilliúr is ar an adharta.
Tá sméara dubha
fuaite ar an mbráillín.

VI

Leagaim síos trí bhrat id fhianaise:
brat deora,
brat allais,
brat fola.

VII

Mo scian trím chroí tú.
Mo sceach trím ladhar tú.
Mo cháithnín faoim fhiacail.

VIII

Thaibhrís dom arís aréir:
bhíomar ag siúl láimh ar láimh amuigh faoin spéir.
Go hobann do léimis ós mo chomhair
is bhain greim seirce as mo bhráid.

IX

Bhíos feadh na hoíche
ag tiomáint síos bóithre do thíre
i gcarr spóirt béaloscailte
is gan tú faram.
Ghaibheas thar do thigh
is bhí do bhean istigh
sa chistin.
Aithním an sáipéal
ag a n-adhrann tú.

X

Smid thar mo bhéal ní chloisfir,
mo theanga imithe ag an gcat.
Labhrann mo lámha dhom.
Caipín snámha iad faoi bhun do chloiginn
dod chosaint ar oighear na bhfeachtaí bhfliuch.
Peidhleacáin iad ag tóraíocht beatha
ag eitealaigh thar mhóinéar do choirp.

XI

Nuair a dh'fhágas tú
ar an gcé anocht
d'oscail trinse abhalmhór
istigh im ucht
ná líonfar
fiú dá ndáilfí
as aon tsoitheach
Sruth na Maoile, Muir Éireann
agus Muir nIocht.

Something about the way the garden hedge looks today gives me a feeling I would have difficulty in describing, although I recognise it very well. I had this feeling before, as a child. Perhaps since then too. But I only recall the first time.

The hedge, let me say, is very still. A quiet, neat line, separating the garden from the road. At the far side of the road is a stone wall, and beyond that the sea, which is an even grey colour, with dark flecks where the waves dip. The sky is the same colour as the sea, only a little lighter. No seagulls, no garden birds, no dogs are visible. Just lines, grey and dark grey and black. It is a foggy day, dull, and lovely.

We were to have our catechism examination. For three months, ever since the Christmas holidays, Miss O'Byrne had been drilling us in the two-hundred-and-thirty questions we, as prospective First-Communicants, were expected to know. We learned five questions every night for the first two months, and then we revised ten a night during the month before the exam. Even the most stupid girl in the class, Mary Doyle, knew nearly all the answers by now.

Miss O'Byrne is a strict teacher. That is her reputation, what the big girls and the mothers say about her. And she lives up to it. She even looks strict: tall, with angular features and menacing butterfly glasses. The frames of her glasses are transparent, but the wings are brilliant royal blue, with diamonds glittering in the corners. Behind, above, her eyes sparkle, sharp and penetrating.

She strides in every morning, her thin legs pushing against her black pencil skirt. The first thing she does is call the roll. When a name is called and no one answers she glares at each face in turn, creating a palpable thrill of excitement in the big, Georgian drawing-room. Her eye rests, briefly, on me and I feel afraid, and oddly pleased. Am I to be punished because, say, Mary Clarke is absent? She does not sit beside me, I have nothing much to do with her, I don't even like her. But Miss O'Byrne's ways are mysterious to me, and to all of us. Her system, if she has one, is not something we understand.

She looks down at the roll-book and we watch her fountain pen, a special Parker kept for performing this important task, scratch a big 'x' beside the name of the absentee. Miss O'Byrne smiles to herself, and shakes her head. Then she blots the roll-book with her pink blotter and the day begins.

Who made the world? Who is God? Who are the three persons of the Blessed Trinity? What is meant by Transubstantiation? What are the Ten Commandments? The Seven Deadly Sins? The Six Commandments of the Church?

Now, in the last week, she goes through all two-hundred-and-thirty questions every day. It takes from nine o'clock until two, given the half-hour break for lunch. She begins calmly, and the class, too, is calm, at first. The girls sit upright in their narrow desks, faces pink and newly scrubbed, hair brushed back and tied in blue ribbons. Gradually the pressure increases. Girls make mistakes, and have to stand out in line to be slapped. Three slaps for each mistake. Miss O'Byrne takes this part of the proceedings seriously. She slaps using three or four rulers, bound together with an elastic band. Rumour has it that she once tried to

introduce a bamboo cane, but the Parents' Committee and the Parish Priest banned it: bamboo can leave marks.

Miss O'Byrne's patience goes, soon, and order vanishes. Girls grow hot and sweaty, waiting to be asked, hoping they will survive the day without punishment, although this hardly ever happens. Their faces become red, their white blouses grow black and floppy. Only Miss O'Byne's sweater, white angora, remains immaculate, smelling of Mum and Dior.

She takes a break to teach us a moral lesson, to tell us about the Missions. Delighted to have a reprieve from the harrowing questioning, and eagerly anticipating the thrills to come, we sit up with suddenly renewed vigour in our desks. I run my fingers along the thick coarse grain of the wood: the wood is golden, and polished brilliantly by generations of woollen elbows, but the deep lines of its surface are filled with a black substance. It looks like fine clay, but it is dust. Ancient dust.

'Hands on your heads!' raps Miss O'Byrne, and we all obediently place our hands on the crowns of our heads. I feel my smooth hair, pulled tight downwards towards its ponytail. Underneath, my skin is hot and pulsating slightly.

The Missions. Nuns and priests and lay people who give up their lives to preach the word of God to pagans. Lay people, what are they? Some sort of hybrid, not fully human, I sense. People like Miss O'Byrne. Brave and unusual. They are killed. Tortured. She tells of pins under fingernails, tongues ripped out. I am not sure who does it, rips out the tongues. Communists, perhaps. Or black people. In Africa or China. Miss O'Byrne mentions South America but I have not heard of it before. Africa, I know all about Africa.

My arms are getting tired. I wish she would let us put them down again. When she does, the questioning will begin.

Nuns and priests and lay people are tortured, because they want to teach catechism to the pagans. And we can't learn ours properly. We are too lazy. Lazy, spoiled little city girls.

Mary Doyle is wrinkling up her face and moving her arms about dangerously. Stupid Mary Doyle. She can't learn, it seems, and she looks terrible. Small, scrawny, with thin blonde hair. Her face is white and sprinkled with freckles. Her gymslip hangs on her bony body.

She cries. Whenever she is punished, which is often, she bursts into huge uncontrollable sobs. Her pale face grows red and spotty, and her body shakes.

There is something wrong with Mary Doyle. I do not know what, but I have thought of her for some time and come to this conclusion. It irritates me that she is on my mind. She is very often on my mind, because she is so strange, because there is something wrong with her. Why doesn't her mother do something about her?

Her mother is all right. I have seen her, sitting in the dark mildewed hall, under the statue of the Virgin: she wears a fawn teddy coat and inside her pink flowered headscarf her face is round and pleasant. Normal. Not skinny and odd. The trouble is, Mary's mother doesn't notice that her daughter is unusual. When Mary emerges from the cellar, where we hang our coats, Mrs Doyle gives her a kiss and says 'Hello lovey', just like any other mother. Then Mary's face lights up as though there were a lamp underneath her transparent skin. And her mouth is really very big. She smiles and her whole face is taken over by the smile. She is like the Cheshire Cat my mummy reads about, at night in front of the fire in the kitchen. And even that, the way she lights up and turns into a smile, is odd. But

Mrs Doyle just doesn't notice. She chats to the other mothers, about the price of First Communion dresses and the French lessons we might get next year, as if Mary were the same as the other girls: solid, sturdy, in mind and body.

'Stop fidgeting, Mary Doyle,' says Miss O'Byrne. Mary's face wrinkles up and becomes pink. The bell rings, clanging violently through the cold gloomy rooms of the school. We are allowed to take down our hands. We are allowed to go down to the cellar, and out to our mothers, waiting in the hall.

Two days before the examination Miss O'Byrne is very nervous. Five pupils, five, are absent. During roll-call, her eyes dart about, stopping to rest for long periods now on one, now on another girl, daring those present to be absent tomorrow, or on the day of the examination itself. I feel genuinely frightened. I don't like Miss O'Byrne, but I have always trusted her not to go too far. She is an adult, she knows the limits. Today her eyes rest, for longer than is right, on me, and on others.

After roll-call, the test begins. It is a mock exam, a rehearsal for the real one, on Thursday. Tomorrow, Miss O'Byrne says, we will rest, and do no catechism. We do not believe her.

First she asks Monica Blennerhasset. Monica has thick glossy plaits, very white socks on slim legs, and a gymslip which fits perfectly and is made of rich deep blue serge, not the black shiny stuff which wrinkles easily, the kind I have. Monica is the best pupil. Her father is a doctor and her mother president of the Parents' Committee, and she never misses. Usually I am disappointed when she is asked a question because the outcome is so certain, no risks involved. Now I am relieved.

Next, she asks me. I am not like Monica Blennerhasset, or Orla O'Connor, who is the prettiest girl in the class and a champion Irish dancer. She has tiny feet, which arch like a ballerina's in her little satin pumps – we call them 'poms'. She points them exquisitely to the floor, before leaping into a star rendering of 'The Hard Reel' or 'The Double Jig'. I am not like them, a certain winner. But I am not a loser, either, and as a rule I do well enough. I know the catechism, inside out. Mummy tests me every night, in front of the fire, before she reads *Alice in Wonderland*, before bed. I can recite the answers in my sleep. I know it so well that it bores me, and I am not afraid on my own account.

After me, it is Mary Doyle's turn. She trembles as she stands up. Oh, Mary Doyle, it's stupid to tremble! Her ribbon is loose, sliding down the back of her head.

'What is the meaning of the fourth commandment of the church?'

Mary begins: 'The meaning of the Fourth Commandment of the Church is . . .' Then she stops. Miss O'Byrne repeats the question.

Mary repeats: 'The meaning of the Fourth Commandment of the . . . of the . . . of the . . .'

She is crying already.

'Stand out,' orders Miss O'Byrne, picking up her bunch of rulers.

My stomach tightens, and I feel a desire to laugh, which I suppress.

'Put out your hand.' The familiar formula has a novel quality.

Slap slap. The rulers bang together in the air, wood on wood. Then the loud smack of wood on flesh.

Six.

She would stop now.

Twelve.

Mary only missed one. Three for one. Mary is howling.

Fifteen.

Mary's sobbing has evened out, it is quieter.

Twenty.

I do not feel excited. I do not feel afraid. I want to get sick.

Twenty-three.

Mary is not howling at all. Her face is white. She is falling onto the floor.

Miss O'Byrne touches her with her foot. She wears black patent shoes with stiletto heels, very high.

'Get up, Mary Doyle,' she raps, in her cross tone. Mary does not get up.

Miss O'Byrne glares at me. I sit in the front row.

'You. Get a glass of water.'

'Yes miss.'

I rise immediately and leave the room. A glass of water. I have never seen a glass in the school. We bring our own plastic mugs for lunch, and pour milk into them from ketchup bottles or green triangular cartons. In winter, Maggie, the woman who cleans, gives us hot water for cocoa. The teachers drink tea from delph cups: we see them, sitting in the Teachers' Room, which overlooks the yard. They sip tea, eat sandwiches from tinfoil wrappers, and talk, as they supervise our playing.

I decide that Maggie might be in the kitchen, and go down the stone stairs to the cellar, where it is situated in a cubby-hole beside the toilets. Luckily, I find her, hunched over a little coal fire, her worn-out navy overall wrapped tightly around her body. She regards me sadly, and doesn't speak, as she hands me a cup of water. The cup is white with a green rim, the kind of cup you get on trains, and it is sinewed with thousands of barely visible veins, but it is neither cracked nor chipped.

'Did you go to the well?' Miss O'Byrne snaps. I make no response: I do not realise that her sarcasm, which is constant, is intended as humour.

Mary is sitting on a chair, her head between her knees. Thin fair hair droops onto the floorboards.

'Here, Mary, drink this.' Miss O'Byrne's voice is a catapult, the words tiny sharp stones.

Mary raises her head. Her face is whiter than ever, and her hand, when it reaches for the glass, is red, with blisters. But no blood.

'You did the ballet and passed out,' says Miss O'Byrne. Nobody knows what she is talking about.

I am standing beside Mary, waiting for the empty cup: I hope that I may be allowed to return it to the kitchen. Idly, I put my hand in my pocket, and feel there a paper tube: it is a packet of fruit pastilles, which Mummy bought for me at Mrs Dunne's, the sweetshop in the lane behind the school. Without thinking, I take the packet and hand it to Mary. Miss O'Byrne does not see what I am doing. Mary takes the sweets and puts them into her own pocket. She does not, of course, smile, but she looks at me with her bright green eyes shiny from all the crying, rimmed with red skin. There is a light in them, though, that lamp she has inside. Ashamed and worried by my rashness I sit down, forgetting about the cup. When Mary stops drinking, Miss O'Byrne puts it on her table and it is still there at two o'clock as the bell clangs and we file out to the hall.

On Thursday we are allowed to wear our own clothes. I have a red dress, nylon with white spots. Underneath is a red silk slip and underneath that a crinoline of stiff net, which scratches my legs but makes the skirt stand out like a lampshade, which is exactly the effect I desire.

All the girls wear their best dresses. Pink and lemon and sky blue. They all have crinolines, but nobody else has a red dress. Mummy made it for me herself, because red suits me so well.

There is an air of great excitement in the classroom, engendered by the party dresses and the prospect of the examination. Girls giggle and scream. Miss O'Byrne, in a navy suit with an emerald-green blouse, bangs her rulers against the desk, but cannot maintain order, because she has to keep running in and out of the office, talking to the other teachers, and wondering when the priest will come.

Fr Harpur arrives at half past ten. His hair is grey and curly, and his face soft. On his cheek is a brown spot, a kind of mole, and when he speaks his voice is very quiet and gentle.

'Hello, girls,' he says, gazing around with a smile. 'I'm sure you know your catechism very well indeed by now. Do you know, a little bird told me, that you are all very good girls, and know everything in the catechism. Is that true?'

Monica Blennerhasset smiles broadly and says, 'Yes, Father.' Some of the others nod.

'Now, I'm going to ask you something very hard, but very important. Can anyone recite the "Our Father"?' We are taken aback, for a moment. The 'Our Father' isn't even in the catechism. But all hands shoot up, and some are waved about, eagerly. He asks Orla O'Connor, who had nodded to his first question. She says the prayer in a slow, considered voice, not the kind of tone we use for real catechism.

'Very good. The Lord's Prayer. It is a beautiful prayer, the Lord's Prayer. Jesus himself taught it to us. Jesus who loved little children, "Suffer the little children to come unto me," he said, didn't he?'

Nobody bothers to reply.

'Will you promise me something, girls?'

We nod.

'Will you promise me to say the Lord's Prayer every day for the rest of your lives?'

'Yes, Father,' we say, in our subdued voices, which probably sound pious to him.

'Very good. And now, since you are all such good girls, and know your catechism so well, I think you should have a half-day. What do you say, Miss O'Byrne?'

'Whatever you say, Fr Harpur,' she says, her voice polite and respectful. She gives us a beaming smile, and we get up and file out. We knew we would get a half-day. The big girls told us about it. Miss O'Byrne warned the mothers, who are waiting, in the hall, under the statue of the Virgin.

'Well, how did you get on?' Mummy asks.

'Oh, all right,' I say. 'The priest was nice.' But I do not like the priest. I do not like him at all.

Instead of going home, we went to the Spring Show. It was my first time, and Ladies' Day. I recall it vividly. The hats. The free samples of flavoured milk and garlic sausage. The combine-harvesters. And the sound of the horses' feet, pounding, pounding, against the fragrant turf in the enclosure. It was a calm April day. Dull and poignant with the promise of summer. Like today.

FEARGHUS Ó CONCHÚIR, choreographer, from *Cosán Dearg*

It was about three years since I'd seen him. And here he was, sweating behind the burger bar in Euston Station, a vision in polyester and fluorescent light. Jesus Christ, so Marion was right that time. Eddie Virago, selling double cheeseburgers for a living. I spluttered his name as he smiled in puzzled recognition over the counter. My God, Eddie Virago. In the pub he kept saying it was great to see me. Really wild, he said. I should have let him know I was coming to London. This was just unreal.

Eddie was the kind of guy I tried to hang around with in college. Suave, cynical, dressed like a Sunday supplement. He'd arrive deliberately late for lectures and swan into Theatre L, permanent pout on his lips. He sat beside me one day in the first week and asked me for a light. Then he asked me for a cigarette. From then on we were friends. After pre-revolutionary France we'd sit on the middle floor of the canteen sipping coffee and avoiding Alice, the tea-trolley lady.

'Where did you get that tray?' she'd whine. 'No trays upstairs.' And Eddie would interrupt his monologue on the role of German Expressionism in the development of *film noir* to remove his feet from the perilous path of her brush. 'Alice's Restaurant', he called it. I didn't know what he was talking about, but I laughed anyway.

He was pretty smart, our Eddie. He was a good-looking bastard, too. I never realised it at first, but gradually I noticed all the girls in the class wanted to get to know me. Should have known it wasn't me they were interested in.

'Who's your friend?' they'd simper, jiggling like crazy.

The rugby girls really liked him. You know the type. The ones who sit in the corridors calculating the cost of the lecturers' suits. All school scarves, dinner dances, summers in New York without a visa – so much more exciting that way. Eddie hated them all. He resisted every coy advance, every uncomfortable, botched flirtation. They were bloody convent schoolgirls. All talk and no action. He said there was just one thing they needed and they weren't going to get it from him.

Professor Gough liked making risqué jokes about the nocturnal activities of Napoleon and everyone in the class was shocked. Everyone except Eddie. He'd laugh out loud and drag on his cigarette and laugh again while everyone blushed and stared at him. He said that was the trouble with Ireland. He said we were all hung up about sex. It was unhealthy. It was no wonder the mental homes were brimming over.

Eddie had lost his virginity at the age of fourteen, in a thatched cottage in Kerry. Next morning, he'd shaved with a real razor and he'd felt like a real man. As the sun dawned on his manhood he had flung his scabby old electric into the Atlantic. Then himself and his nineteen-year-old deflowerer ('deflorist', he called her) had strolled down the beach talking about poetry. She'd written to him from France a few times, but he'd never answered. It didn't do to get too involved. All of Western civilisation was hung up on possession, Eddie said. People had to live their own lives and get away from guilt trips.

We were close, Eddie and me. I bought him drinks and cigarettes, and he let me stay in his place when I got kicked out that time. His parents gave him the

money to live in a flat in Donnybrook. He called them his 'old dears', I went back home after a while but I never forgot my two weeks on the southside with Eddie. We stayed up late looking at films and listening to The Doors and The Jesus and Mary Chain and talking about sex. Eddie liked to talk about sex a lot. He said I didn't know what was ahead of me. He was amazed that I hadn't done it. Absolutely amazed. He envied me actually, because if he had it all to do over again, the first time was definitely the best. But that was Catholic Ireland. We were all repressed, and we had to escape. James Joyce was right. Snot green sea, what a line. It wasn't the same in India, he said. Sex was divine to them. They had their priorities right.

Eddie went away that summer, to Germany, and he came back with a gaggle of new friends. They were all in Trinity, and they'd worked in the same gherkin factory as him. They were big into drugs and funny haircuts and Ford Fiestas. Eddie had the back and sides of his head shaved and he let his fringe grow down over his eyes and he dyed it. Alice the tea-trolley lady would cackle at him in the canteen.

'Would you look!' she'd scoff. 'The last of the Mohicans.'

Everyone laughed but Eddie didn't care. He didn't even blush. He rubbed glue and toothpaste into his quiff to make it stand up, and even in the middle of the most crowded room you could always tell where Eddie was. His orange hair bobbed on a sea of short back and sides.

He went to parties in his new friends' houses, and they all slept with each other. No strings attached. No questions asked. He brought me to one of them once, in a big house in Dalkey. Lots of glass everywhere, that's all I remember. Lots of glass. And paintings on the walls, by Louis le Brocquy and that other guy who's always painting his penis. You know the one. That was where I met Marion. She was in the kitchen, searching the fridge while two philosophy students groped each other under the table. She didn't like these parties much. We sat in the garden eating cheese sandwiches and drinking beer. Eddie stumbled out and asked me if I wanted a joint. I said no, I wasn't in the mood. Marion got up to leave with some bloke in a purple shirt who was muttering about deconstruction. Eddie said he wouldn't know the meaning of the word.

We bumped into her again at a gig in The Underground one Sunday night. It turned out the deconstructionist was her brother and he was in the band. When she asked me what I thought, I said they were pretty interesting. She thought they were terrible. I bought her a drink and she asked me back to her place in Rathmines. In the jacks I whispered to Eddie that I didn't want him tagging along. He said he got the picture. Standing on the corner of Stephen's Green he winked at us and said, 'Goodnight young lovers, and if you can't be good, be careful.'

It wasn't at all like Eddie said it would be. Afterwards I laughed when she asked me had it been my first time. Was she kidding? I'd lost it in a cottage in Kerry when I was fourteen. She smiled and said yes, she'd only been kidding. All night long I tossed and turned in her single bed, listening to the police cars outside. I couldn't wait to tell Eddie about it.

We went for breakfast in Bewleys the next morning. Me and Marion, I mean. She looked different without make-up. I felt embarrassed as she walked around the flat in tights and underwear. It was months later that I admitted I'd been lying about my sexual experience. She laughed and said she'd known all

along. She said I paid far too much attention to Eddie. That was our first row. She said that for someone who wasn't hung up, he sure talked a lot of bullshit about it.

At first Eddie was alright about Marion and me. I told him we had done it and he clapped me on the back and asked me how it was. I said I knew what he'd been talking about. It'd been unreal. That was the only word for it. He nodded wisely and asked me something about positions. I said I had to go to a lecture.

But as I started spending more and more time with Marion he got more sarcastic. He started asking me how was the little woman, and what was it like to be happily married. He got a big kick out of it and it made me squirm. He'd introduce me to another one of the endless friends.

'This is Johnny,' he'd say, 'he's strictly monogamous.'

We still went for coffee after lectures, but I felt more and more alone in the company of Eddie and his disciples. Marion took me to anti-amendment meetings and Eddie said we were wasting our time. He said it didn't make any difference. Irish people took their direction straight from the Catholic Church. He told me we hadn't a hope.

'Abortion?' he said. 'Jesus Christ, we're not even ready for contraception.'

I tried to tell him it wasn't just about abortion, but he scoffed and said he'd heard it all before.

Eddie dropped out a few months before our finals. He left a note on my locker door saying he'd had enough. He was going to London to get into film. Writing mainly, but he hoped to direct, of course, in the end. London was where the action was. He was sick and tired of this place anyway. It was nothing. A glorified tax haven for rich tourists and popstars. A cultural backwater that time forgot. He said no one who ever did anything stayed in Ireland. You had to get out to be recognized.

I was sad to see him go, specially because he couldn't even tell me to my face. But in a way it was a relief. Me and Eddie, we'd grown far apart. It wasn't that I didn't like him exactly. I just knew that secretly we embarrassed the hell out of each other. So I screwed his note into a ball and went off to the library. And as I sat staring out the window at the lake and the concrete, I tried my best to forget all about him.

Marion broke it off with me the week before the exams started. She said no hard feelings but she reckoned we'd run our course. I congratulated her on her timing. We were walking through Stephen's Green and the children were bursting balloons and hiding behind the statues. She said she just didn't know where we were going any more. I said I didn't know about her, but I was going to Madigan's. She said that was the kind of thing Eddie would have said, and I felt really good about that. She kissed me on the cheek, said sorry and sloped off down Grafton Street. I felt the way you do when the phone's just been slammed down on you. I thought if one of those Hare Krishnas comes near me I'll kick his bloody head in.

I got a letter from Eddie once. Just once. He said he was getting on fine, but it was taking a while to meet the right people. Still, he was glad he'd escaped 'the stifling provincialism' and he regretted nothing. He was having a wild time and there was so much to do in London. Party City. And the women! Talk about easy. I never got around to answering him. Well, I was still pretty upset about Marion for a while, and then there was all that hassle at home. I told them I'd be only too happy to get out and look for a job if there were any jobs to look for. My father said that was fine talk, and that the trouble with me was that they'd been too bloody

soft on me. He'd obviously wasted his time, subsidising my idleness up in that bloody place that was supposedly a university.

Eventually it all got too much. I moved in with Alias, into an upstairs flat on Leeson Street. My mother used to cry when I went home to do my washing on Sunday afternoons. Alias was a painter. I met him at one of Eddie's parties. The walls of the flat were plastered with paintings of naked bodies, muscles rippling, nipples like champagne corks. He said it didn't matter that they didn't look like the models. Hadn't I ever heard of imagination? I said yeah, I'd heard of it.

He was putting his portfolio together for an exhibition and living on the dole. He told everyone he had an Arts Council grant. He was alright, but he didn't have the depth of Eddie and he was a bit of a slob. He piled up his dirty clothes in the middle of his bedroom floor and he kept his empty wine bottles in the wardrobe. And the bathroom. And the kitchen. I got a job eventually, selling rubbish bags over the phone. There are thirty-seven different sizes of domestic and industrial plastic refuse sack. I bet you didn't know that! I had to ring up factories and offices and ask them if they wanted to re-order. They never seemed to want to. I wondered what they did with all their rubbish.

'Shredders,' said Mr Smart. 'The shredders will be my undoing.'

'Yeah,' I told him, 'you and Oliver North.' He didn't get the joke.

It was always hard to get the right person on the line. Mr Smart said not to fool around with secretaries, go straight for the decision-makers. They always seemed to be tied up though. The pay was nearly all commission too, so I never had much cash to spare. The day I handed in my notice Mr Smart said he was disappointed in me. He thought I would have had a bit more tenacity. I told him to shag off. I said sixty-five pence basic per hour didn't buy much in the way of tenacity.

'Or courtesy either,' he said, tearing up my reference.

That afternoon I ran into Marion on O'Connell Bridge. We went for coffee and had a bit of a laugh. I told her about chucking the job and she said I was dead right. She told me a secret. It wasn't confirmed yet, but fingers crossed. She was going off to Ethiopia. She was sick of just talking. She wanted to do something about the world. If Bob Geldof could do it, why couldn't she? I said it all sounded great, and maybe I'd do the same. Then she asked me all about Alias and the new flat and we talked about the old days. It seemed so long ago. I had almost forgotten what she looked like. She said her friend Mo had just written a postcard from London. She'd seen some guy who looked just like Eddie Virago working in a burger joint in Euston Station. Except he had a short back and sides now. I laughed out loud. Eddie selling hamburgers for a living? Someone of his talent? That would be the day. She said it was nice to get postcards, all the same. She showed it to me. It had a guy on it with a huge red mohican haircut. Mo said she'd bought that one because it reminded her of how Eddie used to look in the old days. She said she'd always fancied him. Marion said she'd send me a card from Ethiopia, if they had them. She never did.

In the pub Eddie and I didn't have much to say, except that it was great to see each other. When I told him the postcard story he said it all went to prove you couldn't trust anyone, and he sipped meaningfully at his pint. After closing time we got the

Tube up to the West End, to a disco Eddie knew in Soho. Drunks lolled around
the platforms, singing and crying. The club was a tiny place with sweat running
down the walls. Eddie asked the black bouncer if Eugene was in tonight.

'Who?' said the bouncer.

'You know, Eugene,' Eddie said, 'the manager.'

The bouncer shrugged and said, 'Not tonight, man. I dunno no Eugene.'

I paid Eddie in, because it wasn't his pay day till Thursday. He was really
sorry about that.

Downstairs he had to lean across the table, shaking the drinks, to shout in
my ear. The writing was going alright. Of course, it was all contacts, all a closed
shop, but he was still trying. In fact, he'd just finished a script and although he
wasn't free to reveal the details he didn't mind telling me there was quite a bit of
interest in it. He only hoped it wasn't too adventurous. Thatcher had the BBC by
the short and curlies, he said. They wouldn't take any risks at all. And Channel
Four wasn't the same since Isaacs left. Bloody shame that, man of his creative flair.

He'd made lots of friends though, in the business. I'd probably meet them
later. They only went out clubbing late at night. Nocturnal animals, he said. It was
more cool to do that. They were great people; though. Really wild. Honestly, from
Neil Jordan downwards the business was wonderful. Oh sure, he'd met Jordan.
He'd crashed at Eddie's place one night after a particularly wild party. Really
decent bloke. There was a good scene in London, too. No, he didn't listen to any of
the old bands any more. He was all into Acid House. He said that was this year's
thing. Forget The Clash. Guitar groups were out. The word was Acid. I said
I hadn't heard any and what was it like? He said you couldn't describe it really.
It wasn't the kind of music you could put into words.

I did meet one of his friends later on in the night. He saw her standing
across the dance floor and beckoned her over. She mustn't have seen him. So he
said he'd be back in a second and he weaved through the gyrating bodies to where
she was. They chatted for a few minutes, and then she came over and sat down.
Shirley was a model. From Dublin too. Well, trying to make it as a model. She
knew Bono really well. He was a great bloke, she said, really dead on. She'd known
him and Ali for absolute yonks, and success hadn't changed them at all. Course,
she hadn't seen them since Wembley last year. Backstage. They were working on
the new album apparently. She'd heard the rough mixes and it was a total scorcher.
This friend of hers played them to her. A really good friend of hers, actually, who
went out with your man from The Hothouse Flowers. The one with the hair. She
kept forgetting his name. She said she was no good at all for Irish names. She really
regretted it, actually, specially since she moved over here, but she couldn't speak a
word of Irish. She let us buy her a drink each. I paid for Eddie's. Then she had to
run. Early start tomorrow, had to be in the studio by eight-thirty.

'Ciao,' she said, when she went. 'Ciao, Eddie.'

It was after four when they kicked us out. The streets of Soho were
jostling with minicabs and hot-dog sellers. A crowd filtered out of Ronnie Scott's,
just around the corner. Sleek black women in furs and lace. Tall men in sharp
suits. Eddie apologized for his friends not showing up. He said if he'd known I was
coming he would have arranged a really wild session. Next time. He knew this
really happening hip-hop club up in Camden Town, totally wild, but in a very cool
kind of way.

In the coffee bar in Leicester Square he was quiet. The old career hadn't been going exactly to plan. He was getting there alright. But much slower than he thought. Still, that was the business. Things got a bit lonely, he said. He got so frustrated, so down. It was hard being an exile. He didn't want to be pretentious or anything, but he knew how Sam Beckett must have felt. If he didn't believe in himself as much as he did, he didn't know how he could go on. He would have invited me back to his place, only a few people were crashing there, so there just wasn't the room. But next time. Honest. It was a big place, but still, it was always full. People were always just dropping in, unannounced.

'You know how it is,' he laughed.

I ordered two more cappuccinos.

'I have measured out my life in coffee spoons,' he said, and he sipped painfully. He always drank Nicaraguan, actually, at home. Very into the cause. I said I knew nothing about it. He started to tell me all the facts but I said I really had to go. My aunt would be worried sick about me. If I didn't get home soon she'd call the police or something. He nodded and said fair enough. He had to split as well.

We stood in the rain on Charing Cross Road while he scribbled his address on a soggy beermat. He told me it was good to see me again. I told him I nearly didn't recognise him with the new haircut. Oh that, he'd had to get rid of that, for work. Anyway, punk was dead. It was all history now.

'You should come over here for good,' he said, 'it's a great city.'

I shook his hand and said I'd think about it. He told me not to let the opportunity pass me by.

The taxi driver asked me where I wanted to go. He loved Ireland. The wife was half Irish and they'd been over a few times now. Lovely country. Terrible what was going on over there, though. He said they were bloody savages. Bloody cowboys and Indians. No offence, but he just couldn't understand it. I said I couldn't either. In his opinion it was all to do with religion.

By the time we got to Greenwich the sun was painting the sky over the river. He said he hoped I enjoyed the rest of my holiday. I hadn't any money left to give him a tip.

I remember that journey to Ayrshire now. I remember my thoughts that night. The sense of loss at the flashing glass. The sense of death and carbon.

When I set out for Ayrshire, that October day, I risked all my ease, my fine English solvency. I knew how my shored-up peace was at risk. Ayrshire for me was a far gone world, a puzzle of ragged affections. But my grandfather was dying. And the time had come. I held my breath. I packed a bag. I kissed my girlfriend at the bedroom door. I left my car. I took credit cards, and keys, and a brace of shirts. I stood in the kitchen waiting for a taxi. The morning was Scouse.

A notion of old things rained at the station. How well I had held back the years. I stood on the platform, stroking my chest, smoothing my jaw, the bristles there an orderly garden, a place where time could not stand still, or rage. I had come to manhood carefully. My body was pleased to outgrow that boy. At times you forget him, the person who lived in this skin. You find a nick on your thumb. An overlaying of white tissue, like anaglypta. You remember the story of a boy who once cut his finger on a rock. You hear something of his voice. You think of his books and his pencils. You remember the way he looked out through his eyes. And then you see they are your eyes too. Your vision clears. You were that boy. Every room of his house is here. You can never demolish him. He will never leave. Unless you find yourself leaving yourself. The boy is not back there in Ayrshire; he's here. He is always here.

I stood on the platform. The thought of home made me shrink in my shirt.

But calm. I had wanted to make this journey. The time had come. My head was light with other places. And Lime Street fell away, a small memory.

The train was enfolded in darkness. The burning train, the field out there; the tadpoles alight in their pools.

Paisley then Johnstone. The farms of Wester Gavin and Newton of Belltrees. The tram was a strip of yellow light. It shook up the moss and Herb Robert and, running at speed on the wires above, it rackled the moor, and lifted the wind to the rowan trees. A furrow of broom and bracken fern lay snug at the waist of Lochwinnoch.

Up and down the empty aisle, a bottle of Irn-Bru.

To arms, old Ayr, to arms again. The drums of vengeance hear.

We passed Beith then Glengarnock. Over the silt of the Powgree Burn, I saw what I could. A loch of bashed prams and old batteries. The town of Dalry, with the chemical works, a cluster of lights, and night hours. My eyes were lost in the sparks and the solder. The men at their work. And fumes spreading over the Garnock Hills. A cap of smoke: sulphur, azote, ether.

Ayrshire moor.

The bottle rolled at twice my speed. A song lay low in my head.

A brighter meed, a broader frame,
Await our gallant toil;
We hold the hearts our fathers held,
And will preserve their soil.
To arms old Ayr, to arms again,
Her eager warriors cheer.
And Carrick, Coil, and Cunningham,
Together charge the spear.

Ayrshire out there.

A county shaped like an amphitheatre. Bent like the crescent moon. The only Scottish shire with a face towards Ireland. My mind ran out to the tops of the hills as the train moved on. Up go the eyes of rabbits and owls. They peer from the uplands of Kyle and Cunningham, and so do the eyes of people in their high farms, who are mad for the sea, and who applaud the roar from their rocky seats, their island view from the upper tier. I felt them near to me. I felt their breaths at the window.

And the rivers too come down from the hills.

The Garnock, the Irvine, the Ayr, the Doon Water. The Nith and the Stinchar. The Girvan, the Lugar.

How they bend and they turn, with the help of the land, the lift of the wind, and by and by they open their banks, and spill at last, a short collapse in the Firth of Clyde. And still it moves on, south and west, to the bittern graves of the Irish Sea.

At the back of those Ayrshire hills were broken castles. And under them, the putrefied hearts of great men. The open moors now bore the names and the marks of their Covenant spirit. Many a song stood still in the long grass. Over the top of those idle crannogs you might hear words on the south-east wind. The burr of reform still rolled in the Garnock Valley. Out there, in the dark places, men and women had died for Melville and Knox, and the ground was sown with beliefs. And now it seemed but whispering grass. The old stories gone, of ministers and miners, of Union men, of troops, and now the land had been cleared. Japanese factories would be coming soon.

Those fields of blood and carbon. They became the sites for the newer wars, our battles for houses and redevelopment, fought by the likes of Hugh and his mother. The names of those dead warriors, Wallace and Eglinton, Maxton and Hardie, were now known as streets on the council estates, the former glories of Ardrossan and Saltcoats. But some of those houses, built on ruins, were now no more than ruins themselves. In fields they lay as rubble again.

I knew they were out there still. Beyond that bracken our dilapidations lay about in the grass. We had built houses after all. And we had torn them down with our own hands.

The train had slowed.

Kilwinning and Irvine. The lights down there. Once upon a time people crowded into those sandstone houses at the market cross. I could see the remains

of those buildings from the moving train. And a plume of smoke here and there. The people with fires were burning the last of the local coal, to stave off the first bit of winter.

Over the orderly parks lay the housing schemes. The televisions beat out their sickly light, from house to house, from block to block, like some kind of dizzy semaphore. Bonfires were got up at the gable ends. Kids ran down from their dirty-white houses with burning sticks as the train rode past on the embankment. I sat with my head against the window. Light and life now blocked out the stars. The train buzzed slowly to its station stop. The bottle awoke. It rolled down the aisle. I lifted my bag and stepped to the opening door.

Outside you tasted salt in the air. Salt and sulphur and gutted fish. A nervous wind skidded above the station. I could see right down to the harbour lights. The village of Affleck; the church of St Joseph's. The sound of the sea over rocks.

My hands were freezing as I lit a cigarette and smoked it there on the platform. I quickly kissed it down to a stub. I wanted to feel thick with smoke inside; upped with that buzz of deep inhalation. Cigarettes, they make you feel like a super-breather on a cold night. You feel alive smoking them. You feel deeply alive. In the grand smoke you wonder at the depth of your organs. You feel a quickening in the undertow. The grand smoke. It makes you feel healthy on a cold night. Lungs and heart, liver and kidneys.

You feel all right. The lips' tender vent: a jet-stream of smoke and icy air.

I dropped the fag on a wet copy of the *Ayr Advertiser*.

The station was the tidiest in Scotland. It said so on a brass plaque tacked to the wall of the ticket office. The station clock was no secret-keeper either. It whacked out the seconds overhead. The station brae was full of taxis with nothing to do. I was the only one off the Glasgow train. The town behind the car-park was quiet that night. Nothing too mad about the steeples or disco bars. A slow night at the bingo no doubt. Autumn sleet over the tower blocks. All the people who weren't in their beds, or asleep watching telly, or hunkered down in the backs of pubs, would have stayed by the door for the last of the children to come. The night I arrived it was Halloween.

So there was my town for sure. I was happy to see it again. My time on the train had somehow brought me closer. The town had emerged like a place in a dream. Now it stood clear: the reek of fish, and sandstone cut with a Presbyterian trowel.

The unplaceable sadness of belonging was suddenly mine on that station platform. I saw that I wasn't here for much. To do the right thing was all. To put a cool hand in the world that had daunted my adult sleep. I wasn't looking for change or glory or madness or remorse. I don't think I was. I just came home to see my granda. But maybe I was blind. Maybe there is no such thing as an ordinary trip home, to a home as undappled as mine. But I know I had thought that it might be ordinary. It might just have been that I wanted it so.

I stood a minute more. Then I took Hugh Bawn's letter out of my pocket. The paper might have been thirty years old, his writing was a mess. The letter was in green ink.

I mo bhuachaill óg, fadó, fadó,
 d'aimsíos nead.
Bhí na gearrcaigh clúmhtha, fásta,
 is iad ag scread.

D'éirigh said – is thuirling
 arís ar m'ucht
Ormsa bhí muince clúimh
 sa mhóinéar fliuch.

Níor dhuine mé ach géag crainn
 nó carn cloch
ach bhí iontas crua nár bhraith said
 ag bualadh faoi m'ucht.

B'in an lá ar thuirling ceird
 a éilíonn ómós:
is d'fhág a n-ingne forba orm
 nár leigheasadh fós.

Annaghmakerrig has been a welcoming haven since its very first days … an almost mystical home that materializes when I find myself needing distance from the usual interruptions of life. To create a piece of art that will transport others to a timeless place in the imagination, we must first find that space ourselves.

In the summer of 1995 I was surprised to find myself composing a string quartet, having gone to Annaghmakerrig intending to write something completely different. My first quartet had been written twelve years earlier and I knew that there would be another one … someday. Within a week at Annaghmakerrig, out of the immense silence that I associate with the place, my second quartet emerged – 'Mystic Play of Shadows', an evocative work which recalls for me the sounds of the birds settling down at dusk in the woods near the lake. The remarkable counterpoint of their 'chattering' provided the impetus for my strings to converse with each other. The quartet was written for no one in particular and I wondered who would eventually play it. It wasn't long before it began to take flight, reaching listeners around the world. Now, whenever I hear it, I am standing in the woods again, beside the lake, and the Annaghmakerrig birds are making their own magic.

It is not often that pieces just write themselves, but on this particular residency that was exactly what happened.

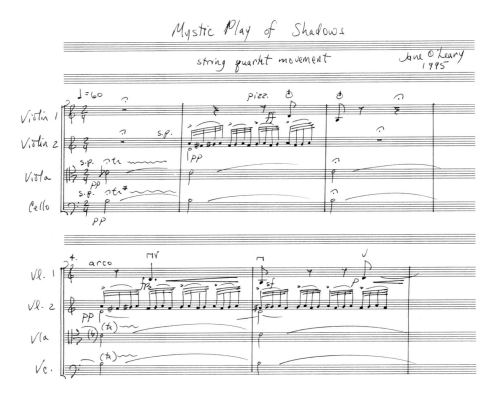

Call him Boyle.

He wiped the rain off the bridge parapet with his sleeve and leaned over for a look at the drop to the water. The river was low and stagnant in its wheaten stone trough. Angular shadows from buildings and spires were under the surface coloured by greens and browns and brief zones of blue from the sky, the moving sky. The green was the reflection from the age-old tapestry of weeds and moss hung on the walls all the royal way through the city to the sea.

Call him Noel Boyle.

Under the murky reflections, he would have been able to see the apocalyptic objects submerged in the mulch bed of the river: a shopping trolley, a metal window frame, a tractor tyre, a long crooked leafy bough, an armchair, a beer keg. Platonic outcasts, he mused and then a snarl appeared on his face, either from distaste with his own mind or because all these things were made invisible by a glare on the water from the sun set free from a nut-squad of cloud. Boyle raised his eyes and watched a train leaving the station.

Say this is Dublin. A man on the bridge watches a train leaving Heuston Station and the windows parry back the light of the Free State morning sun.

Someone passing across the bridge in a car might have noticed him check on either side before his hand moved quickly towards the bouquet inserted into the ironwork curls of the balustrade.

The flowers were white roses, wrapped in white paper. There was no card of In Memoriam.

Boyle seemed to be trying to nip the head off one of the stalks without crushing the petals. None of them would come loose for him. Using both hands, he began to twist the flower more roughly, too roughly because the whole bouquet was dislodged and dropped to the pavement.

Say a woman was walking over the bridge at the same time. She sees a man staring at a bouquet of flowers on the ground between his feet. What would she think? That they have fallen from the sky? That he has dropped them and is appalled by what it might mean?

The man has a thin build, and a smallish face under a tight brown beard although there is a touch of white like a feather in the hair at his throat. He wears denim, new and washed out. The woman is alarmed suddenly by the idea that the man is about to trample on the flowers. She would hate to see that. Violence of that sort would cast a shadow across the rest of her day.

Although the man doesn't look threatening, the woman decides that it would be safer to step into the road to avoid him, making sure to look the other way as though she is engrossed in counting the number of bridges to the sea. It is a lovely morning in Dublin, she repeats to herself. Yes, a lovely summer morning in Dublin. She has always chanted to herself when she feels afraid. Once safely past him, she risks a glance back only to see that he is standing in the same position.

After she was out of sight, Boyle picked up the bouquet and fitted the stems into a sturdier position in the metalwork. Moving slowly along the bridge, he scattered the rain with his hand from the balustrade and leaned out to see the

drops falling and sprinkling the disgruntled water. Maybe as he did this he thought of himself as a boy and was unsurprised that his memories were bandy and trivial and sentimental; the heat from a flaming bonfire that tightened the skin and gave them all the eyes of squinting old men, the nettles grown tall and yellow from piss where he used to hide his warrior stick when he was called in for the night, the lonely summer day he went for a walk out the back roads and got lost but the dark didn't and came down around him in the fields and he prayed to God to bring him home and a woman appeared, a tall pale woman who walked beside him in silence, the imprint of pebbledash in the skin of the first girl he ever pressed hard against a wall and the puddle trembling between her flip-flops a second before the explosion, his mother and father dancing drunk in the kitchen late at night, the last drag on a filter butt from the scarred black fingers of the older boys at the corner.

Boyle stopped; he leaned out further over the bridge. The wind made tyre tracks across the water. Invisible golden chariots, no, tanks of sunlight, caterpillar wheel marks.

A car horn went off and a voice shouted: Jump. Do it now. Don't listen to them.

Boyle worked in a telephone-call shop in Temple Bar, a pedestrian zone of restaurants and bars for tourists in the centre of the city. The shop, Talk Tonic, had eight glass-fronted cubicles along one wall where people could make cheap calls around the world. Boyle sat at his own desk near the door and handed out wooden tablets branded with a number corresponding to each cubicle. When the phone call was finished Boyle checked the cost on the screen and took their money. Somebody arrived every hour to pick up the cash, Boyle would know them only by a password, not by their face. The password changed every week. Boyle did nights mainly, closing at 2 am, before the streets were flooded by the moonless nightclub tides.

He had found the job by accident when he went in to phone Dainty, just before Christmas time when he was trying to decide whether to go back or stay where he was for the holiday. While he was at the desk waiting to pay, an argument started between the black man on the till and another man, Eastern European maybe, Finnish maybe, who didn't have enough money and was complaining the price was too high. The black man stood up and took out his mobile phone, threatening to call the Guards. Boyle offered to pay the extra; it didn't amount to much anyway. The response he got was a mouthful of what had to be abuse from the Eastern European. He saw the void opening in the man's eyes before the punch came and was well clear in time. Then he kicked the man in the balls. There followed a few seconds of tired slack in which Boyle thought he could see something ancient and lonely in all the watching faces and even the rain and lights on the street outside had it, or it was the feeling that he was about to remember what he was doing there, not only in the shop, but on the planet, why he was in existence and those other people were all waiting on him, hoping, part of the performance, and it would free them like it would free him ... just a few seconds of that before the man straightened up again, laughed and slapped Boyle on the shoulder, and put down the full amount on the counter. The black man, Leo, who turned out to be one of the shop's owners, gave Boyle his call for free and told him to come back if he ever wanted a job. Boyle returned the following night.

He spent his Christmas working there.

It was nearly midnight. Boyle was at the door of the shop, smoking. The cloud was low and unbroken and under it the denizens were out looking for amusement, packs of lads in short sleeves, girls staggering along the cobbles in high heels, the greed hard on the eyes. Music came out of the bright tunnel behind the three doormen on the other side of the street. It had been a busy night in the shop, one of the good nights when he heard laughter coming from the cubicles instead of the usual morbid grumbling or fury and then the stunned plaintive eyes of some refugee counting out the coins into Boyle's hands. All night the aching voices went out to the tundra and the mountain, harbour and slum, to the deserted and the waiting in the frozen tower blocks or merciless shanty noon and Boyle, their priest, their shaman, pressed the buttons and stacked the coins. Yet, at the same time, there were others who were simply making a quick call to friends to see how they were doing, like the two American girls that night who had stayed around for an hour to talk to him and ask for advice about their upcoming trip to the North. Or the young Basque couple who were hard at each other in the cubicle long after they'd hung up. Or Tierney, the old Dublin man, who came in regularly to use the sex lines, a well-read man who before he went in always liked to have a discussion with Boyle about whatever he was reading but who never said a word when he came out, his face gone sour, slapped down his money and hurried out of the door.

Boyle was watching a character down the street who was leaning against a lamppost. He'd been there for a while and Boyle was sure he knew the face, a hard man's low sunburned forehead, the whole stocky look of him with the new tight jeans and polished boots, the big watch, every stitch on him fresh out of the shop. A bright brand-new cement mixer. He had a bad instinct about it. The bastard was careful not to look in Boyle's direction. He was wondering what to do when another familiar rose up in front of him.

Martin? How's the form? You been fighting?

Martin was wearing his sleeping bag over his shoulders like a cape. He had a hat on his head like a traffic warden or a park keeper. One side of his face was badly bruised.

You the captain bud?

The number doesn't work Martin.

I'm going home man. I've got leave man, do you hear me?

Martin rummaged inside the sleeping bag and produced a limp piece of cardboard which he handed to Boyle.

I know all about it Martin. But we tried it a fucken hundred times haven't we? There's eight digits here so it's not Dublin. Did you find out where it might be then?

Let me ring her bud. I have to tell her I'm coming. Just let me fucken ring her man. Please man. I want to tell her I'm coming.

Boyle usually let him in and tried to calm him while he tapped in the number again and again. The week before, however, Martin had shattered the handset against the wall.

Look what happened the last time? Who the fuck do you think had to pay for it? You broke the fucken phone.

Martin seemed frightened by the idea, disbelieving, but then it faded mysteriously.

I have to phone her man. I've got leave. I've got leave.

The character by the lamppost had vanished.

I'm warning you, Boyle said to Martin and turned back into the shop. Martin followed him to the furthest cubicle. After watching him dial the number once, Boyle had to go back to the desk where a queue was forming. It was ten minutes before he went back to check on the cubicle; he found Martin sitting on the floor and the strip of cardboard on fire between his feet. Shouting, Boyle stamped it out. People came out of the cubicles for a look and news of what was happening went down the wires to bombed-out villages, African bars and apartments in suburban Korea. Martin wasn't reacting: Boyle put him in a chair. Then he noticed the phone was hanging at the end of its lead.

Hello, is anyone there?

NIGEL ROLFE *Wrapped Hammer*
1995-2006
Unpublished photograph
Colour photograph of private performance
60 x 60 cms

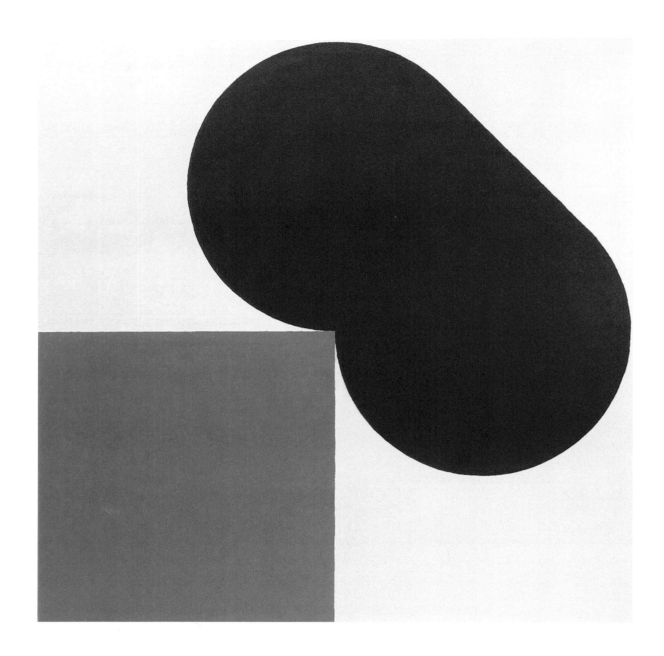

RICHARD GORMAN *Salmon Flyer*
2005
Oil on linen
150 x 150 cms

DONALD TESKEY *Lily Pond, Annaghmakerrig*
1995
Oil on paper
40 x 50 cms

GERALDINE O'REILLY *Trees without Leaf*
2002–03
Conté and charcoal on paper
29 x 42 cms

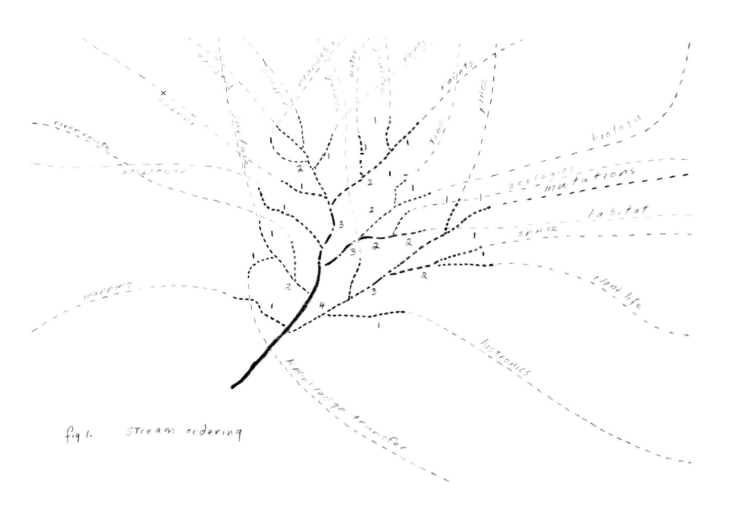

fig 1. stream ordering

CHRISTINE MACKEY *Drawings in progress*
2005–06
Pencil on paper
21 x 29.5 cms

TJIBBE HOOGHIEMSTRA *Untitled*
2004
Mixed media on paper
30 x 18.5 cms

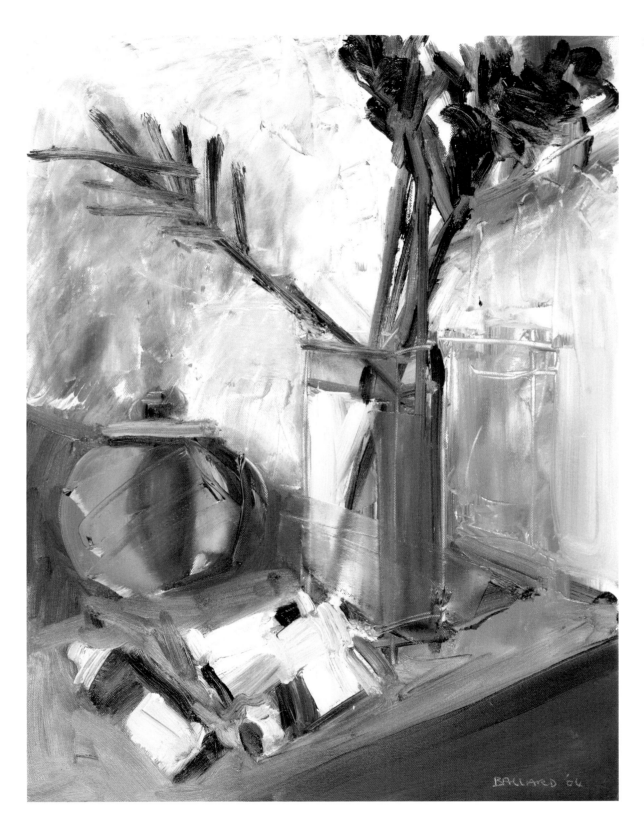

BRIAN BALLARD *Teapot and Paints*
2004
Oil on canvas
60 x 46 cms

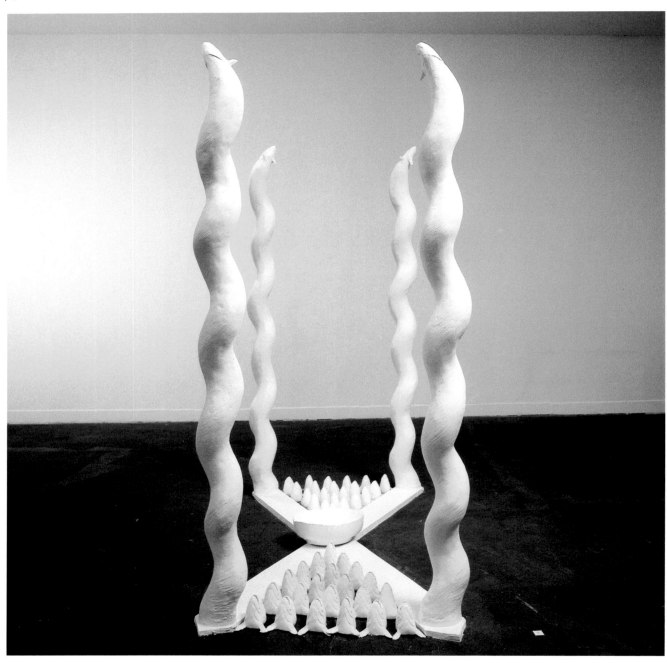

CATHY CARMAN *She is not here*
1999
Plaster
155 x 105 x 109 cms

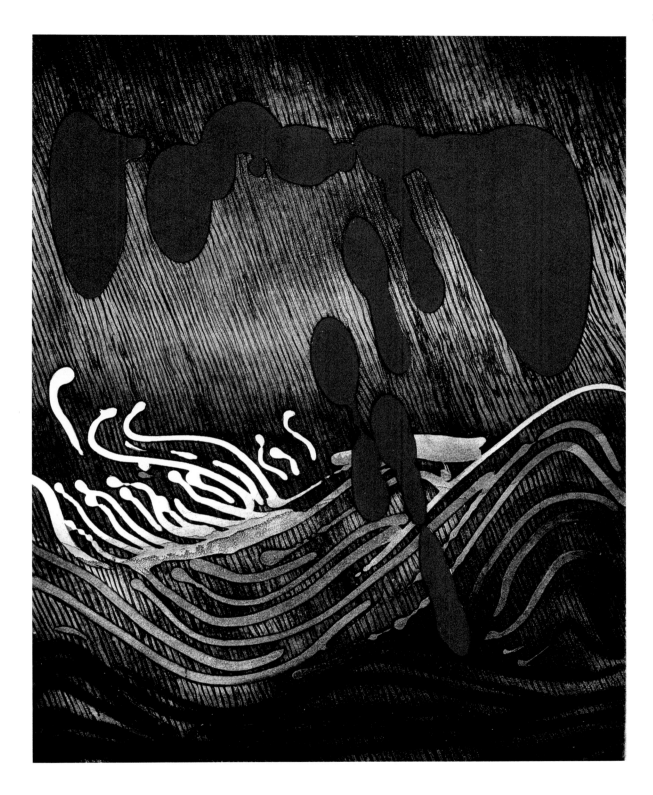

MARY FARL POWERS *Red Rain Seascape*
1977
Etching ed. 50
48 x 38 cms
Courtesy of the Powers family

176

SUSAN TIGER
Top – *9 January 2006. Monday. 12:07pm. Rain of forecasted storm. (3 takes)*
Below – *29 March 2006. Wednesday. 12:36pm. Spring shower, brief shower.*
Water-soluble graphite on Arches watercolour paper
26 x 18 cms

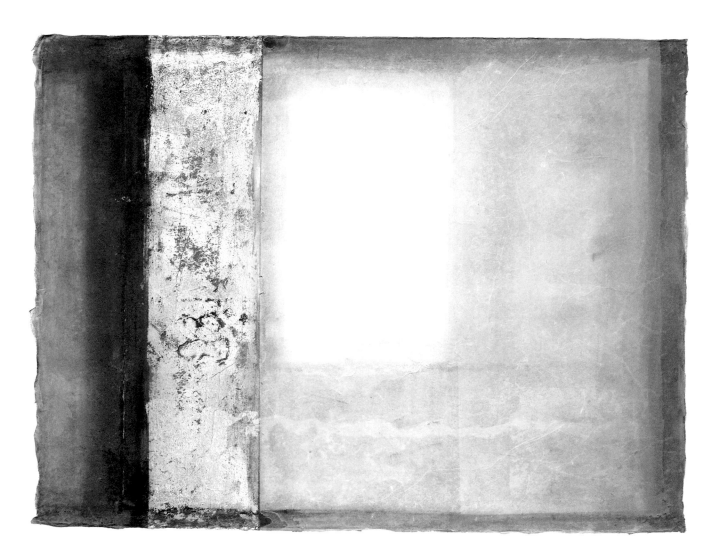

JANET PIERCE *OM*
2006
Gold leaf/mixed media/paper
80 x 100 cms

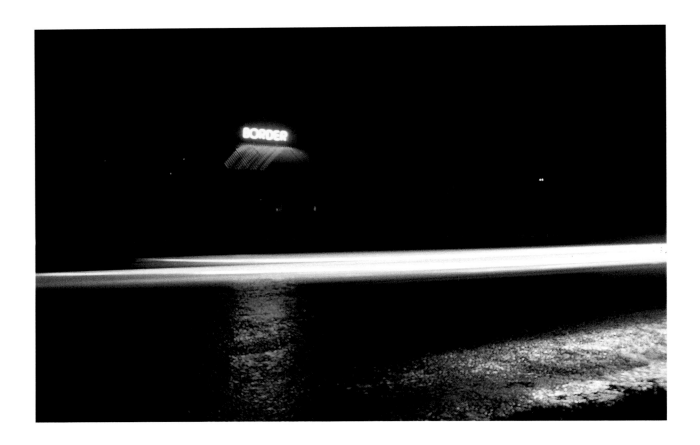

JOHN BYRNE *The Border Interpretative Centre by Night*
2000
Lamda print on dibond
92 x 60 cms

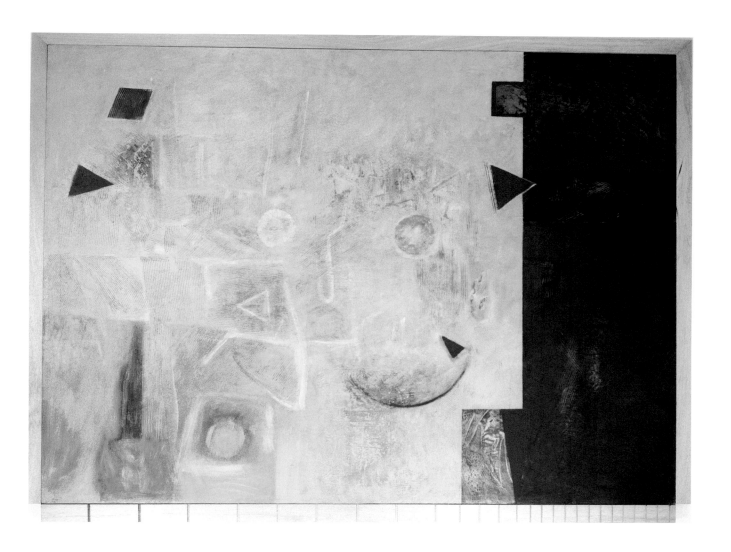

BARBARA FREEMAN *A Song of Circles and Triangles*
1998
Oil on board
125 x 165 cms
Collection Dr John Hart

180

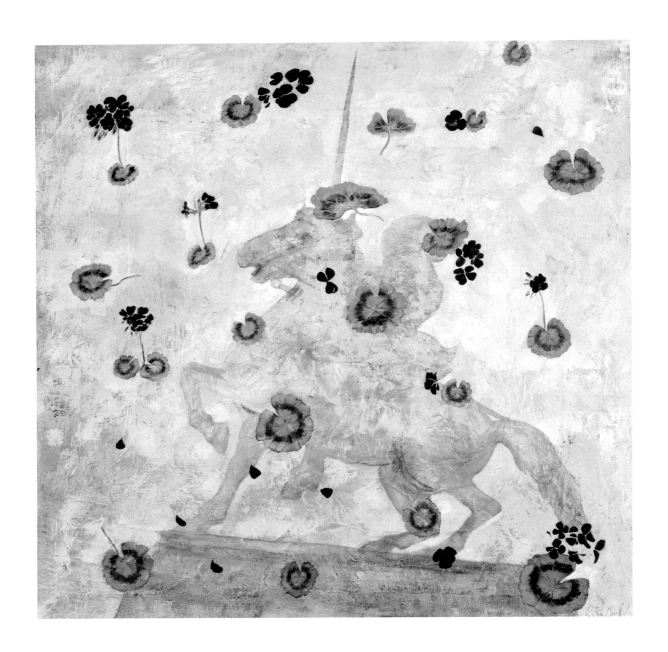

RITA DUFFY *The Madness of Geraniums*
2005
Oil on linen
120 x 120 cms

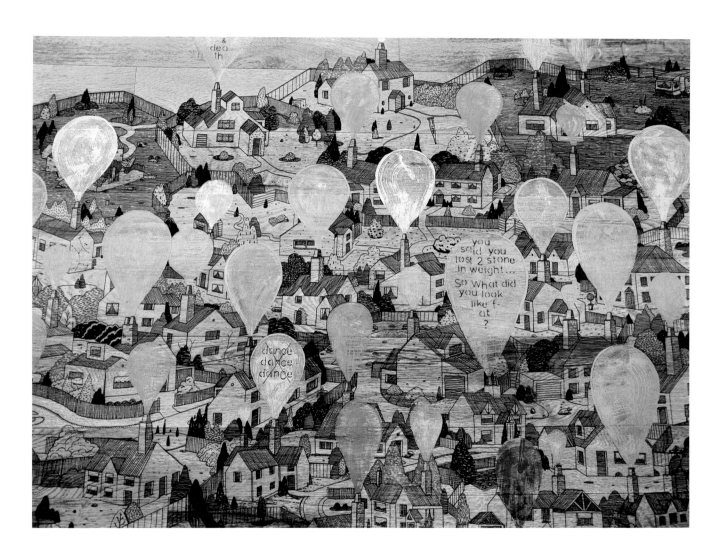

STEPHEN BRANDES *Dresden Grove will rise again*
2005
Oil and permanent marker on vinyl
157 x 270 cms

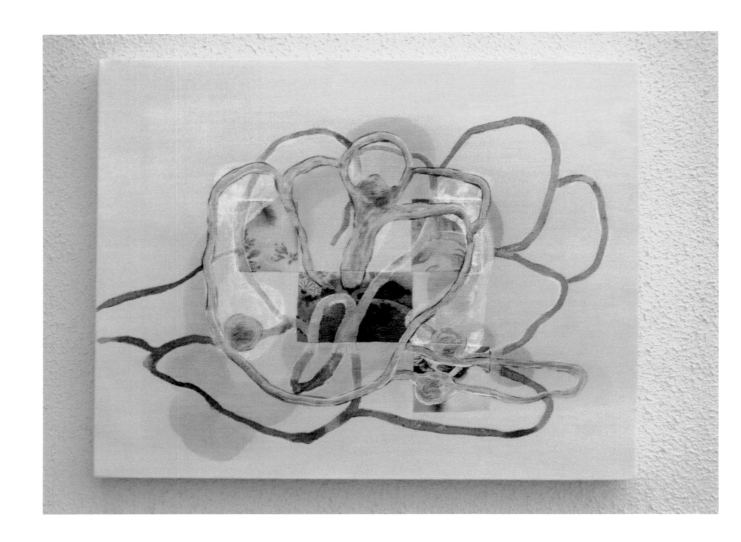

MICKY DONNELLY *Hybrid Series No. 16*
2006
Acrylic, ink and fabric on canvas
41 x 51 cms

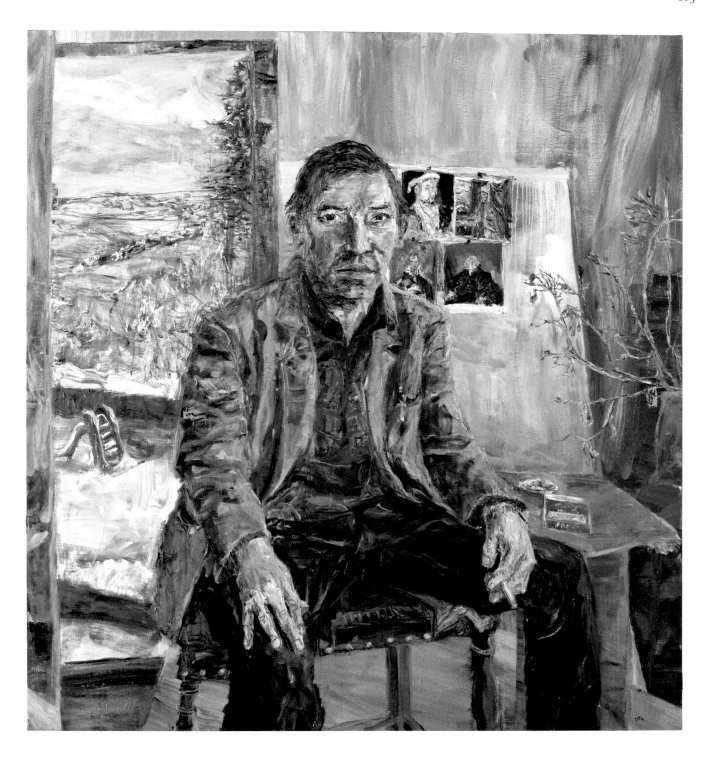

NICK MILLER *Portrait of John Hogan*
2004
Oil on linen
183 x 168 cms

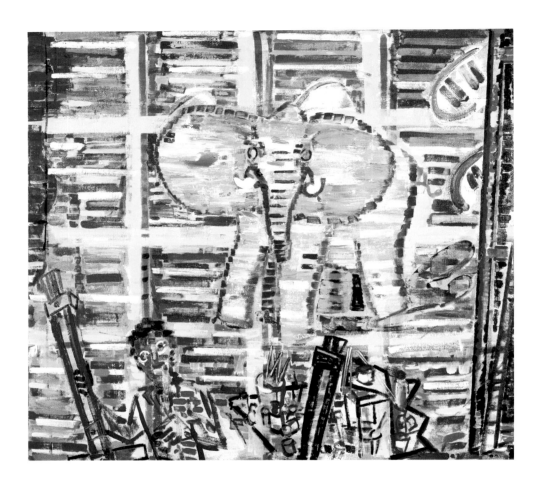

MICHAEL CULLEN *Elephant and Smokin' Painter*
2004
Oil on linen
136 x 146 cms

1. The G.A.A. occasion during 1971 that remains imprinted indelibly on my memory was the moment the Ban was abolished at the Easter Congress in Belfast. For almost sixty-years Rule 27 had prohibited members of the Association from playing, attending or promoting the games of rugby, soccer, hockey and cricket. Then in 1968 the Mayo County Board proposed that Central Council set up a committee to look into the restrictive Rule and draw up a report stating reasons for its retention in a fast-changing Ireland. A six-man committee, consisting of four pro-Ban men and two anti-Ban was appointed and given three years to produce a report. It was completed and published by the end of 1970 and circulated to all G.A.A. Clubs.

The Deletion of Rule 27 from: The G.A.A. in its time author: Pádraig Puirséal artwork: Constance Short

3. Whatever about the rest of Belfast, it would have been impossible to find any spot in all Ireland more peaceful than the Queen's University campus in the soft Spring sunshine of that Sunday morning in mid-April. Somewhere, somehow, one must presume, top security was being ensured, but if so it was nowhere obvious. Nor, although the crowded Whitla Memorial Hall was tense with expectation, were there any high dramatics when the actual moment of abolition came.

5. The President called for a county that favoured removal to formally propose the abolition of Rule 27. For perhaps 10 suspense-filled seconds the attendance of nearly 300 delegates sat in utter silence. Then, Armagh-man Con Short from Crossmaglen rose and moved that Rule 27 be deleted from the official guide. Veteran anti-Ban crusader Tom Woulfe, from Dublin's Civil Service club, seconded the motion. There was another moment of silence, then Fanning was on his feet officially declaring that Rule 27 had ceased to exist. Antrim chairman Jack Rooney quickly went on record for his county as favouring retention, but loyally accepting the decision.

2. That Belfast Congress had long been awaited with growing eagerness and a certain amount of trepidation. There had been heavy majorities against the Ban at grass-roots level, but there were still prophets of woe who kept on insisting there would be dissension, and possibly disunity, at Congress itself when the final hour of decision came. There were other prophets who hinted darkly that every side and shade of opinion in a belligerent Belfast would make this historic G.A.A. gathering the target for at least a demonstration, if not for something far more deadly. As it happened, neither set of prophecies could have been more wrong.

4. President Pat Fanning will never have a finer hour than this. Though his personal views were no secret, he emphasised in his presidential address that the Ban had already been sentenced to death by 28 of the 32 county conventions, stressing that while there would be all the greater necessity, when the ban was gone, for the Association to remain true to its long established ideals. They gave him a standing ovation, well merited, and then came the actual abolition. It was mercifully brief, while noon-day sunshine flooded around the Whitla Hall, blazing through the windows behind a rather sparse muster of spectators in the public gallery.

6. Old-timer Lar Brady, from Laois, rose briefly, but mistakenly, on a point of order... and in less than four minutes the Ban, which for nigh on 70 years had been such a much-gnawed bone of contention both inside and outside the G.A.A. had been quietly interred without rancour or discord, without even the fuss of formal debate. To me, who, down the years had listened sadly to so much dissension, acrimony and bitterness even among devoted G.A.A. men over the same Ban, it was a particularly happy moment. The Ban had gone, not swept out triumphantly by any clique or faction, but discarded by the calmly considered decision of a united Association.

CONSTANCE SHORT *The Deletion of Rule 27 from the Official Guide of the GAA*
1998
Linocut, limited edition print (20)
210 x 210 cms
Commissioned by the GAA

The sunset's slow catastrophe of reds
and bruised blues
leaches the land to its green and grey.
Light thins over the wood; black
colours in each notch and furrow
at the long day's closing-down.
The only sounds are bled,
and far away:
the cough of an axe
and the lowing roar of distant chainsaws
starting and falling, like cattle
calling out to be milked.
And so I wait here, as usual,
in the crushed silence of tinder: steeped,
stepped in shadow,
under the appalling pines.

In shadow, a recessive shade. Greyish-green flakes floating in an elaborate and slightly dishevelled pattern. The eye slowly sorts it out into perhaps five or six triangular fronds. On a closer look an individual frond breaks up into a small number of triangular sprays of five or six leaflets the size of a little fingernail. Each leaflet is fan-shaped, with straight sides and a scalloped outer margin, and is attached at the apex to a fine stalk, which in its turn branches off the slightly thicker axis of the spray, and so is connected back to the stem of the frond. Even these stems are so slender that the fronds bend outwards under their own weight, so that each leaflet offers its upper surface to the eye and the whole array canopies a curved darkness below. The articulations are so delicate that a breath is enough to start a flickering fan-language of display and concealment, chaste provocation, coquetry – or so one reads it, prompted by the fern's English name. The Irish goes bluntly to the root: *dúchosach*, black-footed. Part the foliage and see how the wire-thin stalks emerge in a dense bundle like a jet of earth-force from a crack in the rock, glossy brownish-black, grading into green as they diverge into their parabolic trajectories. The peasant, sturdily rooted in the compost of its ancestors.

Adiantum capillus-veneris (to take up its Linnaean binomial as one would a magnifying glass for scientific objectification) is the Aran plant *par excellence*. It is extremely rare in Britain and in Ireland except on the Burren and Aran limestone, and the earliest Irish record of it commemorates the first visit of a scientist to the island. Edward Lhuyd, writing from 'Pensans in Cornwall, Aug. 25, 1700', says:

> In the Isle of Aran (near Galloway) we found great plenty of the *Adianthum verum*, and a sort of matted campion with a white flower, which I bewailthe loss of, for an imperfect sprig of it was only brought to me; and I waited afterwards in rain almost a whole week for fair weather to have gone in quest of it.

The campion would merely have been the common sea campion; *Adianthum verum* was the old name for the maidenhair fern; and without the rain there would be no such fern here. Lhuyd was Keeper of the Ashmolean Museum in Oxford, and catalogued its collection of fossils; he was at the same time establishing himself as a Celticist, and his visit to Aran was in connection with the preparation of his great work *Archaeologia Britannica*, described on its title-page as 'giving some account Additional to what has been hitherto Publifh'd, of the LANGUAGES, HISTORIES and CUSTOMS Of the Original Inhabitants OF GREAT BRITAIN: From Collections and Observations in Travels through *Wales, Cornwal, Bas-Bretagne, Ireland* and *Scotland*'. In his second chapter, 'A Comparative Vocabulary of the Original Languages of Britain and Ireland', I notice:

> Adiantum ... *The Herb Maydenhair*; Ir. Dúv-xofax ... Black-fhank

which perhaps records the rusty voice of some Araner of nearly three hundred years ago. Another name for the fern I have heard, *tae scailpreach* (*scailpreach*

meaning a place of rocky clefts), probably dates only from the last century when tea became such a comforter of the poor. Dinneen gives it in his Irish dictionary, with the remark that the fern was used as a substitute for tea; this seems unlikely, and I imagine it was the appearance of its sere and shrivelled fronds in winter that made people think of the craved-for drug.

But why does a plant of the warm south grow on these bleak islands, whose other botanical stars are the limestone bugle, from northern and mountainous areas of Europe, and the spring gentian, best known from the Alps? In an old encyclopedia I read that the maidenhair fern is 'abundant in the south of Europe, where it covers the inside of wells and the basins of fountains (as at Vaucluse) with a tapestry of the most delicate green.' Fontaine de Vaucluse is where Petrarch retired to in a vain effort to forget his Laura. What brings the delicate Provençale to Penultima Thule? The answer begins to open up the labyrinth of Aran.

On a hillside like that leading up to St Gregory's tower (through which I am feeling my way into the matter of Aran) one sees the geometry of limestone exposed in black and white. Because this rock originated over a period of millions of years as the layered sediments of a sea that changed in depth, turbidity, temperature and living contents, its strata vary in their chemical and physical constitution. Hence such a slope, carved out of a succession of almost horizontal strata of different resistances to erosion, consists of a number of more or less well-defined terraces separated by vertical 'risers' of anything from a few inches to twenty or more feet. As one climbs, the rim of each step or cliff running across the hillside ahead shows up against the sky. Here, because of the particular direction one takes in coming up from the beach, these successive horizons have an extraordinary appearance that reveals another, vertical, set of divisions in the rock. Each rim, seen from below, has the profile of a row of blocks with gaps of a few inches between them; where the gaps are very close together the blocks are reduced to mere blades an inch or two thick, and the hillside looks as if it were built out of arrays of knives set on edge. These fissures are the surface expression of a system of cracks or 'joints' cutting vertically through the limestone, the result of tensions in these strata caused by movements in the earth's crust at some period after the Carboniferous. Rainwater has eroded out these hairline cracks into fissures of various widths and depths on exposed surfaces of the limestone; once opened up, the fissures receive all the run-off from the level rock-sheets and channel it underground. In the curious international jargon of geology such a fissure is a 'gryke' and the flat rock-sheet is a 'clint' – Yorkshire dialect-words, adopted because such formations are best known from limestone areas like Malham in Airedale. A limestone terrain with subterranean drainage, as here and at Malham, is called a 'karst', a term equally expressive of stony barrenness, borrowed from the name of such a region in the former Yugoslavia. In this particular corner of Aran the grykes are generally only a few inches wide and a few feet deep, but in other parts they are sometimes over two feet wide and ten or more feet deep. The principal set of grykes runs with amazing parallelism across the islands from a few degrees east of north to a few degrees west of south. This happens to be the direction in which one climbs towards the tower, so here the hillside is sliced before one's eyes by the brightness of the sky.

This dissection of the rock not only underlies the detailed accidentation of the coastline, as I have shown in my first volume, but it orders many aspects of life, including that of humans, in the interior. Because of the general nakedness of the terrain, it immediately provides two contrasted environments for lime-loving plants. The differences between the 'microclimates' of the flagstone-like ground-surface and the grykes are as sharp as those between two climatic zones hundreds of miles apart. In the shady water-gardens of the clefts, the maidenhair fern can enjoy a mild, moisture-laden, Gulf-Stream ambience without the concomitant gales; a few inches above, the merest skim of soil provides for plants adapted to extreme exposure, good drainage, heavy grazing and high light levels. Because of this rare conjuncture of oceanic climate and karst topography, the maidenhair can survive so far north as to consort with plants that are equally far from their headquarters on mountain and tundra, here at sea-level in the ultimate west.

Thus the block of stone allots its frugal abstractions of horizontal and vertical to separate plant-communities, neither of which would prosper in fatter conditions. And each contributes to the support of a scavenging fauna. When Synge first stayed in Cill Rónáin in 1898 he walked out to the east end of the island, and on his way back two little girls followed him for a while:

> They spoke with a delicate exotic intonation that was full of charm, and told me with a sort of chant how they guide 'ladies and gintlemins' in the summer to all that is worth seeing in their neighbourhood, and sell them pampooties and maidenhair ferns, which are common among the rocks. As we parted they showed me the holes in their own pampooties, or cowskin sandals, and asked me the price of new ones. I told them my purse was empty, and with a few quaint words of blessing they turned away from me and went down to the pier.

Similar accounts by other visitors make one wonder how the maidenhair survived the Victorian passion for fern-collecting. Fortunately Aran's human children no longer need to exploit this particular ecological niche, and one can still find its delicate, exotic, charm enfolded in the rocks.

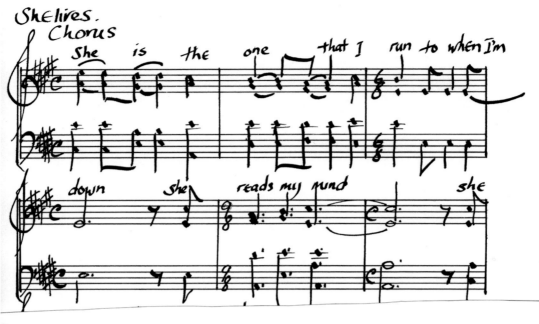

She lives.
Chorus

She is the one that I run to when I'm down she reads my mind she

the Tyrone Guthrie Centre
offers me a quiet space
to think and create.
It is this Artist's Arcadia

Mary Brennan-Keane

I

And what were we to make of that swan
which came crashing through the mist, low
over the house like a lost glory,
so sudden it was gone before it came,
re-assumed into mist, its light
only seeming to reach us then, as if
we only saw it when we breathed the word *Swan*,
as if all recognition were farewell.

II

Slower than sound but faster than words
it came, an echo preceding its source,
the mist rhythmed, strained to breaking
until sound was above us, the air
hallowed by a steady magnificent applause
which drew us up and in until
we both were and were received into
the house of our astonished praise.

Reconstruct me from a closing bookshop,
from the panic of shelves
where old cars trick the spirit, manuals
of self-repair; gods, geography, money

and little time. Sniff the air in poetry,
lay a blanket down and wait
where a furious concentration hunches over
Teach Yourself Amharic, Aramaic:

there's hardly time to say hello, hardly
a hair's breadth of the language to take away;
enough to be silent in, enough to watch
the insistent dust-mote

grow its mountain, the dromedaries
appear. Someone is arguing
in Old Norse, the sun wakes up in Persian
and I am walking out

with grains of light, pyramid crumbs.
Elsewhere, in the desert, in the hilltop village,
on an endless, meandering train
the soul puts down its books, fluent again.

The Magic Mountain

Calm, quiet days in the Pyrenees. The sharp chill of winter yielding to the subtle movements of spring. The foresters were at work in the hills above the village. She watched the elaborate ritual of felling a tree, the long preparations, the shouting, the resting periods. She was intrigued by the unsettling of nature at its source, the disturbed insect life, bird life, wildlife. And what was left behind resembled a battle scene: stumps of trees, blocks of wood, loose briars, brambles, a shorn world still wrapped in by the forest, an oasis of hurt.

She followed the foresters with oil and board and a small easel and she painted the felling of trees, the havoc. She was fascinated by the new colours of dead wood, of wounded stumps by the small clearing in the forest breathing in freely while it could.

The foresters started at dawn. She got up and left Miguel sleeping, his warm body in the bed. It was always freezing and it was too cold to wash. She put her clothes on as quickly as she could, layer after layer of vests and pullovers. She made a flask of coffee, put bread and cheese into a bag which she carried on her back as she did the easel and canvas. Covering herself with a huge rug, she set off in the early morning to the place where the foresters were working a mile or two away. She wore a woollen scarf on her head.

The foresters were already at work clearing the pine trees from the skirting of a small side road. She could place herself far back and paint the devastation they had caused. She mixed colours carefully: the oily brown, fresh green, withered yellow mingling with the flat, cold blue of the sky, the remnants of frost and snow and the beginnings of spring when the world starts to open up.

She had seen an exhibition in London of paintings from the First World War, pictures of landscape as wreck, as a place where men died brutally and cruelly. She had in mind a number of pictures, she could not remember by whom, in which nature itself was the subject, the battlefield as a mutation, as a perversity, in which the violence was done to the natural order, to animals, to birds and insects, to fields and flowers. It was just such a sense of the world and its order and disorder that she wanted for these paintings.

Music came to her all morning as she worked, snatches of tunes listened to the night before, whole arias, or just the feeling in a piece that she had listened to. Michael Graves had brought them the music. He came and went: sometimes they had no idea where he went, but mostly he went back to Barcelona and made what money he could teaching and drawing. She missed him; she had become close to him. Once or twice he had arrived in a state of dejection: ill, broke, quiet, going for walks on his own or staying in bed and not getting up until the evening. But his spirits were usually high, he generally wanted to stay up all night talking. Each time he came he brought them presents.

He came with an old record player he had bought in Barcelona with a handle to wind it up and replacement needles. It worked perfectly. He brought a big box of records and each time thereafter he added to the collection. At first she

thought she would never get to hear them all, there were so many. Michael put himself in charge of the record player. He selected everything and introduced every piece of music, sometimes not telling them what it was until it was over. Miguel was familiar with some of the operas and could sing along and recognize tunes; but Michael knew everything, even the Italian or French words. He had heard it all before in Enniscorthy, he said. Katherine had heard nothing before. She didn't believe him about Enniscorthy.

Symphonies, songs, chamber music, opera arias, sacred music, sonatas, concertos. The records consisted mostly of excerpts. Michael told her the story of Madame Butterfly and she listened as he put the needle down and the static came loud and clear followed by the voice: *Un bel di Vedremo.* He played her Claudia Muzio singing the great aria from *Tosca:* 'I have lived for art, I have lived for love.' He sang it himself before he put it on and told her how poor Tosca had done nothing to deserve her fate. He sang it again. *Vissi d'arte, vissi d'amore.* He put the needle down and the magic happened. He played her arias from the great French operas: Gigli singing from *Samson et Dalila*; the tenor and baritone duet from *The Pearl Fishers*; the soldiers' prayer from Gounod's *Faust.*

Long nights in the Pyrenees. Darkness fell at four in the deep days of winter. They lit candles and stoked up the fire in the kitchen. She tried to learn Catalan from Miguel. She tried to imitate the gutteral clipped accent he used when he spoke Catalan. At first she spoke it as a joke, using just the phrases she knew, trying to put nouns and verbs together to form sentences. When she went for the milk every day down in the village she talked to the peasants in Catalan, but had immense difficulty understanding anything they said.

Slowly it became a language they used between themselves, not replacing Spanish which they still spoke when it was vital that what they said was understood. Slowly it became like the record player on the shelf in the kitchen or the fierce cold of winter, slowly it became another pattern in the fabric they had woven for themselves.

Money too became part of the pattern. It left London and her mother's bank account on the first day of every third month to arrive in the bank in Tremp some time afterwards, usually a week, sometimes more and once, to their consternation, it did not arrive for a month. Money came too from Miguel's gallery in Barcelona, but not much. They lived on her mother's money. One month in every three they lived well, buying cheeses and cured meat in bulk, vats of wine, cognac, chocolate, American cigarettes. When this ran out they were back to rice and lentils until the money came again.

Jordi Gil brought them what materials they needed. He always came in a car with a roof rack to take down some paintings to sell in Barcelona. Miguel worked hard before Jordi Gil's visits. He became interested in mirrors and tried to paint a reflected world, scenes turned upside down, or events distorted in a false mirror. Katherine did not like them, but Gil seemed to think they would sell. Gil would only spend a few hours at the house and then make the long journey back to Barcelona. Katherine made him stay for lunch, put good wine on the table and a strong fire in the grate.

Katherine had placed her own work against the walls of the front room, unframed. There were five or six large paintings of the felling of the trees and many smaller ones, including studies and drawings. She did not want Miguel in the

room when Jordi Gil looked at her work, she was nervous about it; Miguel had paid little attention to her painting and she didn't want him to witness any comment on it now.

She waited until the lunch was finished that day and Miguel's new paintings had been examined and were being bundled together. She whispered to Jordi Gil that she had something she wanted him to look at, but she didn't want Miguel to know. She made him think that they were paintings by Miguel.

She instructed him to tell Miguel he needed a breath of air, he was going for a short walk. Miguel was down in the long room at the end of the house and did not notice them going into the front room. Jordi Gil looked at the paintings. He picked up one of the smaller ones and examined it carefully. She had not signed it. He closed the door behind them and looked at the bigger ones. He did not speak to her. He kept moving from painting to painting. He said that he liked them, rubbed his head and smiled.

They walked back down to the long room where Miguel was battling with paper and twine. Jordi Gil told him that he had signed up a new artist. Miguel smiled and looked puzzled. Jordi Gil took him down to look at Katherine's paintings. She waited in the kitchen.

He took the work to Barcelona and Michael Graves saw some of it hanging in the gallery and wrote to her. Some of it was sold. Michael Graves found a poster and print shop that had just opened in Barcelona; he told her the prices were high but advised her to use the gallery money to buy reproductions. She told Jordi Gil to allow Michael Graves a certain amount of money. Day after day long cardboard telescope-shaped containers came with the jeep that collected the milk from the village. He sent her van Gogh's *Self Portrait* and his painting of Arles at night; he sent her Rembrandt's painting of an *Old Man* and Titian's painting of *A Young Man With A Glove*; he sent her Picasso's blue paintings. He sent her posters of new exhibitions in Paris – Braque, Kandinsky, Paul Klee, which had been on sale in Barcelona. She plastered the walls with the reproductions.

She felt an urge to acquire things, pieces of furniture, these reproductions, new records. She felt an urge to anchor herself in this house in the mountains.

At night Katherine and Miguel got into the bed like children and tried to fend off the cold by huddling together, holding onto each other for warmth under a huge mound of blankets. After a while desire began to ooze between them, another form of heat, and slowly they would make love in the dark room, with the candle out and the blankets undisturbed. They were ravenous for each other.

She asked Miguel if he was happy and he said that he was. He told her he dreamed of being able to live here after the war. He never imagined that they would lose the war. In the early days of the war, they took over a print shop in Lerida and he made posters there, everyone knew things would change, he said, but no one believed they would end. Finally, he told her, they were betrayed by everybody, not just by the fascists, but by the Catalan nationalists and the communists. He fought the war for her again and what had happened became clearer. It seemed so far away from them now: the excitement, the new world that he believed in and wanted to make. The words he used were difficult for her: she did not understand fully when he talked about *freedom, anarchy, revolution.* He had experienced something that she could only imagine. Once or twice, she felt that she would like to have known him then.

She never knew the mountains as he did. He could always find a pathway that she had not noticed. He walked for miles every day with no purpose in mind. Once or twice he showed her where he had hidden after the war, small cabins and ruined houses.

He came back one day earlier than usual; he surprised her in the kitchen where she was washing potatoes. He brought her down to the big window in the long room to look out. It was the first snow; they would be snowed in for a month at least, the snow would lie on the ground for three months. He held her around the waist as she looked out. The memory of this day became as fixed as the rock all around: the memory of watching the first snow and the expectation of being there together, closed in, immune, ready for any happiness that came their way.

Half an hour after a New York playwright arrived at Annaghmakerrig, she came down from her room, sunglasses in hand, and asked: 'Any deckchairs? Are there any deckchairs?' Late that night she looked up at the prussian blue Monaghan sky and said: 'Is this night? Is this it?' We decided she was trying out lines from a play.

Everyone reacts differently to the Centre. I arrived in 1986 with thirty punts in my pocket and nowhere to go until I took up my post as composer-in-residence at Queen's University, Belfast. I was unequivocally welcomed. The luxury of a flickering fire in my bedroom, the delicious food and good company was surpassed only by that of being able to work day and night, undisturbed and disturbing no-one. In those days I was so on edge when I composed I had to sit with my back to a wall. The safe haven at Annaghmakerrig cured me. I returned a number of times when I was able to make a more substantial contribution, but I am grateful above all for that first visit and the friendships formed there have lasted this twenty years in Ireland.

Late October and I'm out
on a fair day you might say for Dublin
but a cold day for the breeze block Qasbah
down at the bottom of the garden, its
lizard eyes thin slits of light
for the sun to hide in corners.
Kennedy's snug is shaped like a ship,
time and the clock collide
forever taking each other to task
and smoke, like a sluggish anaconda,
recoils and glides on polished glass.
A fair day you might say, for a market,
or driving heavy beasts to the buyers
along the first rime-frost of the roadside.
So much for reality: the warm smell of cattle,
thick coats hot whiskies and ash sticks
prodding the side-stepping bullocks.
So much for late October and the season,
a cruel five month journey into March
and the frozen fields all scorched of shelter
as the clock and the year run down.
The Grande Armée crosses the stubble land
as the teeth of a harrow rake,
black horses cross the window panes,
glacial patterns, Cossacks in the shape
of scald crows scrabble on the make.
Pinioned in winter the question is:
year's becoming or season's end?

Another morning shaking us.
The young potted willow
is creased with thirst,
the cat is its purring roots.
Under our chipped window
the frail orange flowers grow.
Now the garden gate clicks.
Now footsteps on the path.
Letters fall like weather reports.
Our dog barks, his collar clinks,
he scrambles, and we follow,
stumble over Catullus, *MacUser*,
Ancient Greek for Beginners,
cold half-finished mugs of tea,
last week's clothes at the bed's edge.
Then the old stairs begin to creak.

And there are the poems for breakfast –
favourites left out on the long glass table
by one to the other the night before.
We take turns to place them there
bent open with the pepper pot,
marmalade jar, a sugar bowl –
the weight of kitchen things.
Secret gifts to wake up with,
rhythms to last the whole day long,
surprises that net the cat, the dog,
these days that we wake together in –
our door forever opening.

III

Dr John Moorhead *m.* Susan Alibone

Martha Moorhead *m.* Sir William Power

Frederick Power *m.* Annie

Norah Power *m.* Dr Thomas Guthrie

Fred Power

**William Tyrone Guthrie
'Tony'**
m. Judith Bretherton

Susan Margaret Guthrie
'Peggy' *m.* Hubert Butler

Tyrone Power

I think we underestimate the extent to which our remembrance of peoples, families, classes and even races is linked with bricks and mortar.
Hubert Butler

The story of Annaghmakerrig house and its lands reveals a rich tapestry that is interwoven with the history of the townlands of Aghabog, Killeevan and the province of Ulster, with its warp and weft of historical fact and mythology creating both pattern and colour, telling the story of the people who over several centuries called this place home. The history of the land stretches back to prehistoric times, and reads like a microcosmic version of the history of the island as a whole. We can trace its trajectory from the recorded presence of a crannóg on Annaghmakerrig Lake and the heyday of the ancient clans until the end of the old Gaelic order in the seventeenth century with, in between, legends and stories relating to St Patrick and the Christianisation of ancient Ireland.

The areas surrounding the present day house and lands are full of ancestral footprints in the clustering of megalithic tombs, known in local legend as *giants' graves*, in the hills of Aghabog and Killeevan. There are many circular raths in the area which were usually occupied by one family and its livestock, the remaining evidence of prehistoric man's imprint on the local landscape. Crannógs are thought to be the homesteads of the wealthier members of early Irish society, with their protective timber palisades warding off any possible intruders. These lake-bound homes were common across south Ulster and were present on many of Monaghan's lakes. Although the physical traces have disappeared, a variety of records provide the evidence – archaeological surveys and genealogical records making it almost a certainty that the crannóg on Annaghmakerrig Lake belonged to one of the MacMahons of Dartry.

The MacMahons, one of the ancient Clans of Ireland, rose to power during difficult times and took advantage of the period of instability and confusion brought about by the Anglo-Norman invasion. They became the most important ruling family for several hundred years until the fall of the old order in the seventeenth century. In the traditional Gaelic system of land division, Monaghan was part of the Kingdom of Oriel and also became known as 'MacMahon Country'. They lived, loved, married, raided and fought with their neighbours and amongst themselves, with little awareness or concern for what was happening on the rest of the island. Such was the ferocity of their internecine feuds over land and power that in 1446 there was a permanent schism in the family. This resulted in the three sons of Ruraí Mór MacArdgal, the then chieftain, each taking a portion of the country and creating separate, independent territories. One of the three brothers took the Barony of Monaghan, another the Barony of Farney, and a third, Eoghan MacArdgal, the Barony of Dartry, which includes the landmass around Annaghmakerrig. Under his stewardship the Barony became a relatively stable and secure territory for himself and his descendants.

In the sixteenth century, the MacMahons viewed the dominant O'Neill Clan, led by the rebel Hugh O'Neill, as more of a threat than the English; hence

not all of them were supporters of his campaign against the invaders. However, Dartry was a staunchly Gaelic area opposed to the invasion, and Eoghan MacArdgal's grandson Brian MacAodh Óg was one of the more vigorous in his opposition to the English presence who firmly allied himself to O'Neill and his cause. The alliance between the rebel Hugh O'Neill and the Dartry MacMahons became increasingly troublesome to the English administration. Their solution was again to reapportion the lands through the 1591 Settlement of Monaghan. The land was partitioned amongst a range of chieftains, making sure that none of them was strong enough to oppose the Crown alone – an early application of the 'divide and conquer' policy that was to prove highly effective. Despite this, the MacMahons retained control of the greater part of the lands in Monaghan. However, slowly land was granted to outsiders from the Pale or from England. Tensions simmered and the MacMahons continued their attacks on English garrisons. The Irish were unhappy with the planters' encroachment on their lands and lives and could not understand or accept that they should pay rent and taxes on properties that had always been theirs. That, together with the concerted efforts of other Ulster rebels, gave rise to the Nine Years' War. This was the last great struggle of the chieftains as they attempted to preserve a Gaelic Ireland.

By the time the Nine Years' War had ended Monaghan was a bleak place, described by the English Attorney General John Davies as 'the wastest and wildest part of all the north'. And its inhabitants struggled to continue to live there whilst all around them their traditions, language and culture, together with their laws, rights and privileges, were being eroded. Gradually, the Irish chieftains sold off their lands to meet their tax obligations and so it was that, in 1640, the lands at Annaghmakerrig passed from the heirs of Rurai MacAodh Óg, the descendants of the original Dartry MacMahons, when the estates of Aghabog were sold to the Ley family. This part of the old MacMahon country then became Leysborough and a new chapter opened in the story of Annaghmakerrig as it moved from the ownership of an old Gaelic family to that of the new settlers.

Ensign William Lye (Ley) seems to have been the first recorded Ley listed in the 1653 Book of Survey and Distribution as holding the lands of Duhate, previously owned by the MacMahons. An ensign was a junior officer, probably close to or even lower than today's rank of lieutenant. In some instances there are records of ensigns as young as fourteen years of age. A list of soldiers who fought in Cromwell's army includes Ensign William Ley of Monaghan. Clones Abbey was a focal point in the later Williamite/Jacobite wars in Monaghan and records show that he also fought here in 1690. He later married Elizabeth Dawson and together they lived out their lives at Leysborough with at least two of their sons, Richard and William. The younger of the two, William, and his second wife, Mary, appear to have had just one son and heir, Richard. William was obviously held in high regard by the establishment and become High Sheriff of Monaghan in 1762. Politically, the descendants of Ensign William were heavily involved in military matters and the name Ley appears on various lists of personnel, High Sheriff and lieutenant. The name also appears on the lists of the Monaghan militia which was notorious for its part in suppressing the United Irishmen in Belfast during the 1798 rebellion. During the latter half of the eighteenth century William and Mary, together with their son Richard, were involved in many land transactions, including the one of greatest importance to Annaghmakerrig. On 12 April 1802

William and Richard Ley sold the Leysborough estate to Dr James Moorhead of Newbliss for the sum of £1,550, which in today's terms would be tens of millions. At that time the lands of the Leysborough estate consisted of Annaghmakerrig, Crappagh, Edergole, Glen, Knockcor, Drumary, Aughareagh and Mullaghmore – a vast tract of land including the lake, known then as Leysborough Lough. Although some members of the Ley family remained in the area into the nineteenth century, the great era of Leysborough was effectively over following the transfer of the lands, perhaps once more through financial difficulties, into the Moorhead family, Sir Tyrone Guthrie's ancestors.

It was during the Moorhead period that the house was built, though no records have been yet located to enable us to pinpoint the exact year. It would appear that much of the development of the estate took place in the early years of the nineteenth century. Popular myth has it that the lands were sold to Dr John Moorhead by the impoverished Leys as part payment for a medical bill. The reality is that it was John's father, James, who made the purchase and bequeathed the property to him on his death. In later years John Moorhead's son-in-law Sir William Tyrone Power K.C.B. leaves us very valuable information on his wife's forebears, written literally in stone, on a memorial tombstone. The inscription reads as follows:

> In memory of John Moorehead, M.D., born 1785, died 1873 and his wife
> Susan Alibone, born 1791 at Philadelphia, U.S.A., died 6th November 1862
>
> In memory of James Moorehead, M.D. born 1761, died 1836 and Martha
> Taylor Moorehead his wife born 1759 and died 1839
>
> Of his sons, William Moorehead born 1799, died 1822. Thomas Moorehead
> born 1797, died 1851. Samuel Moorehead, born 1800, died 1871

John Moorhead studied medicine at Edinburgh University where he graduated in April 1806 aged only twenty-one. Lecture cards in the family archive show him remaining on at the university, either in further studies or as a lecturer, until 1812. Some time later the young Dr Moorhead set sail for America and settled in Cincinnati, where he bought a house and held a Professorship Chair at the Medical College of Ohio. It was here that he met Susan Alibone Humphreys and formed a friendship that blossomed into marriage in 1831. This was not Susan's first marriage, though we know little of her first husband Mr Humphreys, despite the presence of several books in the library that bear his name. A male friend, one H. Douglas, wrote to her from Tennessee to congratulate her on her marriage to John Moorhead; he gently chides her for neither writing nor visiting:

> But say to your lover and master, that in mercy to himself, he had better send you to Nashville for a short time during the spring, or I shall visit upon his head my great disappointment. You are a striking proof, my dear Susan, of the justness of the so often made observation, that one example outweighs a thousand precepts; for here have you kept my *example* of matrimony steadily in view, whilst my many *sage* reflections on the risk of marrying, in general, and my very cogent reasoning against a woman marrying a second time, more especially, have been whistled down the wind.

John and Susan's daughter, Martha, was born later that same year on 6 November 1831. Susan was obviously keen to educate her daughter as best she could according to the dictates of the time and whilst in Cincinnati acquired several books for her – Maria Edgeworth's *Practical Education* and the redoubtable Mrs Sherwood's *The Lady of the Manor*. Dr Moorhead also gave his daughter a small Bible bearing the inscription:

> Presented to Martha Moorhead on her birthday anniversary – November the sixth 1839, when she had just completed her eighth year of her age – by her father as a slight token of his affection and respect.

Meanwhile John Moorhead achieved a degree of notoriety in these years when his name appeared in the *Cincinnati Daily Gazette* through a very public correspondence which took place between himself and a Dr Drake in an argument than ran over several issues of the newspaper during 1834. The controversy concerned the untimely death of a certain patient named Mr Brooke whom both had treated – with each contending that the other was at fault. Rather frustratingly we never learn what the final outcome of this public wrangle was. Two years after this incident, in 1836, Dr James Moorhead died and John inherited the lands at Annaghmakerrig. It was not until 1840, the year following his mother Martha Moorhead's death, that John resigned his Professorship at the Medical College of Ohio and the following year returned with his American wife and daughter Martha to take up residence at Annaghmakerrig.

At the time another of Susan's correspondents, one Thomas Washington, wrote to her on her departure to wish her a pleasant sojourn as if she were heading off on the grand tour of the major capital cities of Europe, rather than moving to a somewhat isolated and remote corner of Ireland. She brought her personal library with her, and many of the older books in the collection today bear her name or inscription in careful copperplate writing. There are some interesting printings, mostly from Philadelphia, of the late eighteenth and early nineteenth century, which we can assume also came from Susan's library.

The Moorhead family seems to have settled well into the lifestyle of rural Ireland. Just five years after his return from America, famine had struck with the failure of the potato crops. The Relief Commission was established and local 'branches' began to spring up. In May of 1846 John Moorhead wrote to the Commission seeking instructions for the guidance of the Aghabog Relief Committee. As the famine continued the English government began a series of initiatives, including the building of roads and the improvement of the drainage and water systems in Ireland. In 1849 one of the men sent to supervise such work in the Aghabog areas was Captain William James Tyrone Murray Power. Here he met the Moorhead family and was immediately taken by Martha, the daughter of the house. This attraction was mutual, and on leaving Annaghmakerrig William Tyrone Power began a correspondence with Dr Moorhead in an effort to smooth the path to a formal relationship with Martha. In 1851 Captain Power was drafted abroad unexpectedly and there begins a long and tortuous correspondence on his part, and a curious disapproval on the part of the doctor, as he instructed Martha not to reply. It is a fascinating tale of obduracy and hope with true love eventually winning through. Some years later the good Captain takes his courage in his hands and writes again – this time to Mrs Moorhead in a letter where he pours out his heart:

The answer I received [from Dr Moorhead] I need not tell you, cut me off decisively from all hope. It was with the greatest gratification therefore that about three years afterwards, while in the Crimea, I took advantage of the opportunity afforded me of reviving my acquaintance with your family, and when I learnt that Miss Moorhead was still unmarried, my hopes began to revive again ... I admire Miss Moorhead – as I have for years – and my mature judgment confirms any early impression. She is amicable, cheerful, kind and good, and possesses every quality that should render a man's home happy. I need not say how I long for such a home after my long wanderings.

There begins a long correspondence between the two – the early letters being addressed to 'My dear Miss Moorhead' where he compliments her on being a 'capital correspondent'. They agree to meet in Bray in the August of 1859 and two months later become engaged. The correspondence was something they carried on all through their marriage and the love and affection they share is palpable. Martha addresses her husband as 'My darling Willie', 'My own dear William', 'My own dear love and darling'. William Tyrone Power responds in like vein calling her 'My one, only love and darling' and in later years 'My own Mattikens'. Captain William Tyrone Power brought to Annaghmakerrig his great love for Martha, a distinguished military career and, in his lineage, an internationally renowned actor, his father William Grattan Tyrone Power.

If the somewhat star-crossed relationship between Martha Moorhead and William Tyrone Power reads like a novel, so too does the history of William Tyrone Power's father, William Grattan Tyrone Power. He was born in Kilmacthomas, Waterford in 1797 and when he was just one year old his father died and his mother moved to Cardiff. When he was fourteen he joined a troupe of travelling actors and gradually learned his craft. He came to fame as the quintessential stage Irishman in Covent Garden in 1826. Following this success he was eagerly sought after by all the leading London theatres, and made an annual appearance at the Theatre Royal in Dublin to rapturous receptions. He published plays and novels and also achieved fame and wealth in America. He published his *Impression of America during the years, 1833, 1834 and 1835*. With considerable acumen he dedicated it to his adoring public:

> As an actor, when managers have appeared indifferent, or critics unkind and
> my hopes sunk within me, I have turned to your cheering plaudits and found
> them support for the present and encouragement for the future.

On 10 March 1841, aged forty-four, he was returning to Europe on board *The President* – the largest and most luxurious steam liner of its day – when the liner sailed into a storm and all on board perished. The Dublin papers later reported:

> On board was Lord Frederick Lennox and his old and close friend, Tyrone
> Power, prince of Irish actors. Fair shone the sun, the weather promised finely,
> and all on board were merry as marriage bells.

He left behind him not just his name and reputation but a family tradition of theatrical fame and his two great-grandsons both made their reputations in the theatre. Tyrone Power became one of the great swashbuckling film stars of the

mid-twentieth century, whilst Tyrone Guthrie left an indelible record of excellence in the theatre in England, Canada, the US, Israel and Australia as well as impacting significantly on the cultural landscape of Ireland.

Meanwhile John Moorhead continued to expand his holdings throughout his lifetime with his acquisition in 1860 of the lands of Crappagh, Mullaghmore and Knockcor in the Aghabog parish. It seems likely that he also sponsored the local national school on the lands in Crappagh as his name appears as lessor of the National School House. John Moorhead was a polymath, corresponding with the leading men of science in Ireland in both Trinity College Dublin and the Royal Irish Academy. On his shelves are works by many famous scientists complete with personal inscriptions, including those of Robert Carmichael and Charles Babbage, the father of modern day computing.

His son-in-law, William Tyrone Power, had a very successful military career and became Commissioner General to the Forces in 1863, was knighted in 1865 and appointed Agent General for New Zealand in 1876. He travelled widely to far-flung places such as Gibraltar, China, New Zealand, South Africa and throughout Europe and wrote and published a number of books recounting his experiences.

The Powers lived mainly in England in their house in Tunbridge Wells, spending holidays and other times at Annaghmakerrig, and in 1873 they inherited the property on the death of Dr John Moorhead. The Powers had five children – Susan Gilbert, John Moorhead, William Tyrone, Norah Emily Gorman and Anne Evangeline – who must surely have enjoyed exploring the forests and lands surrounding the house. Following his retirement from the War Office, William Tyrone Power spent more and more time at Annaghmakerrig and in 1880 was approached as a possible Liberal candidate for the upcoming election. There were many thorny issues raised during that particular election, including Home Rule, the Land Question and Peasant Proprietorship, together with reforms of the Grand Jury, the Education Systems and the Poor Law Systems. Somewhat reluctantly he accepted the nomination and began his campaign. He was principled and had empathy for his fellow countrymen, but he was also a pragmatist:

> I would not expect any man to vote for me who was not voting for himself and
> his own interests.

It became apparent that east Monaghan was less supportive than hoped, and that, together with Martha's ill health, may have been the deciding factor in his standing down. Nonetheless, he accepted the appointment from the Earl of Dartry as Deputy Lieutenant of Co. Monaghan in 1881. The house had been enlarged at this stage to accommodate the large family of children together with a retinue of servants suitable to his status as retired general.

Following the death of his beloved Martha in 1890, William Tyrone Power retreated from Annaghmakerrig, spending most of his time at his home in Tunbridge Wells. He had the practice of keeping a diary – usually very short one-line entries commenting on the weather; however, on her first anniversary on 6 November 1891 he breaks the pattern:

> Friday, 6th November 1891. My Mattie's birthday. Born 1831. God Bless
> my darling's memory and keep it ever fresh in our hearts. She has left a sad
> [illegible] behind, which my girls do their best to fill. A gloomy day in all ways.

Three years later we find him expressing his concerns about the future of Annaghmakerrig to his cousin and family solicitor James Whiteside Dane who ran the estate on behalf of the family. He wrote of the fact that his sons had no interest in the estate, of his own increasing bad health and his anxiety to have all the title papers in order before he died. Of all his children, Susan Gilbert appears to have been closest to her father, as evidenced from his letters and diary entries. Susan, who lived with him in Tunbridge Wells after her mother's death, was something of a political activist and suffragette and was vehemently opposed to Irish Independence. Following the granting of Home Rule to the Irish Government in 1914 Susan is photographed by an Irish newspaper in the midst of a crowd of protestors waving a banner that proclaimed: 'Ulster is right, Ulster will fight'. She later became the first woman town councillor in Tunbridge Wells. The eldest son, John Moorhead, died in 1916 while on military service during the First World War and his second son Ty, also a military man, emigrated to North America. Both Anne and Norah married, with Anne moving to Middlesex and Norah moving into Tunbridge Wells with her husband Dr Thomas Guthrie and their two children, William Tyrone and Susan Margaret. On the death of their father in 1911 each of the Power children inherited an equal share of the Annaghmakerrig estate. That same year Jack, Ty and Anne signed over the entire estate to Norah and Susan as a gift.

Norah Emily Gorman Power married Dr Thomas Clement Guthrie in 1899. Her husband was from a family of strict Scottish Presbyterians whose grandfather, Rev. Thomas Guthrie D.D., was the foremost Scottish Divine of his time. Rev. Thomas Guthrie, shocked by the poverty surrounding him in Edinburgh's old town, founded a 'Ragged School', a privately funded school intended to give the poor a good education on Protestant lines. This model was successfully copied across the country and provided the basis for state industrial schools. He was a renowned preacher and is commemorated by a statue in his honour in Princes Street Gardens, Edinburgh. He was married to Anne Burns and had eleven children, the eldest of whom, David Guthrie, was also a clergyman. David Guthrie married Hannah Kirk from Keady, Co. Armagh – a curious co-incidence in Tyrone Guthrie's view. Both his grandmothers were from the same small townland in Ireland, yet they had never met. It was David and Hannah's son Thomas who became a medical doctor and established his general practice in Tunbridge Wells, the home town of the Powers. There he met and married Norah Power and, together with their two children, spent as much time as possible in Annaghmakerrig, with the young Tyrone Guthrie making his first visit to the house when he was only six months old. Despite the reality that the family lived most of the year in England, the bonds with Annaghmakerrig were strong and were reinforced by the Irish staff who came from Aghabog, Crappagh or Doohat and travelled with the family for the summer holidays and at Christmas.

Tyrone Guthrie, or Tony as he was affectionately known, was born in 1900 and had a typical Edwardian childhood of nursery life with the security of an adoring Irish nurse, a loving mother and a caring if somewhat distant and busy father. His sister Susan Margaret, who was known by all as Peggy, was five years younger. His schooling followed a well established tradition: a stint at daily Dame School, then boarding school at Templegrove followed by Wellington like his Power uncles before him. It was a difficult and tense time historically. Tony arrived in Wellington in 1914 at the outbreak of the First World War and left there as the

war ended in 1918. Meanwhile, Peggy was being schooled at home, joined by Judith Bretherton, the daughter of her mother's friend and neighbour. This was of course the same 'Judy' who was Peggy's best friend and ultimately became Tony's wife. In his final year at Wellington he won a History Scholarship to St John's College, Oxford and it looked as if he might be heading for an academic career. He read history at Oxford, made friends and took part fully in the high-spirited student life of the city of the dreaming spires. Two close friends who had a major impact on his formation were Hubert Butler and Robert Graves. Hubert Butler, a gentle scholarly man whose roots were in Kilkenny, became Tyrone Guthrie's friend at Oxford and subsequently his holiday companion at Annaghmakerrig. Robert Graves also had family ties in Ireland, was an older man, one who had survived the war, was married and lived out, in a house rented to him by the Masefields. As he was about to leave Oxford a Belfast director, James B. Fagan, offered him and another aspiring thespian, the young Flora Robson, roles in his new theatre. This was the beginning of Tyrone Guthrie's very successful international career. Throughout this period the family continued to spend Christmas and summer holidays at Annaghmakerrig, and Norah and Thomas Guthrie had begun planning for his retirement and a permanent return to the place they always thought of as home. However Thomas, who had been battling lung cancer, died on 18 February 1929 and by then his widow's eyesight had begun to fail. So it was decided that Norah would move to Annaghmakerrig together with a companion – Miss Ethel (Bunty) Worby – a former matron at a hospital where Dr Guthrie had worked. Christopher Fitz-Simon who, as a child, visited the house describes her as dressing 'in merging shades of fawn, buff, beige and khaki, and if she had lain down out of doors she might easily have been taken for a sand dune.' Bunty is the unlikely ghost said to still haunt Annaghmakerrig. A year later in 1930 Peggy married Hubert Butler and, following their honeymoon in Latvia, moved into the house to be with Norah. Hubert set about rescuing the bog garden and developing a plan for the acres of unused land. About the same time Tyrone Guthrie brought his friends Christopher Scaife and Judith Bretherton to stay and soon afterward Judy and Tony announced their engagement. They too got married from Annaghmakerrig and there are stories of great festivities in the house with bonfires being lit on the local hill as part of the celebrations.

Mrs G, as everyone called her, though virtually blind seems to have spent her time entertaining the many young cousins and friends visiting the house and also dedicated a large part of her time to working in her rock garden. She took to typing, after a fashion, and annotated some of the family treasures. There is a note in a tiny Bible, bound in finely tooled green leather, which reads:

> The contents of this boc all belonged to Mrs James Moorhead wife of our great franfather who lived in Newbliss and bought Annaghmakerrig but nevr lived here. She was Martha Taylor born 175- and died 1833 and was buried in family grave in Aghabog church yard. Her eldest son was our grandfather John Moorhead who was a doctor and practised for many years in Cincinnati and married Susan Alibone who had previously been married to a Mr. Humphrey. My mother was their only child and was born in Cincinnati but came back here to live when she was nine years old.

Eventually Norah Guthrie went blind but, indomitable to the end, began to learn to read Braille with the evidence of this being still on the library shelves. In 1956 she had a stroke and died; she bequeathed Annaghmakerrig to Tony. For a number of years after Norah's death the house was looked after by the loyal staff, as central to its existence then as now. When Tony and Judy finally settled back into rural life it became the centre of his world, and his energies went into forays into the garden to tackle the wilderness, a venture to bring employment to Monaghan during the dark years of the 1950s and 1960s by setting up a jam factory and his never-waning welcome for all house guests, young and old. In later years, as his health began to fail, Sir Tyrone Guthrie as he was then, having been knighted in 1960, began to consider what would become of Annaghmakerrig after him. He died on 15 May 1971; Judy survived him by less than a year. Tyrone Guthrie's will left the lands to his steward Seamus Gorman, and the house to the State, with the proviso that it be used for the benefit of artists. It was an inspired decision and one that has changed the cultural landscape in Ireland forever. The 'bricks and mortar' that Hubert Butler talks about as so linked to our memories of peoples and places have become an inspiration, a solace and a place where art can, is, and will be nurtured long into the future.

FINTAN VALLELY

When I went to work at Annaghmakerrig in 1981 I was thirty-one years old and had never gardened, not so much as a window box, though I had long had the notion that I might, if ever a garden came my way.

The first garden I ever knew was the walled citadel my father built around our semi-d. in Denewood Drive in Andersonstown in Belfast. Besides the two workshops, a tool shed and a garage, which were the premises for his picture-framing business, this garden had five flowering cherry trees around its perimeter, four cypresses along a waggly wall that ran down its middle, and beds for roses and annuals which were tended by my mother, who also had pots and planters on the patio in front of the picture window of the living room, which looked onto the lawn. In the border along the high wall that separated our garden from the next door neighbours' there was a hydrangea, a fuchsia, a hebe, and, one time, an eruption of policemen's helmets. My fishing brother had seen these tall lilac flowers in bloom along a riverbank one day. He brought home a few seeds and sowed them. What he didn't know was that the adaptation of policemen's helmets for broadcasting their seeds upon a flowing stream is to dry out the sprung capsules that contain them so that the pod triggers with a loud crack which blasts them over the water. For a few seasons our garden was as full of policemen's helmets as a Saracen armoured personnel-carrier on its way to a riot: their late summer small arms' fire of seed-dispersal echoing and mimicking the gun battles of the war beyond our garden's sheltering walls.

Before the outbreak of that war, in my boyhood and early youth, I had known other gardens too: those of our street and surrounding streets where we played rally-o and kick-the-tin and other forms of hide-and-seek; the orchards of the Lisburn Road and Malone Road where we robbed apples and pears in the autumn; and that linear garden bequeathed to Belfast by the Lagan navigation, which is now called the Lagan Valley Regional Park and was then known by us just as the Lagan . This includes three great estates: Lady Barnett's Demesne at Shaw's Bridge, with its junglish shrubberies, Davy Crockett woodlands, and meadows plunging to the river down which you could ride at breakneck speed on your bike; Lady Dixon's Park, more prim and confined and rose-gardeny, though it had the best swings and slides; and the forested frontier of Belvoir, which was on the other side of the river, deep in Prodland, where we ventured only rarely, and always with trepidation.

It was only later, when I was a student majoring in pure and applied *dolce far niente* at Queen's University and used to go for long walks along the same Lagan towpath with my friend Basil Lenaghan – a one-time egg-stealer turned bird-watcher and amateur naturalist like me – that I began to have a sense of these places as contrived, man- and woman-made gardens, rather than as God-given happy hunting grounds for the feckless little savages we had been when we first explored them.

By that time, when we were in our early twenties, Basil had already well established in him the sapling of botanical knowledge which would grow into his many-branched career as a professional forester with Her Majesty's Forest Service of Northern Ireland. It was he who taught me my first names of trees, flowers and plants. All through his student years he also worked a small vegetable patch in his da's back garden in Stewartstown, an annexe of Andersonstown. I think it was watching him there, and

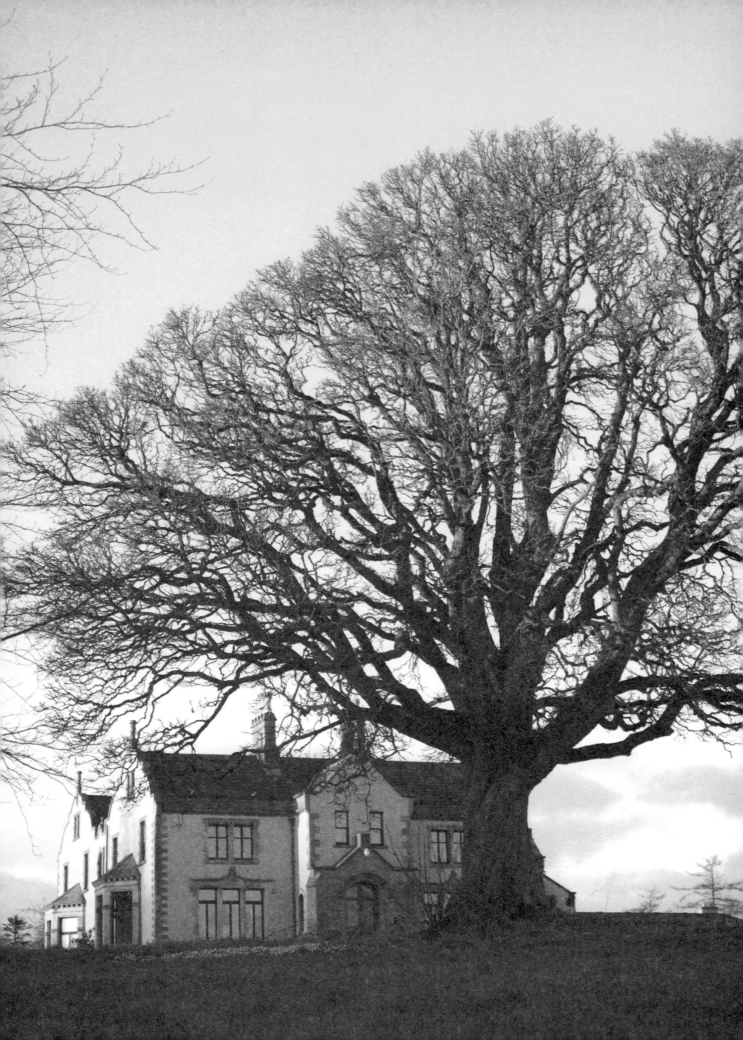

listening to him talk about it with the enthusiasm he brought to everything he did, which gave me my first hankering for a garden of my own.

Ten years later, when we ended up living thirty minutes from one another on opposite sides of the border, Basil became the owner of a couple of acres around his forester's house at Mullynaburtlan in the hills of County Fermanagh. He fenced off a large vegetable patch, planted trees and shrubs, and made mown paths through what would become wildflower meadows where he resettled choice plants – twayblades, orchids, primulas, violas – rescued from the buckets of Poclain diggers or the tips of labourers' shovels, always a scientific experimenter in his gardening, whose first, and unpursued, choice of career had been pharmacy.

At Annaghmakerrig, at the beginning, I had roughly three quarters of an acre on which to make my own experiments: the pond garden, the west lawn, an area around the copper beech and the yews where the septic tank and car park would be, and half of the knot garden in front of the old greenhouse, up to the sundial: the few morsels of the 451 acres that had once comprised the estate which then belonged to the Tyrone Guthrie Centre.

In the spring of 1982, as my first stab at gardening, I made lazy beds for potatoes in a forty feet by ten feet plot below the knot garden. I had seen men making lazy beds when I lived in Donegal. It looked easy. You scatter manure in lines where the potatoes are to grow. Set the seed spuds into this. Spread more manure on top of them. Dig up regular-shaped long sods from either side of the bed, hingeing them at the inner edges with the blade of the spade, and lay them grassy face down on top of the seed, so that the sods from either side meet neatly down the middle, like roll-out lawn. Fill any gaps or cracks in this top layer with soil from the sods or from the ground at the sides, so that the seed is well buried. In a month or so, when the first shoots of leaf are showing, mould the emerging plants with earth from the trenches on either side to safeguard the growing tubers from any taint of light. Thereafter regularly spray the foliage with bluestone – copper sulphate dissolved in water – against blight, especially in sultry, wet spells. Then in the autumn, before the first frosts, elect a day of settled, dry weather to gather the fruits of your labours, and you will have fantabulous, floury, flavoursome Arran Banners (here insert other variety of your choice from the over 5,000 which exist) to last you and your family all winter.

This was all, of course, book-learning and wishful thinking over a five-barred gate. My ridges ran askew and dribbled at the sides; there wasn't enough soil in the iron-pan-bottomed trenches for the moulding, which I missed doing at the right time and so ended up breaking down the by then too lank haulms with hard, clayey clods which fell on them like a hailstoning of boulders, though I did bring good earth from elsewhere and completed the sealing from the light; I did not get round to buying the copper sulphate to make the bluestone mix, or the sprayer to spray it, but fortunately it was not a blighty year. At the end of the growing season I was able to save (that expressive Irishism for harvest) enough potatoes to fill a wheelbarrow, and to encourage me to do better next year.

Turned on to him by Basil, I adopted Lawrence D. Hills, founder of the Henry Doubleday Research Institute, as my garden guru. Lawrence D. had made his first forays into gardening without a chemistry lab, to find vegetables his wife Cherry – who was allergic to much of the twentieth century – could eat without coming out in a rash. I read his *Organic Gardening* straight through in one sitting, like a thriller. His basic philosophy – that you should work on making a hearty, well balanced, complex soil in which to nurture

strong, healthy, disease-resistant plants rather than on forcing hard-skinned, cosmetically coloured, tarty supermarket crowd-pleasers out of a thin-blooded medium for holding the expensive products of the petrochemical industry – was a congenial activator for the composting of the leaf fall of my youthful revolutionary convictions into the belief that the only way the world can be made better is bit by bit, day by day, starting in your own back yard.

As had already been done at Annaghmakerrig long before I got there.

In the nineteenth century, men in the employ of General Sir William Tyrone Power had extended the original house, banked the lawns around it, built the greenhouse, laid out the knot garden, planted the orchard and established the Oak Walk to make a vista to the woods that must have been remnants still of the ur-forests of Ireland. As a garden in the French sense of *parc* – *le parc d'un château ou demeure manoriale* – it reached its maturity in the late nineteenth and early part of the twentieth centuries. This is the always summer, always sunny, always serene epoch of the photographs in which you can see the old general in pride of place for a while, then fading away, to leave his daughter Norah and her husband Dr Guthrie with their children Tyrone and Margaret – also known as Susan, and later to be Peggy – and other relatives and many friends, strolling, or sitting, or having tea, or sometimes clowning, as Tony – pet for Tyrone – and Peggy did when they were gilded youths of the 1920s and 1930s hamming it up with handsome, laughing, brilliant Hubert Butler, whom Peggy would marry. In the background, the scenery of these snapshots and portraits of more formal occasions shows neat borders, dense shrubberies, shady arbours, trimmed hedges, picket fences, a greenhouse that would not have shamed Kew, and lawns smooth and flat enough to play croquet on.

Less than a hundred years later the orchard and the Oak Walk had been ripped out to make pasture. The last of the native forest had been cut and sold by the Forestry Commission and replaced with Sitka and Norway spruce marching with straight-limbed Nordic determination almost to the walls of the house. The knot garden had fulfilled the weedy prophecy of its name. The greenhouse was sunk to its knees in rotted timbers and broken glass. The lawns were full of humps and holes, moss and speedwell, and magic mushrooms in the autumn, as some will fondly recall. In the heat of summer the slurry-eutrophied lake bloomed with carpets of blue-green algae like a Martian bazaar. There was rubbish everywhere. And much to be done if these once proud Protestant gardens were to be born again, as I became determined they would be, half a Protestant as I was myself by then.

We began to employ young professional gardeners to supervise FÁS employment schemes we set up. Three of them were graduates of the National Botanic Gardens courses in horticulture: Liz Nangle, whose provenance from Summerhill, County Meath I took as a good augury when I interviewed her; tall, straight-limbed, fair-minded Brian Brady from Ballybay; and dainty, most knowledgeable, golden-haired Valerie Waters, who gardens there yet, and makes gardening programmes for television, and is as dedicated a follower of rock and roll as she is of Gertrude Jekyll.

There would also be artist-gardeners: the painter Eamonn Colman bluffing and luffing on home-made wings of Latin names; Lindsay Dumas, a Canadian of native Indian extraction, whom I had to stop, with regret, from excavating a piece of land art based on Navajo burial grounds in the front field; and the sculptor Derek Smith, who built a ziggurat out of mushroom compost. One night he invited us all to the inauguration of the ziggurat. He had stuck hundreds of candles all over it. After he lit them they burned

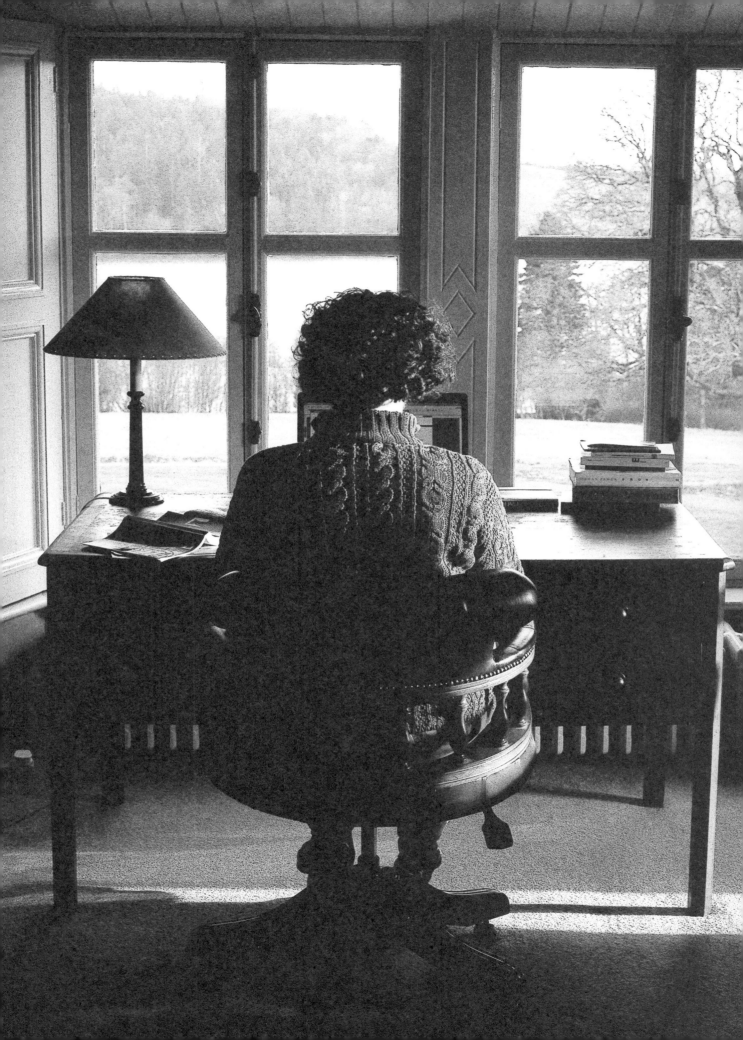

down and set fire to the mushroom compost. The ziggurat went up in flames. Dry mushroom compost is surprisingly combustible. If County Monaghan ever burns down it will be because of all the mushroom compost there is in it.

Dozens of people worked on those FÁS schemes over the years: an IRA man recently released from gaol who hadn't a decent day's work in him and argued black and blue with me that the oak to the east of the house was an ash until I feared he was going to plug me to prove his point; three men called Martin, all at once; Nigel Johnston from Drum, who is now a historian and archivist; Susan Toman who is still a gardener and says she might never have thought of such a career if she had not worked with us; and one Teddy Burns, yes, that Teddy Burns, whom they have since made the estate manager.

Armed with forks, spades, shovels, slash hooks, brush cutters, strimmers, axes, saws and other implements, they peeled mattresses of scutch grass and ground elder from what beds and borders there were. They rooted out dead shrubs. They eradicated eggberry plant. They battled rampant rhodo. They mowed and fed lawns back to swards. They built walls. They made fences. They opened woodland paths. They cleaned ditches. They cambered avenues. They did wonders.

By the late 1980s, when The Tyrone Guthrie Centre Ltd bought the old farmyard and twelve acres around the Big House, I was beginning to see the distinct characters of the different areas of which the garden was made up, even if I did not yet know how to get them to work as the rooms of a single house under one conceptual roof, as the books on garden design I read suggested they should be.

I did though have a strong sense that the Annaghmakerrig estate was a *de facto* nature reserve in the midst of the rolling hills of grant-assisted ryegrass monocultures with which it is surrounded, and as such, a haven for all kinds of animals, including artists, which it was my duty to protect and enhance.

Basil and I had once fantasized about having a garden with ocean-facing cliffs where a white-tailed sea eagle might nest, but now, as a drumlineer by adoption, I was content with the less spectacular creatures who found their nooks and niches in and around the house: a colony of pipistrelle bats that roosted in the roof of the bow window of the drawing room, then in the attic of the resident director's house, then in the ceiling of the Long Building in the yard, part of which would collapse from the weight and wetness of bat-shit and bat-pee; the zoomorphic painter Dermot Seymour brandishing his subject matter of myxied rabbit, run-over pine marten and drowned rat; the vegan illustrator Philip Blythe conducting a life-class with the local children to draw a swan that had electrocuted itself on a high-tension wire; and all the other metaphor-chasers and image-burrowers and music-ruminants who filled the indoors with the colours and calls and smells of their creative confinement.

Outdoors, we learned how to deter the deer that broke through fences and rubbed the velvet from their antlers on young trees. We would sometimes see badgers from the sett beside the Paddock making their way to their night's grazing. A pair of long-eared owls made their home in the copse on the road to Doohat. Ravens were resident on Tomb Hill. There were frogs in ditches and newts in ponds, and, in the early years, shoals of invertebrates in the house's water supply, playfully ticking and writhing in glasses and toothmugs. We built a treatment system which took water directly from the lake, zapped these animalcules with ultra-violet light and then filtered out their corpses through tanks of sand and carbon. The resulting spring-fresh H_2O was fed directly to the drinking troughs of the artist-animals, whose cages were subsequently sluiced out into a deep bed of mussel shells and peat fibre. What came out the other end

ran back into the lake, where pike, perch, bream, rudd and freshwater crayfish thrived in the absence of the blue-green algae which had once threatened to exterminate them.

As the head keeper of this *tiergarten*, my heart soared with delight the spring I spotted a pair of spotted flycatchers establishing a territory around the east side of the house. I was thrilled beyond measure when from a window on the first floor corridor I saw they were building a nest on the ledge at the apex of the stone lintel above the side door of the Big House, sheltered and hidden by the broad leaves of the old Virginia creeper that domineered there. The female laid five eggs. Then one day, shortly after she started to sit round the clock to incubate them, I asked the outside workers – I will never know why, distractedly anyway – for I had lots to distract me there by times – to cut down some of the legs of the Virginia creeper, which was lifting the plaster and causing damp patches on parts of the front of the house and really getting on my nerves. Wishing to please, the FÁSsers cut all the stems, including the one whose upper branches shielded the flycatchers' nest. Over the next days I watched as the leaves around the nest dried and crumpled. The birds deserted. A short time later something ate the abandoned eggs and the nest filled up with bitter gall which slopped all down my shirt front when I put up a ladder and removed it, not able to bear its lorn reproach any longer.

That was the last I saw of spotted flycatchers at Annaghmakerrig.

Around the time we began work on the renovation of the old farmyard as houses and studios we engaged Arthur Shackleton, of that ilk, as garden consultant. In his terribly nice way – the kind of tone his great-uncle must have used to urge his men onwards to the South Pole – Arthur lashed me to my sleigh, geed up my huskies and handed me a map which finally brought shape and themes and boundaries to my action-gardener's herbaceous sprawl, which was by then as blinding in its formlessness as any Antarctic waste.

We put in oak and beech saplings among the existing trees in the wedge between the two northern avenues that had been cleared of *Rhododendron ponticum*; the clay banks behind the studios of the Long Building we terraced with tree trunks held in place with iron rods so that the intervals between them could be filled with good soil and then planted with vigorous creepers and invaders that were left to fight out the bit among themselves; axes and paths were defined by box hedges; the knot garden's darling breeze-block beds put in by the Guthries, were restocked with herbs and perennials; a rose garden was started; and in the field overlooking the lake we planted a couple of dozen oaks, beeches and sycamores, the two of us walking over those loveliest of all the lovely acres until we found just the right spot for each tree, thinking all the time of the view from the house, and how it had to be kept both open to the lake and filled with non-obstructive vegetal interest in the foreground (as we horticulturists say).

Basil often came to visit me, sometimes unexpectedly, when Her Majesty was able to dispense with his services for a morning or an afternoon. I would know when he arrived because from the office in the Butler's Pantry I would hear him talking and laughing with the girls in the kitchen – the unmistakable guffaw that has buffeted about him like a personal typhoon all the forty years I have known him – and Molly the dog, alerted by the boom of his voice, would be whining and whirling outside the door, knowing that a walk was now in prospect.

After a tramp round the lake, or a dander through the woods, or a tour of the raths, or a visit to whatever works we had in progress – where Basil was always able to offer sound advice, who as a trainee forester had done time and motion studies of the how-long-it-would-take-two-men-to-dig-a-hundred-yards-of-ditch-three-feet-wide-by-

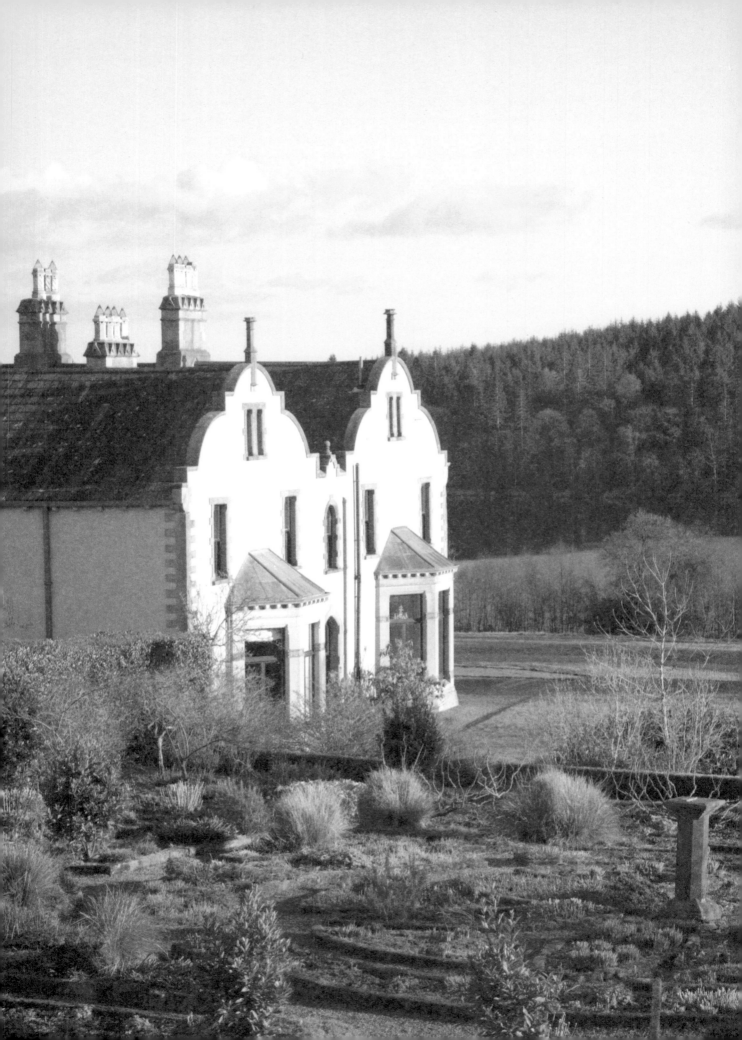

two-feet-deep sort – we always ended up back in the gardens nearest the house: to see how the bulbs we ordered from Lady Skelmersdale of Broadleigh Gardens were naturalizing on grassy banks or under trees, or to examine the progress of shrubs we had gone together to buy from Daisy Hill nursery in Newry, or to peer at seedlings germinated from seed sent from the Deelish Garden Centre in Cork, or to admire some arrangement I was particularly proud of – whether it was deliberate or accidental – where aspect, soil-type, plants, colours and shapes all chimed and harmonised, if not ever in a full opera, then at least in a brief *lied*. Basil was always encouraging, because that's what mates are for, and would heap praise as if it were a mulch around the tender shoots of my efforts, which grew all the better for it.

Such a moment is captured in a painting by Mick O'Dea, bought and still treasured by my wife Mary, and me. It is of a corner of the pond garden in July 1992. In the centre of a dense, lush, Douanier Rousseauesque verdancy, one perfect white calyx of *Zantedeschia aethiopica*, the calla lily, is surrounded by unfurling ferns, a copper-red astilbe, purple ajuga, variegated ivy and the last few blooms on a clump of February Gold narcissus, all set against the russet with white striations of New Zealand flax, *Phormium tenax*, as I learnt to know it, for gardening, as well as being bracing for the back and the soul, is also very good for your Latin.

Working for those eighteen years in the gardens at Annaghmakerrig taught me that gardening is a labour of love that is constantly renewed, season after season, generation after generation. What is most important, as my mentor Lawrence D. Hills would say, is to create a fertile ground in which the plants (and artists and other animals) can flourish. This is done over time, with patience, knowledge, and dung, lots of dung, such as was brought to us by the tractor-trailer load by Freddie Norris, one of the many neighbours who took pride in the job we were doing, and in his own contribution to it, for he never charged us for this benison of cowclap, and always delivered it with a smile of happy complicity.

Our legacy – if I might be so pompous as to call it that – mine, Basil's, Arthur Shackleton's, Brian Brady's, Valerie Waters's, and that of all the other people who have ever worked there, is that Annaghmakerrig could not now be imagined without its gardens.

In Paddy Reilly of Ballyjamesduff's day the Garden of Eden was known to lie 'to the left at the bridge of Finea' and 'half-way to Cootehill', but I think it has drifted northwards over the last two or three decades; across the spiky rooftops of the quirky town of Cootehill, without puncture or mishap, up the road towards New Bliss, past the Black Kesh, over Bob's Brae, into the Mesopotamia of Aghabog, where it has settled and fitted snugly into the 451 acres of the Annaghmakerrig estate, which is, as biblical scholars attest, the exact area of the quondam home of our first parents, to the nearest cubit.

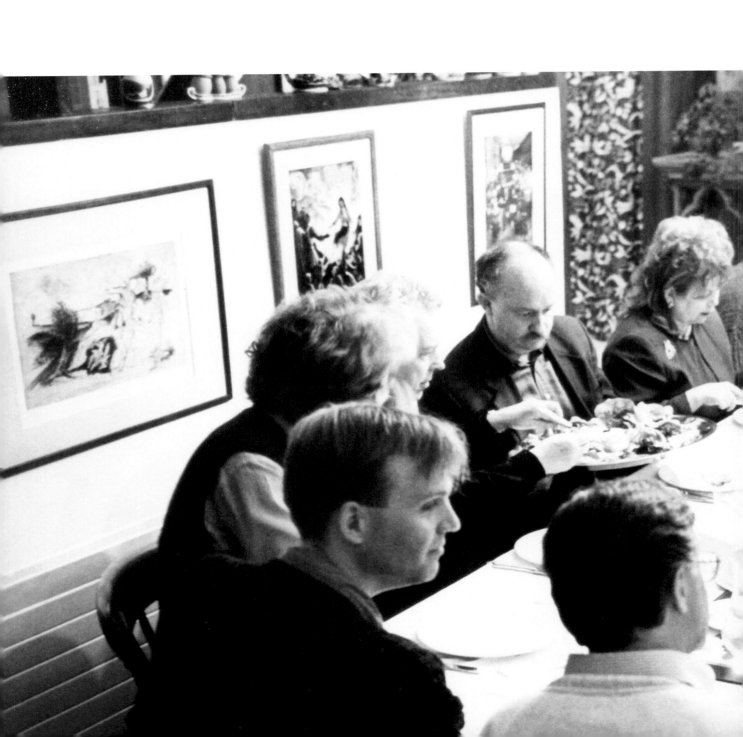

SHEILA PRATSCHKE *The Dinner*

Ask anybody who has stayed at Annaghmakerrig about the meals and they will respond with what may well seem to be excessive hyperbole. Dinner is an important ritual, a punctuation point in long and concentrated working days, a reward at seven o'clock. It is a formal but congenial gathering, candle- and fire-lit, with good food and wine underpinning conversation, argument, song and declamation. Four women have cooked for the Annaghmakerrig artists over twenty-five years – Mary Loughlin, Doreen Burns, Ingrid Adams and Lavina McAdoo. Much-loved practitioners of the culinary arts, they have been responsible for adding substantially to the collective girth of the artistic community! Each has chosen a favourite menu and provided the recipe for one dish. Put together, they make a four-course meal for twelve people: Doreen's soup, Mary's fish, Ingrid's roast and Lavina's dessert.

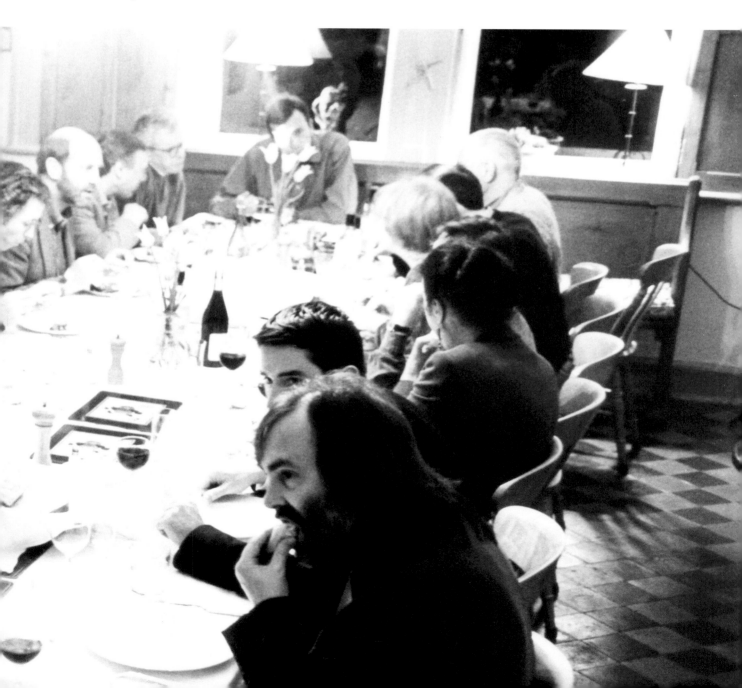

Doreen's Menu

Cauliflower and Blue Cheese Soup

❧

Roast Leg of Lamb
Rosemary and Turmeric Potatoes
Roasted Parsnips
Ratatouille

❧

Plum and Pear Crumble with
Almond Custard

Mary's Menu

Monkfish with Spicy Sauce
Mixed Leaf Salad

❧

Farrera Chicken Casserole with Star Anise
and Prunes with either Boiled Rice, Baked
potatoes or a freshly cooked green vegetable

❧

Caramelised oranges drizzled with white
and dark chocolate and served with
cats' tongues

Cauliflower and Blue Cheese Soup

 3 heads of cauliflower, cut into florets
 1 large chopped onion
 Crushed garlic to taste
 3 large chopped potatoes
 350g stilton cheese

Sauté in melted butter, add 4 pints of vegetable stock, bring to boil and simmer for 30 minutes. Add mustard and stilton. Blend, add dill, lemon juice and season to taste.

Monkfish with Spicy Sauce

 About 125g fish per person
 About 2 eggcups of oil
 3 tbsps butter
 About half a cupful of flour, well seasoned with salt and pepper
 1 fresh red chilli, all seeds removed
 2 tbsps caster sugar
 2 cloves garlic, crushed
 The juice and rind of two limes – lemons can be used but the flavour of lime is preferable
 6 large peeled fresh tomatoes with their seeds removed.
 3 tbsps light soya sauce
 6 tbsps rice wine vinegar
 One half of a small onion very finely chopped by hand
 2 tbsps of chopped coriander leaves and 12 whole sprigs for garnish

Begin by washing the fish and drying it well with kitchen paper or a clean tea towel. Cut the fillets into discs about 1 cm thick.

Next prepare the sauce. Peel the tomatoes and remove their seeds. Setting the coriander and the chopped onion aside, whizz together all the other ingredients with a hand blender or in a food processor with a sharp blade. Then add the onion and place the mixture in a small saucepan over a low heat to warm.

Toss the fish pieces in the seasoned flour and fry in three or four batches, for about a minute on each side, until they are golden. Keep them warm, covered with foil in the oven, as you cook the remaining pieces.

Add the chopped coriander to the warm sauce, pour over fish and decorate with coriander sprigs.

 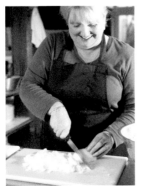

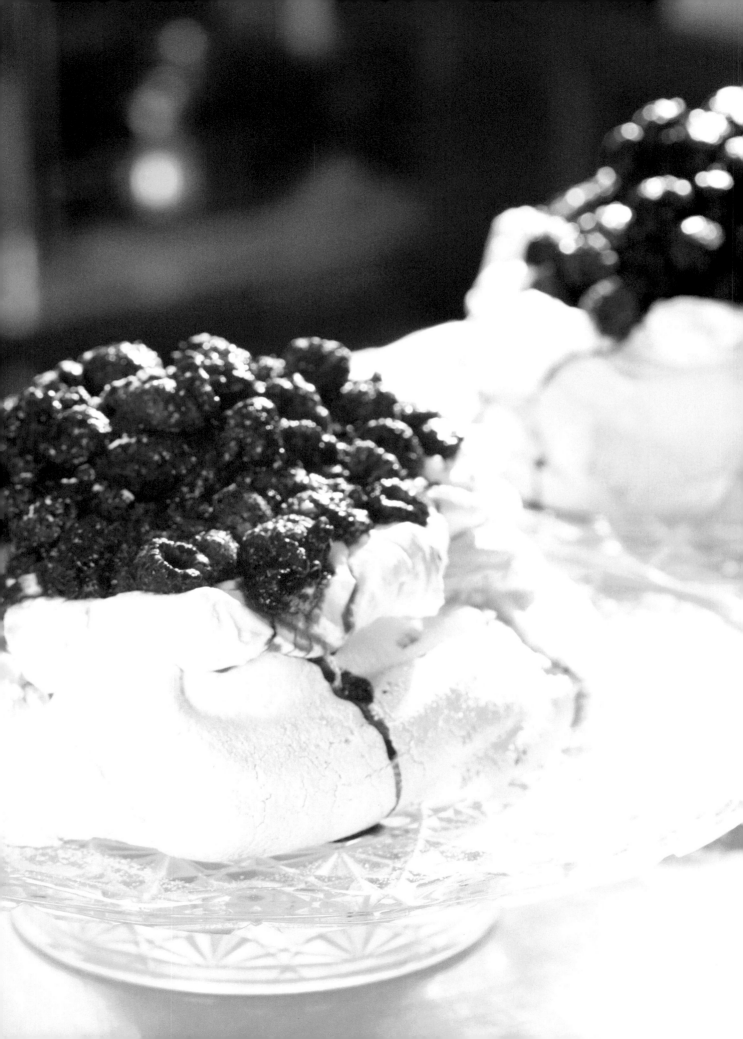

Ingrid's Menu

*Vol-au-vents with White Wine, Cream
and Mushroom Sauce*

❀

*Roast Pork with Apricots and Prunes, Apple Sauce
Cauliflower with Cheese Sauce
Carrots in Ginger, Lemon Juice & Honey
Boiled Baby Potatoes with Chives & Butter*

❀

Rum and Strawberry Trifle

Lavina's Menu

Tossed Green Salad

❀

*Chicken Fillets stuffed with
homemade Italian Tapenade
Cheesy Garlic Potatoes
Sautéd Chillied Onions, Carrots
and Peppers*

❀

Pavlova with Poached Rhubarb

Roast Pork with Apricots & Prunes
5 lb loin of pork studded with whole cloves
Mix together:
 2 tbsps wholegrain mustard
 Freshly ground cloves
 Honey
 Heaped tsp of freshly ground peppercorns

Spread mixture over top and sides of pork. Put in roasting tin with 2–3 cups of water and cover. Cook 1½ hours at 400°C. Uncover and cook for further 30 minutes. Allow to rest for 15 minutes. Gently heat 2 tins each of apricots and prunes in juice, place fruit around meat and pour juices over.

Pavlova with Poached Rhubarb
 8 large sticks of rhubarb
 4 egg whites at room temperature
 8 oz castor sugar
 Pinch ginger & cinnamon
 1 tsp cornflour
 1 tsp white wine vinegar

Cut rhubarb into 1-inch pieces, place in dish with sugar to taste and poach in bain-marie for 45 minutes at 350°C.

Whip egg whites until stiff, add other ingredients and beat together. Pile high on greaseproof paper and bake in preheated oven at 300°C for 10 minutes. Reduce to 150°C and bake for a further hour. Cool, pile whipped cream on top and add cooled rhubarb.

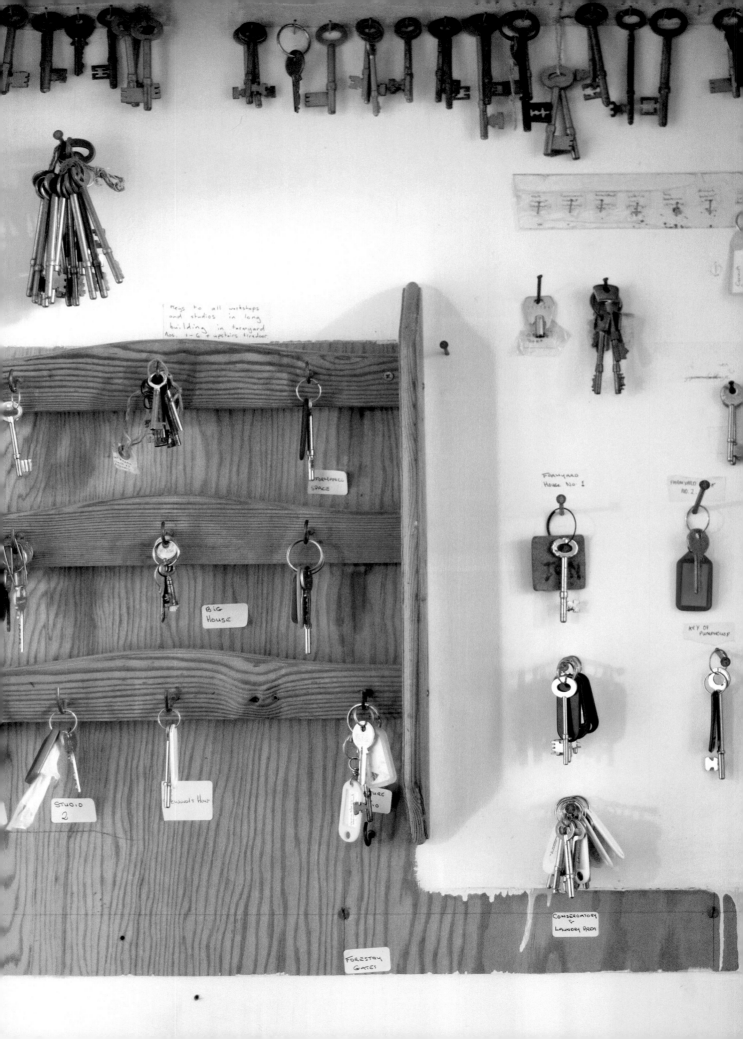

keys to all workshops
and studios in long
building in farmyard
Nos. 1-6 + upstairs firedoor

FARMYARD
SPACE

FARMYARD
House No 1

FARMYARD
No. 2

KEY OF
PUMPHOUSE

BIG
HOUSE

STUDIO
2

Steward's House

CONSERVATORY
& LAUNDRY AREA

FORESTRY
GATES

ANNAGHMAKERRIG RESIDENTS 1981–2006

1981-2
Ackley, Randall
Aherne, Jackie
Ballagh, Robert
Ballymena Youth Drama
Barnes, Ben
Barry, Gerald
Bernelle, Agnes
Bolger, Dermot
Boydell, Brian
Bracefield, Hilary
Bratt, Eyvind
Brennan, Cecily
Brennan, Colm
Brennan, Jimmy
Browne, Joe
Buick, Robin
Bygrove, Helen
Bygrove, Marian
Cabot Hale, Nathan
Caleb, Ann
Cleary, Bernadette
Clifton, Harry
Conlin, Stephen
Conlon, Fred
Corbett, Joe
Craig, Maurice
Craig, Michael
Cullen, Michael
Davis, Virginia
Davitt, Michael
Deane, Raymond
Deane, Seamus
Dempsey, Vincent
Donlon, Pat
Dowland Consort
Doyle, Roger
Drury, Martin
Dupont, Dorothea
Ellis, Conleth
Emmett, Nicholas
Farl Powers, Mary
Farrell, Bernard
Fitzgibbon, Margaret
Fitzgibbon, Marian
Fitzmaurice, Paula
Fitz-Simon, Christopher
Flynn, Mannix
Foley, Imelda
Foley, Michael
Fouere, Olwen
Franklyn, John
Frawley, Monica
Friel, Brian
Friel, Seamus
Gorman, Damian
Grapevine Theatre
Halliwell, Piers
Hammond, David

Hammond, Philp
Hardy, Philip
Harper, Rita
Hartigan, Anne
Harvey, Francis
Haycock Walsh, Barbara
Hayes, Paul
Healy, Henry
Heaney, Seamus
Hickey, Ted
Holmes, Peter
Hutton, Sean
Johnston, Roy
Jordan, Eithne
Jordan, John
Kelleher, Julie
Kelly, Donal
Kelly, Paul
Kennedy, Douglas
Kennedy, Máire
Kennedy, Moira
Keogh, Garrett
Kerr, Virginia
Kilmartin, Annie
Kilroy, Thomas
Lalor, Brian
Lavin, Mary
Linehan, Fergus
Linehan, Rosaleen
Longley, Michael
Luchesi, Bruno
Lynch, Martin
MacGiolla Léith, Caoimhín
MacMathúna, Seán
Magill, Tom
Makower, Anne
Maloney, Mike
Manley, Jim
Maude, Caitlín
McArdle, John
McAughtry, Sam
McBratney, Sam
McCabe, Vinnie
McCafferty, Nell
McCord, Elizabeth
McGuinness, Frank
McIntyre, Tom
McKeever, Jim
McKendry, Donal
McKenna, David
McKeon, Barbara
McMullin, Michael
McNamee, John
McWilliams, Joe
Mok, Judith
Molloy, M.J.
Morris, David
Morrow, John
Moving Theatre

Moxley, Gina
Muldoon, Paul
Mulholland, Carolyn
Mulkerns, Val
Mullen, Michael
Murphy, Francis
Ní Bhroithe, Aideen
Ní Chuilleanáin, Eiléan
Ní Dhomhnaill, Nuala
Ní Rinn, Bríd
Ó Briain, Art
Ó Direáin, Mairtín
Ó Duinn, Proinnsias
Ó hEithir, Breandán
Ó Maolfabhail, Art
Ó Muirthile, Liam
Ó Snodagh, Pádraig
O'Connor, Bryan
O'Conor, John
O'Gorman, Terence
O'Loughlin, Michael
O'Mahoney, John
O'Neill, Tim
O'Reilly, Geraldine
O'Shaughnessy, Peter
Paulin, Tom
Pierce, Janet
Poulter, Chrissie
Power, Edward
Quigley, Martin
Quilligan, Ita
Quinn, Bernadette
Quinn, Niall
Rea, Stephen
Regan, Angela
Regan, Leo
Reid, Christine
Richards, Shelah
Rolfe, Nigel
Romney, Ruth
Rooney, Pádraig
Rosenstock, Gabriel
Rubin, Leon
Ryan, Elizabeth
Ryan, Pauline
Ryan, Thomas
Scott, Patrick
Shannon, Clive
Shea, Wendy
Sheridan, Peter
Silkin, Jon
Simmons, James
Sloan, Bob
Smith, Dennis
Smith, Sydney Bernard
Snoddy, Theo
Sutton, Patrick
Thompson, Bob
Tierney, Mark

Tracey, Lorna
Trimble, Joan
Wall, Mervyn
Wiser, William
Woods, Macdara

1983
Ackley, Randall
Akenson, Don
Allen, Barbara
Ballard, Brian
Bolger, Dermot
Burch, Lawson
Burke, Helen Lucy
Byers, David
Byrne, Kevin
Byrne, Mairéad
Clifton, Harry
Davitt, Michael
Doyle, Kay
Elliott, David
Ellis, Conleth
Emmett, Nicholas
Finkel, Shimon
Finnegan, Gene
Fletcher, Elizabeth
Foley, Michael
Freeman, Barbara
Gaston, Norah
Gillespie, Elgy
Grattan, Kevin
Hartigan, Anne
Healy, Dermot
Holden, Ursula
Hughes, John
Hume, Adrienne
Hynes, Oliver
Ireland, Aideen
Johnston, Fred
Jordan, John
Keegan, Danny
Kelleher, Julie
Kelly, Maeve
Kennedy, Douglas
Lynch, Martin
MacAnna, Pádraic
MacAnnaidh, Séamus
Magee, Dennis
Magill, Tom
McArdle, John
McConville, Michael
McDonald, Evelyn
McKennitt, Loreena
McLoughlin, Joseph
McMenamin, Patricia
McNamara, James
Montague, John
Moran, Frances
Morrow, John

Muldoon, Paul
Nolan, Jim
Ó Curráin, Seán
Ó hEithir, Breandán
O'Connor, Clairr
O'Connor, Liam
O'Conor, John
O'Farrell, Pádraig
Place, Helen
Potter, Nancy
Price, Nancy
Quinn, Niall
Rannsley, Peter
Rice Giff, Noreen
Roche, Billy
Ruark, Gibbons
Sirr, Peter
Smart, Bill
Smith, Sydney Bernard
Sweeney, Matthew
Tallentire, Ann
Theatre Omnibus
Wall, Mervyn
Walsh, Sean

1984
Allen, Jim
Ballard, Brian
Banville, John
Barry, Gerald
Barry, Sebastian
Bellew, June
Betera, Carol
Bevelander, Brian
Bogin, George
Boland, Eavan
Bolger, Dermot
Brennan, Jimmy
Burke, Helen Lucy
Burton, Fred
Byrne, Mairéad
Carman, Cathy
Carnegie, Roma
Carr, Eithne
Charabanc
Conlin, Stephen
Counihan, Alan
Cronin, Anthony
Davis, Gerald
Davison, Philip
Delanty, Greg
Donald, Keith
Donovan, Phoebe
Dowling, Gabby
Doyle, Kay
Dublin Youth Theatre
Duffy, Rita
Duncan, Anya
Durcan, Paul
Edmondson, Philip
Egan, Mick
Elliott, Andrew
Farrell, Bernard
Ferran, Denise

Field Day Directors
Finnegan, Gene
Fitzgerald, Mary
Frawley, Monica
French, Billy
Gallagher, Mary
Garganus, Allan
Gharbaoui, Dorothy
Gillespie, Elgy
Glavin, Anthony
Glennon, Mary Rose
Harding, Michael
Haverty, Anne
Healy, Dermot
Hendlin, Judith
Holden, Ursula
Hughes, John
Hutchinson, Pearse
Jepson, Judy
Jordan, John
Keenleyside, David
Kerr, Eddie
Lennon, Ciarán
Liddy, John
Linehan, Edmund
Linehan, Fergus
Littlewood, Joan
Lynnott, Ray
MacAnna, Pádraic
MacAnnaidh, Séamas
MacCoil, Liam
MacUistin, Liam
Madden, Deirdre
Mason, Patrick
Mason, Shelley
Mathews, Aidan C.
Mathis, Cleopatra
McGowan, Jim
McInerney, Barney
McKenna, Donagh
McKiernan, Ethna
Molloy, M.J.
Monaghan, Patricia
Moran, Frances
Muldoon, Paul
Mulkerns, Val
Newson, George
Nunan Kenny, Colette
Ó Brolcháin, Micheál
Ó hEithir, Breandán
O'Connor, Clairr
O'Connor, Maureen
O'Conor, John
O'Curráin, Sean
O'Driscoll, Ciaran
O'Gorman, Mary Pat
O'Loughlin, Michael
O'Mahony, Matthew
O'Malley, Mary
O'Shaughnessy, Peter
Pierce, Janet
Pierce, Richard
Potter, Nancy
Redmond, Lar

Reid, Chris
Rennie, Barbara
Sandford, Patrick
Saunders, Camilla
Short, Constance
Smith, Sydney Bernard
Snoddy, Theo
Staempfli, George
Sulllivan, Nancy
Team Theatre Company
Theatre Omnibus
Themuns Theatre Company
Thompson, Mavis
Vial, Noëlle
Wagner, Annaliese
Wall, Mervyn
Walsh, Sean

1985
Allen, Barbara
Banville, John
Barry, Sebastian
Berkeley, Sara
Boland, Rosita
Bolger, Dermot
Boyle, Michael
Brennan, Jimmy
Brett, David
Burch, Lawson
Burke, Helen Lucy
Butler, Ruth
Byrne, Maggie
Byrne, Mairéad
Canty, Mary
Chambers, John
Charabanc
Cleary, Brendan
Cohen, Judith Beth
Connaughton, David
Craig, Maurice
Craig, Michael
Cronin, Anthony
Culligan, Molly
Cunningham, Gerard
Dancesync
Davison, Philip
Day, Marie
Delaney, Catherine
Elliott, Andrew
Ellis, Conleth
EU Music Year Composers
Fagan, Kieran
Fairley, Michael
Farl Powers, Mary
Farrell, Anne
Farrell, John
Fletcher, Liz
Folan, Martin
Freeman, Barbara
Gharbaoui, Dorothy
Heemskerk, Marianne
Hennessy, Ben
Higgins, Rita Ann
Hill, Geoff

Hill, Niki
Hiller, Glynne
Holden, Ursula
Hone, Joseph
Howard, Ben
Hughes, John
Jones, Kent
Jordan, John
Keane, Molly
Kerr, Eddie
Kilroy, Mark
Lea, Sidney
Lynam, Shevaun
Lynch, Martin
MacAnnaidh, Séamus
MacMathúna, Seán
Mulder, Nanny
Muldoon, Paul
Mulkerns, Val
Murphy, Francis
Neeson, Eoin
Nelson, Charles
Neylon, Margaret
Nolan, Jim
O'Brien, Eoin
O'Connor, Conleth
O'Conor, John
O'Leary, Jane
O'Loughlin, Michael
Operating Theatre
O'Reilly, Geraldine
Ó Scolaí, Darach
Paradise, Catherine
Pierce, Janet
Pine, Richard
Pleasants, Virginia
Poulter, Chrissie
Power, Larry
Redmond, Lar
Reid, J. Graham
Riddick, Ruth
Serviss, Shirley
Seymour, Dermot
Sheeran, Pat
Sheridan, Jim
Short, Constance
Simmons, James
Skinner, Knute
Smith, Sydney Bernard
Snoddy, Theo
Symes, Adrienne
Tapscott, Stephen
Theatre Omnibus
Tóibín, Colm
Wagner, Annaliese
Wall, Mervyn
Walsh, Ronan
Windsor, Gerard

1986
Akenson, Don
Anderson, Linda
Banville, John
Bardwell, Leland

238

Doolin, Lelia
Dowd, Bernard
Doyle, Kay
Doyle, Roger
Duffy, Ger
Dumas, Lindsay
Enright, Anne
Fallon, B.P.
Farrell, Colette
Ferguson, Eileen
Fingleton, Seán
Folans, Ciaran
Frawley, Monica
Friedman, Daisy
Gibson, Hilary
Gibson, John
Gilhooley, Jack
Goldberg, David
Gorman, Richard
Grant, David
Guidi, Firenza
Halpin, Dymphna
Hannan, Maggie
Hannigan, Marie
Harding, Michael
Hartigan, Anne
Haverty, Anne
Hayes, Kathy
Hayes, Trudy
Heffernan, Michael
Herbert, Mary
Hermana, Louise
Hill, Geoff
Hines, Deirdre
Holden, Ursula
Howard, Ben
Hurl, Patricia
Hutcheson, Mark
Hynes, Garry
Ings, Richard
Irish Patchwork Society
Jones, Marie
Joyce, Ian
Kerr, Jean
Kilmartin, Annie
Kilroy, Mark
Kinnarney, Bill
Kobel, Thierry
Lawlor, Stephen
Leeney, Cathy
Lenihan, Edmund
Lennon, Ciarán
Levi, Henry
Liddy, Kevin
Lopez, Elena
Lynch, Gay
Lyons, J.B.
MacEoin, Gearailt
MacKeogh, Aileen
Maguire, Brian
Maher, John
Maréchal, Francis
Marshall, Oliver
Mason, Patrick

McAnally Burke, Molly
McCaughey, Anne Marie
McCormick, Dave
McEvoy, Angela
McGahern, John
McGookin, Colin
McHugh, Ruth
McKenna, David
Megged, Eyal
Megged, Nona
Methuen, Eleanor
Mofitt, Beth
Monahan, Noel
Monk-Feldman, Barbara
Montague, Evelyn
Montague, John
Moran, Pat
Moriarty, Gerard
Morley, David
Mulligan, Lorna
Murphy, Mary
Murphy, Patsy
Murphy, Tom
Ní Chuilleanáin, Eiléan
Ní Dhomhnaill, Nuala
Nicholson, James
Noble, Louise
Ó Dushláine, Tadhg
Ó Maoileoin, Brian
O'Callaghan, Conor
O'Connor, Clairr
O'Conor, John
O'Hare, Noreen
O'Keary, John
O'Keeffe, Jim
O'Kelly, Donal
O'Leary, Jane
O'Malley, Mary
O'Regan, Kevin
Ourcade, Rémy
Phelan, Berenice
Pierce, Janet
Purcell, Deirdre
Pye, Patrick
Regan, Jean
Robins, Ken
Roche, Anthony
Russell, Mary
Sands, Colm
Scanlan, Carol
Schulkowsky, Robyn
Sexton, Denis
Shea, Wendy
Shepperson, Janet
Short, Constance
Spartz, Mary Lou
Speers, Neil
Spillard, Anne
Stewart, Eamonn
Tennant, Christine
Thornton, Clodagh
Tighe, Fergus
Tóibín, Colm
Volans, Kevin

Wall, Mervyn
Whelan, Lorraine
Wichert, Sabine
Wilson, Clare
Woods, Macdara

1990
Agee, Chris
Akkurt, Cigdem
Alborough, Graham
Allen, Barbara
Almond, David
Aron, Geraldine
Atkins, Robert
Bacci, Barbara
Barron, Tom
Bergin, Mary
Bernard, Anne
Bernelle, Agnes
Berner, Urs
Bogan, Treasa
Bourke, Ken
Brennan, Liam
Brogan, Treasa
Browne, Liam
Burwell, Margo
Byrne, Eoin
Calapez, Pedro
Calvert, David
Cannon, Kathleen
Carr, Marina
Carroll, Joanne
Castelein, Ingrid
Clancy, Antoinette
Clancy, Basil
Clancy, Martin
Clarke, Rhona
Cleary, Brendan
Cole, Mary
Considine, June
Conway, Ray
Costelloe, Mary
Cullen, Paul
Cummins, Mary
Cummins, Michael
Davey, Rosaleen
Davison, Philip
De Faoite, Diarmuid
Deane, Raymond
Deasy, Frank
Dolan, Margaret
Donohue, David
Donovan, Katie
Dorgan, Theo
Dowd, Bernard
Dumas, Lindsay
Dunne, John
Dye, Alison
Eck, Ines
Engels, John
Enright, Anne
Esteban, Claude
Estrada, Adolfo
Fay, Julie

Flynn, David
Flynn, Mannix
Flynn, Pauline
Frawley, Monica
Freeman, Barbara
Galt, Hugh
Garvey, Alva
Giese, Rachel
Golden, Frank
Goodman, Nuala
Gormley, John
Grundy, John
Halpin, Dymphna
Hamilton, Hugo
Hardy, Philip
Harper, Ian
Hartigan, Anne
Hartnett, Michael
Hayes, Nuala
Hayes, Paul
Heemskerk, Marianne
Heller, Paul
Hermana, Louise
Higgins, Rita Ann
Hill, Geoff
Holohan, Kathleen
Hone, Joseph
Howe, Fanny
Hughes, Declan
Hurl, Patricia
Hutcheson, Mark
Hynes, Garry
Kilroy, Mark
Kinsella, John
Koevets, Pamela
Konyioumtzis, Paul
Laheen, Patrick
Lennon, Ciarán
Leonard, Margaret
Liddy, Pat
Loomis, Sabrina
Lorrimer, Will
Lundy, Deborah
MacSweeney, Marie
Maguire, Aisling
Maher, John
Martin, Rosemary
McCafferty, Nell
McCaffrey, Peter
McCannon, Billy
McClelland, John
McGookin, Colin
McGuire, Sarah
McKennitt, Loreena
McManus, Liz
Meehan, Paula
Methuen, Eleanor
Miller, Nick
Monahan, Noel
Montague, John
Mooney, Carmel
Morgan, Tom
Morrow, John
Mortimer, Peter

Muldoon, Paul
Murphy, Bill
Murphy, Pat
Murphy, Patsy
Murtagh, James
Nelson, Charles
Noel, Bernard
Ó Baoill, Niall
Ó Canainn, Tomás
Ó Maonlaí, Liam
O'Byrne, Des
O'Byrne, Maebh
O'Connor, Clairr
O'Connor, Liam
O'Connor, Nuala
O'Conor, John
Oeser, Hans-Christian
O'Farrell, Fiona
O'Neill, Larry
O'Regan, Kevin
O'Reilly, Geraldine
O'Toole, Fintan
Ourcade, Rémy
Parker, Lynn
Pavoni, Verena
Pierce, Janet
Pine, Richard
Purcell, Deirdre
Pylant, Carol
Ragnarsdottir, Gudrun
Regan, Jean
Roche, Anthony
Santarossa, Hella
Scanlon, Carol
Schleitzer, Angela
Shasko, Valerie
Short, Constance
Silcock, Ruth
Slade, Jo
Smith, Kevin
Snoddy, Theo
Stafford Clark, Max
Standún, Dearbhaill
Standún, Pádraig
Strada, Adolfo
Sweeney, Matthew
Taplin, Diana
Thunder, Brian
Tighe, Fergus
Vigil, Luís
Volans, Kevin
Wargo, Richard
Westerlund, Karen
Whelan, Geraldine
White, Victoria
Wichert, Sabine
Williams, Niall
Woods, Macdara
Zaleski, Jean

1991
Agee, Chris
Aldridge, Sinéad
Alexandrovna, Olga
Alimosna, Elena
Allen, Barbara
Allen, George
Anatolievitch, Alexei
Arnold, Heidi
Aron, Geraldine
Athens, John
Bacci, Barbara
Bernelle, Agnes
Blythe, Philip
Boland, Patrick
Boland, Rosita
Boroson, Martin
Bourke, Angela
Bowler, Michael
Boylan, Henry
Breen, Declan
Brennan, Mark
Brett, Heather
Brighton, Paul
Brunet, Luc
Burgin, Katharina
Burke, Helen Lucy
Burnside, Vivien
Bushe, Paddy
Calvert, David
Campbell, Bill
Canarezza, Rita
Carman, Cathy
Casey, Philip
Cassard, Philippe
Cassidy, Patrick
Cheyne, Anna
Cheyne, Donald
Citron, Lana
Clark, Grace
Cleary, Brendan
Clements, Krass
Coburn, Veronica
Cohen, Mark
Coleman, Aidan
Comerford, Helen
Conlon, Evelyn
Conlon, Fred
Connaughton, Shane
Connolly, Brendan
Connolly, Brian
Cooke, Liadín
Corry, Jim
Costello, David
Craig, Maurice
Craig, Michael
Cronin, Brian
Cronin, Siúin
Crowley, Deirdre
Crozier, Morna
Dahinden, Roland
D'Arcy, Margaretta
Davison, Philip
De Fréine, Celia

Deane, Raymond
Denniston, Edward
Donovan, Katie
Dorsey, Mary
Dowling, Gráinne
Downey, Marie Therese
Doyle, Kay
Dudley, Bill
Dukes, Gerry
Dunbar, Séamus
Dunphy, Eamon
Enright, Anne
Fairleigh, John
Fallon, Peter
Feaver, Vicky
Finlay, Sarah
Fitschen, Anya
Fitz-Simon, Christopher
Flynn, Mannix
Foley, Michael
France, Linda
Frawley, Monica
Freeman, Barbara
Gacasse, Louise
Gildea, Kevin
Green, Michael
Greig, Neil
Grennan, Eamonn
Gunne, Wendy
Hall, Fiona
Hall, Graham
Hamilton, Hugo
Hammond, Philip
Hardwick, Neil
Harper, Catherine
Hayes, Cathy
Hayes, Trudy
Hermann, Sabine
Hines, Deirdre
Hone, Joseph
Howard, Ben
Hudson, Henry
Huntington, Cynthia
Hynes, Garry
Jeffreys, Stephen
Johnston, Jennifer
Jones, Marie
Joynt, Dick
Kelleher, Emmett
Killisch, Claus
Kilmartin, Annie
Kleeb, Hildegard
Knott, Janet
Lambert, David
Landweer, Sonja
Lennon, Ciarán
Levy, Henry
Lynch, Martin
MacCormack, Jane
Maguire, Aisling
Maguire, Betty
Maharg, Annie
Maharg, Ken
Maher, John

Maitec, Ovid
Maitec, Sultana
Marxer, Donna
Maxton, Hugh
McCracken, Kathleen
McDonald, Marie
McGlynn, Michael
McManus, Liz
Melody, Kieran
Mok, Judith
Molloy, Michael
Morgan, Tom
Morris, Cathal
Mullan, Lennie
Mullins, Audrey
Murphy, Barry
Murphy, Bill
Murphy, Patsy
Ní Bhriain, Deirdre
Ní Bhriain, Doireann
O'Brien, Eugene
O'Clery, Joan
O'Connor, Anne
O'Connor, Clairr
O'Connor, Joseph
O'Conor, John
O'Dea, Mick
Oeser, Hans-Christian
O'Hanlon, Ardal
O'Leary, Jane
O'Loughlin, Michael
Ó Maoileoin, Brian
O'Regan Kevin
O'Reilly, Katie
O'Riordan, Dan
O'Shaughnessy, Peter
O'Toole, Fintan
Owens, Catherine
Parker, Imogen
Pawni, Verena
Pierce, Janet
Power, Larry
Puill, Sián
Purcell, Deirdre
Ribeiro, Carlos
Roche, Anthony
Rogers, Killian
Roper, Martin
Rothery, Seán
Schmid, Louise
Seaver, Michael
Sedgwick, Lindsay
Sexton, Denis
Sheehy, Ted
Short, Constance
Smith, Derek
Stafford-Clark, Ann
Stafford-Clark, Max
Stapleton, Frank
Stauder, Michael
Stephenson, John
Stuart, Ian
Teevan, Colin
Titley, Alan

Tóibín, Colm
Verstraete, Désirée
Volans, Kevin
Wallace, Amy
Walsh, Niall
Wanshed, Jeff
Westerlund, Karen
White, Victoria
Wichert, Sabine
Wilkie, Curtis
Williams, Niall
Zaleski, Jean
Zell, Ann

1992
Agee, Chris
Agrafiotis, Demosthenes
Akenson, Don
Allen, Barbara
Allen, Heather
Anaman, Denyse
Anderson, Caroline
Bannon, Maree
Bardwell, Leland
Barrett, Marie
Beck, Anne
Bernelle, Agnes
Berner, Urs
Blunk, Joyce
Boland, Rosita
Bolay, Veronica
Boran, Pat
Boroson, Martin
Breathnach, Páraic
Breslin, Rory
Burns, Brian
Byrne, Paul
Caffrey, Gerry
Carmody, Isobelle
Carr, Marina
Carson, Ciaran
Casey, Philip
Chadwick, Anne
Clancy, Martin
Clarke, Anne
Clear, Christine
Cleary, Brendan
Coggin, Janet
Comerford, Helen
Conlon, Evelyn
Costelloe, Eileen
Crowe, Catriona
Cruickshank, Peggy
Cullen, Barbara
Curtis, Tony
Daniels, Doreen
De Craig, Art
Deane, Raymond
Dear, Eliza
Degoutte, Eric
Delanty, Greg
Dillon, Siobhan
Doran, Seán
Dorgan, Theo

Dowling, Gráinne
Dowling, Joe
Doyle, Kay
Drake, Robert
Duane, Paul
Duggan, Catherine
Duimitrache, Simion
Dunbar, Séamus
Edmondson, Philip
Enright, Anne
Eytan, Miriam
Feaver, Vicki
Finnan, Paschal
Fleeton, Ann
Fokas, Nikos
Foley, Imelda
Freeman, Barbara
Gallagher, Brian
Gavin, Frankie
Gharbaoui, Dorothy
Gilmore, Jane
Gleeson, Gerry
Gore, Patricia
Gorman, Damian
Grace, Susan
Graham, Brendan
Grant, Máirín
Green, Michael
Grenier, Mark
Groarke, Vona
Hall, Albyn Leah
Hall, Fiona
Hamilton, Hugo
Hanrahan, Johnny
Hardie, Kerry
Harper, Ian
Hayes, Trudi
Healy, Dermot
Henderson, Ann
Hermana, Louise
Hickson, Paddy
Hill, Lucy
Hinds, Andy
Holland, Vincenza
Howlin, Adam
Hughes, John
Ingoldsby, Maeve
Jeffars, Anne
Johnston, Fergus
Johnston, Roy
Keane, Fiona
Kearney, Michael
Keinig, Katell
Kelly, Finbar
Kerr, Eddie
Kilroy, Mark
Kirkpatrick, Anna
Kohl, Sybil
Kuusinen, Asta
Lalor, Seán
Langhammer, Eric
Lejeloux, Paul
Lentin, Louis
Leonard, Mae

Liddy, Pat
MacAnnaidh, Séamas
MacLennan, Oscar
Madden, Aodhán
Magill, Rosemary
Maguire, Aisling
Maguire, Katriona
Manley, Jim
Marcus, Adrienne
Markey, Berni
Matthews, Troup
Maxton, Hugh
McAdam, Trish
McAllister, Patrick
McAnally Burke, Molly
McCarthy, Oonagh
McCarthy, Owen
McDonagh, Tom
McDonald, Marie
McDonald, Siobhán
McGlynn, Michael
McGuckian, Medb
McKnight, Michael
McManus, Liz
McQuinn, Austin
Meehan, Paula
Menashe, Samuel
Merrigan, Sarah
Merriman, Julie
Methuen, Eleanor
Millar, Seán
Morgan, Tom
Morris, David
Mulcahy, Lisa
Mulder, Nanny
Murphy, Bill
Murphy, Hugh
Murphy, Patsy
Murphy, Tom
Murray, Brigid
Newman, Kate
Nicolaou, Nicos
Ní Dhuibhne, Eilís
Ní Fhaoláin, Máiréad
O'Boyle, Evanna
O'Brien, George
O'Brien, Loretta
O'Carroll, Ursula Retzlaff
O'Connor, Paula
O'Dea, Mick
O'Doherty, Finola
Ó Faolain, Nuala
Ó hOgáin, Daithí
O'Leary, Jane
Ó Maoileoin, Brian
O'Neill, Tim
O'Toole, Helen
Patrickson, Tony
Peacock, Gordon
Pennell, Jacqueline
Pierce, Janet
Pratt, William
Quinn, Bob
Regan, Leo

Robinson, Tim
Roche, Anthony
Roche, Vivienne
Rousseau, Ann-Marie
Russell, Mary
Russell, Nicola
Saunders, Maeve
Scanlan, Carol
Schreibman, Susan
Seaver, Michael
Semple, Sally
Sharpe, Anne
Smart, Bill
Stephenson, David
Stephenson, John
Stuart, Imogen
Sweeney, Matthew
Tanham, Gaye
Teevan, Colin
Thompson, Kate
Tierney, Monica
Tóibín, Colm
Verriere, Kirsten
Walker, Brian
Wallace, Amy
Walsh, Dolores
Warburton, Nick
Waters, Mark
Waters, Terry
Whelan, Kitty
Wichert, Sabine
Woods, Fiona
Woodworth, Paddy

1993
Allen, Barbara
Anderson, Daryl
Archard, Dave
Armstrong, Robert
Ashlene, Aylward
Baker, Dessie
Barrett, Anne
Beckett, Darren
Bell, Sandra
Benton, Suzanne
Bernelle, Agnes
Bond, Silvia
Borros, Rita
Boyle, Dominic
Boyle, Paul
Boyle, Ronan
Breathnach, Páraic
Brighton, Pam
Broadhead, Caroline
Browne, Vincent
Byrne, Mags
Caffrey, Noeleen
Caffrey, Peter
Campbell, Bill
Casey, Philip
Chambers, Thelma
Claffey, Una
Clancy, Sarah
Clare, Anne

Clarke, Anne
Cleary, Brendan
Collins, Michael
Conlon, Evelyn
Corcoran, Michael
Coyote Wurly Mav
Craig, Michael
Cregan, Conor
Cruickshank, Peggy
Cullen, Sylvia
Cummins, Cindy
Cummins, Paula
Darling, Julia
Davey, Rosaleen
Dignam, Margaret
Dolan, Martin
Donlon, Pat
Donohue, David
Dorgan, Theo
Dorrestein, Renata
Dowling, Gaby
Doyle, Kay
Dracopoulou, Soula
Du Chalet, Caroline
Durcan, Sarah
Dwyer, Gary
Dyson, Bob
Enright, Anne
Evans, Chris
Evir, Ann
Fallon, B.P.
Fearon, James
Fernandez, Casonova
Figuerido, Violetta
Finnan, Pascal
Fisher, Tanya
Fitzgerald, Michael
Flannery, Bridget
Flynn, Mannix
Flynn DeCosse, Sheila
Foris, Matt
Foster, Neil
Fox, Robert
Frawley, Monica
Freeman, Barbara
Frogoulakis, Yarris
Fuensalida, Sandra
Games, Christa
Gastine, Marc
Gaston, Phil
Gillespie, Stephen
Gilliland, David
Gorman, Sheila
Graeve, Jobst
Graham, Brendan
Grandison, Anita
Green, Michael
Gregg, Helen
Grut, Vicky
Haerdter, Michael
Hall, Leah
Hall, Patrick
Halpin, Malachy
Hamburger, Claire

Hanlon, Marie
Hayman, Carol
Hayward, Colleen
Healey, Elizabeth
Hickey, Aidan
Hill, Jeff
Irvine, Brian
Johnston, Jennifer
Johnston, Paul
Johnston, Roy
Jones, Marie
Jordan, Dan
Kaufman, Pat
Kavanagh, John
Kearney, Michael
Keen, Paul
Keinig, Katell
Kelleher, Ger
Kerr, Eddie
Kilroy, Mark
Kotanidis, George
Krooy, Danielle
Lalor, Sean
Landweer, Sonja
Lennon, Ciarán
Long, Miriam
Long, Vivienne
Lyne, Dolores
MacAnnaidh, Séamus
Mangan, Kathy
Marinaki, Katerina
McArdle, Cathy
McCabe, Anne
McCann, Róisín
McCullough, Donncha
McDonald, Marie
McGill, John
McGlynn, John
McGlynn, Michael
McGuckian, John
McKegney, Orla
McLennan, Andrew
McLoughlin, Sharon
McManus, Liz
McNamara, Emer
McNeill, Christine
Meehan, Paula
Mellet, Laurent
Miller, Marian
Moffat, Sean
Molloy, Catherine
Monaghan, Brendan
Moore, Dalian
Morgan, Daragh
Morgan, Tom
Morin, Carole
Morrison, Conall
Mulholland, Fiona
Mullen, Siobhán
Murado, Miguel
Murphy, Patsy
Murphy, Paul
Murray, Bridget
Murray, Melissa

Neylin, Jo
Ó Baoighill, Pádraig
O'Beirne, Gerry
O'Connell, David
O'Connor, Thomas
O'Connor, Clairr
O'Conor, John
O'Doherty, Cahir
O'Doherty, Cathal
Oeser, Hans-Christian
O'Flynn, Seán
Ó Laighléis, Ré
O'Leary, Jane
Ó Lionáird, Iarla
O'Malley, Mary
O'Neill, Geraldine
Orange, Mark
O'Reilly, Patricia
O'Reilly, Paul
O'Shaughnessy, Peter
Owens, Catherine
Padel, Ruth
Palm, Brian
Panesi, Susan
Patterson, Evangeline
Pepper, Mark
Petrides, Elly
Pheby, John
Pierce, Janet
Pilcher, Emily
Priestly, Ruth
Prior, Aisling
Pyle, Hilary
Quinlan, Geraldine
Reardon, Marcella
Ribeiro, Artur
Ribeiro, Fatima
Risley, Joanne
Robinson, Sharon
Roodenburg, Simcha
Roper, Martin
Roussin-Graney, Aliki
Russell, Nicola
Salouki, Mahdra
Saunders, Maeve
Schenelberg, Melissa
Schurmann, Killian
Scott, Anne
Seaver, Michael
Sexton, Karen
Shaw, Alison
Sheerin, Bláithín
Shepperson, Janet
Shilton, Jo
Sinclair, Peter
Skinner, Knute
Smith, Philip
Snoddy, Theo
Stembridge, Gerry
Stemer, Lisa
Stemmerman, Jan
Stokes, Mary
Summerscales, Rachel
Sur, Donald

Sutton, Patrick
Taylor Black, Donald
Teevan, Colin
Templeton, Fiona
Thomas, Elaine
Thompson, Alice
Tongue, Alan
Torrado, Antonio
Tuffy, Margaret
Valentine, Joan
van der Grijn, Cléa
Vernon, Mary
Waller, Angela
Walshe, Alan
Walshe, Dolores
Walshe, Lorcan
Walshe, Noreen
Ward, Brendan
Watters, Michael
Weir, Grace
Whitney, Sharon
Wichert, Sabine
Wilkes, Cathy
Windsor, Gerard
Wolf Brennan, John
Woods, Macdara
Wyley, Enda
Yelin Hirsch, Gilah
Zell, Ann

1994
Agee, Chris
Allen, Barbara
Astley, Neil
Baumgartner, Jill
Bell, Sandra
Bernelle, Agnes
Bond, Marj
Bond, Sylvia
Booth, Tim
Brady, Maureen
Burns-Knutson, Sharon
Caffrey, Laura
Campbell, Anna
Campbell, Bill
Campbell, Douglas
Campbell, Siobhán
Carman, Cathy
Carmody, Isobelle
Casey, Maeve
Caulfield, Marie
Cheek, Mavis
Cherry, Rab
Cheyne, Don
Clancy, Basil
Clark, Grace
Clarke, Victoria
Clear, Christine
Cleary, Brendan
Cloughley, Ann
Coghlan, Donal
Comerford, Helen
Comerford, Oliver
Cone, Michel

Conlon, Evelyn
Connolly, Pat
Conway, Frank
Corcoran, Sharon
Corcoran, Terry
Coyle, Pádraig
Coyle, Richard
Darling, Julia
Davitt, Michael
Dawson, Barbara
Deane, Raymond
Des Marais, Paul
de St. Croix, Blond
Donnelly, Theresa
Donoghue, Emma
Dowling, Gaby
Downey, Marie Therese
Doyle, Cliona
Drake, Nicholas
Duchatelet, Caroline
Duffy, Martin
Duncan, Jean
Durcan, Paul
Enright, Anne
Evan, Chris
Farrell, Carissa
Fearon, James
Ferguson, David
Fitzpatrick, Marie-Louise
Fitz-Simon, Christopher
Fleming, Sam
Foley, Marie
Forde, Patricia
Freeman, Barbara
Galligan, Frank
Gebler, Carlo
Gil, Milagros Mata
Gillespie, Elgy
Graham, Brendan
Gribbon, Deirdre
Gribbon, Tristan
Groarke, Vona
Hall, Albyn Leah
Hall, Patrick
Hamilton, Ian
Hamza, Najada
Hannigan, Marie
Hansbury, Vivienne
Hardie, Kerry
Hardie, Sean
Harper, Ian
Harrington, Paul
Harris, Peter
Hartigan, Anne
Hawkswell Theatre
Healy, Darina
Hewitt, Joan
Hooghiemstra, Tjibbe
Hooley, Ruth
Howard, Ben
Hughes, Jane
Idstrom, Tove
Ingoldsby, Maeve
Johnston, Gail

Johnston, Jennifer
Johnston, Máirín
Jordan, Maureen
Joyce, John
Kareva, Doris
Kearney, Michael
Kelly, Deirdre
Kennedy, Christine
Kennedy, Kieran
Kirkpatrick, Anna
Kostick, Gavin
Landweer, Sonja
Langan, Clare
Langhammer, Eric
Lawlor, Mark
Le Fanu, Nicola
Liddy, Pat
Lide, Elizabeth
Litherland, Jackie
Livingstone, Richard
Long, Vivienne
Lordan, Éidhlís
Louise, Dorothy
Lowry, Miles
Lynch, Catherine
Macbeth, Penny
Mais
Marxer, Donna
McCabe, Anne
McCann, Colum
McCann, Róisín
McCluskey, Molly
McCormick, Jeri
McDonal, Hugh
McDonald, Marie
McGettigan, Charlie
McGlynn, Michael
McGuane, Antonio
McGuinness, Mairéad
McGuinness, Michael
McHugh, Ruth
McKeon, Barbara
McKinnon, Carol
McLoone, Tess
McNulty, Kieran
Methuen, Eleanor
Mew, Tommy
Mills, Jackie
Mills, Lia
Minnikin, Liz
Mitchell, Gary
Monaghan, Brendan
Montague, Evelyn
Morrison, Conall
Mortinelli, Tom
Moulter, Alexis
Moxley, Gina
Mullen, Siobhán
Murphy, Idris
Murphy, Jimmy
Murphy, Pádraig
Murphy, Pat
Murphy, Patsy
Murray, Brigid

Murray, Christopher
Murray, Miriam
Nash, Andrew
Nelson, Charles
Ní Chuilleanáin, Eiléan
Noah, Stephanie
Noone, Marie
Ó Baoighill, Pádraig
Ó Baoill, Eilis
O'Beirne, Gerry
O'Brien, Helen
O'Brien, Mags
O'Byrne, Des
O'Connell, Paula
O'Donoghue, Mary
Oeser, Hans-Christian
O'Hanlon, Redmond
Oliver Brown, Betty
O'Mahony, Deirdre
Ó Muirthile, Liam
O'Sullivan, Michael
Owens, Catherine
Padel, Ruth
Page, John
Peterson, Jackie
Pierce, Janet
Pilcher, Emily
Pilling, Christopher
Pybus, Christine
Racmolnor, Sandor
Rafferty, Eddie
Ranocchi, Augusto
Regan, Thomas
Riordan, Arthur
Robertson, Robin
Roche, Anthony
Rooney, Pádraig
Rothschild, Stephen
Scanlon, Carol
Scully, Paddy
Sexton, Karen
Skinner, Knute
Sloan, David
Smale, Alan
Smith, Alison
Smith, R.T.
Smyth, Cherry
Szoverdi, Csilla
Tennant, Chris
Thompson, Kate
Tierney, Pat
Tiplea, Bianca
Tobin, Gráinne
Toft, Michael
Tongue, Alan
Tracy, Monica
Trew, Helen
Urch, Marian
van der Grijn, Cléa
Venables, Laura
Vial, Noëlle
Wallach, Joelle
Walsh, Roxy
Weatherhead, Tim

Wichert, Sabine
Woods, Vincent
Wyse, Christine
Zell, Anne

1995
Affeldt, Doris
Aiken, Jim
Aktunc, Hulki
Anderson, Rachel
Archer, Ian
Attala, Jenny
Bardwell, Leland
Bashford-Synnot, Marie
Bauhaus, Franz
Bell, Sandra
Booth, Tim
Boran, Pat
Borgs, Janis
Bourke, Angela
Boyd, Pom
Boyd, Stephen
Bradley, Ciaran
Bradley, Stephen
Brandes, Stephen
Braun, Renate
Brighton, Pam
Brown, Gabriel
Browne, Corinne
Burnside, Vivien
Burrows, Mary
Byrne, Elizabeth
Campbell, Anna
Campbell, Brian
Carey, Lisa
Carmody, Isobelle
Carr, Eithne
Carville, Daragh
Casey, Philip
Clarke, Rhona
Cleary, Brendan
Cleland, Malcolm
Comerford, Oliver
Connolly, Lynn
Connor, Colette
Cooke, James
Corcoran, Margaret
Craig, Michael
Cruickshank, Peggy
Cullen, Michael
Cummins, Maurice
Curtis, Tony
Darling, Julia
Davey, Maggie
Davison, Philip
De Helen, Sandrea
Deane, Raymond
Dejean, Daniel
Dewhurst, Madeleine
Dillon Byrne, Jane
Dimmick, Kathleen
Dolan, Teresa
Donnelly, Ciara
Donnelly, Paddy

Donohue, David
Dorgan, Theo
Dormer, Richard
Doyle, Cliona
Dromgoole, Dominick
Egan, Anne
Enright, Anne
Fahey, Diane
Farrell, Carissa
Feahan, Claire
Feahan, Niamh
Fitschen, Anya
Flannery, Bridget
Fleming, Sam
Foley, Marie
Frank, Ann Marie
Freeman, Barbara
Freixinet, Merce
Gallagher, Rachel
Gardner, Stephen
Gaston, Phil
Gebler, Carlo
Gil, Milagros Mata
Ginn, Angela
Graham, Brendan
Grant, Máirín
Gray, Roma
Gregory, Nuala
Guilfoyle, Ronan
Hall, Albyn Leah
Hanlon, Marie
Hannigan, Marie
Harding, Michael
Hawkes, Gay
Hayman, Carole
Healy, Eithne
Helme, Sirje
Herbert, Bill
Herbert, Kathy
Hill, Sylvia
Hogan, Desmond
Holbrook, Victoria
Horgan, John
Hotai, Tomoyuki
Hughes, Declan
Hynes, Frances
Irish, Margaret
Jacobsen, Soren
Johnson, Tim
Johnston, Jennifer
Jordan, Anne
Joyce, Conor
Jurenaite, Raminta
Kavoc, Lenke
Kavocs, Flora
Keating, Loretta
Kelly, Margaret
Kelly, Nick
Kilroy, Tom
Kinsella, John
Kocak, Orhan
Lambkin, Romie
Lawlor, Mark
leBat, Karen

Lennon, Ciarán
Liddy, Pat
Llevot, Antoni
Lohan, Mary
Long, Quincy
Loughran, Mary
Lynch, Martin
Magee, Aoife
Maher, John
Mason, Patrick
McCabe, Maureen
McCarthy, Seán
McCreary, James
McDonald, Maureen
McDwyer, John
McFarland, Anita
McGann, Anthony
McGlynn, Michael
McGuckian, Mary
McKeogh, Aileen
McKeown, Laurence
McLennan, Oscar
McMahon, Tony
McPherson, Conor
Miller, Nancy
Mitchell, Gary
Miya, Itsuki
Montague, Evelyn
Montalban, Begona
Montgomery, Bill
Morgan, Tom
Morrison, Conall
Morrison, Margaret
Murphy, Martin
Murphy, Pádraig
Murphy, Tom
Murray, Bridget
Murray, Miriam
Murray, Patrick
Ní Chionaola, Sinéad
Ní Fhionnachtaigh, Máire
Ní Riain, Nóirín
Nolan, Kim
Norton, Norah
Ó Baoighill, Padraig
Ó Rocháin, Michael
O'Brien, John
O'Carroll, Aidan
O'Carroll, Noreen
O'Connell, Kevin
O'Connor, Joseph
O'Connor, Patrick
O'Conor, John
Oeser, Hans-Christian
O'Gaora, Colm
Ogle, Tina
O'Grady, Geraldine
Oliver Brown, Betty
O'Hagan, Felim
O'Hagan, Seán
O'Kelly, Donal
O'Leary, Jane
O'Malley, Mary
O'Neal, Alex

O'Neill, Mamie
O'Reilly, Geraldine
O'Rourke, Tina
Orr, Ann
O'Sullivan, Michael
Padel, Ruth
Parker, Lynn
Paschen, Elise
Patterson, Evangeline
Pemberton, Helen
Perry, Kate
Pessarodona, Marta
Pierce, Janet
Pilling, Christopher
Polman, Maarten
Poynder, Michael
Puig, Eugenia
Pybus, Christine
Pyle, Hilary
Raciti, Cherie
Rafferty, Eddie
Richmond, Helen
Riordan, Arthur
Robinson, Mairéad
Robinson, Mark
Robinson, Tim
Roche, Anthony
Roche, Christopher
Rojas, Nestor
Rosko, Gabor
Rouquette, Max
Ryan, Mary
Sandford, Irene
Schepps, Shawn
Schuenke, Christine
Secker-Walker, Sebastian
Shortt, Desmond
Sloan, David
Smyth, Sally
Stapleton, Frank
Stevenson, John
Stewart, Jim
Susanna, Alex
Sutton, Dorothy
Szabo, Gabor
Teevan, Colin
Teskey, Donald
Theodores, Diana
Thomas, Elaine
Tóibín, Bairbre
Tobin, Gráinne
Tongue, Alan
Treacy, Patricia
Turner, Lucy
Tyler, Viv
van der Wiel, Frans
Waller, Claire
Walsh, Aidan
Walshe, Jennifer
Wargo, Richard
Warren, Margaret
Waters, John
Weyermann, Diane
Whelan, Geraldine

Wichert, Sabine
Woods, Macdara
Wyss, Christine
Zabel, Valeska
Zell, Ann
Zeuli, Giuliana

1996
Agee, Chris
Allnutt, Gillian
Andrews, Alan
Angelin, Patricia
Aron, Geraldine
Banahan, Chris
Barker, Elisabeth
Barnes, Ben
Barrington, Judith
Bjornsdottir, Harpa
Bolay, Veronica
Boylan, Clare
Bradbury, Helen
Brady, Brian
Brandes, Stephen
Braun, Renate
Brophy, Catherine
Burrowes, Norma
Campbell Crawford, Anne
Candoux, P.K.
Carey, Lisa
Carville, Daragh
Casey, Mona
Casey, Philip
Chmiel, Tomasz
Clark, Malcolm
Cleary, Brendan
Cleary, Carmel
Cleland, Patricia
Comerford, Helen
Cooper, Robert
Craig, Maurice
Cruickshank, Peggy
Cullen, Michael
Dallatore, Marcella
Daly, Daragh
Davey, Rosaleen
Davison, Philip
Deane, Raymond
de Buitléir, Eoin
Demitchiva, Zina
des Marais, Paul
Desmond, Noreen
Dewhurst, Madeleine
Dillon, Robbie
Donohue, David
Doran, Beatrice
Dowdall, Aoife
Dowling, Gráinne
Downey, Maria
Duffy, Seán
Duggan, Dave
Duncan, Jean
Dunsmore, Amanda
Duran, Ernesto
Enright, Anne

Fahy, Marie-Therese
Farrell, Ciaran
Fitzgerald, John
Fitzgerald, June
Fitzpatrick, Marie-Louise
Fleming, Vincent
Flynn, Mannix
Freeman, Barbara
Frew, Ivan
Gallagher, Brian
Gallego, Marco
Gannon, Laura
Gharbaoui, Dorothy
Ginn, Angela
Golden, Frank
Graham, Angela
Graham, Brendan
Graham, Carol
Gribben, Deirdre
Grimes, Angie
Groarke, Vona
Guilfoyle, Ronan
Gunkel, Thomas
Hall, Albyn Leah
Hamilton, Colin
Harkin, Margo
Harrigan, Anne
Hayes, Katy
Henderson, Ann
Heron, Martin
Heron, William
Hinds, Andy
Howard, Ben
Hull, Gerry
Hurl, Patricia
Ingoldsby, Maeve
Irish, Margaret
Jones, Kent
Jordan, Anne
Kabdeho, Thomas
Kampmann, Anne
Keegan, Claire
Kelly, Ann Marie
Kelly, Eamonn
Kelly, Pat
Kilroy, Tom
Kostick, Gavin
Kravis, Judy
Krstic, Ivan
Lally, Anne
Lawlor, Brian
Lawlor, Stephen
le Fanu, Nicola
Lennon, Ciarán
Livingston, Andrew
Long, Vivienne
Lynch, Brian
Lyons, Alice
Lyons, John
Mac Aodha, Risteárd
MacGabhann, Brian
Magill, Tom
Maguire, Aisling
Maher, John

Marber, Patrick
Martin, John
Martinkevich, Vitalia
Masterson, Bernie
Mastrangelo, Susan
Maxwell, Jules
McCabe, Anne
McCormick, Jane
McCully, Karin
McDonald, Peter
McEnroy, Mary
McKeown, Mairéad
McManus, Liz
McSherry, Helen
Mims, Amy
Mitchell, Lucy
Morgan, Peter
Moxley, Gina
Muldoon, Paul
Murray, Melissa
Murphy, Pádraig
Murphy, Tom
Murphy, Vinnie
Murray, Brigid
Ní Chaoimh, Bairbre
Ní Dhomhnaill, Nuala
Ní Dhuibhne, Éilís
Nolan, Anto
Ó Baoighill, Pádraig
Ó Maoileoin, Brian
O'Brien, Molly
O'Brien, Peggy
O'Callaghan, Conor
O'Connor, Bridget
O'Connor, Joseph
O'Connor, Paula
Odem, Jennifer
O'Doherty, David
O'Donnell, Mary
O'Driscoll, Robert
Ó Gaora, Colm
O'Grady, Mark
O'Hagan, Sean
O'Hanlon, Redmond
O'Keefe, Noëlle
O'Kelly, Donal
O'Neill, Charlie
Orange, Brian
O'Sullivan, Carmel
Oliver Brown, Betty
Owens, Catherine
Padel, Ruth
Pederson, Ole Munch
Perry, Kate
Petrescu, Adrian
Philips, Ruth
Phillips, Sean
Pierce, Janet
Pierce, Valerie
Plummer, Pauline
Power, Edward
Pratt, William
Proulx, Annie
Pybus, Christine

Quinn, Yvonne
Rackard, Liz
Reddan, Marie
Reid, David
RES ARTIS
Riller, Audrey
Robinson, Hilary
Roche, Jenny
Roche, Tony
Rosko, Gabor
Rouwolf, Gerlinde
Russell, Norman
Ryan, Aaron
Ryan, Mary
Rzhanov, Mikhail
Seymour, Dermot
Sheehan, Aurélie
Simpson, Bill
Sloan, David
Sutton, Pat
Sweeney, Moira
Teevan, Colin
Tóibín, Bairbre
Tongue, Alan
Trent Hughes, Jenni
van Kampen, Marja
Vard, Colin
Vassiliera, Igleka
Vedres, Carla
Walsh, Noreen
Ward, Margaret
Waters, John
Whelan, Geraldine
Whybrow, Graham
Wichert, Sabine
Zebriunaite, Ula-Ulijona
Zell, Ann
Zeuli, Giuliana

1997
Agee, Chris
Allnutt, Gillian
Alsberg, Rebecca
Banahan, Chris
Bardwell, Leland
Beirne, Gerard
Bentolila, Daniel
Berdague, Roser
Bernelle, Agnes
Bevan, Wendy
Blythe, Philp
Boland, Ruairí
Boran, Pat
Boucher, Sandy
Brady, Philip
Brite, Philip
Campbell, Douglas
Capp, Fiona
Cardiff, Grace
Casson, Bronwen
Choi, Ho-man
Clark, Malcolm
Cleary, Siobhán
Cole, Aisling

Cronin, Maggie
Cruickshank, Peggy
Cullen, Mick
Cullen, Shane
Cullen, Yvonne
Cunningham, Claire
Curtis, Tony
Dáibhís, Bríd
Davis, Marie-Therese
Delrieu, Bernadette
Desmond, Noreen
do Carma Figueria, Maria
Donohue, David
Dorgan, Theo
Duffy, Martin
Dufour, Françoise
Duncan, Jean
Dungan, Myles
Egan, Jo
Elliot, Alistair
Emporion Project
Enright, Anne
Erwin, Gale
Ferguson, John
Fiori, Umberto
Fitzpatrick, Mary
Flynn, Mannix
Fors, Curt
Frabotta, Biancamaria
Frawley, Monica
Freeman, Barbara
Friel, Maeve
Gannon, Laura
Gelgota, Povilas
Gibson, Anna
Ginn, Angela
Golding, Michael
Goodman, Nuala
Graham, Carol
Graham, Gordon
Green, Deirdre
Gribben, Tristan
Grimes, Angie
Groarke, Vona
Guilfoyle, Ronan
Hahlweg-Elchlepp, Ursula
Harlow, Wayne
Haughton, Jenny
Healy, Biddy
Henry, Martha
Hirsch, Gilah Yelin
Hirst, Barbara
Holmes, Frank
Hone, Joseph
Hughes, John
Hughes, Sean
Jackson, Alice
Jaivin, Linda
Janzon, Leif
Johnstone, Ruth
Joyce, Marie
Joyce, Mark
Juelson, Crystal
Keegan, Claire

Kennedy, Brian
Kennedy, Declan
Kenny, Mary
Kerrett, Etgar
Kiely, Kevin
Kilroy, Tom
Kirk, Brian
Knight, Trevor
Kostick, Gavin
Kpakra, Mary Elizabeth
Kuhn, Laura
Law, Carol
Leipold, Inge
Lennon, Ciarán
Levine, Susan
Logan, John
Lovett, Marian
Lowry, Miles
Lynch, Martin
MacAnnaidh, Séamus
Maher, John
Martikainen, Kaari
McCann, Roger
McCarrick, Jaki
McCarthy, Marie
McLoughlin, Paddy
McManus, Liz
McNulty, Margo
Menashe, Samuel
Mims, Amy
Montague, Evelyn
Morgan, Michael
Morrison, Conall
Morrison, Jaime
Moxley, Gina
Murphy, Lorrayne
Murphy, Pádraig
Murray, Brigid
Murray, Melissa
Nelson, Carole
Nelson, Niamh
Ní Dhuibhne, Eilís
Ní Mhóráin, Bríd
Nielson, Rose-Marie
O'Connell, Kevin
O'Doherty, David
O'Donnell, John
O'Donnell, Mary
Oehr, Jane
Oeser, Hans-Christian
O'Flynn, Liam
O'Hagan, Sheila
O'Hanlon, Ardal
O'Leary, Jane
Olivieri, Lucia
Ostergren, Jan
Parsons, Ivy
Perry, Kate
Rainer, Mate
Raubo, Justyna
Ray, Gypsy
Read, Michelle
Reidy, Ger
Richmond, Helen

Robinson, Hilary
Ruchner, Koranna
Russell, Mary
Sexton, Eugene
Short, Constance
Sirr, Peter
Solomon, Sandy
Stapleton, Colum
Stephenson, John
Taylor, Paco
Teevan, Colin
Terrill, Richard
Thompson, Alison
Thornton, Eileen
Tomlins, Charles
Tongue, Alan
Urch, Marian
Valcells, Montserrat
Veselina, Olga
Ward, Margaret
Wargo, Richard
Waterhouse, Andrew
Wichert, Sabine
Wilson, Paul
Wollaston, Nicholas
Woods, Vincent
Woolfe, Sue
Wynne, Michael
Zell, Ann

1998
Alcorn, Michael
Arbones, Jordi
Arlander, Annette
Aron, Geraldine
Artt, William
Barry, Alice
Behan, Maria
Bennett, Ed
Bernelle, Agnes
Boland, Rosita
Bourke, Angela
Boylan, Clare
Brady, Maureen
Bridgeman, Pam
Brom, Veronique
Bruce, Hazel
Butler, Sue
Campbell, Patricia
Carey, Lisa
Carrol, Ann
Casey, Sinéad
Caulfield, Marie
Cepan, Cevat
Cheek, Mavis
Citron, Lana
Cleary, David
Clerkin, Seán
Coggin, Janet
Colman, Eamon
Comerford, Helen
Copperwhite, Diane
Corcoran, Margaret
Cordrescu, Ian

Cordrescu, Michela
Coyle, Pádraig
Cruickshank, Peggy
Cullen, Leo
Cunningham, Sophie
Curry, Neil
Curtis, Tony
Dáibhís, Bríd
Davies, Luke
Davison, Philip
Dawe, Gerard
Deegan, Loughlin
des Marais, Paul
Donaldson, Moyra
Dorgan, Theo
Duggan, Dave
Duncan, Jean
Egan, Jo
Egan, Michael
Einstein, Sylvia
Elmes, Hilary
Erridge, Alison
Esteban, Claude
Fahy, Ann
Fanning, Arnold
Farrell, Carissa
Feldman, Claudia
Finn, Mike
Fiss, Brigitte
Flynn, Brian
Foley, Marie
Footsbarn
Fraser, Hugh
Freeman, Barbara
Friday, Gavin
Friel, Maeve
Gallagher, Mia
Gaughan, Gleigh
Gebreurs, Adrian
Glynne, Rachel
Graham, Brendan
Groarke, Vona
Guilfoyle, Ronan
Hackett, Angela
Hafler, Max
Hannigan, Marie
Hardie, Kerry
Hardie, Sean
Harvey Jackson, Paul
Hone, Joseph
Horne, Heide
Hourcade, Remy
Hrabak, Petra
Hugh, Anne
Hughes, Jane
Hughes, John
Hughes, Martha
Hunter, Susan
Iorio, Giovanna
Jamieson, Gale
Johnston, Maura
Johnston, Sandra
Jokiranta, Rita
Kaklamanakis, Roula

Kavanagh, Patricia
Kay, Allie
Kennedy, James
Keret, Etgar
Kiernan, Pat
Knight, Trevor
Lally, Teresa
Lapas, Helena
Lavin, Kevin
Lawlor, Stephen
Le Fanu, Nicola
Leipold, Inge
Lenihan, Conor
Lentin, Louis
Lorant, Zsusa
Lynch, Declan
Lynch, Martin
Maher, Alice
Maréchal, Frances
McAdam, Trish
McCafferty, Frankie
McCaffrey, Peter
McDonald, Marie
McDwyer, John
McElligott, Grania
McGlynn, Michael
McGovern, Iggy
McGuinness, Clodagh
McHugh, Ruth
McKay, Deirdre
McKenna, Patricia
McManus, Liz
McNamee, Eoin
McNulty, Margo
McWilliams, Susan
Mish'ol, Agi
Mitchell, Jane
Molloy, Dymphna
Montague, Evelyn
Morrison, Conall
Mulhern, Teresa
Munarriz, Jesus
Munch-Pedersen, Ote
Murphy, Pádraig
Murphy, Tom
Mythen, Sue
Neukirchen, Dorothea
Newman, Joan
Ó Baoighill, Padraig
O'Boyle, Louis
Ó Cearnaigh, Ciaran
O'Donnell, Hugh
Ó Flaithearta, Seán
O'Hagan, Andrew
O'Hagan, Seán
O'Halloran, Beth
O'Loughlin, Michael
O'Malley, Mary
O'Neill, Charlie
O'Neill, Patti
Or, Amir
O'Rowe, Mark
Padel, Ruth
Peile, Sheelagh

Philpott, Ger
Pierce, Janet
Pierpoint, Katherine
Pine, Richard
Póirtéir, Cathal
Ramberg, Mona Lyche
Rankanen, Mimmu
Razum, Kathrin
Read, Michelle
Robben, Bernhard
Roche, Anthony
Roper, Rebecca
Rowlands, Ian
Rubert, Beate
Russell, Mary
Russell, Nicola
Ryale, Natalie
Scammell, William
Scannell, Rita
Schermer-Rauwolf, Gerlinde
Schumacher, Sonja
Seymour, Dave
Short, Constance
Staunton, Tracey
Susanna, Alex
Taillefer, Lydia
Tierney, Moira
Trouton, Jennifer
Valdes, Nano
Vaughan, Ronald
Walsh, Orla
Walshe, Noreen
Waters, John
Weiss, Robert
West, Katharine
Whybrow, Graham
Woods, Joseph
Woods, Macdara
Wynne, Brian
Yde, Charlotte
Zaparoli, Marco

1999
Anderson, Anne
Arlander, Eva
Arnfiels, Neil
Bacho, C.
Barry, Alice
Beardsley, Ellen
Bianchi, Tony
Biggs, Conor
Brandes, Stephen
Brown, Jenny
Bryce, Colette
Caragan, Emily
Carey, Lisa
Carville, Daragh
Christe, Anthony
Clerkin, Seán
Cleary, Brendan
Cleary, Carmel
Coburn, Veronica
Comerford, Helen
Corcoran, Mark

Coyle, Patrick
Craig, Michael
Creedon, Conal
Cullen, Barbara
Cullen, Yvonne
Cunningham, Paula
Dáibhís, Bríd
Darling, Julia
Daragh, Simon
Davison, Phillip
della Luna, Gogo
Dempsey, Brendan
de Pracontal, Mona
Doherty, Mark
Donohue, David
Dorgan, J.
Doyle, Elizabeth
Doyle, Rose
Duncan, Ray
Dunne, Jonathan
Enright, Anne
Fahey, Diane
Fairleigh, John
Fish, Harold
Fitzgibbon, Joe
Fitzgibbon, Josephine
Fitzgibbon, Margaret
Fitzpatrick, Joe
Fitzpatrick, Josephine
Fitzpatrick, Ruth
Flack, James
Foutz, Antony
Fox, Jim
Gaborian, Linda
Gilchrist, Jim
Gilligan, Hilary
Glazebrook, Chrissie
Goulding, A.
Graham, Brendan
Grant, David
Grimes, Angie
Groake, Vona
Hackett, Angela
Halton, Pauline
Hannon, Vincent
Hardie, Kerry
Herbert, Phyl
Hogg, Gavin
Hone, Joseph
Hubbard, Sue
Hughes, Eithne
Hughes, John
Hussey, Tom
Hynes, Aidan
Ingoldsby, Maeve
Iorio, Giovanna
Irish, Margaret
Irvine, Brian
Joyce, John
Keane, Raymond
Kearney, Mary
Knight, Trevor
Lawlor, Mark
Le Fanu, Nicola

Leipold, Inge
Lentin, Ronit
Lindsay, Andrew
Lovett, Tara
MacAodha, Sinéad
Maher, John
Markova, Aglika
Martin, Neil
McAleer, Clement
McAuley, Daniel
McAuley, Deirdre
McCarry, Kevin
McCullough, Andrea
McEneaney, Paul
McGowan, Julie
McGuinness, Eithne
McGurran, Rosie
McKeown, Gary
McLennan, Oscar
McLoughlin, J.
McManus, Liz
Millar, Andrew
Molloy, Deborah
Mongey, Iarla
Murfi, Mikel
Murphy, Barry
Murphy, Henry
Murphy, Marion
Nelson, Kathryn
Newman, Denise
Newman, Kate
Ní Chionaola, Sinéad
Niven, Allister
Nolan, Collette
Ó Baoighill, Pádraig
Ó Dálaigh, Margaret
Ó Dálaigh, Tony
O'Driscoll, Mary
Oeser, Hans-Christian
O'Hare, Niall
O'Hea, Honor
Ó Laoghaire, Michael
Olaru, Victor
O'Leary, Helen
O'Leary, Jane
O'Loughlin, Nicola
O'Malley, Tom
O'Neill, Charlie
O'Reilly, Geraldine
Oteiza, Daniel
Pacheco, S.E.
Parnell, David
Penrose, Michael
Pierce, Janet
Pierce, Rory
Póirtéir, Cathal
Popplestone, Brendan
Quinn, Marion
Regan, Morna
Robinson, Hilary
Robinson, Mark
Robinson, Wendy
Roche, Christopher
Seigel, Jessica Allegra

Selmer, Nicole
Seuss, Rita
Shafi, Janet
Shermer-Rauwolf, Gerlinda
Sirr, Peter
Smyth, Cherry
Teevan, William
Walitzex, Brigitte
Weinstock, Rose
Weinstock, Seymour
Weiss, Andreas
Weiss, Robert
West, Michael
Whelan, Tony
Whybrow, Graham
Wichert, Sabine

2000
Aron, Ger
Askin, Corinna
Azimi, Roxanne
Barrett, Anne
Barry, Alice
Beatman, Lisa
Beattie, Angeline
Bech, Claus
Begley, John
Begley, Kay
Bergsma, Peter
Bernascone, Rossella
Bertoni, Barbara
Bleakney, Jean
Bleton, Claude
Boland, Patrick
Boyd, Pom
Braun, Renate
Breen, John
Brewer, Gaylord
Browne, Gemma
Bryce, Colette
Burke, Miriam
Burnside, Vivien
Bush, Peter
Byrne, John
Caffrey, Seán
Cahn, Suzie
Campbell, Bill
Carolan, Bruce
Carrière, Anne Marie
Carthy, Angela
Carville, Gavin
Cathcart, Margaret
Chidester, Paul
Christians, Ralph
Clay, Isobel
Cleary, Brendan
Coggin, Janet
Comerford, Helen
Condren, Mary
Conway, Joan
Cotter, Karen
Creedon, Conal
Cruickshank, Peggy
Cummins, Carmel

Cummins, Pauline
Cunningham, Paula
Davison, Philip
Dawe, Gerald
de Pracontal, Mona
Deane, Raymond
Deazley, Stephen
Delaney, Eamonn
Devlin, Anne
Dowdall, Leslie
Dowling, Gráinne
Downey, Brigitte
Downey, Patricia
Dullea, Mary
Dunne, Catherine
Dunne, Jessica
Egan, Jo
Egan, Karen
Ennis Price, Barbara
Fahey, Diane
Fairleigh, John
Farrell, Ciaran
Fehsenfield, Martha
Fitzgibbon, Mags
Fitzpatrick, Joe
Fitzpatrick, Marie Louise
Fitzpatrick, Ruth
Fitzpatrick, Tamara
Fogarty, Mary
Fogarty, Sharon
Freaney, Paul
Gilson Ellis, Jools
Glavin, Anthony
Going, Jo
Graham, Brendan
Greenwood, Nell
Griffin, Patricia
Groarke, Vona
Guilfoyle, Ronan
Halton, Pauline
Hardie, Sean
Harding, Tayloe
Harkin, Margo
Hartigan, Ann
Hayden, Tom
Hazelton, Gail
Hegarty, Irene
Herbert, Phyl
Heylin, Liam
Hirst, Barbara
Hollywood, Brian
Hone, Joseph
Hugel, Hélène
Hughes, Jimmi
Hussey, Tom
Hynes, Aidan
Ingoldsby, Maeve
Iorio, Giovanna
Irish, Margaret
Jackson, Alasdair
Jenks, Alison
Johnston, Alex
Johnston, Fergus
Johnston, Gail

Johnston, Sandra
Joyce, Conor
Keane, Mary
Keegan, Claire
Keena, Colm
Kelly, Nick
Kierans, Rachel
Kilroy, Ian
Kilroy, Mark
Kinsella, Julie
Knight, Trevor
Kogel, Robert
Kouinesbelt, Annaleis
Laurens, Joanna
Lawlor, Niamh
Leeney, Cathy
Leipold, Inge
Lennon, Ciarán
Lennon, John
Lindsay, Nicola
Livingstone, Ken
Lynch, Martin
MacConghail, Cuan
MacConghail, Fiach
Maher, Alan
Maher, John
Martin, Neil
Massey, Jeremy
Masterson, Bernie
McAdam, Trish
McAleavey, James
McAllister, Cecilia
McAnna, Ferdia
McAviney, Caoimhe
McBride, Liz
McCabe, Ann
McCabe, Pat
McCarthy, Bríd
McCarthy, Charlie
McCullough, Andrea
McDonald, Daragh
McDwyer, John
McEwen, Helen
McGee, Noel
McGlynn, John
McGlynn, Michael
McGrath, Jerry
McGuinness, Eithne
McGuinness, Clodagh
McGurk, Tom
McHugh, Vera
McKee, Mary Ann
McKee, Noel
McKenna, Grace
McLachlan, Nicholas
McLennan, Oscar
MacNamee, Eoin
Mercier, Paul
Mezzetti, Frances
Monahan, Patrick
Moran, Siobhán
Moxley, Gina
Mulcahy, Lisa
Mulvey, Gráinne

Murphy, Judy
NicAonghusa, Clár
Ní Chionadh, Deirdre
NicAodha, Colette
NicEoin, Una
Nolan, Colette
Ó Neachtain, Joe Steve
Ó Searcaigh, Cathal
Ó Maoleoin, Brian
O'Donovan, Síofra
O'Dwyer, Adèle
Oeser, Hans-Christian
O'Hagan, Seán
O'Hanlon, Redmond
O'Kelly, Donal
O'Leary, Helen
O'Leary, Jane
O'Loughlin, Nicola
O'Reilly, Lisa
O'Sullivan, Michael
Pasternak, Lena
Payne, Daniel
Perry, Art
Perry, Paul
Philpott, Ger
Pierce, Janet
Pilbro, Anthony
Pittman, Al
Power, Glen
Prats, Carlos Rafael
Rane, David
Rani Sami, Ursula
Read, Michelle
Reilly, Monicia
Rice, Noreen
Robben, Bernhard
Robertson, Deborah
Robertson, Robin
Robinson, Hilary
Roche, Christopher
Scannell, Rita
Schneberg, Willa
Schute, Jenny
Sharkey, Helen
Sheehy, Wayne
Sheils, Martin
Smith, Brenda
Smith, Paki
Smyth, Cherry
Solana, Maite
Sparrow, Annie
Stanley, Mary
Stapleton, Colum
Stewart, Mark
Stratling, Uda
Thorisson, Marteinn
Thornton, Darren
Torrens, Jacqueline
Velissaris, Catherine
Vilkovsky, Jan
Wade, Maggie
Walker H.
Walshe, Lorcan
Walther, Mattias

Wedd, Cassandra
Wells, Judy
Whelan, Geraldine
Whybrow, Graham
Winters, Carmel
Woods, Macdara
Woods, Vincent
Wuilmart, Françoise
Wynne, W.
Young, Sally
Zeuli, Giuliana

2001
Archer, Julie
Aron, Geraldine
Arthur, Margaret
Askin, Corinna
Azizi, Idlir
Azoulay, Aline
Baker, Lindsay
Ballagh, Peter
Banks, Margo
Barnecutt, Mary
Barry, Alice
Bateman, Colin
Bennett, Edmond
Boland, Rosita
Bracken, Niall
Braun, Renate
Breen, John
Brezing, Thomas
Browne, Paul
Bryce, Colette
Burns, Breda
Burnside, Vivien
Burwell, Carter
Byers, David
Byrne, Jason
Byron-Smith, Deirdre
Cafolla, Terry
Campbell, Bill
Carthy, Angela
Clarke, Kay
Cleary, Brendan
Cleary, Siobhán
Coggin, Janet
Coghlan, Donal
Connors, Eamon
Connors, Fi
Corbett, Joe
Cosgrove, Aedín
Coyle, Donal
Crampton, Suzanna
Crenshaw, Mary
Crowe, Frances
Cullinane, Jeremiah
Cummins, Jonathan
Dáibhís, Bríd
D'Aughton, Mark
Davis, Amanda
Davis, Gerald
Davison, Philip
de Vries, Suzanna
Deegan, Loughlin

Delaney, Eamonn
Devine, Derrick
Doherty, Jeremy
Donohue, Dave
Dowdall, Leslie
Downey, Brigitte
Dudley, Helen
Duffy, Martin
Duffy, Rita
Dunbar, Séamus
Dunne, Catherine
Dunne, Jonathan
Dunphy, Ann
Egan, Jo
Egan, Karen
Egan, Mick
Eliass, Dorte
Farrell, Carissa
Farrell, Ciaran
Feldmannn, Claudia
Fine, Rosemary
Fink, Hannah
Finlow, Vanessa
Fitzgibbon, Margaret
Flack, James
Flynn, Leontia
Foerster, Richard
Fogarty, Sharon
Foster Fitzgerald, Lynne
Foutz, Anthony
Foutz, Victoria
Fuller, Janice
Gallagher, Fionnuala
Gillespie, Rosalind
Ginna, Robert
Gorman, Damian
Gorman, Roddy
Graham, Brendan
Griffin, Fiana
Grimes, Angie
Grimes, Conor
Groarke, Vona
Guilfoyle, Ronan
Hamilton, Judy
Harman, Mark
Harper, Colin
Harris, Ann
Healey, Eileen
Herbert, Phyl
Herlihy, David
Hill, Coral
Hinds, Andy
Holten, Katie
Hone, Joseph
Hooghiemstra, Tjibbe
Hosty, James
Hourihane, Ann Marie
Houston, Anna
Hughes, John
Hurson, Tess
Hussey, Tom
Hynes, Aidan
Irish, Margaret
Jack, Zachary

Jeffmar, Marianne
Jolley, Patrick
Jonusys, Laimantas
Joyce, John
Kalmanovitch, Tanya
Keane, Mary
Kearns, Peter
Keegan, Claire
Kelleher, John
Kennedy, Janice
Kenny, Lynn
Keogh, Garrett
Keys Colton, Ann
Kilroy, Mark
Kinahan, Deirdre
Kripz, Nathan
Laherty, Bernie
Lawlor, John
Leahy, Ann
Leipold, Inge
Lennon, Ciarán
Lentin, Louis
Lindsay, Nicola
Loane, Terry
Louise, Dorothy
Lynch, Gerry
Lynch, Martin
Lynch, Paul
Lyons, Michael
Mackenzie, Lauren
Macklin, Nuala
MacMathúna, Seán
Magill, Ciaran
Maher, John
Maleczech, Ruth
Massey, Jeremy
Maxton, Hugh
McAdam, Trish
McAllister, Cecilia
McCann, Anthony
McCann, Nuala
McCannon, Billy
McCarthy, Bríd
McCarthy, Charles
McCarthy, Fergal
McGlynn, John
McGrath, Jerry
McGuinness, Eithne
McHallem, Chris
McHugh, Eina
McIvor, Emma
McKee, Alan
McManus, Liz
McQuaid, Sarah
McWilliams, Anthea
Meagher, John
Mika, Tomás
Mills, Lia
Monahan, Patrick
Monroe, Robert
Mooney, Martin
Moran, Aida
Mulgrew, Geraldine
Mulligan, Hugh

Mulrooney, Deirdre
Murray, Miriam
Nesbitt, Ian
Nesbitt, Shirley
Ní Chinnéide, Cliona
Ní Chinnéide, Fiana
Ní Chionaola, Sinéad
Ní Chuilleanáin, Eiléan
Ní Ghallchoír, Bríd
Nichol, Jock
Nolan, Colette
Ó Baoighill, Pádraig
Ó Maoileoin, Brian
O'Connell, Anne
O'Connell, Kevin
O'Connell, Pauline
O'Conor, John
Odin, Jacqueline
O'Driscoll, Mary
O'Halloran, Mark
O'Hanlon, Redmond
O'Hehir, Debi
O'Kelly, Donal
O'Loughlin, Nicola
O'Neill, Charlie
O'Reilly, Audrey
O'Sullivan, Michael
Osment, Philip
Ouzman, Robin
Perry, Kate
Philpott, Ger
Pierce, Janet
Price, Stanley
Pryor, Aisling
Pybus, Christine
Quinn, Gavin
Quinn, Karl
Quinn, Marion
Rackard, Liz
Read, Michelle
Reilly, Monica
Reynolds, Hilary
Rice, Noreen
Robertson, Robin
Roche, Chris
Roycroft, Deirdre
Russell, Nicola
Schneider, Anthony
Sheehy, Wayne
Sibulescu, Emil
Simoni, Mary
Slattery, Helen
Smyth, Cherry
Stewart, Mark
Stonich, Sarah
Taylor, Paco
Thiessen, Gesa
Tintner, Chryssy
Tóibín, Bairbre
Tongue, Alan
Tyrell, Thomas
Walsh, Sinéad
Walshe, Lorcan
Walshe, Nóirín

Waters, John
Wedemann, Silvana
Weixbach, Sabrine
West, Michael
Whelan, Geraldine
Wichert, Sabine
Williams, Pauline
Winters, Carmel
Woods, Vincent
Wyley, Enda
Zell, Ann
Zhecheng, Wang

2002
Alcorn, Michael
Almeder, Melanie
Aron, Geraldine
Arthur, Margaret
Aydon, Deborah
Banks, Margo
Barnecutt, Mary
Barry, Alice
Bartlett, Rebecca
Beals, Ellen Wade
Beckman, Madeleine
Binchy, Chris
Blackman, Jackie
Blair, Margot
Boland, Rosita
Bourke, Angela
Braun, Renate
Brenock, Cormac
Byrne, John
Byrne, Lizzie
Byrne, Patricia
Byron-Smith, Deirdre
Campbell, Dominic
Campbell, Frances
Carragher, Anna
Cartmill, Deirdre
Carville, Gavin
Caulfield, Debbie
Ceric, Ludo
Challenger, Melanie
Clamp, Paula
Clarke, Kay
Clearfield, Andrea
Clyne, Jean
Coggin, Janet
Collins, Michael
Comer, Marion
Comerford, Helen
Conroy, Roisín
Cooper, Robert
Corkery, John
Cosidine, June
Cottle, Sarah
Coulter, William
Crowley, Niamh
Cruickshank, Peggy
Cummins, Pauline
Cunningham, Danny
Cunningham, John
Curran-Mulligan, Patricia

Dawe, Gerald
de Witt, Abigail
Deevy, Elsie
Delamere, Neil
Doherty, Jeremy
Donnelly, Mary
Donohue, Dave
Dorgan, Theo
Downey, Michael
Doyle, Maria
Dubris, Maggie
Duffy, Martin
Duffy, Rita
Dungan, Brian
Earley, Brendan
Elmes, Hilary
Enright, Anne
Falconer, Delia
Feehily, Fergus
Fitzgibbon, Margaret
Fitzpatrick, John
Fleming, Ian
Foley, Catherine
Foutz, Anthony
Foutz, Victoria
Fredrick, Peter
Fricker, Karen
Fuller, Janice
Gallagher, Fionnuala
Garrard, Charles
Gilbert, Denis
Gill, Fionnuala
Gill, Liz
Golden, Frank
Graham, Brendan
Gray, Aaron
Groarke, Vona
Guilfoyle, Ronan
Hammond, Barbara
Hannan, Rosemary
Hardie, Kerry
Harman, Mark
Healy, Cormac
Heaney, Elaine
Hedley, Anne
Henshaw, Diane
Herbert, Tony
Higgins, Judith
Hodges, Adrian
Hone, Joseph
Hooghiemstra, Tjibbe
Hopkins, Bernadette
Horgan, Conor
Hough, John
Hourihane, Anne-Marie
Houston, Anna
Huettinger, Berit
Ingoldsby, Maeve
Irish, Margaret
Jacob, Lucinda
Johnston, Sandra
Jolley, Paddy
Joyce, John
Kames, Louise

Kane Dufault, Peter
Keane, Mary
Kelly, Brian
Kelly, Nick
Kennan, Pat
Kennedy, Brian
Keogh, Garrett
Keogh, Patrick
Keys-Colton Ann
Kilroy, Ian
Kilroy, Tom
Knight, Trevor
Kripz, Nathan
Laherty, Bernie
Lambert, David
Largey, Caelinn
Leahy, Ann
Lennon, Ciarán
Lentin, Louis
Leslie, Sammy
Lillis, Anne
Lindsay, Namara
Louise, Dorothy
Lowe, Louise
Lowndes, Maureen
Lunny, Judy
Lynch, Emer
Lynch, Gerry
Lynch, Paul
Lynch, Sarah
Lyons, Michael
MacCormaic, Paul
Machin, Barbara
Mackenzie, Lauren
MacMathúna, Seán
Madden, Christine
Maginn, Carmel
Maher, John
Mahloujian, Azar
Mahood, Kim
Maidment, Sally
Malone, Martin
Martin, Neil
Massey, Jeremy
Maxton, Hugh
Maxwell, Alison
McCann, Peter
McCarrick, Jaki
McCarthy, Doris
McCarthy, Fergal
McCarthy, Michael
McClarey, Angela
McCloskey, Molly
McClure, Martin
McCormack, Selma
McDermott, Karl
McDonnell, Melissa
McDwyer, John
McGill, Anne
McGlynn, John
McGlynn, Michael
McGookin, Colin
McGowan, Julie
McGrath, Billy

McGuckian, John
McKenna, Malachy
McKennitt, Loreena
McLennan, Alastair
McManus, Liz
McQuaid, Sarah
McSkeane, Liz
McWilliams, Anthea
Medbh, Maighréad
Moran, Aida
Moxley, Gina
Mulcahy, Lisa
Mulcahy, Louis
Mulgrew, Geraldine
Mulrooney, Deirdre
Murfi, Mikel
Murphy, Pat
Murtagh, Caroline
Nash, Tanya
Nesbitt, John
Ní Chaoimh, Bairbre
Ní Chinnéide, Deirdre
Ní Chinnéide, Fiana
Ní Chionaola, Sinéad
Ní Dhubháin, Marina
Nic Aodha, Colette
Norris, Peter
Nouvell, Martin
Nunan, Betty
Ó Duiríos, Seán
O'Connell, Kevin
O'Connor, Colin
O'Connor, Joseph
O'Donovan, Síofra
O'Driscoll, Ciaran
Oeser, Hans-Christian
O'Hanlon, Ardal
O'Hannigan, Elaine
O'Hehir, Debi
O'Keefe, Maura
O'Leary, Jane
O'Loughlin, Nicola
O'Neill, Charlie
O'Neill, Seán
O'Reilly, Geraldine
O'Reilly, Jacinta
O'Reilly, Johnny
O'Reilly, Patricia
O'Sullivan, Michael
Osment, Philip
Parker, Lynn
Patten, Kieran
Power, Edward
Price, Stanley
Pybus, Christine
Quinn Cotter, Bonnie
Quinn, Yvonne
Rackard, Liz
Read, Michelle
Reidy, Ger
Rich, Susan
Richardson, Heather
Ring, Bee
Robb, Deirdre

Robinson, Brian
Robinson, Hilary
Roche Conroy, Jenny
Roper, Mark
Scullin, Anne
Sewell, Lisa
Sheehy, Wayne
Short, Constance
Slevin, Chris
Smyth, Cherry
Soye, Paul
Spain, Una
Sterling, Joe
Taylor, Paco
Thornton, Clodagh
Tierney Keogh, Lisa
Titley, Alan
Toner, Jim
Towsin, Sue
Turley, Sandra
van den Berg, Ricky
Vaughan, Stephen
Vavakova, Ivana
Vida, Sandra
Vollath, Norbert
Wade-Beals, Ellen
Wall, Lorraine
Walsh, Sinéad
Walshe, Lorcan
Waters, John
West, Michael
Whelan, Geraldine
White, Ali
Whitticase, Derek
Whitworth, Valerie
Whybrow, Graham
Woodford, Anna
Woods, David
Wright, Stephen

2003
Abbott, Richard
Allen, Page
Anderson, Ioanna
Antunes, Miguel
Aron, Geraldine
Azizi, Idlir
Ballagh, Peter
Banks, Margo
Barnecutt, Mary
Barry, Alice
Behan, Maria
Binchy, Chris
Bingham, Roberta
Bissette, Frank
Blackman, Jackie
Blair, Margot
Blecher, George
Bloom, Valerie
Boland, Rosita
Bradbury, Helen
Brankin, Una
Brogan, Ethna
Brosnan, Geraldine

Browne, Gemma
Brusasco, Paola
Bryce, Colette
Burns, Brian
Byrne, Kate
Byrne, Pat
Callaghan, Mary Rose
Campbell, Neil
Carr, Shane
Carson, Liam
Cartin, Damien
Cartmill, Christopher
Cartmill, Deirdre
Carville, Daragh
Carville, Gavin
Cassidy, Michelle
Challenger, Melanie
Chamberlain, Cynthia
Chapman, Usula
Clamp, Paula
Clark, Patricia
Clarke, Jocelyn
Clarke, Victoria
Cleary, Siobhán
Clyne, Jean
Coggin, Janet
Collier, Rosemary
Connaughton, Michael
Connors, Fi
Conroy, Roisín
Considine, June
Cooper, Robert
Corob, Tricia
Corrigan, Caoimhín
Cosgrove, Katherina
Coyle, Pádraig
Crean, Emma
Cruickshank, Peggy
Cullen, Catherine Anne
Cullen, Leo
Cunningham, Paula
Davis, Gerald
Dawe, Gerald
De Brún, Ursula
de Figueiredo, Marie José
de Pracontal, Mona
Deegan, Loughlin
Deegan, Sheila
Delamere, Philip
Delaney, Eamonn
Demaree, Liz
Doherty, Linda
Doherty, Patricia
Donoghue, Bríd
Donohue, Dave
Donovan, Katie
Douglas, Colm
Dowdall, Leslie
Doyle, Sally
Driscoll O'Shea, Quinn
Drohan, Declan
DuBose, David
Dunne, Catherine
Dunne, Eleanor

Durkee, Savriti
Earley, Brendan
Egan, Jo
Elliot, Jenny
Fairleigh, John
Farrell, Connie
Farrelly, Susan
Feldman, Claudia
Fewer, Tom
Finlow, Vanessa
Flannery, Bridget
Fogarty, Sharon
Ford, Beverly
Foutz, Anthony
Fox, Donal
Fricker, Karen
Fritz, Franca
Gallwey, Maria
Gartland, Roisín
Gaston, Norah
Gaughan, Marilyn
Gibson, Valerie
Gildernew, Colm
Gleeson, John
Glynne, Rachel
Gordon, Marie
Goss, Kieran
Graham, Brendan
Granato, Giovanna
Grant, Máirín
Granville, Gary
Gray, Marie
Grimes, Angie
Grimes, Conor
Groarke, Vona
Grothuis, Irma
Guerzoni, Giora
Guilfoyle, Ronan
Hamilton, Judy
Hammond, Barbara
Hanson, Stephen
Hardie, Kerry
Harding, Michael
Harkin Petersen, Anne
Harper, Catherine
Harrold, James
Harten, Brian
Hayden, Cathal
Hayes, James
Hegarty-Lovett, Judy
Henshaw, Diane
Higgins, Judith
Hill, Kathleen
Hines, Deirdre Ann
Hollis, Matthew
Holmes, Frank
Holten, Katie
Hone, Joseph
Hooghiemstra, Tjibbe
Horan, Lorna
Hough, Jon
Hourihane, Ann-Marie
House, Stephen
Hughes, Morven

Hynes, Aidan
Irwin, Sharon
Jacob, Lucinda
Johnston, Maura
Jones, Marie
Jordan, Cathy
Joyce, John
Karnes, Louise
Keane, Mary
Kearns, Terry
Kelly, Brian
Kelly, Catherine
Kelly, Julia
Kelsey, Jamie
Kennan, Pat
Kennedy, Brian
Keown, Mary T.
Kidney, Joanne
Kilroy, Mark
Kinahan, Deirdre
Knorr, Julia
Kripz, Nathan
Langan, Ken
Lawlor, John
Lawlor, Stephen
Layden, Bernadette
Lehman, Miriam
Leipold, Inge
Lennon, Ciarán
Lindsay, Namara
Lord, Collette
Lovett, Michael
Lowe, Louise
Lynch, Gerry
Lynch, Martin
Lynch, Seán
Lyons, Alice
MacConghail, Somhairle
Mackenzie, Lauren
Mackey, Christine
Madden, Christine
Maginn, Carmel
Maguire, Brian
Maher, John
Maidment, Sally
Maloney, Darren
Marinescu, Andrei
Martin, Neil
Mayer, Clemens
Mayock, Emer
McBurney, Helen
McCann, Bert
McCarthy, Anne
McCarthy, Fergal
McCarthy, Michael
McCarthy, Charlie
McCartney, Annie
McCloskey, Molly
McClure, Martin
McCoole, Sinéad
McCudden, Michael
McDermott, Karl
McDonald, Marie
McDonnell, Ruth

McDonnell, Caitlín
McDonnell, Melissa
McElhinney, Ian
McElroy, Karen
McEneaney, Paul
McFetridge, Paula
McGarry, Maria
McGill, Ann
McGrann, Molly
McGrath, Jerry
McGuinness, Eithne
McKee, Alan
McKenna, Jackie
McKeown, Jill
McLoughlin, Mags
McMahon, Deirdre
McQuaid, Sarah
Meaney, Liz
Meaney, Roisín
Mee, Teresa
Meehan, Ursula
Meenan, Martin
Milford, Tricia
Mills, Geraldine
Mills, Lia
Mok, Judith
Molloy, Rosaleen
Moloney, Dominique
Montague, Mary
Moran, Aida
Morrisey, Sinéad
Morrison, Conall
Morrissey, Joan
Moxley, Gina
Moynihan, Mary
Mulcahy, Siobhán
Mullan, Marie
Muller, Natasha
Murphy, Irene
Murphy, Réiltín
Murphy, Suzanne
Nash, Tanya
Navratil, Igor
Nelson, Katherine
Ní Chionaola, Sinéad
Nolan, Conor
Nunan, Betty
Ó Baoighill, Pádraig
Ó Briain, Colm
Ó Cuív, Ruairí
Ó Fionnáin, Traolach
Ó Riordáin, Cathal
Ó Searcaigh, Cathal
Ó Tiomáin, Brian
O'Byrne, Rory
O'Connell, Kevin
O'Connor, Eimear
O'Connor, Martin
O'Connor, Nuala
O'Connor, Rebecca
O'Dea, Maureen
O'Doherty, Isobel
O'Donnell, Mary
Oeser, Hans-Christian

O'Flanagan, Mary Kate
O'Hehir, Debi
Okamura, Kusi
O'Kane, Marianne
O'Leary, Sally
O'Loughlin, Michael
O'Loughlin, Nicola
O'Malley, Thomas
O'Neill, Brendan
O'Neill, Charlie
O'Regan, John
O'Reilly, Christian
O'Reilly, Geraldine
O'Reilly, Jacinta
O'Reilly, Johnny
O'Reilly, Liam
O'Reilly, Monica
O'Reilly, Seán
Organ, Margaret
O'Shea, Barbara
O'Sullivan, Michael
Parker, Lynn
Parkinson, Siobhán
Patten, Kieran
Pierce, Janet
Popplestone, Brendan
Power, Edward
Prosser, David
Pybus, Christine
Rafferty, Ed
Read, Michelle
Regan, Nell
Reilly, Catherine
Remson, Michael
Rich, Susan
Riley, Jon
Ring, Bee
Robben, Bernhard
Robinson, Anita
Robinson, Brian
Rosser, Peter
Russell, Lucinda
Russell, Mary
Russell, Nicola
Sansom, Ian
Schneider, Jurgen
Scott, Melanie
Sheridan, Vincent
Shields, Helen
Shortt, Desmond
Smith, Ned
Smyth, Cherry
Smyth, Damian
Spencer, Andrea
Stack, Allyson
Sterling, Joe
Synott, Cathal
Talen, Bill
Taylor, Paco
Thiessen, Gesa
Thomas, Maggie
Tinley, Bill
Tongue, Alan
Traynor, Des

Trigg, Kate
Troya, José
Turpin, John
Twomey, Anne
Vabaliene, Dalia
Vallely, Fintan
Vernon, Carolyn
Vida, Sandra
Vollath, Norbert
Von Stuckrad, Benjamin
Wall, Stephen
Walsh, Dermot
Ward, Sandra
Watkins, Neil
West, Michael
Wetzig, Karl Ludwig
Whisker, Charlie
White, Adrian
White, Willie
Whybrow, Graham
Wichert, Sabine
Wiesenberg, Menachem
Wiesenberg, Mimi
Woodcock, Martha
Woods, Angela
Woods, David
Woods, Vincent
Wright, Stephen

2004

Adams, David
Agnew, Stewart
Aikin, Helena
Aikin, Morag
Alander, Eva
Allen, Page
Anderson, Patrick
Ardiff, Karen
Astley, Neil
Atkins, Chris
Bailey, Stephen
Barrett, Sheila
Barry, Aidan
Barry, Kevin
Bayers, Johnny
Beecher, Donal
Binchy, Chris
Boland, Gerry
Boland, Rosita
Brancescu, Mimi
Braun, Renate
Breen, John
Brett, Heather
Brogan, Ethna
Brosnan, Geraldine
Brown, Alison
Brown, Noelle
Burke-Kennedy, Mary
 Elizabeth
Butler, Eoin
Byrne, Aisling
Byrne, Fergus
Byrne, Frances
Byrne, Jason

Cahill, Brona
Carbonariu, Geanina
Carswell, Jaimie
Cartmill, Deirdre
Carville, Gavin
Champion, Lucy
Chawla, Asha
Clancy, Majella
Clarke, Jocelyn
Clarke, Rhona
Clemminson, Nicola
Coates, Harry
Cole Kronenbourg, Lisa
Collins, John
Collins, Michael
Comerford, Helen
Commiskey, John
Conlon-McKenna, Marita
Connaughton, Michael
Conrad, Gisela
Conroy, Roisín
Conway, Thomas
Corriente, Federico
Cottle, Sarah
Coyle, Pádraig
Coyle-Greene, Enda
Crawley, Peter
Crouch, Joe
Cullivan, Yvonne
Cumiskey, Rose
Cunningham, Paula
Cunningham, Sarah
Daniels, Huw
Davis, Gerald
Dawe, Gerald
De Brún, Ursula
Deakin, Bonnie
Deakin, Ian
del Ojo, Alfonso
Delaney, Bryan
Dempsey, Ciaran
Dempsey, Kate
Dennard, Linda
Devine, Ruth
Devlin, Anne
Doherty, Patricia
Donegan, David
Donnelly, Johnny
Dowling, Gráinne
Doyle, Sally
Doyle, Teresa
Duff, Claire
Duley, Mark
Dunbar, Séamus
Durin, Aoife
Earley, Brendan
East, Louise
Egan, Jo
Eliass, Dorte
Feeney, Julie
Ferguson, Carlos
Ferguson, David
Fitz-Simon, Adrian
Flanagan, Nancy

Flannery, Bridget
French, Mel
Gallagher, Donal
Galligan, Frank
Gallwey, Maria
Gantner, Vallejo
Gaston, Philip
Gibson, Valerie
Gildea, Anne
Gleeson, Paula
Glynne, Rachel
Gordon, Alice
Gormley, Jacinta
Gormley, Jeffrey
Graham, Brendan
Griffin, Elaine
Griffin, Fiana
Grimes, Conor
Guilfoyle, Ronan
Hall, Tom
Halligan, Liam
Halpin, Sarah
Hamilton, Aileen
Hardy, Philip
Hareide, Vigdis
Harkin Petersen, Anne
Hartenstein, Elfi
Hassett, Sue
Henshaw, Diane
Hickey, Kelly
Higgs, George
Hill, Kathleen
Hirst, Barbara
Hogan, Joan
Hone, Joseph
Hooghiemstra, Tjibbe
Houston, Sally
Hugget, Monica
Hussey, Tom
Hussey, Peter
Hynes, Aidan
Ingoldsby, Maeve
Jenkins, John
Jimenez, Jorge
Jones, Gail
Keane, Mary
Keane, Tom
Kearney, Oonagh
Kelleher, Bea
Kelly, Irene
Kennan, Pat
Keown, Mary T.
Kidney, Joanne
Kiely, Bernadette
Kim, Ji Soo
Kinahan, Deirdre
Kinirons, Michael
Kinnane, Dave
Kostick, Conor
Koubareli, Antonia
Kripz, Nathan
Kronenberg, Lisa
Lawlor, Mark
Lawlor, Stephen

Leahy, Ann
Leahy, Deirdre
Leavy, Anne-Marie
Lehmann, Lucy
Leipold, Inge
Lenehan, Paul
Lennon, Ciarán
Lennon, Kym
Lentin, Louis
Lew, Michael
Lewis, David
Lindsay, Namara
Litt, Toby
Long, Marie
Lovett, Ann
Lowe, Louise
Lowry, Miles
Ludlow, Charles
Lynch, Martin
Lyons, Alice
MacCormaic, Paul
MacDonald, Shona
Mackey, Christine
Maginn, Carmel
Maher, John
Marciano, Elisheva
Marinescu, Andrei
Marshall, Frank
Marshall, Oliver
Martin, Neil
McAleer, Kevin
McCafferty, Frankie
McCann, Dolores
McCarthy, Fergal
McCartney, Annie
McClarey, Angela
McCormack, Selma
McCracken, Ruth
McCullagh, Maedhbh
McCurdy, Marie
McDonald, Marie
McDonnell, Aoife
McDonnell, Melissa
McDonnell, Ruth
McGarry, Maria
McGimpsey, Kevin
McGlynn, John
McGlynn, Michael
McKay, Rob
McKee, Alan
McKeon, Belinda
McLennan, Oscar
McLeod, Jean
McManus, Colm
McMillan, Shirley
McNulty, Margo
McShane, Sheelagh
McSorley, Teresa
Meade, Declan
Meade, Paul
Meagher, Robert
Meaney, Roisín
Melville, Derek
Mestres, Albert

Mimnagh, Lorraine
Mims, Amy
Minnock, Kate
Moffat, Sarah
Morkuniene, Asta
Morrison, Conall
Mullen, Marie
Murfi, Mikel
Murphy, Réiltín
Murphy, Valerie
Nash, Tanya
Neave, Elizabeth
Ní Mhóráin, Bríd
Ní Riain, Ailis
NicAodha, Colette
NicCoitir, Sinéad
Nocter, Jimmy
Ó Baoighill, Pádraig
Ó Conaire, Brendan
Ó Conchúir, Fearghus
Ó Cuilleanáin, Cormac
Ó Riordáin, Cathal
O'Brien, Martin
O'Brien, Maura
O'Connell, Helen
O'Connell, Kevin
O'Connor, Eimear
O'Connor, Joseph
O'Dea, Maureen
Odin, Jacqueline
O'Donnell, Lyn
O'Donnell, Mary
O'Donoghue, Martin
O'Donoghue, Mary
O'Hanlon, Eleanor
O'Hanlon, Jim
O'Hehir, Debi
O'Kane, Marianne
O'Leary, Jane
O'Mahony, Ann
O'Mahony, Deirdre
O'Neill, Charlie
O'Reilly, Audrey
O'Reilly, Christian
O'Reilly, Jacinta
O'Reilly, Johnny
O'Reilly, Monica
O'Toole, Jim
Oxley, Lisa
Panttaja, Erin Marie
Perry, Kate
Pharaoh, Ashley
Phelan, Paula
Pierce, Janet
Pinder, David
Power, Edward
Price, Stanley
Pybus, Christine
Rafferty, Aran
Read, Michelle
Reidy, Ger
Richardson, Heather
Riedel, Jana
Robertson, Robin

Robinson, Brian
Robinson, Priscilla
Roper, Mark
Ryan, Breda
Schuenke, Christa
Shaffrey, Cliodhna
Sharkey, Siobhán
Sheehy, Wayne
Silberman, Brian
Sloan, David
Smith, Sydney Bernard
Smyth, Phil
Spence, Patrick
Sprackland, Jean
Stack, Danny
Steffen, Heike
Stewart, Norma
Sweeney, Richard
Symes, Derval
Tauragiene, Violeta
Thiessen, Gesa
Thomas, Maggie
Thompson, Esmé
Thornton, Corina
Tiger, Susan
Toolan, Donal
Valk, Steve
Vedres, Anita
Vedres, Clodagh
Verlaque, Amanda
Vernon, Carolyn
Vollath, Norbert
Walsh, Enda
Walshe, Jennifer
Waters, John
Watkins, Neil
Watson, Tony
Weir, Liz
White, Adrian
White, Trevor
Whybrow, Graham
Winters, Jennifer
York, John

2005
Aceto, Federico
Adams, David
Agnew, Stewart
Allen, Page
Almeder, Melanie
Anderson, Carmel
Archbold, Elizabeth
Ardiff, Karen
Armstrong, Jacqueline
Aron, Ger
Atkins, Chris
Baker, Melanie
Banks, Margo
Barlow, Anne
Barrett, Pauline
Barrett, Sheila
Barry, Aideen
Beattie, David
Bellew, Ali

Bengtson, Kathrina
Benson, Eithne
Berner, Urs
Blackman, Jackie
Blake, Stasia
Blayds, Stephen
Boland, Gerry
Boland, Rosita
Bond, Kate
Botsford Fraser, Marian
Bourke, Gerard
Bourke, Marie
Bowden, Debra
Bowman, Deveren
Boyd, Alan
Boyle, Barbara
Bradley, Marian
Braun, Renate
Brennan, Joe
Brett, Heather
Bryce, Colette
Bunbury, Turtle
Burke, Alison
Burns, Paul
Burns, Ursula
Bussolo, Emiliano
Butler, David
Butler, Eoin
Byers, Johnny
Campbell, Helen
Carlotta, Ioanna
Carolan, Stuart
Carswell, Jaimie
Casement, Leo
Clarke, Rhona
Clarke, Victoria
Cleary, Brendan
Coffey, Seán
Colreavy, Seamus
Commiskey, John
Conlon, Declan
Connolly, Susan
Copus, Julia
Corrigan, Caoimhín
Cotter, Margaret
Coyle Greene, Enda
Coyle, Pádraig
Craig, Michael
Cranitch, Ellen
Crawford, Barbara
Creighton, Jane
Cullivan, Yvonne
Cunningham, Paula
Curtin, Brenda
Dalton, Helen
Daly, Fiona
Daniels, Huw
Deane, Raymond
Deegan, Loughlin
Deegan, Sheila
Delaney, Bryan
Delaney, Eamonn
Dempsey, Kate
Desmond, Yvonne

Dintinjana, Mia
Doherty, Isobel
Doherty, Pat
Donlon, Pat
Donohue, Dave
Dougherty, Judith
Dowling, Vincent
Downey, Michael
Doyle Kennedy, Maria
Doyle, Roger
Duff, Sheelagh
Duffy, Martin
Duggan, Brian
Duggan, Dave
Duley, Mark
Durin, Aoife
Duyn, Corina
Earley, Brendan
Egan, Eilis
Egan, Jo
Egan, Maura
Elsafty, Roisín
Ennis Price, Barbara
Fairleigh, John
Farmer, Beverley
Feehily, Stella
Fitzgerald, Ann
Flegg, Aubrey
Forester, Catherine
French, Mel
Fuller, Janice
Fullerton, Raymond
Gallagher, Djinn
Gallagher, Ger
Gallwey, Maria
Gaughan, Marilyn
Gibney, Simon
Gildea, Ann
Gilsenan, Alan
Girvan, Deborah
Gleeson, Paula
Glynne, Rachel
Gordon, Dan
Graham, Brendan
Greene, Declan
Grehan, Mark
Grimes, Angie
Grimes, Conor
Groener, Anita
Guilfoyle, Ronan
Halligan, Liam
Hallinan Flood, Frank
Halton, Pauline
Hardie, Sean
Harding, Michael
Hardy, Philip
Harper, Catherine
Harrington, Elaine
Harris, Robbie
Harrison, Noelle
Harrold, James
Hay, Andy
Hayes, Martin
Hearne, Kate

Hegarty, Neil
Hennessy, Carolyn
Hill, Tobias
Hoffer, Susan
Holmes, Jill
Hone, Joseph
Hooghiemstra, Tjibbe
Hopkins, Bernadette
Horgan, Conor
Huggett, Monica
Hundere, Guy
Hynes, Aidan
Ingoldsby, Maeve
Jackson, Mary
Jacob, Lucinda
Jamie, Kathleen
Jankel, Annabel
Johnson, Liz
Johnston, Joan
Jones, Marie
Joyce, John
Jungerson, Christian
Keane, Mary
Kearney, John
Keenan, Marita
Kelly, Brian
Kelly, Rosemary
Kennan, Pat
Kennedy, Brian
Kennedy, Kieran
Kennelly, Maureen
Kenny, Gillian
Kenny, Orla
Keown, Mary T.
Kerr, Rachel
Kerr, Tim
Kilgallon, Noel
Kinahan, Deirdre
Kinirons, Michael
Kirkpatrick, Kathryn
Kostreva, Natalya
Kripz, Nathan
Kroll, Jeri
Lambert, Kenneth
Lawlor, John
Leahy, Ann
Leal del Ojo, Alfonso
Lennon, Kym
Lentin, Louis
Linehan, Conor
Lovett, Ann
Lynch, Gerry
Lynch, Martin
Lyons, Alice
MacAnnaidh, Seamus
Maccici, Vlad
MacConghail, Fiach
MacGiolla Bhríde, Eoghan
Mackenzie, Lauren
Madden, Christine
Maginn, Carmel
Mahkota, Tina
Majuaric, Anya
Mannion, Siobhán

Martin, Neil
Mason, Sheelagh
Mayock, Emer
McAdam, Trish
McAuliffe, Mary
McBurley, Helen
McCannon, Billy
McCarthy, Kevin
McCartney, Annie
McCaughtry, Anna
McConville, Bríd
McCormack, Sarah
McCormack, Selma
McCrory, Margaret
McDaid, Laura
McDevitt, Mo
McDonnell, Melissa
McDonnell, Ruth
McDowell, Lorraine
McGarry, Maria
McGlynn, Michael
McGowan, Pauline
McGrath, Billy
McGuinness, Katy
McHugh, Eina
McHugh, Ruth
McKay, Allison
McKay, Deirdre
McKee, Alan
McKenna, Patricia
McKinney, Heather
McLeod, Jean
McLoughlin, Mags
McManus, John
McPartland, Mary
McPeake, Francis
Meade, Paul
Meagher, Robert
Meagher, Sheena
Meaney, Liz
Melville, Derek
Melville, Jenny
Minish, Susan
Mitchell, Conor
Moddell, Peter
Moffat, Sarah
Moroney, Anne-Marie
Morrison, Conall
Moynihan, Áine
Mulhair, Michelle
Murphy, Fergus
Murphy, Martina
Neave, Elizabeth
Ní Bhroin, Áinín
Ní Chonchúir, Nuala
NicAodha, Colette
NicCoitir, Sinéad
Nica, Radu
Nichol, Jock
Noonan, Mary
Norling, Beth
Ó Cléirigh, Éamon
Ó Domhnaigh, Micheal
Ó Gráda, Cormac

O'Brien, Maura
O'Clery, Joan
O'Connell, Helen
O'Connell, Kevin
O'Connell, Sandra
O'Connor, Eimear
O'Dea, Jennifer
O'Donoghue, David
Oeser, Hans-Christian
Ofstad, Knut
O'Halloran, Mark
O'Hare, Helen
O'Hehir, Debi
O'Herlihy Dowling, Olwen
Okamura, Kusi
O'Kane, Paddy
O'Kelly, Donal
O'Meara, Ursula
Ó Neachtan, Seosamh
O'Neill Jamie
O'Neill, Charlie
O'Neill, Elizabeth
O'Neill, Maura
O'Reilly, Audrey
O'Reilly, Jacinta
O'Toole, Jim
Parker, Lynn
Perry, Kate
Phillips, Áine
Pierce, Janet
Power, Edward
Price, Stanley
Pybus, Christine
Rafferty, Aran
Read, Michelle
Regan, Morna
Reuben
Richards, Tom
Richardson, Heather
Riordan, Arthur
Robinson, Brian
Robinson, Malachy
Robinson, Priscilla
Roper, Mark
Rosenstock, Gabriel
Rosenteel-Savalla, Christine
Rudolf, Ewa
Sadowski, Andrei
Scannell, Ray
Schuenke, Christa
Schneider, Heribert
Schulenberg, Melissa
Schwendinger, Laura
Scott, John
Sheil, Conor
Sloan, David
Sorrell, Martin
Spain, Karl
Stafford-Clark, Max
Steffan, Heike
Sweeney, Richard
Tavakoli, Lynda
Taylor, Sean
Thomas, Maggie

254

Tibbell, Hannah
Townsend, Ian
Turley-McGrath, Mary
Turner, Lucy
Valderrey, Eduardo
Varrelmann, Claus
Vedres, Anita
Vedres, Carla
Vedres, Clodagh
Villaró, Albert
Vitanen, Annu
Vogl, Richard
Walsh, Dermot
Waters, John
Watkins, Neil
Weil, Marianne
West, Michael
Whelan, Geraldine
Whelan, Olive
White, Adrian
White, Ali
White, Victoria
Whitworth, Valerie
Whybrow, Graham
Wichert, Sabine
Wickham, Steve
Wingfield, Ann
Wingfield, Leslie
Woodcock, Martha

2006
Alda, Enrique
Aranzasti, Iñigo
Arruti, Rosa
Aston, John
Banks, Margo
Binchy, Sarah
Bogue, Anne
Boland, Gerry
Boland, Rosita
Bolger, David
Bourke, Marie
Bowen, Christine
Boyle, Maureen
Brady, Anne
Breatnach, Cormac
Breatnach, Linda
Bunbury, Turtle
Burns, Ursula
Burrowes, Norma
Byers, Jonny
Byrne, Deirdre
Cahill, Brona
Caldwell, Lucy
Carman, Cathy
Charvát, Radovan
Clare, Mark
Clarke, Victoria
Coffey, Seán
Comanescu, Denisa
Commiskey, John
Conway, Zoe
Corry, Julia
Cosby, Peter

Cotter, Frances
Coyle Greene, Enda
Cruickshank, Peggy
Cullen, Carmen
Cullen, Leo
Cullivan, Yvonne
Dáibhís, Bríd
Dawson, Eleanor
de Pracontal, Mona
Dedourge, Rapahelle
Delaney, Bryan
Dempsey, Kate
Deniard, Cécile
Dennis, Cormac
Desmond, Yvonne
Devaney, Daragh
Dillon, Mary
Doherty, Pat
Donlon, Pat
Donnelly, Mary
Donohue, David
Donovan, Dave
Donovan, Katie
Dormer, Richard
Dowdall, Leslie
Dowling, Vincent
Downey, Michael
Duff, Claire
Duffy, Francis
Duggan, Brian
Duggan, Dave
Duggan, Gary
Dunbar, Seamus
Dunlea, Martin
Durnin, Aoife
Fairleigh, John
Farrell, Antony
Farrell, Connie
Fastner, Irene
Ferguson, David
Finnegan, Brian
Fullop, Peter
Gallagher, Ger
Gavron, Assaf
Ginnane, Matthew
Grimes, Conor
Guilfoyle, Ronan
Halpin, Sarah
Hannan, Greg
Harper, Jamie
Harrington, Elaine
Harrington, J.J.
Haslett, Andrew
Hassett, Sue
Hearne, Kate
Hegarty, Neil
Hellwig-Schmidt, Regina
Higgins, Judith
Horgan, Conor
Huggett, Monica
Hynes, Aidan
Ingoldsby, Maeve
Irish, Margaret
Jameson, Alison

Jenkinson, Rosemary
Jimenez, Jorge
Johnston, Joan
Jolley, Paddy
Jones, Marie
Joyce, John
Joy, Breda
Keane, Mary
Kelly, Hugo
Kelly, Nick
Kennedy, Kieran
Keogh, Garrett
Keys Colton, Ann
Kinahan, Deirdre
Kolle, Dorothy
Kotani, Akiko
Kramer, Sheila
Laird, Nick
Lambert, Ken
Leal del Ojo, Alfonso
Lennon, Ciarán
Lennon, Kym
Linehan, Conor
Lowe, Louise
Lowry, Miles
Lynch, Gerry
Lyons, Michael
MacLeod, Anna
Maguire, Tom
McCannon, Billy
McCarthy, Charlie
McCarville, Denis
McClure, Shirley
McCormack, Gigi
McCormack, Selma
McDonnell, Ruth
McDwyer, John
McGarry, Maria
McGill, Annie
McGinley, Ruth
McGlynn, Michael
McGuinness, Katy
McHugh, Eina
McKay, Allison
McKee, Alan
McMahon, Sarah
McManus, Maria
McPhillips, Áine
Meade, Paul
Meagher, Sheena
Michel Long, Adrienne
Mioni, Anna
Moddell, Peter
Morrison, Conall
Mosse, Richard
Mulcahy, Lisa
Murfi, Mikel
Murphy, Fergus
Murphy, Gerard
Murphy, Mary
Murray, Brendan
Nesbit, John
Ní Chonchúir, Nuala
NicCoitir, Sinéad

Ó Cathaoir, Brendan
Ó Tuairisg, Darach
O'Brien, Laoise
O'Donoghue, David
Ofstad, Knut
O'Hehir, Debi
O'Herhily Dowling, Olwen
O'Kane, Marianne
O'Neill, Charlie
O'Neill, Maura
O'Reilly, Liam
O'Rourke, Kathleen
O'Sullivan, Amanda
O'Toole, Jim
Potter, Noreen
Prelipceanu, Nicolae
Proud, Malcolm
Rafferty, Aran
Robinson, Brian
Schneider, Jurgen
Schuenke, Christa
Schwendinger, Laura
Sloan, David
Sloan, Victor
Sweeney, Richard
Tauragiene, Violeta
Thomas, Maggie
Traynor, Des
Tuhkanen, Marja
Vardi, Brigitta
Varrelmann, Claus
Vedres, Clodagh
Vedres, Anita
Vedres, Carla
Villaró, Albert
Waters, John
West, Michael
Weston, Gavin
Whelan, Geraldine
Whelan, Nicola
Whybrow, Graham
Wilcock, Mike
Williams, Peter
Wright, Debi

**By kind permission
of the author**
'Mock Orange' by
Melanie Almeder
'Maggie's Cottage' by
Leland Bardwell
'Lines for the Centenary
of the Birth of Samuel
Beckett (1906-1989)' and
'Perdu'
by Paul Muldoon
'Feis' by Nuala Ní
Dhomhnaill
Shaft by Anne Enright
Salt by Claire Keegan
with my lazy eye by
Julia Kelly
Say Could That Lad Be I? by
Mary Lavin by kind
permission of the Lavin
family
The Tea Set by Gina Moxley
The Catechism Examination
by Eilís Ní Dhuibhne

**By kind permission of
The Abbey Press**
'Swan House' by Mark
Roper from *The Home Fire*
(1998)

**By kind permission
of Bloodaxe Books**
'Anything is Better than
Emptying Bins' by Rita Ann
Higgins from *Throw in the
Vowels* (2005)

**By kind permission of
The Dedalus Press**
'Wordsworth was Right'
by John Jordan from
Collected Poems (1991)
'Release Papers' by Macdara
Woods from *Stopping the
Lights in Ranelagh* (1987)
'Poems for Breakfast' by
Enda Wyley from *Poems for
Breakfast* (2004)

**By kind permission
of Faber & Faber**
'Cuttings' by Nick Laird
from *To a Fault* (2005)
and from
Portia Coughlan by
Marina Carr (1996)
*Observe the Sons of Ulster
marching towards the Somme*
by Frank McGuinness
(1986)
Our Fathers by Andrew
O'Hagan (1999)
The Swing of Things by
Sean O'Reilly (2004)

**By kind permission
of The Gallery Press**
'Flight Paths' by Rosita
Boland from *Dissecting the
Heart* (2003)
'Viol' by Moya Cannon from
The Parchment Boat (1997)
'The Seamstress' by Harry
Clifton from *Comparative
Lives* (1982)
'The Stone Grove' by Peter
Fallon from *News of the
World* (1998)
'Maize' by Vona Groarke
from *Flight* (2002)
'Muince Dreoilíní' by
Michael Hartnett from
Necklace of Wrens (1987)
'After Pasternak I & II' by
Derek Mahon from *Collected
Poems* (1999)
'Passages' by Aidan Carl
Mathews from *Minding Ruth*
(1983)
'Playing House' by Paula
Meehan from *Pillow Talk*
(1994)
'History Walk' by John
Montague from *Collected
Poems* (1995)
'Ferryboat' by Eiléan Ní
Chuilleanáin from *The
Second Voyage* (1986)
'Desire' by Peter Sirr from
Selected Poems (2004)

**By kind permission of
The Harvill Press**
'Elvira Tulip,
Annaghmakerrig' by Paul
Durcan from *Greetings to our
Friends in Brazil* (1999)
and from
The Bend for Home by
Dermot Healy (1996)

**By kind permission of
Jonathan Cape**
'Ceasefire' by Michael
Longley from *The Ghost
Orchid* (1995)

**By kind permission of
The Lilliput Press**
Maidenhair by Tim
Robinson from *Stones of
Aran: Labyrinth* (1995)

**By kind permission
of Methuen**
from
The Gigli Concert by Tom
Murphy (1994)

**By kind permission
of New Island**
'The Lover' by Anthony
Cronin from *Collected Poems*
(2004)

**By kind permission
of Picador**
'Tryst' by Robin Robertson
from *Slow Air* (2002)

**By kind permission
of Penguin Books**
from
How Many Miles to Babylon?
by Jennifer Johnston (1988)
Nothing Simple by Lia Mills
(2005)
The South by Colm Tóibín
(1992)

**By kind permission of
The Raven Arts Press**
from
Last of Deeds by Eoin
McNamee (1989)

**By kind permission of
Secker & Warburg**
from
The Newton Letter by John
Banville (1982)

**By kind permission of
Sinclair & Stevenson**
Last of the Mohicans by
Joseph O'Connor from
True Believers (1991)

**By kind permission of
The Vintage Press**
from
One Day as a Tiger by
Anne Haverty (1997)
Sixty Lights by Gail Jones
(2004)

**By kind permission of
Weidenfeld & Nicolson**
from
Dancer by Colum McCann
(2003)

The Staff

Bernard Loughlin
Mary Loughlin
Doreen Burns
Ann McGuirk
Ingrid Adams
Fred McKenna
Seán Clerkin
Yvonne Toman
Lavina McAdoo
Teresa Rudden
Regina Doyle
Valerie Waters
Marion Gentilhomme
Orla Kennedy
Gráinne Miller
Karen Hennessy
Teddy Burns
Mary Clerkin
Marcella Leonard
Sheila Pratschke
Martin McCaffrey
Denise Burns
and many FÁS workers.

First published November 2006
by THE LILLIPUT PRESS LTD
62–63 Sitric Road, Arbour Hill,
Dublin 7, Ireland
www.lilliputpress.ie

in association with
The Tyrone Guthrie Centre,
Annaghmakerrig,
Newbliss, Co. Monaghan
www.tyroneguthrie.ie

Art direction, typography and book design
Anne Brady, Vermillion Design
Print and production management
www.vermilliondesign.com

Photography: Richard Mosse
with Radek Charvát, Suzanna Crampton,
Conor Horgan, Miles Lowry and Jonathan Pratschke

End papers: Michael Craig
Botanical illustration (p.218): Wendy Walsh

A CIP record for this title is available from
The British Library

ISBN 1 84351 090 1
(after Jan. 2007) 978 1 84351 090 1
Limited Edition: ISBN 1 84351 091 X
(after Jan. 2007) 978 1 84351 091 8

The Lilliput Press receives financial assistance from
An Chomhairle Ealaíon / The Arts Council of Ireland

The Tyrone Guthrie Centre receives financial assistance
from An Chomhairle Ealaíon / The Arts Council of Ireland
and from The Arts Council of Northern Ireland

Set in Jenson, Caslon Expert and Frutiger

Printed by Estudios Gráficos Zure, Bilbao

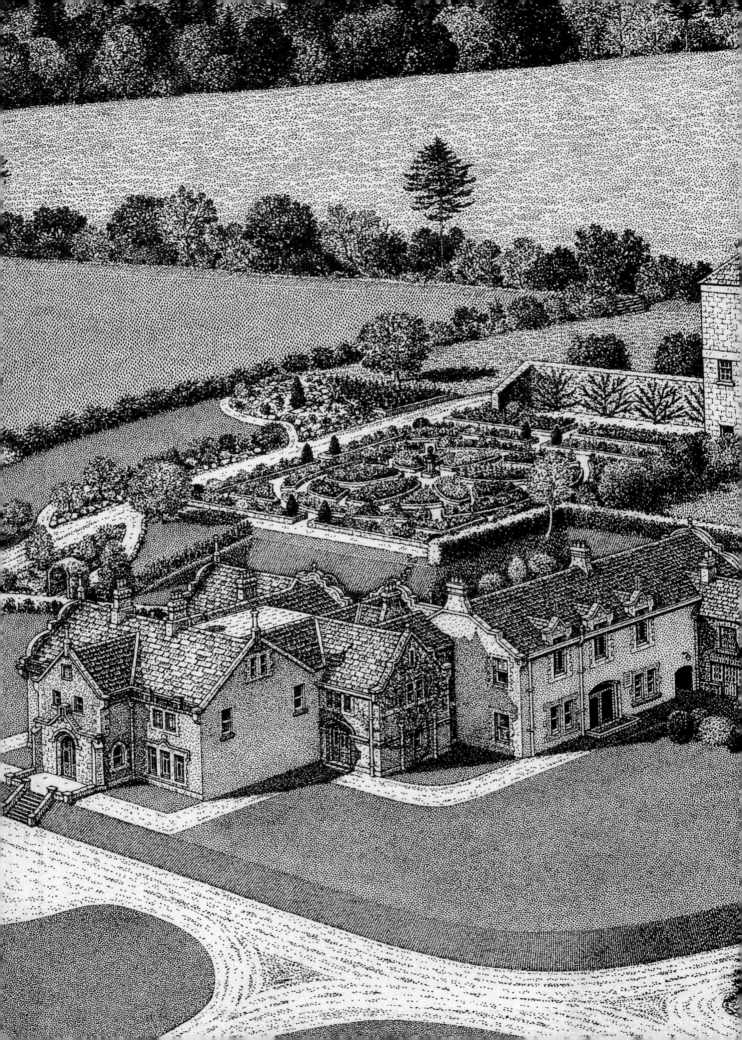